From Daughters & Sons
TO FATHERS
WHAT I'VE NEVER SAID

From Daughters & Sons
TO FATHERS
WHAT I'VE NEVER SAID

Edited by Constance Warloe

Preface by Sydney Lea

STORY LINE PRESS
Ashland, Oregon

Copyright 2001 by Constance Warloe
Each author retains copyright to her/his individual letter.

First Printing

Published by Story Line Press, Three Oaks Farm, PO Box 1240, Ashland, OR 97520-0055 / www.storylinepress.com

This publication was made possible thanks in part to the generous support of the Andrew W. Mellon Foundation, the Oregon Arts Commission, and our individual contributors.

Book design and cover photograph by Lysa McDowell
Cover photo: "A Day To Remember," Story Line's publisher and his son at the end of a brilliant day of kite-flying at Three Oaks Farm.

Library of Congress Cataloging-in-Publication Data

> From daughters & sons to fathers: what I've never said / edited Constance Warloe; preface by Sydney Lea.
> p. cm.
> ISBN 1-58654-003-3
> 1. Father and child—United States—Case studies. 2. Authors, American—Family relationships—Case studies. 3. Authors, American—Correspondence. 4. American letters.
> I. Title: From daughters and sons. II. Warloe, Constance.

HQ755.85.F77 2001
306.874'2—dc21 2001020711

When 82 writers stay with a project that first began in 1996 but did not go into print until 2001, saying thank you seems pitifully inadequate. Yet I do thank each of the contributors here for their extraordinary loyalty to this project and for the extraordinary letters they have written. I have been keeping very good company, but they do not really feel like company any more. We're family now.

I thank my father, Harlan Goodwin Bower, and all our fathers. I have dedicated this book to them.

Many of the men writers in this collection were referred to me by women writers from the first volume in this series: *From Daughters to Mothers: I've Always Meant to Tell You*. I find myself expressing my appreciation in this collective way because I've long since lost track of their generous calls, their notes with names and addresses, their enthusistic comments: "You just have to ask..." Thank you for access to writers I would never have found and for letters that would not have been written.

For their help at various stages in this often delayed process, I wish to thank June Vargas, Lynn Doiron, Roger Warloe and Marvin Brams. They've done the practical things that kept me, and the project, going: typing, xeroxing, data-basing, cutting, pasting, stamping, mailing. In addition, my thanks to *Sacramento Bee* photographer Dick Schmidt for his help with hazy photographs. It's been a cottage industry where the "employees" are seldom paid. I am deeply indebted, also, to Sydney Lea, who agreed to write the Preface but also cheered me on when I most needed it.

Thanks once again to my agents, Laurie Fox and Linda Chester, who tried their best to sell this project to the major publishing houses, tried to the point of becoming a faint buzzing in the ears of New York editors, being told they were getting "a bit pushy" with this project, weren't they? They are my believers, always.

Finally, with Robert and Lysa McDowell and their fine staff at Story Line Press, who have seen this dream through to reality, we raise our glasses high and say, Cheers! Hallelujah! Mazeltov! *From Daughters and Sons to Fathers: What I've Never Said."* Amen.

Constance Warloe
Cambridge, MA
March, 2000

From Daughters & Sons

TO FATHERS
WHAT I'VE NEVER SAID

PREFACE .. xv
 True Gothic
INTRODUCTION ... xix
 The Mercy of Fathers
ART BECK .. 8
 Not My Face, But Yours
CHRIS BELDEN ... 14
 Home Movies
MEG BELICHICK ... 19
 Metasearch
MARVIN BELL .. 26
 In Memory of H.G. Grand (5–10¢ to $1.00)
PINCKNEY BENEDICT ... 32
 The Day the Silo Came Down
SALLY RYDER BRADY .. 38
 Rounding the Curve
IANTHE BRAUTIGAN ... 43
 Montana
RITA MAE BROWN ... 47
 On My Best Days
DON MEE CHOI .. 50
 Ink Blossoms
JUDITH ORTIZ COFER .. 53
 Marinero
WANDA COLEMAN .. 55
 For Dad, On What Would Have
 Been His 84th Birthday

An Anthology of Letters

From Daughters & Sons

RAND RICHARDS COOPER .. 59
 Material Men

NICHOLAS DELBANCO ... 65
 What You Carry

LYNN DOIRON .. 69
 Stone Wall in Cottonwood

TESS ENROTH ... 74
 To the Lonesome Cowboy

LESLIE FIEDLER ... 79
 To My Father

ANNIE FINCH ... 81
 Elegy for My Father

SESSHU FOSTER .. 85
 Something Else

JOAN FRANK .. 93
 A Secret Life

DONALD FREAS .. 98
 Father in the Mill

LYNN FREED ... 104
 Not Much of a Funeral

ALBERT GARCIA .. 108
 On Making Wood

SONIA GERNES ... 111
 Two Dreamers

MARC J. GOULET ... 116
 Kilojoules and Coulombs; Brick and Art

JAN HAAG .. 121
 Dateline: Granite Bay

PHEBE HANSON .. 127
 Close Call

JOY HARJO ... 131
 The Vulnerable Architecture of Memory

An Anthology of Letters

From Daughters & Sons

LOLA HASKINS .. 136
 Daddy, 1959
MARY HEBERT .. 139
 Summer Shoes
CRAIG HEVERLY ... 144
 A Further Fanfare for the Common Man
RICK HILLIS ... 149
 Riding Shotgun with a Family Man
KATHRYN HOHLWEIN ... 154
 Circling at Umbria
GARRETT HONGO ... 159
 Let Me Go
JAMES HOUSTON ... 162
 Mirrors of Kinship
ALEXANDRA JOHNSON ... 167
 There. Not there.
LAURA KASISCHKE ... 171
 Dear Fire
SUSAN KELLY-DEWITT .. 174
 Nitro Moons
HARRY W. KENDALL .. 179
 Folly Music
JAMES KILGO .. 184
 Off to a Great Start
SYDNEY LEA ... 188
 That Little Boy You're Holding
ANNE D. LE CLAIRE ... 195
 In Brief: Dispatches from a Daughter
MARY MACKEY .. 198
 The Big Seal
DALE MAHARIDGE ... 201
 Winter Morning, 1963

An Anthology of Letters

From Daughters & Sons

NJOKI MC ELROY ... 205
 Episodes
JOHN MC KERNAN .. 211
 Letter for My Father
PABLO MEDINA ... 214
 Letter for My Father
E. ETHELBERT MILLER ... 218
 Daybreak
JUDSON MITCHAM .. 223
 This Morning
JIM MOORE ... 225
 Just Like *Casablanca*
PAMELA MOORE ... 229
 Meeting My Father After Many Years
DAVID MORSE ... 233
 You Dance Outside My Frozen Images of You
MIRIAM MORSEL NATHAN ... 238
 Such a Beautiful World…
NAOMI SHIHAB NYE ... 242
 The Orange, the Fig, the Whisper of Grapes
JOYCE CAROL OATES ... 247
 To My Father: What I've Never Said
CAROLE SIMMONS OLES ... 250
 Traced With Your Longing
WILLIAM O'ROURKE .. 254
 Us Together, Alone
LINDA PASTAN .. 259
 Letter to a Father
DAWN RAFFEL ... 261
 Further Adventures in the Restless Universe
KEITH RATZLAFF ... 265
 Letters

An Anthology of Letters

From Daughters & Sons

ANNIE REINER ... 269
 Century City Hospital
SCOTT RUSSELL SANDERS ... 273
 Father Inside
STEPHEN SANDY ... 279
 Letter to my Father: Decoy
GREG SARRIS .. 284
 Your Blue-Eyed Son
HAROLD SCHNEIDER ... 290
 Into the Love
JOHN SEARLES .. 293
 Second Life
DAVID SHIELDS .. 297
 Life & Art
LOUISE FARMER SMITH .. 300
 Memo
DONNA BAIER STEIN ... 302
 Indirect Marketing
MICHAEL STEIN .. 306
 A Sliver from Your Life
SHARAN STRANGE ... 311
 In This Now I am Living
AUSTIN STRAUS .. 314
 Small Talks with My Father
ARTHUR STRINGER .. 319
 Reiterations: A Letter to My Father,
 with Stories and Poems
JERVEY TERVALON ... 324
 Hurrying Home
JOHN THORNDIKE ... 327
 Broken Hearts, Emotions and Feelings
ALMA LUZ VILLANUEVA ... 332
 You Always Brought Me Water in the Desert

An Anthology of Letters

From Daughters & Sons

CONSTANCE WARLOE ... 340
 Time-Share
WILLIAM WHARTON .. 349
 Interruptions
MARGARET ROSE WITHERS .. 353
 Ragged Mountain Dream
HILMA WOLITZER ... 359
 The Good Daughter
IRENE ZABYTKO .. 364
 Fall Off From a Good Horse
MARY ZEPPA ... 368
 Hello! from the first-born, the black sheep
FEENIE ZINER ... 372
 The Same Stars

WRITING TO YOUR FATHER
 Tips For Getting Started .. 378

A NOTE TO BOOK GROUPS & WRITING GROUPS 381

An Anthology of Letters

PREFACE

TRUE GOTHIC

"Gothic art is sublime. On entering a cathedral, I am filled with devotion and awe; I am lost to the actualities that surround me, and my whole being expands into the infinite...the only sensible impression left is that 'I am nothing.'"

—Samuel T. Coleridge

Anthologies with thematic intention have a double mission: by way of acknowledging their theme, they must be somewhat reiterative; yet, in order to avoid mere redundancy, their every installment needs freshness, originality and—in the best sense—eccentricity. Constance Warloe's collection admirably accomplishes that double mission.

When Ms. Warloe approached me about writing a preface to *From Daughters and Sons to Fathers: What I've Never Said*, she not quite casually observed that a noticeably large number of her writers had something to say about their male parent's hands. Such a fact might have impelled me to vulgar sociology, simplist generalization. It would be easy, too easy, on one hand (the pun seems inevitable) to conclude that men are given to self-manifestation in a physical way. Yet how relate such a reduction to the widely held notion that the tactile, the hands-on, the intimate is more peculiarly a maternal/womanly trait? Or is it that there's the physical and the physical, the male version assertive, even on occasion assaultive, the female more assuring?

As I ponder the contents of this volume, I am more than ever convinced that no single woman is "women," no single man "men." (Likewise, then, there are no "fathers" as a category.) The artists who contribute to the following book are, each and all, discrete and, again, eccentric individuals. So are their fathers, whose hands do show up with curious regularity; sometimes those hands are gentle, sometimes rough.

Often, tellingly, they are both.

The fact of touch may indicate a common thread in this collection; the fact proves as complex, however, as human beings do. We will here confront works by authors whose fathers made their ways and their livings by the actual and frequently dangerous application of hand to task; there are likewise works by authors who were raised with every conceivable middle-class privilege. There are people from the traditionally dominant cast and color of American society; there are representatives of other castes and colors. There are of course male and female writers in the following pages.

Given such multiplicity, the most I can confidently say is that each contributor here has in every sense been touched by his or her father. What each makes of such a matter is, to the anthology's (and the reader's) immense benefit, idiosyncratic. In that measure, the book may actually transcend its own apparent thematics and tell us something about the human imagination.

On reading *From Daughters and Sons to Fathers*, it occurred to me, vividly, though not for the first time, that whatever our chosen genres, writers are forevermore trying to Get It Right—and failing. That's why we write more than one essay or poem or story or book. Ours is in many ways a constant process of inadequate revision.

The lives we lived as children, which is to say the lives we yet live, childhood being a haunt that as real children we never imagined it would be, those very lives are also subject to the revisionary process, and they turn out to be overwhelmingly hard to chart in retrospect, as any writer in this volume could testify.

How explain such difficulty? As the ones who have lived our own pasts, should we not be flawless witnesses to them? But, just as the figure of the hand is at once an altogether ubiquitous and ambiguous one in the pages ahead, so is the presence (or sometimes the absence) of any author's father, whatever his race, or class. Like everything else, our views of our fathers are constantly subject to redaction: we dream of some synoptic account of where we've been, what we are doing, where we will go. It is inevitable that the male parent should have much to do with such dreaming. And yet, if literature really has anything seizable to teach us about human life (a matter now under skeptical scrutiny by trendy academicians), it may be that both enterprises are labyrinthine, rife with contradiction. We speak certain truths, and in the process edit out all manner of other truths.

Similarly, as these authors demonstrate in their widely various ways, we recognize that the qualities we most admire in a parent may have their darker aspects. And vice versa. The hand that soothed our brows in last night's sickbed may today fetch us the slap we'll never forget. The giant gulping his booze in the darkened kitchen may, when morning comes, be the longed-for slayer of other monsters.

From Daughters and Sons to Fathers addresses, poignantly, provocatively, diversely, at least one aspect of what Freud called The Family Romance. That romance is as multi-faceted and, for very good reason, ultimately as inconclusive as any literary romance, as any so-called "Gothic."

Gothic. In our time, the word has a bit of a pejorative ring for serious writers and readers. But the great Coleridge had a different take on the adjective; he knew on the one hand that the Gothic was designed to make us feel almost unbearably tiny, childlike in the frightening sense; on the other—and this is surely true of the present volume—the experience of Gothic sublimity could be enriching, stimulating, and thus, paradoxically, restorative of the spirit. There was something bracing in the notion that even (or perhaps especially) the most comfortable of bourgeois existences could be invaded by huge forces.

And make no mistake: the mildest father depicted in this volume is a huge and abiding force in his son's or daughter's estimation. My bet is that both the sense of radical diminishment and of regeneration will attend the reader's journey through the anthology at hand; it is true Gothic.

Sydney Lea
Newbury, VT
1998

INTRODUCTION

THE MERCY OF FATHERS

In the last lines of his recent play, *The Steward of Christendom*, Irish playwright Sebastian Barry paints a tender scene. The character based on Barry's great grandfather comes to a resolution about all the losses in his life by remembering his own father. The memory involves the father's decision to not kill his son's favorite dog after the dog has killed a valuable sheep:

> And he put his right hand on the back of my head, and pulled me to him so that my cheek rested against the buckle of his belt. And he raised his own face to the brightening sky and praised someone, in a crushed voice, God, maybe, for my safety and stroked my hair. And this dog's crime was never spoken of, but that he lived till he died. And I would call that the mercy of fathers, when the love that lies in them deeply like the glittering face of a well is betrayed by an emergency, and the child sees at last that he is loved, loved and needed and not to be lived without, and greatly.

The mercy of fathers: Reality for some. Fantasy for others. But known, somehow, by all of us. We recognize it when we hear it described. As if programmed into our psyches, some cellular residue in the ancient collective memory, the mercy of fathers is as much a longing as an experienced reality. That's certainly the case in Barry's play, for early on, the audience has heard evidence of the father's darker side, his violence toward his son:

> See this thumb? See the purple scar there? My own Da Da did that, with a sheath knife. What do you think of that? Do you want to see my back? I've a mark there was done with a cooper's band, and on a Sunday, too. But he loved me...

As with *The Steward of Christendom*, so too with this anthology of commissioned letters from writers to their fathers. The letters here show the willingness to be candid tempered by a reluctance

to bring down final value judgments—ambivalence and forgiveness at play in the fields of memory. We seem to be saying that in thinking about our fathers, we have had to think about the world that formed them. Maybe more than with our mothers, the mercy and the virtue of fathers come at a higher price, in smaller doses, for shorter periods of time, with different kinds of struggles and limitations along the way.

The very history of this book reflects our culture's ambivalence toward hearing narratives about men told by their grown children. Originally proposed as a sequel to my first anthology, *From Daughters to Mothers: I've Always Meant to Tell You*, this book was to be a collection of letters written by men writers to their fathers. But none of the large corporate publishers were interested. As one acquisitions editor told my agent, "There's no way in for the woman reader—and women buy the books."

I wanted to interpret the publishers' reluctance as the reflection of a true and healthy power shift in which women's stories are valued and esteemed, but I had to conclude that women were being valued simply as consumers in the bottom-line mentality of corporate takeovers. And I didn't have time, then, for further analysis of gender and the marketplace. I had over forty men writers committed to the project; I was not going to abandon them.

I now suspect that in the media-driven publishing world, there was a worry that gushing sentimental tributes would *not* rule the day. There might be letters more about absence than presence, more about disparity than commonality, more about violence than mercy, more about disappointment than a satisfaction of our longings for the love of fathers. Did marketing personnel wonder if such material expressed in letters might be too direct, addressing the authority figures we seldom addressed directly in our childhoods? And what *would* these letters tell, anyway? It couldn't be good! With shadows of regret and betrayal lurking around the edges, might these narratives be better left untold? Let the Father's Day gift buyers purchase their usual hunter-green-and-tan greeting cards, with drawings of ducks taking wing in the wetlands!

By the time my agents gave up on the major publishers in the fall of 1997, I had become convinced that an anthology with *both* women and men writing letters to their fathers actually would make a better book. For reasons that had less to do with filling publishers'

needs and had more to do with finding an inclusive and balanced perspective, I began inviting women writers to join the project.

So it was with the anthology's already long history trailing behind me that I sat down with Robert McDowell (Publisher of Story Line Press) in the Commons at Bennington College, late on a snowy afternoon in January 1998. He listened patiently and then took less than a minute to decide that he was very interested in *From Daughters and Sons to Fathers: What I've Never Said*. He never mentioned women book buyers, or men book buyers for that matter. He simply took the proposal to his editorial board. To my delight, Story Line became the publisher and the project took on its current shape.

The concerns expressed by some of the major publishers about possible "downer" letters may well have been validated on some of these pages. Many of the letters *are* as much about absence as about presence. Alexandra Johnson's letter to her father, "There. Not There," tells about a man who was seldom available to her and seemed real only at the end of his life, in the spotted x-rays that accompanied his death from bone cancer.

There are letters about near misses: Greg Sarris's letter, "Your Blue-Eyed Son," describes being adopted, discovering his Indian blood years later, and, after an abiding effort to find his father, learning just weeks after his father's death that they had been living only several blocks apart.

But there are also connections, letters that describe fathers and children who *did* make the journey together, who found a good measure of the mercy and humor and closeness that resides in all our longings for fathers. William O'Rourke's letter, "Us Together, Alone," provides an image of steadfastness in his description of pre-car-seat America—the 50s. During an outing when a neighbor was driving and his father held a younger brother in his lap, the passenger door flew open on a curve and his father and the brother rolled out, neither seriously injured:

> You never changed position…landing on the street, knees still bent, arms still locked around Terry, as you had become, many years before they were introduced, his human car safety seat… The image of you and your young son flying through the air has always been vivid in my mind…. I thought two things: one was that you were a hero. And two, I knew that you would have done the same if it had been years earlier and me in your lap. You would have never let me go, either,

never flung me out into peril. You behaved, I thought then, like a father. A man who could be trusted... That trust has never been violated, or that clear picture shattered of you my father, flying through the air, my dear dad.

In some poignantly vicarious way, we are all sitting in the lap of William O'Rourke's father, bumping out onto that perilous highway, held. It is the mercy of fathers.

So read on. You will find your father in these pages, or you will find the father you longed for. Maybe you'll find both. And as you read, you will find yourself seized by an itching of your fingertips, a rustling in your heart: you will want to write your own letter to your own father. You'll get out paper and pencil, or start the computer humming.

But I know—from the many readers' letters I received after the first volume of letters to our mothers—that you may feel at a loss as to just how to begin such a task. So I've made it easier for you to write that letter (I wasn't a teacher of writing for nothing!). I've included some Tips for Getting Started at the back of this book. I hope you find them helpful.

Read on. Write on. Express, as the title of this volume suggests, "What I've Never Said." Or say again what you've said many times before. And if you still find no words of your own, turn back to these letters. *From Daughters and Sons to Fathers: What I've Never Said* will say it for you.

With warm best wishes,

Constance Warloe
Contributing Editor

From Daughters & Sons TO FATHERS
WHAT I'VE NEVER SAID

ART BECK

Art Beck in his father Rudy's shadow. Chicago, 1945

Art Beck was born in Chicago in 1940. He lives in San Francisco with his wife of thirty-five years. He is the author of two books of poetry: *Enlightenment* (Red Hill, 1977), a long narrative poem based on the autobiography of Casanova, adapted for radio on KPFK, Los Angeles; and *The Discovery of Music* (Vagabond, 1977), a collection of shorter poems. A chapbook-length selection of poems also appeared in the 1981 Duckdown Press six-poet anthology, *NewWorks*. Translation books include *Simply to See* (Poltroon, 1990), selected poems of Luxorius, 6th century Latin poet, and an earlier chapbook, *Art Beck Translates Luxorius* (New York Book Arts, 1987). Magazine credits include *Alaska Quarterly Review, Painted Bride, Passages North* and many others. "Art Beck" is the pseudonym for a man who works in a corporate environment and once worked for a collection agency where his boss told him to pick a phony name because "no one's mother raised him to be a bill collector."

His father, Rudy, was born in Chicago in 1913.

NOT MY FACE, BUT YOURS

There's a photo of me, taken I think in 1945 or '46. I was 5 or 6 and the buttoned up suit and little man's hat I'm wearing are undoubtedly a new Easter Outfit. Even so, I can tell by the wince in my face and the way I'm clutching my collar that the Chicago winter had lingered. And by the long coats the shadows who took the photograph are wearing. Because, stretched out over me as I'm grimacing into that uncertain sun are long, distinct shadows of a man and woman. Your sister, Lisa thinks—possibly—that she and Paul took the photos. But she's not sure, and I've always felt those shadows have to be you and your Mother. One's aunts and uncles don't cast such serious shadows.

So much of early life is shadow. But the few disconnected things I do remember from those murky days are almost blindingly bright. I somehow remember lying in my cradle in a sunny room. Mother was singing and counting my fingers and toes. Later, I remember swinging between you and mother, holding your hands as we ambled down the street. That was when we all lived in Grandpa's four flat. I remember the marks on the door frame for each inch I grew and playing in the big attic with the stained glass windows and bare wood and turpentine smell. The constant party of aunts and uncles and Grandma

What I've Never Said

cooking. Kielbasa, capusta, chickens with true dark meat and pruney duck blood soup, czarnina. And your friends, coming from and going to the all-pervasive war.

Was it during the war that we used to visit your father in the State asylum at Dunning? The memories of those visits seem so fractured, like unconnected from the time I could still speak Polish. I remember a gentle, stubble cheek, foreign man, Remember sitting close to him on the green bench in what still feels like October sunlight, listening to his voice try to become precise, then slip back into confusion as he tried to speak English to me. But around the time the war ended—the visits stopped. Had he become violent, catatonic? As I grew older, we rarely talked about your father. He'd been hospitalized from the twenties, through the Depression, the war, and - then, the Cold War. The term un-person comes to mind. I realize now, we must have only stopped visiting because we gave up hope. As if he, too, were finally a casualty of war rather than his own troubled nature, as lost and defeated as any of the actual dead. At his funeral, people joked how madness and not having to work for a living had kept him young. How he didn't have a gray hair on his split-combed head at the age of 72. I was 16 when he died. I have two memories of his death. Grandpa Bolchawa walking up to open the casket at the wake and putting his callused big hand over Grandpa Bek's dead white hands, comforting him like an old friend whose troubles were finally over. And then, I remember returning from the cemetery with mother on the bus. We buried him on a weekday, and as soon as it was over, you went back to work. I especially distrust that memory. You must have taken the day off. But I've never asked. Over time, I learned some of the story. He was somewhat of a book reader, a cut from the neighborhood's transplant farm hands. The treasurer of his Polish club. A good father to his six kids. But, a drinker like all of them and, like some of them, a fighter. Lisa remembers two of his club members bringing him home one morning unconscious, with his head smashed. You once said you vaguely remember him moving around the house, becoming sadder and sadder, then, finally, very quiet. But how reliable are your memories? You weren't much older than 5 or 6 yourself. What you do remember—what you've never been able to forget—is the Depression. The family barely surviving. Your mother scrubbing floors for a living. You, proudly, getting a job as a rat catcher in a Polish butcher shop. Piece work. A dime for every rat you suffocated with burning newspaper in a scratched metal garbage can. And

then you got the job that you'd keep for fifty years. The job at the bank that somehow kept you home with me and mother, classified as "essential to the war effort." The job you'd finally retire from as a full vice-president with 2000 people under you. How did you ever get hired? Some pull from your precinct captain? A favor redeemed by a neighborhood bigshot? You didn't get your high school equivalency diploma until I'd finished high school. And all through high school I remember how you'd never, Monday through Friday—even after dinner, watching television with a beer—change out of your vest and tie. But how you kept that job and got ahead is no mystery. It was more then just heeding your Polish mother's admonition: "Rudy, keep your tongue behind your teeth." It was that—just as for mother and me—you were always there. And you knew from the start that trying to take too big a bite out of the world wasn't for the likes of us. We'd be crushed like mosquitoes. Our best chance was to cultivate a certain bounce. If they kept slapping you down—the way they slapped everyone down—you kept getting up with a smile. Sooner or later they get tired of trying to get your attention that way. Whatever you did, you weren't, like your poor damaged father, going to let yourself get sadder and sadder. You'd do whatever it took. Even to the point of adding a "c" before the "k" in our name so it would sound less Polish, Now that I'm 57 and you're 85, I have to say I don't think either of us ever quite spoke our bosses' language. It required a certain reticence, a complicit smirk, an apologetic yawn our thirsty mouths could never master.

 In our own ways, we're both as helplessly foreign as the grandparents. Who could have predicted that in your old age, living with your immigrant caregivers, Polish is once again the daily language of your home? And for my part, what began as a mere seed of inherited embarrassment at underclass Europe ripened into a dark, rich continent America could never hope to invade. I'm haunted by Uncle Joe's stories. Last month, they changed again. Those kinds of "old days" stories always do. It's no longer little Mr. Chepok with the ankle length overcoat and big felt hat who puked in Grandpa's pocket, It was—who am I to challenge this?—tall, skinny Ignatz Gonder, married late in life to little Katie, who so neatly deposited his dinner, and at a lodge meeting, not Grandpa's wedding. Joe's tales have their own urban-pastoral life. Hitching rides on trains to secret swimming holes in the quarries and railroad yards. Near amputations and disasters as

the freights unexpectedly switched tracks. Boys forever lost between the wheels. Those waterholes in the middle of industrial Chicago must have been polluted run-off or stagnant pools, but in the memory they're crystalline mountain lakes. Where you and Joe still dive from rocks and swim like fish in a Chicago that never existed.

It seemed fitting that in the middle of all this fancy, Joe's recently implanted tooth came out, stuck in a piece of pork. I loved the way he held it in his fingers, inspecting it like a diamond while he reminisced. There's a story you used to tell, drinking with my uncles and Grandpa. It was what—1943? You had a toothache and, on your lunch hour, you went to the dentist. He tapped, picked, frowned—then pulled the tooth. Back at the office, your coworkers noticed you spitting blood, groaning. Who could help it? You were making them sick and your boss sent you home. Left to yourself, you'd have stayed at work. You could count on one hand the days you'd called in sick in a lifetime. Then there was the story about Grandpa- Mother's father. How with four kids in the middle of the Depression, he found his teeth had to go. "Too much money. "Psiakrew" (sonofabitch, "dogs blood" in Polish), he growled at the dentist who wanted $5 a tooth. And so, he retreated to his basement and patiently went to work with a pint of whiskey and a pair of pliers. He was a modern man. A Chicagoan, by then, who knew about hygiene and the need for a real dentist, "Here, goddamit," he sat in the dentist's chair, "I loosened them. You can pull them with you fingers, How much?"

You told these stories for years—never mentioning that until you were nearly 75, you were too frightened to set foot in a dental office again. Just last month when I was visiting—the morning after the big thunderstorm—you strangely remembered what you'd dreamed under the dentist's ether that day. You were being bombarded by warplanes. For the first time, you revealed that before you'd visited the downtown American dentist your boss sent you to, you had tried Grandpa's dentist. The sullen Polish dentist ushered you into his second floor flat, then opened a closet full of liquor bottles to get his white coat. The ominous garment, as he slipped it on, was bloodstained like a butcher's apron. You sized things up, then ran back down the stairs, toothache and all. Is it any surprise I shared your dental phobia? I stopped going to the dentist at 16 but finally surrendered when I broke a neglected molar on a French roll at 50. You'd already told me how, with enough laughing gas and Novocaine, one

could even enjoy modern dentistry. But I did you one better and demanded Valium and Bach with the Nitrous. And drank a split of champagne before settling in. So that in midst of the procedure I could even admire the silver pick glittering in the spotlight like a majestic baton conducting Glen Gould's erupting fingers. That's progress. We've come a long way from that old foreigner sweating and cursing at the workbench with his pliers and Old Fitzgerald. But what about that sonofabitch dentist Mother took me to when I was 10? He told me when he revved up his drill, "Here, kid, I want to show you my little airplane," He was a creature of the times. That he chain smoked compulsively while dive bombing into the decay only served to make it obvious that he, too, knew this was a desperate business.

The stories go on, but always, from the start, I sensed a kinship with the 6-year-old in you. Even as a child, I felt a huge protectiveness toward you. I remember being 7 or 8. We'd just moved to the north side with Martin and Ann... But it was the same way when I was 4 on VJ Day, and ran out to the end of the block waiting for the boys to come marching home. That's the way I felt, waiting at the bus stop for you to get back from work on those six o'clock summer evenings. Standing there patiently with my holstered cap guns, ready to escort you home. And—I don't know how strange or common this is with other people—but when I look at the photograph of my five-year-old self grimacing at the long shadows, it's not my face I see, but yours. All through my grown life, when I've seen photos of boys with a certain round face, it's been you. The beaming Sherpa boy on the cover of Everest, the West Ridge. The Henri-Bresson kid with the wine bottles. The perplexed boy hiding in the 50 year-old-face on my driver's license. Because the greatest gift you've given me as a father is to always be the child in me.

CHRIS BELDEN

l) Dan M. Belden, London, ca. 1960

r) Chris Belden, Canton, OH, ca. 1960

Chris Belden was born on July 1, 1960, and raised in Canton, OH. He attended the University of Michigan, graduating with a B.A. in film. He has been a surgical orderly, a musician, a department store clerk, an office temp and a book publicist. He is co-author of the independent feature film *Amnesia*, and has had several of his short plays and songs performed at the Ensemble Studio Theater. His stories have been published in *Treasure House*, *Zine Zone* (London), and the anthology *Not Black & White* (Plain View Press). He lives in Brooklyn.

Dan M. Belden was born on July 20, 1917, and raised in Canton, OH. He received a B.A. from the University of Michigan and graduated from the Western Reserve University Law School in 1942. During World War II he served as captain and company commanding officer in Gen. George Patton's 4th Armored Division, and received five battle stars, a Purple Heart, a Bronze Star and a Silver Star. From 1946 until his retirement more than 40 years later, he was a trial attorney with the Canton firm of Black McCuskey Sours & Arbaugh. Married in 1942, Dan and Julia Belden had seven children, of which Chris is the sixth. Throughout his adult life Dan Belden was an active community volunteer, serving as president or director of several organizations, including the Red Cross, the Stark County Bar Association, and the Canton Amateur Baseball Association. Upon Dan Belden's death in September 1996, the Canton *Repository* editorialized that "the death of this civic leader... represents a loss the community can ill afford."

HOME MOVIES

1.

February 14, 1943. You are 25 years old. Six feet tall, thick-chested in a heavy three-piece suit, with your dark hair combed back and parted slightly off-center. Recently graduated from law school—several months early so that you can go off to war—you are now a married man. As you and your new bride charge down the stone steps of the church beneath a shower of tossed rice, you laugh and pull your tortoise-shell glasses from your face. Then, before following the bride into the back seat of a waiting car, you pause, look straight into the camera, and smile.

2.

We find the film among your things as we search for the life insurance policies you bought over the years. *Your father was a real sucker for new insurance salesmen*, mother tells us. *His heart went out to them.* Policies are found in drawers, cabinets, files. And there among them, a yellow box with your name on it. Inside, a reel of eight millimeter film that no one can recall ever seeing before. Holding the narrow strip of celluloid to the light I make out a male figure. You? The

image is too small to tell. When I finally see your face on the screen—in vivid, full-color Kodachrome—it is like staring into a mirror. That chin thrust forward, that heavy-lidded, self-satisfied smirk. I have seen all the old photos—the thick-faced teenager on the arm of his daddy's chair; the lean infantry captain posed in front of a tank; the proud father of one, two, three, four, five, six, seven children—but I have never before seen you as a young man *moving*: walking, talking, laughing. I carefully note how the limbs operate together, how the facial muscles stretch and relax, how the eyes send signals. There I am, seventeen years before being born.

3.

I remember: Father and Son; as you hover over me, a Taryton dangling from your lips, I am not afraid; you unhook my soiled diaper, toss it aside; *Bottoms up!*; I giggle and lift my legs into the air; you wipe my little rear end, humming a song; you wrap a clean diaper around me and expertly pin the corners together; I am not afraid; you hoist me to my feet and pat me softly on my dry, powdered bottom, nudging me forward as if I were a toy boat in a pond; I am not afraid.

4.

At the reception you pose beside your silent, glowing bride and the two families. You say something amusing, revealing your famous gap-toothed grin, and the others laugh. A call goes out for a kiss and you bend to place your lips on hers. After a moment you lift your face to the camera and there is a flash of light that illuminates everything for just a frame or two, as if lightning has struck. In two year's time you will be trudging through blood-stained snow amidst the lightning of mortar shells, beside men who will never come home to their wives. But, for now, everyone is alive.

5.

Today I went to see your newly installed headstone. It is small—*too small for such a big man*—with just your name and the years of your birth and death. There is still no grass over your grave, just a rectangle of dirt frozen solid by November and sprinkled with snow that

falls slow and fluttery, like chicken feathers. Off in the near distance a train moans. A cat sits watching me from the cemetery fence. It's cold here. Searching for a way to say goodbye, I say "I miss you" out loud, but it rings false. Even with you gone—and six feet of cold, hard dirt between us—I am afraid of you.

6.

I remember: in the back yard, Father and Son; I sit on the blue bicycle; you hold the seat and handlebars, a Taryton dangling from your lips; you walk the bike along the bumpy grass (faster); my little legs move along with the pedals (faster); *Hold on*, you say, and then I'm on my own (faster), bumping along for a few yards until I tip over; the bike lands on top of me; I wince; you throw up your hands and tell me to stop crying, *stop being a baby*; but I am crying, I am being a baby; and we start over again, then again; my bare knees bleed; and again, until I get it right; I'm pedaling on my own over the grass (faster), to the driveway (faster), to the sidewalk (faster, faster), and far, far away.

7.

The cake is three-tiered, white icing and two bells on top. You wrap your huge right hand around your bride's small one and force the knife through the cake's dense sponge. JUMP CUT *to you holding the thick wedge of white cake in your hand. Mother takes a characteristically small bite, then you taste the cake yourself, chewing thoughtfully, as if on some complex bit of philosophy. You raise your eyebrows and, just as you are about to make your pronouncement, the screen goes black.*

8.

The house is quiet and strange without you. In the morning I expect to find you at the breakfast table with a cup of coffee and the newspaper. At noon I listen for the tinkle of ice in a tumbler. At night I lie awake waiting for the reassuring rhythm of your snore. Every creak of floorboard is your footfall.

9.

I remember: Father and Son in a hospital room; you say you have to use the toilet; I pull you to a seated position on the edge of the bed and you stand; you lean on the walker, taking tiny steps to the bathroom; you back yourself up to the toilet; you look me in the eye; *You'll have to pull my pants down for me*; I step toward you; I am afraid; I take hold of your pajama bottoms and tug; I tug until they are bunched at your ankles; you sit; *I'll holler when I need you*; I wait in the hall, afraid.

FADE TO BLACK.

MEG BELICHICK

l) Ed Belichick holding his daughter Meg. CT, 1968

r) Meg Belichick and her stepfather Alfred Franci. On his wedding day. CT, March 11, 1978

What I've Never Said

Meg Belichick was born July 29, 1967, in Youngstown, OH. She is a sculptor living in Brooklyn, NY. Her work has been shown both nationally and internationally.

Joe Belichick was born October 23, 1943. He is a dentist and cattle rancher and lives in New Waterford, OH.

Alfred Franci was born July 19, 1941, in Bridgeport, CT. He is a technical writer and lives in Sunnyvale, CA.

METASEARCH

Subject: Re: metasearch sites
Date: Thu, 01 Oct 1998 17:18:54 -0500
From: Meg Belichick <ghwnewyork@earthlink.net>
Organization: Galerie Hauser & Wirth
To: Alfred_Franci@peoplesoft.com

Dear Alfred,

Loved your message tonight about the new search engines. I wonder if I can finally find Dan listed somewhere. Maybe he's getting lazy now that we have been separated a year and a half and I still don't know where he lives. I am going to look for him as soon as I finish the piece I am writing. I have been enslaved by it since Friday, seriously involved in it since early August and somewhere in the middle of it since two years ago last April. It's about my Dad. Or to my Dad; my father, the subject or non-subject of my life.

I have been thinking about you a lot while working on it and today is the final call. I was thinking about my wedding and how I never considered asking my father or you to walk me down the aisle. There was no aisle and there was not going to be any giving away. I remembered you waiting with Dan and me crouched out of the wind on New Year's morning. The three of us shivered in the fog and anticipation while we waited for the people to march out onto the cliff for the ceremony. You told us something important about marriage. You said, "Someone always has to say they're sorry first."

Although I think I inherited my father's manual dexterity, Alfred, it was your huge vision that encouraged me to be an artist. The first loft I ever saw was yours. Bridgeport:1975. You are decades ahead of your time. You recognized me as an artist before I did. You were also the first man to call me oppressed.

When I call home to ask what you think about me buying a 1962 pushbutton transmission Rambler, you say "Great! You only live once." Later when I call from the side of the road with descriptions of heat and smoke, needing a diagnosis, you go through each noise and smell and tell me it's the flywheel or the starter, the generator or the battery.

Ours is an active relationship, although I couldn't allow you to be my father before I was an adult. Now when I call home crying and missing Dan you tell me you will talk to me as long as I want, all night if that is what it takes. I am like an infant, hysterical in the middle of the night and you are walking me around and around, patting me lightly on the back.

I don't think I can ever finish this piece about my Dad and be satisfied. What I've learned is I cannot put everything into it and wrap it up, pull out some kind of conclusion. It is a loss of the past.

Will you read what I have so far?

I begin writing about you, Dad, in the way I approach my day job, bookkeeping, where I am determined to find the two dollars and fifty four cents I am over and get everything to balance to zero. I want to rout out the problem, you, and the obvious way is to write down every memory I have of you. I can record all of the information and calculate the accurate sum of the pieces. It seems possible, if difficult, and I write for six weeks everything I can dredge up about you.

I have one memory of you before you left our house.

You washing the green convertible Buick in the driveway and telling me that after dinner we are going to go and buy my first two wheeler. I am almost five and it is the coolest purple bike with a yellow flowered banana seat and Miss America in thick white enameled letters on the chain guard.

What I've Never Said

One of you leaving.

Watching the long glowing lines of the tail lights on the Buick and thinking of your thin, wide smile driving away in the dark.

And one after you left.

In the middle of the night you and your friends driving all over our huge new lawn, tearing it into ruts.

Others are from visits to you after we'd moved away.

Getting a bracelet that allowed me to go on the rides all day at the amusement park when you went to the bar with your friends. Once when it was rainy and there were no lines, I rode the rollercoaster seventeen times in an afternoon.

Playing a game in a bar where you had to swing a heavy metal ring hanging on a long string tied to the ceiling and try to hook a nail across the room. I found a way to aim by lining the string up with the edge of the paneling and made twenty six dollars betting against people and winning.

Bars like the one at Conneaut Lake and The Starlight in Youngstown and Friar Tucks somewhere in between. You telling me that I look just like my mother when I shrug my shoulders and not to do it anymore.

You yelling in the car all the way to the airport and wearing a chunky gold ring that says F-U-C-K.

You having scars from cysts cut out of your back.

The list goes on and it frustrates me. I cannot categorize it or break it down. It is random and whiny and irritating. I let my husband, Dan, read the list of memories to date and he thinks it is humorous. I hadn't considered that.

I e-mail the list to my friend Mary who has done some time writing about her own father. She wants me to write what you look like. I

don't want to and I don't know why. I resist and write nothing for a week. Then I sit down at my typewriter and tap this out:

> My father has the most beautiful green eyes.
> This is why my favorite color is green.
> I always wished that I had gotten my
> father's green eyes.

My method of deduction is not working. I cannot lift the truth of you from an inventory of memories. I put the file called *MY DAD* away and concentrate on my marriage falling apart.

Two and a half years later I begin again. I am writing every day. I watch my moods when I write for a few hours each morning. I watch them change. I write runoff, trying to break through a heaviness I cannot identify or toss off. When I break through, I can ponder the endless rain and fall through images from the past and today all mixed in. After a week, I have crept up on my voice, the old one I recognize, and I challenge myself to write on Monday morning. Write all day. Write until your mind is empty and then begin "Dear Dad" whenever you come to this emptiness.

Funny thing, Dad, I never got to the emptiness. I wrote and I wrote and I had no need for "Dear Dad."

Before I go to bed, I force myself to sit down and try again. This is what I get:

Dear Dad,

I am in Brasil visiting my friend Marta and her family for three and a half weeks. I am trying to get some work done as I can't seem to do it at home anymore. The hardest part is to let go and see what comes. I don't know how to go easy. I don't know how to trust that it will all come in its own good time.

Have I always been this way? Or is it almost ten years in New York that have made me driven? Do you remember me being any way at

What I've Never Said

all when I was a little girl? What *do* you know about me after so many years of not knowing me? Are there still things about me that are the same as when I was five? Maybe that I cry easily. But I am no longer shy.

I remember making a tree house in the big oak next to the house on Katadin Drive. I dragged a heavy plank up into the tree with me for my foundation. When I fell out of the tree, it dropped after me and landed on my head, making a lump like a doorknob over my left eye. Mom took me in the car to the emergency room. We stopped at your office on the way. You came out into the huge gravel parking lot, looked closely at my forehead on the front seat of the Buick and said, "Will you ever make it through your childhood, Meggy?"

I made it, Dad. I made it through my childhood. I grew up without you. I made it through my teenage years. I grew up in spite of you. I made it through college and getting married. I made it without the benefit of your experience. I made it through an abortion and an affair and now I am trying to make it through a separation and maybe a divorce. I say maybe because I still want to have hope that it won't happen. I used to blow out my birthday candles every year wishing that you and Mom would somehow be married again, that we could be a normal family. When I gave that up I started a new mantra: I will never get married. I will never get married because I don't want to get divorced. Not so strange then that I have been telling myself for the last year that I don't want to live. I want to fix it and have a normal family. I want to have children with my husband and I want to find out together what it feels like to stay with someone for a long long time.

Finally I realize I cannot write *about* you, Dad, to find a part of you inside of me. It is your absence that has shaped me. It is your absence that made me retract my capacity for a father; like the dash of an old car without the deluxe features: where the air conditioner or radio would have been there are only chrome plates covering the holes. I covered the hole you left with something shiny and hard a long time ago. Apparently, I couldn't be better for the loss. It is much cleaner this way, not to be reminded of what is missing.

I have mined the facts. It is the feelings I am diving for now. My task is like wiping brown slime out of a refrigerator that has not been cleaned since moving in. Kneeling down on the floor with a sponge and a big bowl I soak up the liquid and squeeze it out one spongeful

at a time. My feelings, caked around your absence, are brown too, all mixed together.

The memories that I comb to find you inside of me are not held together by your presence. It is *my* body I remember in these memories, my body in space, the smoothness of the cement floor in the two-car garage, the one step to the kitchen door cool on the back of my calf as I lean into it watching our neighbor, Mr. Finney, try to fix my purple bike with the banana seat. He is showing me how to tighten the handlebars. Maybe he knows more than I know at this point, that you are not coming back and I am going to have to learn to make these kinds of repairs myself. He is giving instructions aloud, holding the wrench in one hand and the handlebars in the other. He has turned the bolt so that it is tight but still the bars slip when he releases them. He looks up at me and asks, "What do we do now?"

"Force it," I offer up, confident I have the solution.

* * *

My certainty and his pause are tucked away in my mind as if they had slipped into the cuff of my pants where I have carried them with me unknowingly.

Forcing it has always been my way. I do not remember Mr. Finney's response as I did not consider heeding his advice. I carry with me a steel grey determination, the seed of which had already been planted by the time I was five. I considered it to be one of my greatest assets until recently.

Meg

What I've Never Said

MARVIN BELL

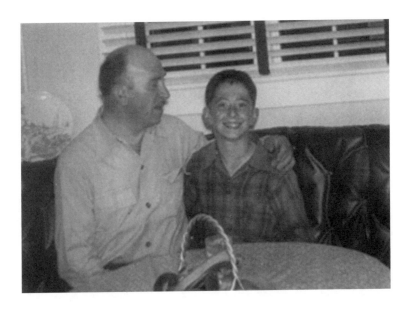

Marvin Bell and his father, Saul Bell.
Center Moriches, NY, ca. 1948

"At the kitchen table in our house on Union Avenue."

Marvin Bell, born August 3, 1937, grew up on eastern Long Island. He now lives in Iowa City, IA, and Port Townsend, WA. Mr. Bell is Flannery O'Connor Professor of Letters at The University of Iowa. He has published sixteen books of prose and poetry.

Saul Bell was born in the Ukraine ca. 1904. He escaped to the United States as a teenager, working in various east coast cities until he opened a five-and-ten in Center Moriches on the south shore of eastern Long Island. He died in 1959.

IN MEMORY OF H. G. GRAND
(5-10¢ to $1.00)

Dear Pop,

The pivotal moment of my youth is your death. Until that moment, I was privileged. You made a good living for us and visibly enjoyed it. I never saw another man so happy to be his own boss. You are a hero for how you treated your customers and employees. How different it is now. You must have sensed already in the Fifties that small-town five-and-tens like yours were doomed. The big drug stores and grocery stores were already beginning to stock items traditionally reserved to the variety store. To steal customers, they were selling selected merchandise at a loss. The new term was "loss leader," and the new sales tactic was volume. Stores which had been open 9-5 Monday through Saturday were adding evenings and Sundays. The traditional small town, in which people distributed their shopping so that every merchant could make a living, was fatally wounded.

You were supposed to be a peddler. That was how teenage immigrant boys from the Ukraine could make a start. In your passport photo, you look like a tough kid.

One had to be tough to survive the Ukraine then, especially if a Jew. You rarely spoke of your life in the Old Country. Later, I wished you had told us more about it. But I came to realize that your life was so much better in America, that you were not given to complaint, that you had left the old life behind without regret, and that you knew how to be happy with hard work and good luck.

But when you bought a few sundries at the five-and-ten and went out to peddle, it was never going to work. You weren't built for that sort of rejection. The first housewife slammed her door on you, and you immediately returned everything you had bought to the store. It would be a few years of roofing and retail before you would manage a five-and-ten with your older brother, Harry. And a while longer before you would strike out on your own.

Your young wife thought you were crazy to start a business in a village of 1500 on the south shore of eastern Long Island. Mr. Hartstein,

the grocer, thought you were daffy to put a five-and-ten in a building where he and others had failed previously. No one but you knew how hard you were willing to work to be your own boss.

I loved going with you when you drove to New York City on Sundays to buy stock for the store from the wholesaler. Salesmen came regularly to the store to itemize inventory and restock the counters, but you went to the City yourself on what might have otherwise been Sundays off to buy other things the store needed. Whether it was wholesalers or salesmen, clerks or customers, you enjoyed the small talk. Like you, I am most comfortable with the give-and-take talk of clerks and blue collar workers.

Recently, I was staying in a motel in Memphis. It was Sunday. I had no car. The only store around was a 7-11 across the highway. I walked over to buy milk and a newspaper. While he rang me up, the cashier greeted a grizzled old man in shabby clothes. "It looks like a good day," he said. And the worn-down old fellow said, "Every day's a good day." It was what you would have said.

You liked everything about the store. When the doctor told you to take a belt of schnapps daily to help your weak heart, you invited a different customer each afternoon into the back room to "have a drink on my birthday." The old saw is that it's bad luck to drink alone, but I think you felt even more strongly that it was good luck to be with friends.

We never knew your birth date. The papers had been lost with just about everything else in the Old Country. All that is left now is your passport and a fading sense of what it must have been like to be attacked by both the Cossacks and the Bolsheviks, to hide by day and bury corpses at night, to forego school to work in an orchard, to hide in the woods whenever one angered the authorities, and finally to be spirited out of town under a wagon load of hay, to ride bareback to Poland, and to make it to America.

You never mentioned that your heart muscle was weak, though I knew something was not right the day I came driving home from school and you asked for a ride less than a block from our house. I could tell you had been holding onto a tree. You said you had just grown dizzy for a moment. It wasn't your way to dread the future or to allow the family to worry. But forever after, I would picture that moment as the beginning of your dying.

My eyes tear when I think of what you missed by dying early. I was

told that you danced on the store counters when I was born. Yet when you died, you knew only that I had married too young and perhaps unwisely, and was little more than a graduate student working nights in a law library. You were proud of me, but just then my future could not have seemed promising.

I would like you to know that, after that brief marriage, I married again, that Dorothy and I have been together 38 years, and that we are as suited to one another as, it seems, you and Mom were. You would like Dorothy. Mom thinks she's an angel sent from Heaven.

And you would like our sons. Nathan, who was born soon after your death, carries your name, Saul, as his middle name. After a music career, he went to work in the cell phone industry and rose quickly without a college degree. He jokes that some of your business genes must have come to him, and of course they did. He named his firstborn Colman Saul.

Jason, who works for a computer software solutions firm, must also have some of your genes. His heart is big like yours and Nathan's. When his big brother left home and wrote letters back, Jason was unable to open them because they made him miss his brother too much to bear.

Such was your heart, beyond an ever-weaker heart muscle. Mom tells me that when I told you not to kiss me goodnight in bed any more because I was "too old for that," you came downstairs with tears in your eyes. I haven't forgotten that I used to ask you if you liked me and when you said Yes, I'd make you say it again, telling you to "say it nice." It's terrible not to be able to say "I love you" to your father until it's too late. My own sons aren't like that, but times have changed.

You never got to know that I ended up a professor and wrote about you and published books. I even wrote an entire book's worth of poems about you, starting with your life in what we called Russia, though in the end I published only a baker's dozen. I see now why I tried to recreate you in those poems. "You Would Know," the final poem of the series, says it: "I just want to be happy again. That's / what I was, happy, maybe am, you would know." The title of the book in which the poems appeared is *Residue of Song*, which now seems to me unutterably sad.

Residue of Song. I should have seen it. You sang all the time in your store. You were too happy not to. You worked evenings and weekends, you worked hard with your head and your hands, but never

mind, you had reached the promised land, you were your own boss, you had American kids, and you sang.

Without knowing any songs. You had taught yourself English by going to the movies. Your newspaper was the *New York Daily News*, known even then as a "picture paper." Along the way, you hadn't learned any songs beyond Jewish prayers. So you sang radio commercials: musical ads for Robert Hall ("where the values go up up up, and the prices go down down down"), Brylcreem ("a little dab'll do ya'"), and Ajax ("the foaming cleanser"). And so there came a day when Mom asked you for Heaven's sake to learn the words to one song, which you duly did. That song was "Ramona."

The writing years went on for me, and so did the poems in which you appeared. I thought I had finished the conversation with you in "To an Adolescent Weeping Willow" in which I imagine what you felt from the perspective of a grownup and say (to myself) that when things are smooth and easy (like the movements of a young weeping willow), it is because "you are a boy." Only a boy.

By then I had seen posed photos of you in which your look betrayed your public face. I was surprised when first I noticed in those pictures the private sadness that surely any adult must feel, but which you hid from me, from your customers, from your employees, from the town. I was by then old enough to know the weight of adulthood, and to understand that being a grownup means knowing that things end. The weeping willow poem ended our conversation. But it did not complete the long journey I was still making back to your grave. Now I know that the pain of losing you, the fear that rushed in when safety left—these shocks to the system put me into an emotional coma from which I surfaced occasionally to find the pain as sharp as ever. If you had written letters back to me, I could not have opened them.

I think it is because of your early departure that sometimes I am barely able to face the prospect of loss with the stoicism I bring to the idea of my own death. I see now the extent of your courage.

I saw you weaken only once, when your older brother died suddenly. At the wake, you cried out, "Why wasn't it me?" It scared me to hear you say you were willing to die. But now I see that, because you were willing to die, you were not afraid to strike out on your own in a foreign country.

Eventually, I wrote the poem of my utter loss, ending it with the words Shakespeare's King Lear speaks over the body of his daughter Cordelia:

ENDING WITH A LINE FROM LEAR

I will try to remember. It was light.
It was also dark, in the grave. I could feel
how dark it was, how black it would be
without my father. When he was gone.
But he was not gone, not yet. He was only
a corpse, and I could still touch him
that afternoon. Earlier the same afternoon.
This is the one thing that scares me:
losing my father. I don't want him to go.
I am a young man. I will never be older.
I am wearing a tie and a watch. The sky,
gray, hangs over everything. Today
the sky has no curve to it, and no end.
He is deep into his mission. He has business
to attend to. He wears a tie but no watch.
I will skip a lot of what happens next.
Then the moment comes. Everything, everything
has been said, and the wheels start to turn.
They roll, the straps unwind, and the coffin
begins to descend. Into the awful damp.
Into the black center of the earth. I
am being left behind. The center of my body
sinks down into the cold fire of the grave.
But still my feet stand on top of the dirt.
My father's grave. I will never again.
Never. Never. Never. Never. Never.

Your heart muscle grew weaker. The doctor advised you to sell out and retire. Resting in Florida, you missed your store, your employees, and your customers, so you bought back the business at a loss and worked in it till you dropped dead. You were right to return to the store. When you died, the town closed down for your funeral. You were some guy, and those were the days.

Love,

What I've Never Said

PINCKNEY BENEDICT

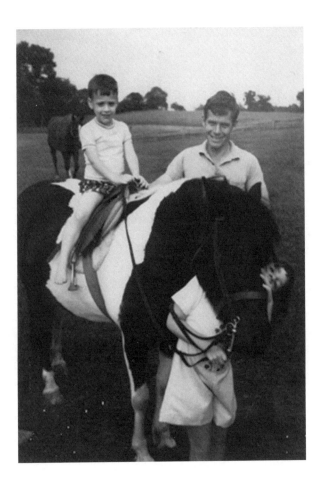

Pinckney Benedict on the pony, and his father Cleve Benedict standing behind the pony. Ben Buck Farm, north of Lewisburg, WV. Summer, 1969.

"Taking Guapo the pony for a ride. My sister Ruth is peering out from beneath the pony. Sugar-babe the saddle mare approaches at a leisurely pace from the rear."

Pinckney Benedict was born in Ronceverte, WV, on April 11, 1964. He is the author of one novel and two short story collections, including *The Wrecking Yard*. He is a professor at Hollins University in Roanoke, VA.

Cleve Benedict was born in Harrisburg, PA, on March 19, 1935. He is a dairy farmer.

THE DAY THE SILO CAME DOWN

To my old man:

We thought that we were the first ones to notice that the silo had fallen, my wife and I. Eighty feet of storage space, another thirteen feet (unlucky number!) of shining tin roof-cap—at ninety-three feet, one of the tallest structures in the county when it was built, still one of the tallest on the day that it came down. I was twelve the year of the silo's construction, and oh! how proud I was of it. Other farms in the county had pricier silos, certainly, fabulously expensive glass-lined Harvestores many of them, what you always called (with contempt) Blue Jewels. Our silo was bigger than any of those, made of rough tongue-and-groove concrete staves banded around with steel. Better than any damn Blue Jewel. Far taller.

We took a picture of you standing on top of the silo the day it was finished. In the picture, I recall (no knowing where that picture has got to now, if we wanted to find it—if, in the light of the silo's fall, we would want, could bear, to look at it again), it was difficult to tell who it was exactly standing up there on that thing, wickedly backlighted, just the nuanceless silhouette of a man dressed in heavy blue coveralls. It took somebody who knew you well to see that, yes indeed, that was good old Cleve Benedict up there, that was my old man up there on top of that silo, and somebody who knew you even better than that to see in the way that you carried yourself, in the set of your shoulders, there was more than a hint of pride.

"Pride goeth before destruction, and an haughty spirit before a fall." How many times did I hear that warning from you when I was

growing up? Never to show pride, lest it be mistaken for arrogance, lest pride mistake itself for virtue. And how many times the story of the tower of Babel, the hubristic House of the Terrace of Heaven and Earth, rising upward to touch the very face of God? The works of man, I knew from you, were impermanent and doomed, and overreaching led only and always to destruction. Still, I was proud of that great storehouse that rose up in my twelfth year beside the dairy, and so were you, no denying it. I wonder whether it was your pride, or mine, that brought it down?

The night before the silo fell, you and I talked about it, remembered its construction, our amazement and the amazement of our neighbors at the sheer size of it up close, the volume of silage that it could hold. Do you recall that conversation now, I wonder? The silo had never been full before that summer, there had never been that much corn on the place; but for the first time, in its nineteenth season, the silo couldn't hold any more. The rain had fallen in abundance and at the right times, the summer weather had been obligingly hot but not witheringly so, and the harvest of chopped corn was staggeringly rich.

Very wet silage, the juice that ran out of the cut stalks pooling at the foot of the silo, fermenting in its base. What a rich rich smell! of nutrition and fermentation and thick green rot. Impossible to walk by the dairy without that smell clinging to my clothes, to my skin and hair, so that when I entered into the house afterward my wife drew in a great breath of me through her nostrils and said, You smell to me like something grown straight up out of the earth.

(New wine in old bottles! You taught me that one too. What happens to new wine in an old bottle? It ferments, it is too rich for the container, the force within too powerful, and it splits the container, and both container and wine are ruined and lost.)

So much corn. You were coughing and wheezing as we talked at dinner that evening before the fall, talked about the silo and the corn, because you were cleaning out another, more conventionally-sized silo that belonged to our neighbors to the east. They didn't use that one anymore, and our own was full (full to bursting!), and so you had leased the use of it. You and one of the men who worked on the farm had spent the day forking the old fodder—years old, no telling how many years it had lain there uneaten in the dark—out of the unused silo, to prepare it for the new, and the stifling dust of the nasty work

in that closed space had filled your nose and mouth and lungs, so you coughed and hawked into your blue pocket handkerchief as we talked. Still, though, you seemed happy. Even the ugliest, meanest sort of work makes you happy.

My wife saw that the silo had fallen before I did. It dominated the eastern view from our house. It always surprised her, this edifice like a great finger pointing up at the sky. When the clouds lowered mightily, you could lose the top of it in the rolling vapor. When the sun shone, the tin cap gleamed white. I didn't even notice the thing anymore, I guess. So much wallpaper to me. After it fell, I could probably have walked past the windows that opened onto the dairy at the foot of the cornfield a dozen times, could have looked out those windows right onto it, without noticing that it was gone. Probably I did walk past those windows without noticing. Such an event, such a disaster was inconceivable to me; just as easy to imagine that the entire great line of the Blue Ridge had sunk down into the earth.

And so my wife called me to the window to ask me where the silo had gone, and I blinked, and looked, and blinked again. I had no answer. The dairy was still there, but the silo that should have stood behind it was not. And the phone rang. My mother. She told us that the silo had come down a quarter of an hour before, nobody knew why, it had just split at its base and tumbled down, that you were there, that cattle were dead and dying, that all was ruined.

At the dairy, chaos. The silo, with its incalculable burden of silage, had come down like a tree, right onto the center of the cattle barn. Its tin roof-cap lay tilted against the last of the line of little calf-hutches nearby, the calf within (spared by inches) peering out anxiously at the battered dented metal. Twelve milk cattle killed outright, legs poking from the wreckage, heads, the broad black-and-white backs of your treasured Holstein cows, intermingled with the shattered concrete staves and twisted steel hoops of the silo walls. The bawling of the injured cattle resounded from the smashed walls of the barn, the tilted surfaces of the concrete slabs, the steel reverberating weirdly. A mound, in the center of the cattle barn, of silage, perhaps twenty-five feet high. The smells of blood, and crushed flesh, of shit and of the terror of sudden death. And over it all, over it all and under it the sweet stinging jungle smell of that juicy rich too-green silage.

Here is what I saw you do that day: Still coughing, sick and bent from breathing the years-old dust from the leased silo, you went from

cow to cow trapped in that greasy, bloody, still-fermenting pile. The heat that came off it was palpable. I had never seen you look so weak. (You had shrugged off your injuries that time when you were pulled into the teeth of the silage spreader, your back slashed in a dozen places by the whirling teeth of the machine; you refused a doctor's aid, made my veterinarian uncle stitch you up, bade my mother remove the stitches when the gashes were well enough closed—I was witness to that, to your pale strong broad back with its constellation of scars like mute, unsmiling mouths.)

Moving cow to cow, checking ear tags. To discover whether a half-buried cow was still, by some miracle, alive, you drove your thumb hard into its flesh to look for a pulse, against the big artery in its neck, drove it hard enough to make me wince as I watched. Finding nothing there, you would prize open the cow's eyelid and thrust the same thumb against the ball of the eye. No reaction there, and it was proof enough that the cow was dead and the effort to unearth her abandoned.

How hard were your hands! I could hardly approach the cattle amidst the wreckage. Later, of course, I went from corpse to corpse, taking from each neck the chain that held the transponder that identified the cow to the automated feeding system. Those were worth thirty-five dollars apiece, and must be salvaged. At the beginning, though, I could only watch, and wish for hands that were hard enough to do what needed doing. My own hands are terribly terribly soft. I am terribly terribly soft.

How many other things have needed doing, during my lifetime and before? The horse that put its leg through the cattle guard and had to be shot. The cattle slaughtered for meat, the dogs that outlived their working lives, the barn cats with distemper, the rabid raccoons—the thousand brutal acts that the world demands. Who will accomplish them when you are unable to? Not me, O Lord, not me.

You sold the remaining cattle. The only practical thing to do. No barn in which to house them over the winter, and no silage left to feed them. (It was impossible to salvage the stuff from the wreckage, though you tried.) Put up a big yellow-and-white-striped tent and hired an auctioneer and led the remaining cows in front of the crowd—friends and neighbors and also, principally, strangers—that gathered, and sold them, this herd that you had built over the years. The prices were not good, these were bargain cattle, the folks who came to the sale got them dirt cheap. Our disaster, their good fortune. Another

time things will go well for us, ill for them, is the way you put it to me. The sun don't shine on the same dog's ass every day.

I was not there for the sale. I went away. I could not bear it. You could. You could bear it. I do not know how. And all that day, away from the farm (my relief was palpable as I left the place, and shameful to me), all day as I knew the cattle were being led into the big striped tent and sold, I could hear ringing in my head the words of the single surviving servant of Job, fleeing disaster, eager to deliver himself of awful news and be done with it: "I only am escaped alone to tell thee."

SALLY RYDER BRADY

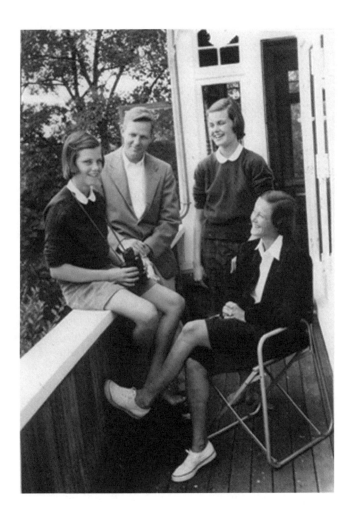

Sally Ryder (Brady) with her father, Francis C. Ryder,
sister Joan Ryder (Wickersham) and mother Dorothy C. Ryder.
Woods Hole, MA, ca. 1952

Sally Ryder Brady was born on May 26, 1939, in Boston, MA, and spent most of her childhood in the Cape Cod village of Woods Hole. She is the author of a novel, *INSTAR* (Doubleday) and Volumes I & II of *A Yankee Christmas* (Yankee/Rodale), as well as numerous fiction and non-fiction pieces for *House Beautiful, Good Housekeeping, Woman's Day, Family Circle, New Woman, The Boston Globe* and other publications.

Francis Clark Ryder was born on March 31, 1908, in Middleborough, MA, graduated from Dartmouth College, and served in the U.S.Navy in the Pacific Theater during World War II. He was an administrator for the Woods Hole Oceanographic Institution and a member of its corporation, and on the staff of the Massachusetts Institute of Technology. He died on September 20, 1994.

ROUNDING THE CURVE

Dear Daddy,

The last time I talked with you, really talked with you, was four years ago. You were mending your running shoes so they would be all ready for you when your new aortic valve was in place, and your fit eighty-six year old body healed. Elective surgery, and to you and Joany and me, your choice was the obvious one. You wanted to jog again, to drive, to be a part of the Woods Hole community, things that would be impossible with the threat of more mini-blackouts like the one you'd had swimming only a few weeks earlier. But for Mummy, your decision was a kind of betrayal. You had chosen to put your diminishing life with her at risk, in the hope of returning to your familiar active one. In sixty-three years of marriage this is one of the rare times you did what you wanted to do and put your own self first. Unfair that it worked out the way it did, the operation a huge success, its effect, fatal.

In your six weeks of dying as your kidneys, liver, lungs, one after the other failed, and your strong heart with its new valve beat on and on, you never had a newspaper, your glasses, or a toothbrush, and the only hint of a watch on your sun-tanned arm was the white skin where

it used to be. Every day, the imprint became less distinct, and yet you grew more beautiful. I would study your face, trying to commit each feature to memory. I would graze your arm or cheek with my finger, afraid that even this might cause you pain. The one thing I could have done was talk to you. Say things that mattered. And I didn't. Because I knew that you would hear in my broken voice that you were dying. And what I wanted to give you, at first, anyway, was hope.

Writing this letter now gives me a chance to say what I couldn't then. That my earliest memory is of you. I am very young, a toddler, standing in my crib, the early sun streaming in. I hear you. I watch the door. Suddenly it opens and there you are! I reach up my arms and then I am up, up high in the air above your head. I squeal. You make airplane noises, and then you chuckle.

Next memory, four years later, November 1945. The war is finally over, and you are coming home. We are huddled in the huge Providence railroad station, Mummy, Joany and I. It is dark and cold here beside the tracks, and I wonder if I'll know who you are. All I know is the handsome man in navy whites inside the leather picture frame on Mummy's bureau. The daddy we've been asking God to bring home safely. Finally the train comes, car after car sliding past. When it stops, there is an instant flood of men. I am scared, afraid I'll lose Mummy and Joan in this tide of uniforms, when all of a sudden it happens again. I am lifted up, way up out of the sea of people. At first, I think someone is stealing me, but when I look down, there you are! Blue eyes wet and smiling. Handsome. Safe. Daddy.

On Sundays, long after I knew how to read, remember how I would sit beside you on the blue velour couch while you tried to read the paper? "Read me the funnies," I'd beg, and you would, and then I would start talking and talking, telling you my stories, and you would listen, probably dying to get back to the news. Once, I must have been eight or nine, there was a mention of the millennium in the comics, and I asked you what it was. You explained about the year 2000, and I can remember being wildly excited.

"We'll watch it happen together!" I said.

You squeezed my shoulder the way you often did and looked at me with those kind, blue eyes and said sadly, "I don't think so. I don't think I'll be around. I'll be 92 by then."

"You'll be around!" I remember how strong, how fierce I felt. How scared, too, that you might be right. "Don't worry! Don't worry,

Daddy, I won't let you die."

It must have been a shock for you who grew up in a household of gentle, quiet men —followed by Exeter Academy and Dartmouth College and four years in the Navy—to come home to three bossy, busy, chattering females. You never seemed to mind our talk. Was it because you loved stories? Loved us? You never hurried, either, and never hurried us. And yet, paradoxically, you loved to run. When we ran together you told me never to run so fast that I couldn't tell a story. And the last note I have from you says: "I think you are living in the fast lane these days. Just be careful as you round the curves." I think of these two things almost every day as I dash through my life, slowing down just enough to get the story told.

When the hope for your recovery grew daily dimmer, I wanted to tell you you were dying. I was sure you knew it, and I wanted you to know that we knew, too. I wanted to ask you what it was like, and whether you had intimations of eternity. Did you see a beckoning light? Was your mother waiting, her arms wide open? Your beautiful mother who died of influenza the Christmas you were ten? But again, I didn't say these things. Because I knew that I would fall apart. And my role had switched. Suddenly, I was no longer the indulged family baby (cry-baby I should say), but captain of the team. With Joan and Mummy in Woods Hole, I was running the show there at the hospital, logging in each day's decline, keeping Joan and Mummy informed. I was the one who forced your living will on Dr. Akins. I was the one who finally insisted that he pull the plug.

Last month, we all (Mummy included) went to Saratoga Springs to see Alexander dance. You would have been proud of your grandson. One of the ballets was called Big Band, a medley of tunes from the late thirties and forties—Glenn Miller, Tommy Dorsey. The boys were dressed in khaki uniforms, with hats like the one you wore in the navy (and yes, Alex looked very like you), and the girls in skirts that swung from their narrow hips and swirled around their legs. When the music segued into Moonlight Serenade, I felt Mummy tremble a little next to me, and saw that her cheek was wet. I put my hand on hers and asked if she were all right.

"Daddy and I danced to this, the night before he was shipped to the South Pacific. We danced in the moonlight on the end of a long pier in Galveston, Texas." Her fingers tightened in mine. "It was the only time he ever danced in time with the music."

What I've Never Said

I think of you on that moon-washed pier, so young and handsome, with your pretty bride in your arms. This is a part of you I only just found out about. I wish I had asked you more about you, I wish I had listened more, slowed down. I wish I had heard your stories.

Love,

IANTHE BRAUTIGAN

Ianthe Brautigan with her father, Richard Brautigan.
New York City, ca. 1969
Photo © Edmund Shea

Ianthe Brautigan was born March 25, 1960, in San Francisco. She has a fifteen-year-old daughter, Elizabeth. She holds an M.F.A. in Creative Writing from San Francisco State University, and has written *You Can't Catch Death: A Daughter's Memoir* published by St. Martin's Press. She has liked the same flavor of ice cream for over twenty years: mint chocolate chip.

Richard Brautigan was born January 30, 1935 in Tacoma, WA. He committed suicide in 1984. He wrote eleven novels, including *An Unfortunate Woman* published posthumously by St. Martin's Press, a book of short stories, and nine books of poetry. When he was about four or five years old, he was convinced that he had originated the saying "I scream, you scream, we all scream for ice cream." He is missed and loved by many.

MONTANA

Dear Daddy:

I'm sitting in the soft light of my tiny study with its huge window that overlooks my back yard in Northern California. The last peach has fallen from the tree. Tomatoes are ripening on the vine and the birds are singing shrilly. But you know this because you are alive, although the physical evidence tells a very different story. I have your ashes resting in an urn tucked away in a drawer.

If I pick up a book of yours it will say that you committed suicide in 1984. Some editors of anthologies get it wrong, even with correct information, informing me that you died as late 1985 or as early as 1983. I never get upset, because the truth is that death hasn't touched your blue eyes and not all of me is sitting at my desk typing these words. A part of me is in Montana at the ranch trying to convince you to live.

Don't. Please, Daddy, Don't. Please, live. A fourteen-year-old girl is sitting in a kitchen in Pine Creek, Montana, not far from the Yellowstone River, painting a picture of a future that never will be: You as a grandfather, a future with Larry Bird coaching the Indiana Pacers. (He's doing a fine job.)

The problem is that she needs to come home because you're dead. I have been asking her to come into the present, but she will not leave. She just shakes her long brown hair, keeping her green eyes fixed on you, watching as you lift a glass of whiskey to your lips. The whiskey is a beautiful amber color and the ice cubes shimmer like stars. The glass sweats beads of water, and your long, elegant fingers hold your poison tenderly. She is waiting for you to be sober so she can talk to you. She pours your liquor down the sink. She provokes your drunken ire by asking you why you drink. She is fierce.

She stands still as a stone while you tell her that if it were not for the fact that she was here, you would have killed yourself last night. "I didn't want you to find the body," you tell her.

But today she will convince you to live. This time you will put down the glass and you will both come home. Safe. No guns. No blood. No rotting flesh. Home. To the ranch, to Montana, to the huge white freezer that you purchased intending to fill with enough food to last the winter.

Daddy, your future has been determined. You, in a moment of despair, killed yourself. The facts are printed on the page. I know all about the battle you waged with death. Only most days, you wanted to live. You fretted about your cholesterol, only allowing yourself five eggs a week. We drank a lot of instant coffee together, laughing until the morning had long passed. You worked harder than anyone I have ever known. For a long time I thought all writers wrote a book a year. And I know all about the goodness and the dignity that you have imparted me. I dream about the good. What you gave me was enough. I embody so much of who you were. I have worked it out. I have a beautiful daughter and a life and a house that won't have to be sold for debt. Your books are read throughout the world. People in France love you. Right now, what I need is my teenage self.

For a long time I thought I could do without her. She is, after all, just a girl, shy, silly and awkward. She can't cook at all. She can only make teenage foods: Bisquick waffles, fried potatoes, and she doesn't like to touch raw chicken. She plays Reggae music and listens to the *Band on The Run* album over and over again. She likes to use Herbal Essence shampoo and has an unrequited crush on John Fryer, the owner of the local book store in Livingston. She is afraid of spiders. She likes to go on walks with you and answer your many questions, because she knows that you are interested in what she has to say. She loves to drift through the house, listening to all the conversations

that you and your friends have about life. No one pays her much attention because she is just a teenager.

 I have to teach her to cook and how to cut up a chicken. She has to remind me of what I put aside. This young girl knows secrets. She can see my future.

 So I'm coming to get her. The plane ticket came in the mail yesterday. When I get to Bozeman, I'm going to drive straight to Livingston, stay at the Murry Hotel, (your favorite place to stay in town) and then I will drive until I find her. I have five days. She could be lying under the Pine Creek bridge, her eyes closed, listening to the water rush by. Maybe she's up in Luccock Park riding on the horse that died in her arms while you were away in Japan. I have to feel the cold night air and breathe in the sharp, sweet smell that belongs in Paradise Valley and look up at the real stars. I'll go to the ranch. If she's not there, then I'll keep going up the valley, tracing the path of the thunderstorms until I'm finally at the Fire Hole, where she might be sitting in the grass, trying to read, waiting for you to return. The fish are jumping, leaving small rings on the water.

 When she finally lets you go and she takes my hand, she and I can say good bye to you, because neither one of us can do this alone.

 Love, love, love,

RITA MAE BROWN

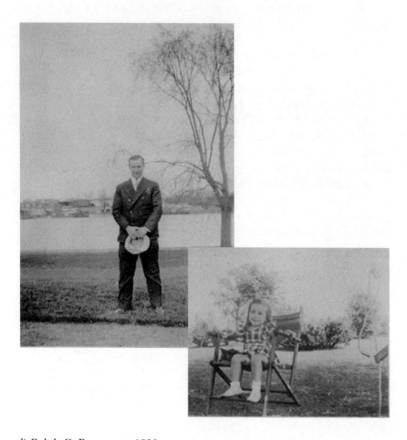

l) Ralph C. Brown, ca. 1930s

r) Rita Mae Brown and Tuffy Cat, ca. 1946

Rita Mae Brown was born November 28, 1944, seven miles north of the Mason-Dixon Line, the only thing for which she can reproach her father. In her life she merrily upsets applecarts and gleefully points out that the Emperor has no clothes. She kind of loves people. She truly loves animals and they love her right back.

Ralph Clifford Brown was born August 7, 1905, in York County, PA. He died July 13, 1961, in Broward County, FL. In between, he was a

dutiful son, an almost faithful husband and a wonderful father. He had a great sense of fun allied with a buoyant sense of humor. He loved people and they loved him right back.

ON MY BEST DAYS

Dear Dad:

You sure knew how to handle women. Other men fuss, fume, walk out, drink, piss up a rope. You smiled and the ladies fell all over themselves. Course, it helped that you were handsome, Dad, handsome and very masculine with that deep, deep voice. But even if you'd been a pipsqueak, you'd have dazzled women.

When I was small I took this magic of yours for granted. As I marched into grade school I began to realize you were special so I studied you because I wanted to be special, too, just like you.

I learned that even if Two Ton Tessie lumbers into the room, a gentleman rises, comments favorably on some aspect of her enlarged person and offers to fetch her a refreshment. I learned everyone's name, the names of their husbands, children, sisters, brothers, cousins, uncles, aunts and shirttail cousins. I actually think you could recite back to cousins out the second degree once removed but I'm not that smart.

You smiled each time you met someone even if it was an old drunk who could talk the flies off a cow. And you meant it.

I remember the first time I realized you were more than special, you were good. Times had been hard immediately after World War II. Jobs were scarce and winter was hard. I guess it was late 1949, snow was piled up back at the loading ramp of your butcher shop and grocery store. Your two brothers left early getting ready for Christmas. You and I swept up the store and then you told me to gather up day old bread. You filled baskets with meat and canned goods. When the church bells rang out seven o'clock you opened the back door. There must have been thirty colored people (that was the polite name then) and you handed out the food calling every person by their last name. White people didn't do that. They called black folks Uncle

Joe or Auntie Lou or Fred but not Mr. Larkins or Mrs. Parker. You knew everyone.

The next day, your middle brother pitched a goddamned fit and fell in it because you cost the store money. He punched you but you didn't hit him back.

"Calm down, Earl," you said.

"You're an idiot! Those people will suck you dry. Hell, they probably picked up the food and drove it home in a Cadillac."

You turned your back on Earl, I think because you were ashamed of him. He jumped on your back which was kind of funny because he was wiry whereas you were a big man with a forty-two-inch chest. One blow and Earl would have been smashed like a Christmas ball. He kept pounding you on the back and screaming how stupid you were, you trusted people. You shook him off, walked out the back door and he opened the door, cold air, blasting in. He shouted that you were stupid, you'd never get rich and uglier things.

He forgot I was behind him. I was five then and I rolled up hitting him right behind the knees. He dropped hard.

I shook my fist in his face. "My daddy's not stupid!"

He slapped me down and I tumbled outside. You flew up those steps, picked me up (I didn't cry) and put your hand under Earl's armpit. You pulled him up.

"Earl, if you ever lay a hand on this child again it will be the last thing you do." You didn't raise your voice.

Earl rarely spoke to me after that. I didn't much care.

I will never know how you had the discipline not to pulverize your hairy ape of a brother. Obviously, I didn't have it then and I don't have it now.

You're a better man than I will ever be or perhaps I should say better person since gender seems to be an overriding issue for my generation. I am somewhat thankful you died before the advent of identity politics. After you stopped laughing you would have been bored silly.

I don't know if I am a lesser person or I live in lesser times but on my best days I can come close to you.

Momma always said we were two peas in a pod. Dear God, that was a woman whose tongue could blow rust off a cannon. I miss her, too.

At the risk of sloppy sentiment, I hope you two are together. The only little snag to an afterlife is does that mean Earl is there, too?

DON MEE CHOI

[Handwritten Korean note, dated OCT 9, 99, signed 아버지]

"In place of a photograph, is this note my father wrote to me. He always told me that one's spirit shows through in one's handwriting."
—Don Mee Choi

Don Mee Choi was born in South Korea in 1962 and came to the United States in 1981. She now lives in Seattle.

I. J. Choi was born in South Korea in 1931. A gifted photographer, he moved his family to Hong Kong, Germany, and eventually to Australia.

INK BLOSSOMS

Dear Father,

Summer is nearly over in Seattle. For you spring must be near. Is this my first letter to you in English? How is Mom? I had a dream about us. I was leading you and Mom along a forest path. I wanted to show you a volcano covered in snow. We were at a lake and Mom was drowning beneath a sheet of ice. Sister stood nearby and watched; so did I, and I was upset with her for not rescuing Mom.

All summer I've been carrying your letter around in my bag. I sent Sister a card. I told her I'd be home for Christmas. It's been three years already. Have you fixed the door yet? Her elbow hitting the glass door...

I stop there, on the first page of your letter, and wonder how your handwriting could be so beautiful. Every word, like a blossom born from ink. *Our lives would have been different...* Do you think the same would have happened to Sister if we hadn't left Korea? You stuttered as you told me how you hid in the cellar, the attic, on the roof of your father's house from the soldiers. How your sister threatened you and wished that you'd be taken away to war. You said, *I would have died and none of you would be here*, and got up as if I didn't hear you and went to your room. Now you live in a house that looks out to a forest. Rainbow lorikeets fly over your roof. No one comes to look for you.

Here, I get up to drink my tea and you are there, asking the psychiatrist if there's a cure for Sister and if there's something for Mom's trembling heart. *Life should be over*, you wrote in the letter. You filmed people fleeing at the end of the Vietnam War, the air raids in Cambodia, the rain of missiles in Lebanon, the poppies of northern Thailand, a charred body inside a church amidst the Kwangju uprising in Korea, and the last scene is your daughter, striking Mom while condemning you.

I dare not ask whether you are homesick. Mom used to say that we are scattered all over the place. Now she says that we are all together except for me. She reminds me every time I come home: *I'll cut my*

four fingers and let's see which one doesn't hurt. Each child is, after all, the same to a parent. You ask me to come and live with you, *This is our home.* I say no, home is still Korea. You say I'm fooling myself. Father, you have your sons that you wanted. Your living room is filled with your photos of roses and I send you mine, a tree covered in blossoms, and say it's just like home.

JUDITH ORTIZ COFER

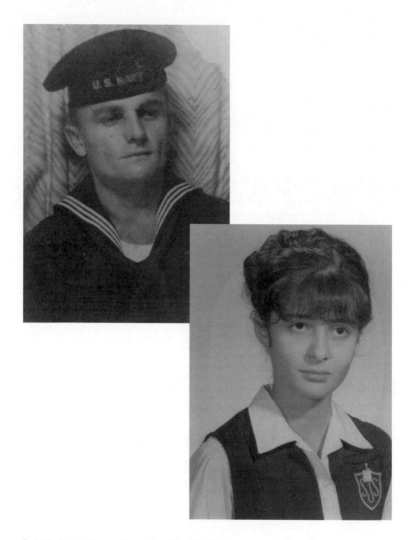

l) J.M. Ortiz-Lugo, Brooklyn Yard, NY.
"This was a wallet-size photo my mother carried with her for many years. I didn't notice until I had it enlarged that it has a fingerprint on it—Whose? Hers? His? Mine?"

r) JUDITH ORTIZ (Cofer), 1966, 8th grade,
St. Joseph's School Paterson, NJ

What I've Never Said

Judith Ortiz Cofer was born in Hormigueros, Puerto Rico, February 24, 1952. Her work has been widely published and she is the recipient of numerous awards and fellowships. Her most recent book is *Woman in Front of the Sun: On Becoming a Writer*, University of Georgia Press 2000. She is also the author of a collection of short stories, *An Island Like You: Stories of the Barrio*, (Orchard Books 1995, Penguin U.S.A., 1996), which was named a Best Book of the Year, 1995-96 by the American Library Association. Forthcoming: A collection of New and Selected Prose and Poetry, *The Year of Our Revolution*, from Arte Publico Press, 1998, and also from the same press: the Spanish Translation of *Silent Dancing, Bailando en Silencio*. She is the 1998 recipient of the Christ-Janer Award in Creative Research from the University of Georgia. A native of Puerto Rico, she now resides in Georgia and is a Professor of English and Creative Writing at the University of Georgia.

J.M. Ortiz-Lugo was born in Hormigueros, Puerto Rico, March 2, 1933. He was a career Navy man. He died in a car accident in 1976.

MARINERO

Dear Father:

Today, the word *poetry* frightened me because I knew I had to write about you. They assure us, the scientists of the brain, that we cannot be haunted, that it is all chemical. You are then, dear ghost of my father, a molecular traveler in my system. You map out your route with the same care as your tours of duty, our road trips, the frequent moves from house to house, and from peace to despair and back again. Today, on the anniversary of your death, you have made a rest-stop in my heart, I know you are there, Father, by its weight. You will notice that its rhythms are not quite regular when you are near: you were always good at detecting mechanical troubles, could tell at once if an engine was about to fail. But you could not, you claimed, see a problem until you took a thing apart. You never knew that my heart's pace was always altered by your presence. It leapt and tumbled in fear, in longing, or in grief. You always left before the trouble was clear. Make your final destination my soul's locale, you are almost there now. It's a deep green valley where clouds appear or disperse at my command, no oceans in sight, Father. Stay.

Judith

WANDA COLEMAN

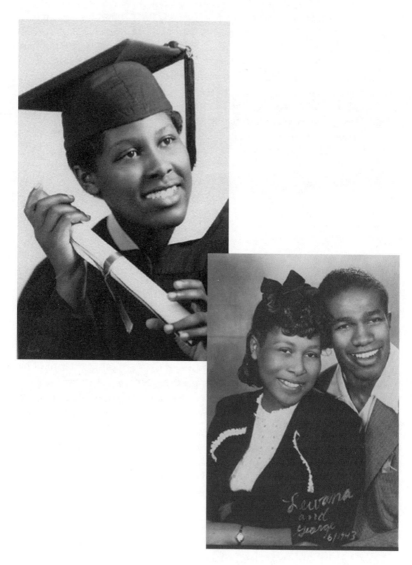

l) Wanda J. Evans (Coleman). J.C. Fremont High School graduation. Los Angeles, 1964

r) Mother, Lewana and father, George Evans. Los Angeles, June, 1943

Wanda Coleman, née Evans, was born in the Watts community of Los Angeles, CA in November, 1946. Her books from Black Sparrow Press include *Imagoes, Heavy Daughter Blues: Poems & Stories, A War of Eyes and Other Stories, African Sleeping Sickness, Hand Dance, Native in a Strange Land: Trials & Tremors,* and *Bathwater Wine* (winner, 1999 Lenore Marshall Prize, the Academy of American Poets.)

An artist and advertising man, **George Evans** was born in Little Rock, AR, in October, 1914, and died in Los Angeles, CA, in 1991. He was educated to the age of eight, then earned his own living by delivering newspapers, shining shoes and herding cattle. He loved his mother, a minister, and his half sisters but never knew his father. He left Arkansas as a teenager, when a young colored man was lynched from a church steeple, hitchhiking into Los Angeles. He lived with an aunt until he met and married Lewana Scott. They had four children. He was the sparring partner and long-time friend of Archie Moore, Light Heavyweight Champion of the world 1952–1960.

FOR DAD, ON WHAT WOULD HAVE BEEN HIS 84TH BIRTHDAY

Father.

Just a few days ago I remembered you in the light of my near death. I felt the tension and the strength in your arms, muscles working to the heft by the rhythm of your steady walk. I have since discovered that the medical name for my "brain fever" was encephalitis.

But at that moment, we were once again standing off the hospital admissions stall of Children's Hospital. It was October, 1957. I was ten years old. Your forty-third birthday was days away, and my eleventh soon after. I was sick with delusions and sweats (you know, they've never left me). I was wrapped in my favorite blue rayon blanket. You had pulled it straight off the bed in your panic. Mama had given me a sponge bath and had half-talked, half-forced me into my fresh hand-sewn white flannel jammies peppered in tiny blue and gold flowers. I was so sick I couldn't walk. You carried me through the darkness that night.

(How do I remember all of this? How could I forget. Memory is fluid, and the fever left its strange residue on my psyche.)

As I went in and out of consciousness, I listened to your voices. I hear them still, you and Mama weighing our bleak circumstances. Despite the long hours and the hard work. Mama labored as a seamstress. You worked around the clock, as a janitor nights, as a sign painter days. As diligently as you obeyed the maxim of early to bed, early to rise, you would never achieve wealth, and thirty-three years later, a brain tumor would deprive you of the remnants of your health and wisdom.

You had no money. And no medical insurance. What chance did I have to get the help I needed?

Dr. Lewis, one of the few Negro physicians who made house calls in our neighborhood, had sent you across town, from his South Central office to the charity hospital in Hollywood. And now I am listening through my fever to you and Mama as you argue with the coldly officious blonde admissions nurse. I can see her, Pop. I can see her immaculate starched white collar and uniform, her fine knit gray-blue sweater. And I can see her helper, the auburn-haired candy striper who keeps sticking the glass thermometer in my mouth. Temperature of 104. I can see their crisp white caps. Yet there are no angels of mercy here.

Mama doesn't know I'm awake. She thinks I'm sleeping. She cries as she begs for them to let me see a doctor. Her hushed whimpers say that I will die without emergency treatment. You stand behind her, fists rammed into your pockets.

But they don't treat poor colored children here. And not unless the referring physician has privileges. Not even for emergencies.

I am refused admission.

I can still hear the clack of Mama's thick leather heels against the linoleum as she rushes outside to bring the car around to the front. You wait with me. The security guard was summoned to watch against potential violence. Everyone senses your rage. You are a big man, an ex-boxer, your thick honey-brown arms bulge beneath your worn brown woolen sports jacket, the one you wore home from the shop that evening, the one that makes me itch. The blanket prevents me from coming in contact with it. Once, when my cheek brushes your shoulder, I feel the bite and sting of the wool.

How the guard stares at us. I wonder what he sees. He knows you were once some kind of athlete and is impressed by your size. I can

see his badge and his gun. There's the distant honking of the car. You're tired. Your shoulders slump, suddenly. You take a deep long breath. And before you bend over to lift me, you look the White security guard in the eyes and say, "Be a man, be decent. My child is dying."

Your words shock him. He holds the double doors open for you. You've shamed him into cooperating. You cradle me in your arms with a grunt. I weigh a hundred pounds. I can hear the scrape of your shoe leather as you carry me outside, into the dark morning, and down the concrete stairs. I look for the moon but can't find it. The old sedan is there, Mama behind the steering wheel. She leaves the motor running, jumps out and opens the door. You lay me in the back, then take the driver's seat. County General is ten minutes away, by Mama's count. But you must be careful not to speed. We can't afford to be stopped by the police.

Your prayers to "Jesus help me father" for my recovery are answered within two weeks. I receive the treatment needed, undergo the spinal taps, the electroencephalograms, the drugs. I live. And now I'm telling about it.

In some strange way, that night—our night—was the most significant of my childhood spent fighting allergies and illnesses. Yet, it is only now, some forty years later that I've come to recognize this as fact, to examine it, to ask myself why, to grapple for the answer, which still eludes me at this writing. Save to say what I have never said. No child on Earth could have loved their parents more than I loved mine that night.

And you?

You, were magnificent, Pop. You never won the title belt, but at heart you were the truest gentleman champion I've ever known.

Wanda

RAND RICHARDS COOPER

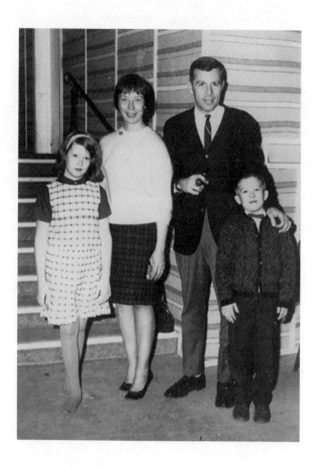

Rand Richards Cooper, to the right of his father, Donald Cooper, at a ski resort called Chanticler in Quebec, Canada. February, 1965

"Next to my father is my mother, Mary Ann, and my older sister, Carrie. Note that both Mom and Dad have their respective tobacco pleasures at the ready. With my clip-on tie I seem to be practicing to be a waiter, or maybe a jack-in-the-box."

Rand Richards Cooper is the author of *The Last to Go* (HBJ) and *Big As Life* (The Dial Press). He has taught at Amherst and Emerson colleges; his stories have appeared in *Harper's*, *The Atlantic*, and many other magazines. Cooper was born in New Haven, CT, in 1958. Having followed his wanderlust during years of living abroad, he now makes his home in Hartford, CT.

Donald W. Cooper was born in Philadelphia in 1928. After graduating from Swarthmore College, he studied medicine at the University of Pennsylvania and at Yale, and spent two years in the U.S. Public Health Service in Arizona. An avid athlete, he worked for many years as a weekend ski instructor in Vermont. He retired from practicing neurosurgery in 1993, and now divides his time between Connecticut and Arizona.

MATERIAL MEN

Dear Dad:

Who was it who said that a letter is fiction written for an audience of one, while fiction is a letter to the world? Well, I guess this is a little of both.... Anyway, I know you mistrust the view "through the retrospectoscope." A surgeon makes decisions with life-and-death consequences, and can't afford to second-guess himself. But a writer, notwithstanding what Frost said about the game being played for mortal stakes, shops the past at lower cost.

The other day I recalled a funny moment. A day when I had a pair of jeans that needed mending—I was maybe thirteen—and you were in the den as I waltzed by, looking for Mom. "Get me a needle and thread," you said. "I'll do 'em." I was deep into my *Yeah, right, Dad* look, when it came to me—Oops! I guess a neurosurgeon *can* sew. It was hard to connect anything mundane with the glamorous and action-packed world I believed you lived in. (Remember the TV show "Medical Center?" In my view, you were as cool as Chad Everett.) Your job had status and flash and drama, and it paid well too. A career without a downside. It was a social asset for us kids, too. I doubt the human brain Carrie brought to school in a jar has ever been equaled in the annals of third-grade Show-and-Tell.

But what did your career do for *you*? I remember a night at dinner, during my senior year in high school. You and Mom and I were talking about college. "I can just see it," you groaned. "Next year you'll come back wearing some kind of beard, reeking of pot, and you'll tell me what a materialist I am." You always enjoyed these rueful scenarios—stridently idealistic student berates cowed Dad for materialism while living off his money—and somewhere behind the joke you were worried, too, about various kinds of distance college was soon to put between us. But I think now there was even more to it than that.

Let me take the long way round on this one... A few years ago, when the poet James Merrill died, a friend of his remarked that Merrill was the wittiest man he ever knew whose wit never worked at another's expense. I thought then about the humor I grew up with—your humor, really. There was always a touch of the wicked to it, a glee taken in humiliating predicaments. Like Nani's lifelong campaign against constipation, and how she came into the living room that time telling Pop about a satisfying bowel movement, only to find the priest there on a social call. Or Jon Wool's story of trying to impress a popular girl in 8th grade, when he sneezed, and out flapped a long pennant of snot. And how many times did I get you to tell how you and your two frat brothers ate beans and garlic and raw eggs to arm yourselves for stinking up the car while a fourth brother went in to pick up his date? "Totally *befogged*," you said, laughing. "Completely *beclouded*."

This streak of adolescent humor never seemed to fit with the charming, debonair rest of you. Yet those comedies of embarrassment have something serious to them: they plumb the gap between propriety and physicality, between what our egos tell us we are and what our bodily needs can reduce us to. They highlight the body—its demands, its limits and malfunctions. Do you remember in the bathroom one time handing me the mirror and telling me to lower my face over it and look? "Now look what happens when *I* do it," you said. Your face, older and slacker than mine, was distorted by gravity into a mask. It had to do with changes in fat and muscle tone, you explained. "I look like a monster, don't I?"

Identity mystifies, our own no less than others'. Who *is* that looking back from the mirror? I think about the things that caught your imagination. Stories about the elusive nature of the self, the person seen from outside vs. who's really there—or not—on the inside.

What I've Never Said

Secrets... The man who walks down to the corner for a pack of cigarettes and never returns. The campus hero who years later has failed to live up to predictions. Jekyll and Hyde themes, cheesy thrillers (like "The Stepfather") about placid-seeming men who turn out to be psychotic killers. Impersonators have always been favorites of yours—Rich Little, David Frye—and you did an excellent Jimmy Stewart and Humphrey Bogart, as well as some comic routine which ended with a lurid Frankenstein grimace. All this was done for fun, but there was a subtext... As if to say, I may not be who you think I am.

What *is* the self? For you, identity was less often a philosophical challenge than a technical one. The brain was the seat of the mind, the mind was identity, and that was where you worked, day after day. Drugs, trauma, strokes, tumors, the inroads of age: both the things that went wrong, and the measures taken to make them right again, could alter the self, sometimes devastate it. Aphasia fascinated you; I remember you telling us about a patient who couldn't summon the word "belt," and kept saying "the thing that holds my pants up" instead. Or the way a stroke could wipe out specific aptitudes. You'd snap your fingers: "There go the piano lessons." Again that grim, in-the-trenches humor. Identity was something you scooped out and cut into and patched up; it was plumbing; it was wiring. The self was far less stable, and far more precarious, than the rest of us imagined.

You were never a distant father. You made time, you took avid interest. But *we* must have been a distant family to *you*. I mean the chasm between the world you lived in and the world Mom, Carrie, Laurie and I lived in. At dinner you'd tell about your day: A guy with a massive hematoma. A carotid endarterectomy on a 52 year old. Then we'd tell you about our days: Mom's garden club show, the riding camp Carrie wanted to go to, Coach Gino's latest antics with my Little League team.... Everyone had a turn; one person's world was—on its own terms—as full of drama as anyone else's. That's an important truth in a family, and one you shared.

But it's also true, I know now, that there *is* no career without a downside. Over time, we become our (pre)occupations, and unless these are explored and voiced—doubts and despairs included—then compensations like humor, which armor and protect, can become a burden. Which brings me back to sewing, and to that dinner conversation. *You'll tell me what a materialist I am.* Decades later, I hear nervousness in those words; uncertainty, even a plea for understanding.

I think you meant "materialism" not just in the monetary sense, but the medical, corporeal one. What to do when you spend day in and day out seeing people as material, torn and sewn up again? Where to put that knowledge? Men compartmentalize. But that takes a lot out of you, and it's risky. A man builds a wall between parts of his life, and one day wakes up to see the people he lives with on the other side. When you left Mom, two years after that dinner conversation, it was for someone who knew your world inside out.

That was twenty years ago. You've been retired from medicine for the last five of those twenty—happily retired. I know that toward the end you found yourself increasingly gloomy about neurosurgery. You could never think of the successes, you said, only the failures. Then you knew it was time to quit.

Of course, a writer treats people as material, too; and at what cost of his own? The novelist John Gardner told of coming upon the scene of a car accident, and imagining, even as he rushed to help the victims, how he would *write* it. For my part, I've cadged so much from memory, added so much *to* memory, that sometimes I'm unsure whether an event in our family in fact happened, or whether I dreamed it up. I've written—and you've read—stories involving characters drawn in various measure from you. That seemed less a way to say things I couldn't otherwise say than to know things I couldn't otherwise know.

As for the real me and the real you, we've had our disagreements, but we've made it through to an easy comfort with each other, including each other's differences. To be sure, the accumulating perception as one goes through life is of similarity. There's a short story by Ethan Canin (a physician as well as a writer, by the way) told from the point of view of a young man who has had a lifetime of struggle with his father. The son is complaining about not really ever having gotten to know the father. "You don't have to get to know me," the father says. "And you know why? Because one day you're going to grow up and then you're going to *be* me."

I know you'll like that line with its nod to inexorable destiny. But I think the father has it wrong: becoming one's parents means, in part, continually *getting* to know them. (I've watched you keep on learning about your parents, long after their deaths.) There's a lot of you in me. It's eerie at times—such particular gestures and habits. A certain way of putting my hand to my chin, with thumb and index

What I've Never Said

finger covering my mouth, when someone is telling me something I may not want to hear. An irrepressible urge to count the bills I've left on the table at a restaurant, not once, not twice, but three times, just to make sure. And larger traits, too: affability; pleasure in telling a story; a powerful nostalgia; a tendency to experience self-doubt as threatening, and to respond critically to it in others. At the same time I'm less responsible than you, and more argumentative; less polite; much less neat. I look at my bitten fingernails and picture your perfect ones, which you were always filing—"the magic fingers of the brain surgeon," you joked, holding them up.

A few months ago I wrote a short story about a retired man looking back over his life. The story included this line: "He was laughably, bizarrely, inescapably seventy." Well, today, September 29, you're turning seventy. *Does* it seem bizarre? Knowing you, I imagine rueful humor and, above all, gratitude at having gotten here healthy. But some amazement, too. Not only because you're youthful and vigorous (as I write, you and Paula are biking through Holland!), but also because the passage of time—that tantalizing near-and-closeness of the past—has always been a treasured theme of yours.

Anyway, Dad, happy 70th birthday. I hope you look back with pride. While you always took pleasure in being better read, better dressed, more athletic, etc., than the typical small town physician, I have a feeling you vastly underappreciate your life's work. Maybe you just didn't like to talk about it. You never trusted the do-gooders, you said; you never believed your med school classmates when they said they wanted to "save humanity." But I think a lot about the many people you did save. And I know they think about you.

Thank you for everything you've done for us, Dad—the time and love and support; the laughter too. Oh, and by the way. Next time I see you, could you maybe mend a pair of pants for me?

Love,

NICHOLAS DELBANCO

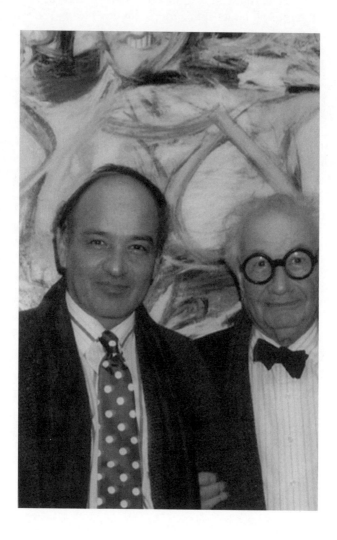

Nicholas Delbanco and his father Kurt Delbanco at the Museum of Modern Art. New York City, ca. 1995

Nicholas Delbanco was born August 27, 1942, in London, England. He is the editor and author of numerous works of fiction and nonfiction. He is a professor at the University of Michigan, Ann Arbor.

Kurt Delbanco was born October 27, 1909, in Hamburg, Germany. For many years he has been an art dealer and an artist.

WHAT YOU CARRY

IF YOU READ THIS when it is published you will be more than ninety, Kurt Delbanco, and I can only hope and trust you'll still be here to read. The odds are good; you come from long-lived stock. Your mother died at ninety-seven; your elder brother and sister survived well into their nineties before time took them down. And, as of this writing, you are in excellent health. A *boulevardier*, an enthusiast, an old man that young men and women praise for seeming-perpetual youth. Still happy to go to a concert or the theatre or, most of all, a museum, still happy to buttonhole strangers or friends—not to mention family—with your theories on "globality," the virtue of perspective on the land when seen from airplanes, the idea of international taxation to support a *United States of the World*. Just last night on the phone you announced you'd been at the easel all day long, reworking a series of paintings, and the new work is splendid, remarkable, and you strongly recommended painting as a remedy for boredom and a cure for the ills of old age...

In the photograph we stand side by side, and the resemblance seems clear. I don't wear glasses or a bowtie but there's little doubt of lineage: the hand that grasps the arm. Your hair is more white, your mouth more broad; you've contracted a little but we're the same height. Together we smile at my wife, your daughter-in-law; she takes our picture on a visit to Manhattan and the MOMA you go to so often. Behind us looms a late De Kooning, one of those overweening portraits of women, a gaudy giantess. My mother—your first wife—died young, and you've been happily remarried now for more than twenty years. A "sunshine child," they called you back in Germany, the country you were forced to flee, and now—after half a century in America, the country we came to from England—you stand here

smiling still. With your striped shirt and horn-rimmed glasses and ancient well-cut Saville Row suit, a template that endures...

Yet death does happen, finally; it isn't a question of whether but when. And you the youngest have become the oldest of the elder generation; the child has fathered not only the man but men who're long since fathers in their turn. You have three sons, seven grandchildren, one great grandchild, and your second son—he who writes this—is but a small part of the chorus when we foregather ceremonially in order to wish you good health. Such celebrations count, it seems: the birthday parties, the toasts. And because this is the sort of letter I don't write and you don't read it seems all the more important, somehow, to get and say it right...

In truth you don't read much these days, have never done; your relation to the world of words is largely confined to newspaper articles and the occasional art-book. One eye, alas, has dimmed. But you still peer at pictures—those you buy and sell and keep and make—with a preternatural acuity. I used to think, indeed, you had some difficulty remembering my name or which of your children was up to what—but you have no difficulty remembering the way the light fell in the gallery in 1924 when you first saw the Brueghel or the Degas that focussed your attention. When I think of you these days and decades I think of you with brush in hand or staring at the graphic work of those who went before. You call them mannerists—Goya, Piranesi in his imagined city-scapes, Durer, Rembrandt, Daumier, Toulouse-Lautrec. These are your glad companions still, the great undead, the work that lasts. You study it on walls; you see it on the eyelids' screen each time you shut your eyes. May these lines stay with you a little, also, and these words remain.

For you have been a splendid father, Father, and I want to attest it in print. A little abstracted, a little abstract, but clear beyond the possibility of all confusion that family matters and family matters do count. Our lineage is long; you've just sent me a book about the family Delbanco in Padua in 1520, in Venice some years after that. At the start of the seventeenth century the Delbancos moved to Germany and were assimilated merchants who couldn't quite believe the little house painter was serious with his plan to exterminate Jews. *Mephisto*, you call Hitler, *Mephisto*, and horror and iniquity remain, for you, defined by the Third Reich and men with jackboots and torches on the rampage: *Crystallnacht*. It was, I think, your own defining moment and an engine of change: from pampered youngest

What I've Never Said

child in Hamburg to fatherless refugee…

When asked what you are proud of, you answer: my three sons, their wives, their children my grandchildren—not a single *schlemiel* among them, and everybody still talks to everybody. No mean feat. What I've never said is *Go away, Don't bother me, You're wrong.* Because you've never been a bother and I don't want you to go. What I've not yet said is how these mornings in the mirror I see the old man I will become, and how he reminds me of you. So when I forget my keys or say "Just a minute, just a minute" in answer to some waiting someone I hear the proleptic echo of your own weakening voice. And when I think that my own children might perhaps write some such lines to their father in the future, I hope they will offer an echo to this: you have been much admired, much loved.

LYNN DOIRON

l) Delores Lynn (Due) Doiron, age 5
River Ranch Dairy. Mira Loma, CA, 1952

r) William Harvey Due at River Ranch Dairy. Mira Loma, CA, 1954

What I've Never Said

Delores Lynn Due Doiron was born in Upland, CA, on January 11, 1947. Until her graduation from Rubidoux High School in 1965, she lived with her parents, uncle, brother and two sisters in housing provided by the River Ranch Dairy Company, Mira Loma. After her husband's death in 1988, she obtained her B.A. in English at CSU Sacramento, winning the Bazzanella Literary Award in both fiction and nonfiction while in attendance. Her work appears or is forthcoming in various literary magazines and anthologies, including *The Baltimore Review, The MacGuffin, Visions, The Lucid Stone,* and *From Daughters to Mothers: I've Always Meant to Tell You* (Pocket Books, 1998).

William Harvey Due, the third child of Emma and Ralph Due's thirteen children, was born on November 13, 1916, in Grandfield, OK. As a young man in California he worked various jobs from furniture mover to ranch hand to wine taster at a Mira Loma vineyard. He married Opal Ivy in 1945 and, in 1947, began what would turn out to be a 30-year job with River Ranch Dairy Company—plowing, planting and harvesting alfalfa fields, repairing farm machinery, and tending the ranch's large calf operation. He loved western movies, Louis Lamour books and gardening. He died at home when pneumonia took his life on February 24, 1984.

STONE WALL IN COTTONWOOD

Dear Daddy,

 Three years before you died, Mama asked me to put away my trowel and bucket of mud and come inside to spend time with you. I knew that meant listening to stories about good old days and good old boys in the Oklahoma of your youth, stories I'd heard a thousand times.
 Those were the days when you lived on the dairy in Hilmar, five hours south of my home on Cottonwood Creek. For the first time in thirty-five years of marriage, Mama worked as your partner, feeding, medicating, and watering over a hundred young calves at sun-up, noon, and sunset. She wore Red Ball rubber boots to shuffle through the calf barns hauling buckets of water to each pen; her feet grew bunions the size of tennis balls.

Your worn-out maroon bedroom slippers covered her feet that afternoon as she stood beyond rows of rocks I'd spaced and sorted according to size, color and texture. "We'll be going home early tomorrow. Why don't you come in and talk with your Daddy for a while?"

I looked at the unfinished planter wall, the fresh mud I had troweled over two adjoining rocks, and hefted granite, shaped like a wedge, into place. I answered without turning, "Ask Daddy to come outside. We can talk while I finish this bucket of mud."

You didn't come out to join me, Daddy. I didn't go inside.

On the eve of your death, Al met me as I came through our front door after work. He said, "Lynn, you should go over and talk with your dad. He's not looking well."

I didn't pause. "It was dark when I left this morning and it's dark now and I'm too tired tonight. I'll walk over tomorrow after work." Upstairs, I unloaded briefcase and purse, exchanged tight, high-heeled shoes for moccasin-style slippers and headed back down to start dinner. Al stood where I had passed him on my way in. "I really think you should go see him tonight."

Al's solicitations, offering space on our property for you to live against my better judgment, made him appear as your natural son rather than an "in-law." From our front door I could see moths circling your single-wide mobile's porch light, the flickering glow of your T.V. behind the sliding glass doors.

In my kitchen, I pulled potatoes from the bin, drew a paring knife from the drawer and began peeling. I dug the deep eyes out of potatoes with a tired anger. Who did Al think he was, telling me how I should perform as a daughter? Of course, I should, and could walk across the yard, sit by your side, pat your hand, ask about your day, but who were you to expect that from me? You, who couldn't be bothered to change the oil in Mama's car? Who, through all the days of my youth, bought a new car every two years when Mama didn't have a cup and saucer that matched or a single plate without chips or hairline cracks ruining its surface?

As I quartered those potatoes and dropped them in boiling water, I knew exactly who you were—a daddy who could wait one more day for a visit from me.

When Mama called the office the next afternoon, she apologized for interrupting my work before asking me to come home. She said

you weren't acting "right," that you'd fallen down on your way to the bathroom, that she had helped you to a kitchen chair. She said she was scared. I left work within five minutes, but when I got home you were dead.

Fourteen years have passed since we buried you, Daddy. Mama never got over the guilt of it, the fact that you died at home of pneumonia. The physician you'd seen just two days before assured her of how easily she could have misunderstood your symptoms, mistaking them for a reaction to your most recent prescription for a bladder infection. Nothing he said eased her conscience.

I viewed your death (the nerve of you dying at home!) as one more way of adding to her misery.

When Mama died in 1993, almost a year went by before I stopped lifting the phone receiver to call and share some trivial thing from my day. I wrote letters addressed "Dear Mama" with no place to send them, no forwarding address. I missed her so absolutely. With each thought of Mama, a thought of you would glide in and out, usually unkind. I had layers of resentment against you, each layer as textured as an individual stone, all stones mortared together into a puzzle-work creation of a "You" I could blame for Mama's often unhappy life.

Last year, when I began pouring words into letters addressed to you for this anthology, I wrote scenes from my life as your daughter. As I described hayrides when you took my friends and me to a eucalyptus grove down near the river, wiener roasts with flaming marshmallows, camp songs you grinned at while we all sang, the focus of *What I've Never Said*, became less important than *Why Have I Never Grieved Your Death*. I wrote about picnics at the pond, how you taught me to swim underwater like a frog, about mornings when I rode high on your shoulders out to the calf barn where you worked, how you let me break eggs into the powdered milk for the calves. I wrote about flood-irrigated fields where I floated in the troughs between long mounds of pasture-covered earth while you adjusted rate flows or maintained the water pumps, about how you taught me to catch crawdads in the irrigation canals, where to grip their red shells so their claws couldn't pinch me, and how to run for a tree I could climb if I happened upon a Brahma bull—or cow. I wrote about the one time you ever lifted a hand against me in anger and slapped me so hard I nearly fell down. (You only did what you'd witnessed me

doing to Randy. You taught me well. I never slapped my little brother again.) I wrote about county fairs and carnivals where I trailed after you with my fingers tucked into your Levi hip pocket so I wouldn't get lost in the crowd. You never walked too fast for me to keep up.

Scene-by-scene I rediscovered a time in our past when I didn't take Mama's side against yours—a time when I was as much your girl as Mama's. I'm sorry for the ungrateful child I turned out to be. Always too busy, always moving too fast to slow down, I lost you, the relationship we had shared, in a crowd of mundane complaints. I built a wall from those complaints. Now, I'm knocking it down.

I still live in the house with the rock planter. As I write, chrysanthemums lean out over the capstones. Perennial flowers, they've regrown year after year since your death. By Thanksgiving enough will remain to cut a centerpiece bouquet for the table. And perhaps I'll tell a story to my children and grandchildren, a story about how tall my daddy sat a saddle and how bluer than Oklahoma skies were his eyes, and how he listened and smiled along with songs we sang on a hayride. If I'm lucky, they'll listen.

All my love,

Lynn

TESS ENROTH

Theresa (Tess) McElwee (Enroth) and her father, Frank McElwee, Minneapolis, MN, 1938

Tess Enroth was born in Minneapolis on August 20, 1925. She grew up and was educated in Minnesota, earned her M.A. while living in California, and later earned a Doctor of Arts in the writing program at the State University of New York at Albany. She taught college English for more than twenty-five years, has published poems and short fiction, and is writing a novel. She lives in Oregon.

Frank (Daniel Francis) McElwee was born in Wesley, IA, June 6, 1890, and died January 20, 1973, in Sacramento, CA. He quit school in 1904 to take care of his mother and three sisters. In 1918, he married a school teacher, and they had two daughters. He spent most of his life "moving dirt," driving teams of eight horses and later supervising men operating powerful machines.

TO THE LONESOME COWBOY

Dear Dad,

I am almost the age Mother was when she died and left me to look after you for the rest of your life, Aunt Stella warned me not to. "Our mother spoiled him. Your mother spoiled him," she said. "Now it will be your turn to spoil him." Well, she probably had a few bones she'd like to pick with you, but I'm not sure the advice quiets my conscience when I think of the ways I might have made those seven years better for both of us.

In that house with my husband and Kate and Sarah still at home, things seemed a little hectic. You and Sarah had some good moments, and our dog became yours. But you and I seldom talked about feelings or wishes or even about the memories we shared. Just once, when things were going very wrong in my marriage, you offered comfort, but I brushed away my tears and denied my need. I still wonder how much you knew, and if you wondered if I knew.

You could still tell stories, surprising me sometimes with a new one. I wish I had taped them—wanted to, but I couldn't draw them out, or you couldn't talk on cue. A few years later when Sarah retold some of them in an essay for her freshman writing class, she sent it home with her prof's appreciative comments in the margin. I've added it to the family history my kids nag me to record.

You were a great storyteller. (Cousin Jim, who reminds us all of you—the dry wit and understatement—tells me he has even verified one or two of them.) But you were not much at what is now termed "meaningful conversation" with Mary or me. I don't believe you understood your children or thought you should. I wanted to understand you but was too concerned with your authority, never sure when

you'd wield it or how. I didn't believe that you ever noticed my small triumphs, either, and I cried when I found that worn and faded letter in your billfold after you died—the one from the University dean congratulating you because I made the honors list. Now that I think of it, I do remember how proud you looked the night I got my degree at the U. But when I got my Master's you didn't seem to know that it had been harder for me and meant more.

You were pleased, too, when Dan was born, your first grandchild—the only grandson. You used to treat me as if I were your boy when I was about four or five, praising me when I was quick or agile, or seemed fearless. You called me "a real humdinger." My independence that pleased you, then, would infuriate you when I was older.

Remember the boots, Dad? I couldn't have been much more than three years old when you were commuting to St. Paul on the Empire Builder. One summer evening you came home with a package tied with a string—and it wasn't even my birthday. The boots were shiny black rubber with a red stripe around the top. I wouldn't take them off, and you tucked me in bed with my feet dangling over the edge.

I was your pal then, the boy you never had. You told me about John L. Sullivan and taught me to box. You showed me how to make a proper fist with the thumb bent down, taught me to keep my guard up, just like Jack Dempsey did. When you got on your knees to spar with me, you were just about my height. Remember the time I slipped in under your guard? I landed a swift upper cut on that dimple in your chin, that spot you dared me to hit. Then, with a right cross, I hit your nose. Your eyes watered and your face got red. I felt confused and sorry, but you laughed and called out to Mom that I had "landed one right on the button."

You talked about the old days building the Great Northern across North Dakota and Montana. You knew Indians and could twirl a lariat. I loved to sit at your feet while you strummed your guitar and sang sad cowboy songs like "When the Work's All Done this Fall" and "The Lonesome Cowboy (with a heart so brave and true)." I still know the words to them and would probably still cry to hear "Nellie Gray," about slavery, and "The Letter Edged in Black."

When I was in grade school, I didn't understand what "The Depression" meant, except that for a few years you lived at home and didn't build roads any more. You went to work at night and tried to sleep during the day. I didn't know you were working two jobs, both of them dangerous—sheriff's deputy and night man at the Skelly gas

station on Highway 12. We never went hungry, but we ate a lot of fish you caught through the ice on the lake and venison brought by cousins—you would not shoot deer. You spoke scornfully about "relief" and would never ask for a "handout" or WPA work, but I couldn't know how you worried. You must have been terrified about what would happen to your wife and kids if one night you didn't come home from a brawl or a holdup. Just recently I found the papers for a few thousand dollars borrowed against your life insurance, the only savings you had. Worried, tired, you often unleashed your Irish temper on Mary or me, never on Mother, though.

During that time you exploded at me one afternoon—I must have been nine or ten. I had gone out on my bike, not knowing or saying where. When I came home and Mom asked where I'd been, I said I'd been down by the dam below the railroad trestle. Her dismay caught me by surprise, and I made excuses rather than apologies. You came into the kitchen, having heard enough to understand Mother's distress, and you turned me across your knees. You told Mother to bring your razor strop and said if I worried her like that again, I'd be sent to reform school. Mom didn't bring the strop, and I got off with a tongue lashing. I had never been closer to a spanking, but your words hurt more than a blow could have. I had no way to express how indignant I felt, but your threat of reform school left me doubting my worth for years.

Times grew better in the late thirties; you again had work that paid well, but which also took you away from home most of the time. In the summers we would pack up and go to live in a cabin on a lake near wherever you were building a highway. I swam all day and Mom sat on the porch and read magazines until dinner time. You ran three shifts, so you went to work at four in the morning, came home for dinner, and afterward went out again, taking us along, to see that the night shift was okay. Did you love it as much as we did? You seemed to—you and Mom so happy, with jokes and secrets that I couldn't hear.

You taught me to drive, using more patience than I ever dreamed you had. I could hardly believe it when you let me sit behind the wheel of the Ford out there on your unfinished roadbeds in northern Minnesota. It was safe there, and even when you grabbed onto the dashboard, pretending to be scared, I knew I was doing okay.

In the winters, you came home every few weeks. I knew it was hard for you to be away, sleeping in hotels, eating greasy food, and

What I've Never Said

missing Mom. At home, you would sit on a kitchen chair near where she stood fixing dinner. I could see you wanted her on your knee. When I showed you a drawing of *you* that won me a scholarship at the Minneapolis Art Institute, you scarcely listened, and I felt ignored and resentful. You wanted me to stay home, out of harm's way, but out of your way.

On one such night, I simply announced that I was going out. You must remember that time, Dad. You yelled at me and I yelled back, and you grabbed me as I reached the front door. What awful things did we say to each other? You held my shoulders, and I beat on your chest with my fists—probably with thumbs carefully bent like a bare-knuckle boxer's. Then we looked each other in the eye, tears came, and you held me close and told me to be careful. You probably told me not to get run over; that's what somebody always said when I went out to play.

That was the last confrontation I remember, Dad. When I married and had kids, they loved you and you adored them. You grew old, and I tried to take care of you. When I was little and had tonsillitis, you sat by my bed and told stories about bears, and when I was grown up and feeling ill, you coddled me, bringing me steaming black tea—not in a mug but in a proper china cup with a thin edge. Then you'd rub my back.

When I stood by your high, narrow hospital bed, rubbing your chest and stroking your brow, I heard you whisper how you hurt. The nurses said you had been "bad," pulling out the tubes so that they had to tie your arms down. When one nurse said, "Frank has been a naughty boy again," my own Irish temper flared, and I told her never to speak that way again: "Never, never call him a naughty boy, and don't call him Frank either!" I asked your doctor if all those tubes were necessary, if they did you any good, and he answered that it was up to me. The decision was right, yet I wept inconsolably afterward. My comfort lay, eventually, in a raft of memories.

Love, hugs,

Treasie Lou

LESLIE FIEDLER

Younger brother Harold, father Jacob Fiedler, and Leslie Fiedler
New Jersey, ca. 1920s

"I have chosen this photograph because of the ambiguous way in which my father is holding us in what might be an embrace or an effort to choke us."

Leslie Fiedler was born in Newark, NJ, in 1917. He is the author of *Love and Death in the American Novel*, and numerous other works of literary criticism. Most recently he received the PEN Center USA West award in recognition of the body of his work in criticism, among many other awards. He is presently the Samuel Clemens Professor and SUNY Distinguished Professor in the Department of English at State University of New York at Buffalo.

Jacob Fiedler was born in Newark, NJ, in 1894. "This [birthplace] is perhaps the only thing we had in common, except for a love of playing with words. My father would have liked to become a writer of musical comedy or of popular songs. But he ended up a pharmacist, a trade he cordially hated. He was, however, successful at it but bankrupted by the Great Depression. From then to the end of his life at the age of sixty he thought of himself as a failure. He died at the point when my first book was about to appear and therefore never had a chance to comment on it. If he had done so, it would doubtless have been with words with which he responded to everything I had done in my life up to that point: 'You are a constant series of shocks and surprises.' He did not like shocks and surprises."

TO MY FATHER

To speak
With the dead
Is forbidden by many religions…
Now I know why.

ANNIE FINCH

Annie Finch and her father, Henry Leroy Finch
Kifissia, Greece, 1963

"The family was living there for several months during one of his sabbaticals from teaching."

Annie Finch was born on October 31, 1956, in New Rochelle, NY. She published her first poem at age 9; her first full-length book of poems, *Eve*, appeared in 1997. She has also edited anthologies, including *A Formal Feeling Comes: Poems In Form By Contemporary Women* and *An Exaltation of Forms: Contemporary Poets Celebrate the Diversity of Their Art*. She was educated at Yale, Houston, and Stanford, where her doctoral dissertation became the book on prosodic theory, *The Ghost of Meter: Culture and Prosody in American Free Verse*. She teaches poetry writing at Miami University, OH.

Henry Leroy Finch was born in New York City on August 8, 1918, and lived most of his adult life in New Rochelle, NY, where he died at home on August 22, 1997. A devoted student and professor of world religions and philosophy, he was educated at Yale and Columbia, taught philosophy at Sarah Lawrence and Hunter Colleges, and in retirement coordinated the Studies of Religion seminars at Columbia. He was author of three books on the philosophy of Ludwig Wittgenstein (*Wittgenstein: The Early Philosophy*; *Wittgenstein: The Later Philosophy*; and *Wittgenstein*), as well as two posthumous books, *Simone Weil and the Intellect of Grace* and *The Philosopher Shamans: Wittgenstein, Gutkind, and Weil*.

ELEGY FOR MY FATHER

> "Bequeath us to no earthly shore until
> Is answered in the vortex of our grave
> The seal's wide spindrift gaze towards paradise."
> —*Hart Crane, "Voyages"*

> "If a lion could talk, we couldn't understand it."
> —*Ludwig Wittgenstein*

Under the ocean that stretches out wordlessly
past the long edge of the last human shore
there are deep windows the waves have not opened,
where night is reflected through decades of glass.
There is the nursery, there is the nanny,
there are my father's magnificent eyes
turned towards the window. Is the child uneasy?
His is the death that is circling the stars.

In the deep room where candles burn soundlessly
and peace pours at last through the cells of our bodies,
three of us are watching, one of us is staring
with the wide gaze of a wild sea-fed seal.
Incense and sage speak in smoke loud as waves,
and crickets sing sand towards the edge of the hourglass.
We wait outside time, while time collects courage
around us. The vigil is wordless. Once you

saw time pushing outward, the day in the nursery
when books first meant language, as your mother's voice
traced out the patterns of letters. You saw
words take their breath and the first circles open,
their space collapse inward. They sparkled. Your pen
would scratch ink deliberately, letters incised
like runemarks on stone as you heard, quoting patiently:
Wittgenstein, Gutkind, Gurdjieff, or Weil.

You watch the longest, move the furthest, deliberate in breath,
moving into your body. You stare towards your death,
head arched on the pillow, your left fingers curled.
Your mouth sucking gently, unmoved by these hours
and their vigil of salt spray, you show us how far
you are going, and how long the long minutes are,
while spiraling night watches over the room
and takes you, until you watch us in turn.

He releases the pages. Here is the mail,
bringing books, gratitude, students, and poems.
Here are kites and the spinning of eternal tops,
icons, parades, monasteries and boardwalks,
gazebos, surprises, loons and unspeaking
silence. Pages again. The words come
like a scent from a flower. Geometry is clear.
Language is natural. The truth is not clever;

Lions speak their own language. You are still breathing.
Here is release. Here is your pillow,
cool like a handkerchief pressed in a pocket.
Here is your white tousled long growing hair.
Here is a kiss on your temple to hold you

safe through your solitude's long steady war;
here, you can go. We will stay with you,
loud in the silence we all came here for.

Night, take his left hand, turning the pages.
Spin with the windows and doors that he mended.
Spin with his answers, patient impatient.
Spin with his dry independence, his arms
warmed by the needs of his family, his hands
flying under the wide, carved gold ring, and the pages
flying so his thought could fly. His breath slows,
blending its edges into the night.

Here is his open mouth. Silence is here
like a huge brand-new question that he wouldn't answer.
A leaf is his temple. He gazes alone.
He has given his body; his hand lies above
the sheets in a symbol of wholeness, a curve
of thumb and forefinger, ringed with wide gold,
and the instant that empties his breath is a flame,
faced with a cathedral's new stone.

SESSHU FOSTER

Ray Foster and his son, Sesshu Foster
Chico, CA 1998

Sesshu Foster was born in Santa Barbara, CA, on April 5, 1957. In the second grade he wrote and illustrated books about dinosaurs and about exploring outer space and received much encouragement from his parents. He is co-editor with Naomi Quinonez and Michelle Clinton of *INVOCATION L.A.: Urban Multicultural Poetry*, winner of a 1990 American Book Award, and author of *Angry Days* (West End Press, 1987), and *City Terrace Field Manual* (Kaya Production, 1996). He teaches high school composition, creative writing and literature at Francisco Bravo Medical Magnet School in East Los Angeles.

Ray Foster was born in Vallejo, CA, on September 16, 1923. A World War II veteran, he saw action in North Africa with the signal corps. He worked as a laborer, railroad worker, gardener, groundskeeper, landscaper, galley hand in the merchant marine, caretaker, and as a student of abstract expressionist painting, gin and Buddhism.

SOMETHING ELSE

Dad,

Everything they say you did, you did. Even if you didn't do it exactly the way they say you did, how are you going to tell anyone it was any other way? Trapped in the solitary confinement of alcoholic age, a death wish manifest as final enfeeblement and erasure, your anguish subsumed within the grimace or grin you show each visitor to apartment 26, 1369 East Lindo Avenue.

The manager has warned you that if you don't stop lighting your stove on fire you will be evicted. You continue to send me recipes and reports of eating well. Lamb, deviled eggs, gallo pinto.

Sometimes the choice comes down to money for postage for your almost daily letters to me, or food, or gin. Which explains the gap since your last letter.

All the bad shit they said you did, I believe it of course.

It's not even worth mentioning.

So what? Let's just mention one thing, just one thing out of that whole file, that you broke Mom's nose and her hand on the last day that she spent in the same house with you, and you grinned, big and drunk on the side of the highway as the state troopers cuffed your wrists behind you and Mom drove us away in the Dodge.

She doesn't hold that against you. She doesn't bother to think about you. Even when she does, she wishes you well. That's the kind of person she is. Nothing you could do to change that, to erase that person. Instead, you went about breaking the things you were given freely, because people loved you. I've marked that against you. I'm the one who remembers to tell it. Mom wiping the blood off her face with her hand, stifling her hurt as she called us to follow her to the car. It would've been me who made sure the youngest ones followed, walking the rutted yellow clay road to the highway. The younger ones, all they can recall is the stuff that comes after, the third marriage you threw away after Tina laid down the ultimatum against drinking, all the drunken scenes that followed. The others recall how you invited yourself to live with them, how you overstayed your welcome, drank yourself under every night; then before you slept in the

chair, or the floor, or the hallway, vomiting a vast bleat of self-pity, wailing the outraged accusations all around, and maybe just as bad, the stink of fouling yourself and not changing your clothes, and afterwards, horrible choking noises as you snored, as if you were dying in your own filth, as indeed, you were. When you ran out of places to live, people who would have you, you slept in parked cars and garages on the streets of San Jose. They remember you for that, too.

All the ones with your name and the rest that have someone else's, that's what you may have left them to think about you.

Grandpa, the old man who spends his Social Security check on drinking binges with the Indians, and wakes up days later in a Northern California town, arrested as accessory to murder. The old man who can barely walk. How does he get his gin?

But just as your actions left me forever in doubt of people who were too charming, too good with words for their own good, too good to be true, I think these most recent memories overshadow and stain living memory with distortions of another kind—flat, unreflective realities that erase you more than they capture you. And therefore partially erase the rest of us, we who come from you.

I don't mean to suggest that there isn't a hard truth to alcoholism, that it doesn't erase everything of any good and leave only itself, the alcoholism. I don't mean that. That's true enough.

But there always had to have been something else, something more than that—indeed—actually, there must have been something else that had been the most important part. So if that's what everybody knows about you, the old guy destroyed by alcoholism, then they won't ever know you. They'll know the leftovers of a disease.

Is that what Estela is about, hunched and bald and prematurely aged, her cancer? Is that what we should know about Ronnie, only that he was a twelve year old hit by a car, or Sixto, wasted and burnt by leukemia and the failed treatments? Surely Sixto's children should know there was more to him than his last six months, from the bleeding gums and the bloody toothbrush to the closed casket with his picture on top.

That's the kind of cheap shot that betrayers can take at any of us sooner or later.

This fake knowledge we have about you, this false memory of actual events, this reality that distorts the rest, is another way you travel away from us, you who were always traveling.

What I've Never Said

Vallejo, Sebastopol, Santa Rosa, Oakhurst, Santa Barbara, Los Banos, Los Angeles, Carmel, North Africa, Naples, Managua...

From this distance, the names are a little like constellations taken together. You can draw whatever lines between the destinations that you want to. Vallejo, center of the Barbary Coast when you grew up there. That is gone, and the kids growing up there now couldn't even imagine how it was even if anyone was around to tell them. Whatever town it was outside Naples, after your tour of duty in the Sahara, where you courted and married Alberta's mother under the olive trees. She died decades ago, long after having left you and remarried. She had, according to her plan, married a wealthy American and sent an offer to your door of several thousand dollars if you'd relinquish your daughter's surname; you laughed when you told of your refusal. Santa Barbara, where you married mom and where I was born shortly thereafter; Jack's bar, the Azteca Restaurant and the Greek delicatessen where you hung out on Lower State Street are gone now. Your drinking buddies are all gone. State Street has become one big shopping mall full of college kids spending their parents' money on a good time. Carpenteria where you drove the ambulance but couldn't take what you found on the highway, like the woman after the motorcycle accident who looked alive, her back flayed to the bone "as if someone had taken an ax to it." Our daughter's friends have a beach house there now, where they go for weekends. Santa Rosa, where your parents are buried. Oakhurst, where Emmy got rickets because there was no milk. Sebastopol, where you worked in the Apple Time plant, then a fish packing plant, and the orchards. Where Mom fed us out of the garden and the rabbit hutch whenever you drank the food money. Where we ate the goats, or at least I did, because I was hungry, and the other kids were whining about not wanting to eat their pets. The Eel River, where mom followed you from camp to camp in the mountains when you worked on the railroad. She could not even grow food there, except to harvest mustard greens and watercress from wet places along the tracks. People would give her food for us, chicken bones for soup stock, leftover birthday cake, ducks they shot but didn't feel like cleaning. Los Banos, where all that, your Buddhist vow of poverty and your artistic impulse for one consumate gesture, fell apart when you smashed the furniture to pieces and beat the last hope out of your wife.

Los Angeles, where you lived on a mattress with an uncased pillow

smelling of your sweat in a vacant storefront on Wabash Avenue in City Terrace, where you did make some attempt to see us regularly. You spent a year after that in the merchant marine, washing pots from South America to South Vietnam and back around the world the other way around, through the Indian Ocean. Los Angeles again, where you were shot through both legs by a sniper in a house across the street from where you worked, the tractor you'd been operating going off across the field by itself, and your girlfriend picked us up to visit you when lay convalescing in the full-body cast and afterwards, learning to walk all over again, learning to use your legs again, the one with the steel pin shorter than the other. She brought you your children and your liquor the year you spent lying on your back.

Vallejo, sometimes where you lived with your mom on and off. With her persimmon trees and her preserves.

Santa Barbara sometimes, the YMCA across from the Greyhound station now an empty lot.

A year in the streets of Managua, the last of a defrauded expedition you'd joined by answering an ad in the *L.A. Times* where you ended up broke in the streets of Central America; at least part of the time you lived with Tina in a tin warehouse partitioned into open rooms for the poor, the rain beating on the corrugated roofing and the wails of babies and smells of cooking mixing in the fetid air.

Carmel, where Paul was sent to live with you at twelve and at thirteen lived on alone in a basement room at the Highlands Inn, gardening for the rent himself when you were gone, you having been fired or quit and moving your new family to Vacaville where you walked home through the alfalfa fields and fed the cows twice a day for rent. Fairfield where you threw away the suit and the job that went with it, drove your car into an orchard and left it there, and, the same as with the others before, threw your marriage with Tina away as well. So she moved in with some twisted little Japanese American air force man who first abused your ex-wife and then your ten-year-old daughter in turn, as the county files and court documents for the later restraining orders would state, and restate.

But in any view across a broken terrain looking up at the slopes or down into the canyons, it would be completely and absolutely erroneous to characterize the land as all downhill, or all of it just a climb. Every failure documents some ambition encapsulated in an attempt at transcending the past, every disaster some kind of grappling with

circumstances that are finally beyond us all, every small triumph at becoming some better human being under these same circumstances a triumph against the things that finally unman us all.

You who were a collegiate boxer and reveled in hard labor throughout your sixties, then in a Vallejo alley your nose broken a third time by a gang of Black kids who tried to beat you to the ground but could not when you were sixty-something and drunk and alone, you no longer retain the semblance of that strength. Once, on a whim, I took a bus from Oakland to Vallejo and forgot your address; but I remembered you said you lived above a Chinese restaurant so I walked the town until I found one with an apartment above it that looked like something you could afford, and when I called out you came downstairs, laughing. I asked about the tape on your face and you explained, *without rancor*, as ever.

You who were charming enough that a few drinks could keep friends day or night, and without any effort on your part the women one after another kept throwing their lot in with yours, like they must've thought themselves lucky (at first) to leave behind their old life and join this interesting new one. Of all of that, of all of them, you don't even have photographs. You only have your solitude and your stories.

It's true, I admit, that your stories are better than photos. But these days the great stories you've told perish with your breath within the void surrounding you in every direction. You traveled hard and fast all those years, but now you couldn't travel far enough or fast enough by foot or car or ship or plane or any other means to make the slightest difference in the vast solitude that remains to you.

You must know that I don't mean to suggest that I'm entirely different, even though I am different. You are the father, finally, in that you have gone first. I expect to follow. And I believe your stories are true, your side of the story is true. As far as that goes.

Just because it was our side of the story didn't mean it had to be right, you taught me that.

At the same time, because I knew there was some truth to every story you told (you never tried to hurt anyone when you were sober; you never made excuses for what you'd done to us, you never covered any of it with lies, you never denied any of it; you tried to deal with it, you gave up drinking again and again and failed, each successive failure like a hard mechanical scoring of an abrasive instrument

on an unprotected surface which bore the scoring deeper and deeper over time), I knew the relatives who were forced to take us in as children, who beat me and called you the scum of the earth, who treated your children worse than you'd ever have permitted even when drunk, were not simply wrong, but lying and incapable of anything like truth. If I hated you then, it was because you forced us to live with people who weren't any good even when they were sober.

So it is that these so-called Christians who are least generous or merciful or forgiving of all, who hated you for reading Gorky's *Lower Depths* and Daisetz Suzuki's and Dogen's Zen essays, Robert Bly's translations of Vallejo (especially) and Neruda and talking about them as if you believed in all that, they're in charge of telling your stories among your children's children. The people who do what they're told, who live unimaginative lives, who try to accommodate themselves to a fear greater than themselves all the time, who do not read any poetry and who never speak of their ideals—let alone try to live by them—they are the ones you are compared to and by that standard judged a failure.

And so you are.

You'd admit to that yourself, I know. You'd laugh and allow as to the fact (with a shrug, perhaps) that your whole life's been like an accident. You never knew what you were doing. You surely never would've lived such a life on purpose. Anyone would have to be crazy to do that (we'd both laugh then).

So it is that your grandchildren will not know you. From their point of view you are a tiny figure, almost insignificant in the immense wasteland of solitude where you are exiled. Self-exiled, they are told in various ways. With your intermittent attempts at painting, your books, your Mediterranean recipes. With Ada, your neighbor who used to bring you coffee but who is now in the hospital and may never return, and Jim, your Indian neighbor with whom you can no longer watch boxing matches because he believed you the last time you said you'd quit drinking for good. And your daughters, who take care of the things you need now and then.

You write often. At 75, you say you've outlived Czechoslovakia (when the doctors said liquor would kill you twenty or thirty years ago). You said you were once out walking when you were caught in a terrific downpour and a car pulled up alongside you. You were soaked to the skin and a man ran around the car and stood in the rain to try

and talk you into accepting a ride home. But you were not far from home, you said, and thanked him and refused. So he asked you to please take his hat and placed his new hat on your head. And drove away, without an address or any way for you to return the new hat. Those stories—such as how the old lady (it wasn't Ada was it?) drove into the living room of an apartment in front of yours, after driving all the way across the wide lawn—and others, come often.

You mention your loneliness now and then. I try write as often as I can. I expect to receive mail there someday myself.

<div style="text-align: right;">Yours,</div>

P.S. Oh, and this when you weren't around: the hot wind blowing the alkali dust across the flats; the sound of semis coming off the highway all night through the screen of pubic brush down in the creeks; the earth scraped raw and pink at constructions sites under cloudless skies; the smell of rust and rubber heated by the sun—the smell of an abandoned vehicle, the steering wheel hot in my hands, glass from the gauges scattered about; the pinkness of my own scars underneath my fingertips; the incessant glare and the hot dry breeze on the side of highway after highway.

JOAN FRANK

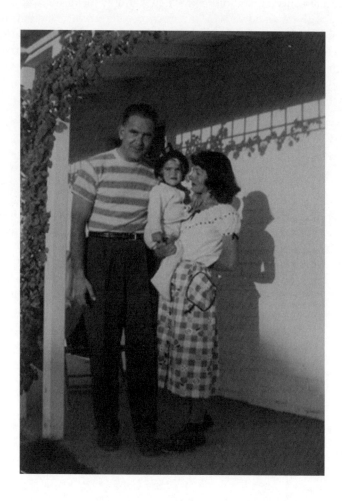

Robert Frank, with daughter Joan Frank, and her mother, Marion. Phoenix, AZ, ca. 1951

Joan Frank, born in Phoenix, AZ, October 2, 1949, is a San Francisco Bay Area writer. A MacDowell Colony fellow and Pushcart Prize nominee, she is the author of an essay collection, *Desperate Women Need to Talk to You* (Conari Press, 1994) and a short story collection, *Boys Keep Being Born* (University of Missouri Press 2001).

Robert Frank, born in New York City, December 28, 1920, was a professor of English, Humanities, Philosophy, and Comparative Religions. He helped write the textbook series *The Living Language*, lectured, produced numerous articles for teachers' journals, and later authored a book on mutual funds. At his death, his college established an honorarium in his name.

A SECRET LIFE

> ... [A]nd the trouble with ghosts is that no one but oneself knows how zealously they stalk the everyday air.
> —Edna O'Brien, "The Small-Town Lovers"

My dearest, only father,

Though you kindly told us little girls that she died of a heart attack in her sleep, you knew our mother had died from an excess of barbiturates in her tiny system (pills prescribed for your big frame), and you also knew at some level that she had died of loneliness—a slow, steady ebbing after years of accelerated loss of you: to other women and to drink. It was 1961, Phoenix, and you moved us to a new life in California.

You died thirteen years later. And though you had remarried, secured a good home and resumed your teaching, that event of your first wife's death, the intractable violence of it, the haunting accusation of it, must never have left you. It must have driven at least some of the drinking that became more sporadic and furtive; must have clouded the middle-distance gaze that always sought to reason.

Yet we almost never spoke of Marion during those remaining thirteen years.

I wrote a letter to my late, sad mother a few years ago, in the full righteous overdrive of the New Archeology that memoirs effect: compulsion to name, to drag the unspeakable under hot light, to bleach bones in the sun. I thought then I understood more about what writer Anne Beattie called "strange, complicated lives," and that such a letter would set our house of souls in order. For indeed that house of

souls never leaves you, that initial constellation: the handsome, flashing-eyed, wavy-haired professor with his sonorous voice, freshly emigrated west from Columbia University; his petite black-haired wife with her intelligent, musical sweetness; two little girls who darted around gleefully in the "matchbox" house (your words) at the edge of the raw Arizona mountains in the 1950s. A mobile of ghostly lights.

I can rove my memory's eye over every detail of your Phoenix den, the "sanctum sanctorum" you called it, air conditioned, fragrant with book-leather, cherry pipe tobacco, burnt-caramel smell of whiskey-in-cola. One wall of high-fidelity stereo equipment, two walls of books, another wall of record albums—the great classics, opera, mainstream jazz, Broadway. I made up dances to Martin Denny's "Exotica" and "Around the World in 80 Days"; to Indian sitar while a small brass Buddha's lap cradled slow-burning sandalwood incense. Your lovely old Royal Portable typewriter hammering staccato as the stereo played, the wine-cooler on your big wooden desktop sweating in the lamplight: enchantment!—all those particulars piercing me so deeply, as they must. "You hear a big bang in childhood," says a wise writing friend.

Our story rides quietly with me every day. At intervals I forget it a little. At some point it can seem that everyone's father was, for all his contributive tenderness or brilliance, a drinker and womanizer and worse. People grow up and live with their misshapen sadnesses, and with time and their own mistakes, lulled by present-tense rhythms, may cease trying to comprehend.

A beautiful little boy elected King of the May in the New York City of the 1920s: you smile shyly out, in the *Times* cover photo, from under a gigantic crown. Shaking off a punishing set of parents in their Brooklyn apartment, repudiating their dour Jewishness, you adored and emulated your genius older brother Joe, who had his Master's degree by 17 and was teaching university French at 22, who was by turns a diplomatic attaché, scholar, mystic. You took your own degrees in philosophy and English literature, thrilling to the superb minds of the era—Trilling, Santayana, Krutch, Richards. You accepted a position as instructor of English and drove west with your new wife, herself a Bronx native and fellow secretary during the war. Your colleagues marveled at your dynamism and hunger for innovation in the classroom; your students simply worshipped you. You

bought a brand-new house for $10,000 in a dusty new Phoenix suburb, two stubby infant palm trees posted in each corner of the just-planted front lawn. I was born. And that was when, according to friends, my anxious mother became less available to you in her absorption with the new baby's care. You began to seek gratification elsewhere; drinking accelerated. A common tale, a worn tale, it spiraled out and down, and took us all with it.

Surely in your teaching you confronted again and again the riddle of the longing that I believe caged and tormented you, your own appetites—for sublimity or obliviousness, or were they finally the same thing? A colleague's wife once asked you—after you had made a clumsy, drunken pass at her, which she successfully laughed off—whether your teaching philosophy hadn't helped your life. And you, my handsome, gifted, bored, burning father, answered (in a tone it pains me to imagine), "No."

"It was as if," ventured another colleague who was close to you then, his voice now wobbly with age, "your father had something to prove."

In the last years of your life, teaching and living calmly with my stepmother, you had quit smoking, tried to stop drinking, were seeing a therapist. But a lifetime of fervently indulged appetites began to claim its dues. You took pills for angina. You told my sister that the fact that they worked, frightened you. She wrote me you were afraid, and I will never forgive myself for not getting on a plane the very day of receiving that letter. The heart attack that cut short your life at 53 was at least swift—your stated ideal had been to go in a finger-snap. I had let two years elapse since embracing you goodbye when I flew away to the Hawaiian Islands in search of a self, a life apart. At least we had written and phoned each other constantly; declared love at every turn. At least I understood your unexpressed ache of worry for me, your unshapeable wishes for me—that I be brilliant, that I find brilliance. I understood, was terrified, and always, moved to my soul.

In William Maxwell's sly short story "What He Was Like," an aging man keeps a private diary in which he jots "his feelings about old age, his fear of dying, his declining sexual powers, his envy of the children he saw running down the street." As time passes, though externally "cheerful as a cricket," the man writes "dark thoughts, anger, resentment, indecencies, regrets, remorse. And now and then the simple joy in being alive." When he dies, his wife respects the

privacy of the diaries. But his grown daughter is curious.

"[S]he loved her father, and felt a very real desire to know what he was like as a person and not just as a father." She reads a volume, and is devastated: "He had all sorts of secret desires. A lot of it is very dirty. And some of it is more unkind than I would have believed possible. And just not like him—except that it *was* him."

Not like him—except that it was *him*. Betrayal. A loving father, teacher, husband, brother—was in his fantasies a despoiler, satyr, predator. But the difference between telling a diary fantastic desires and *acting* on them—toppling the little house of souls in result—how can these consequences not have weight? For the grown daughter I became, who could not but pledge love to her towering handsome father even though his actions in effect killed her mother—who could only adore his incomparable vigor, tenderness, wit, his valorous efforts to earn a living, nurture his daughters, make a decent second marriage, inspire his students, track and anguish over the world's suffering—all the brave passion of his art and soul—it is not possible to find an answer.

She loved her father. I now know that all of us have some form of a secret life, Daddy, because all of us have an interior life, a consistent presence aiming the videocam and narrating the perpetual voiceover—a hodgepodge of the exalted and the gross, like what Maxwell's protagonist recorded in his diaries—jealous, vain and lustful; fearful, wondering and grieving. Yet what can we really have but our own interiority, that last sanctum sanctorum? Whatever else, I always felt your yearning for an ineffable ideal.

One of your favorite lines, you wrote somewhere, was from *Corinthians*: "When I was a child I spake as a child, I understood as a child, I thought as a child: but when I became a man, I put away childish things." And now I tell myself that to *deny* the secret interiority of strange, complicated adult lives is ironically one of those childish ideas we sooner or later learn, if we are paying attention, to put away. That after a certain age it is not possible nor reasonable, to demand that what we see, be what we get. But I would be a liar if I did not admit it still confounds me, to live with what I know.

Joan xx

DONALD ARTHUR FREAS

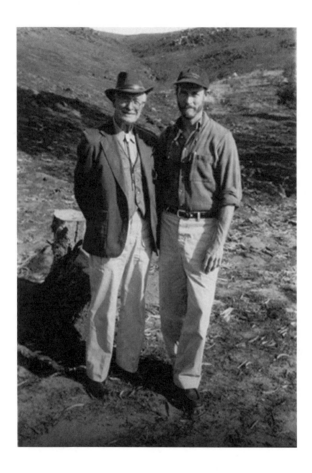

Arthur Freas and and his son, Don Freas
San Diego, CA. November, 1996

Donald Arthur Freas was born in Norwich CT, July 6, 1951. He was raised in Steubenville, OH, and York, PA. He has worked as a carpenter, furniture designer and craftsman, sculptor, and founder/operator of a spa and massage facility. He began writing poetry in 1987 following five days of Robert Bly's eloquent delivery of poetry during the first Northwest Gathering for Men—from which point "everything else seems to have

fallen away." He has since developed a series of writing workshops called GETTING LOST and has been a group leader and facilitator at men's movement gatherings in Washington and Montana. He holds an M.F.A. in creative writing and literature from the Bennington Writing Seminars. He has a chapbook of poems in print entitled *In Creation* (Lost Books; 1996.) Between poems he works now as a hands-on healer. He is father of two daughters, Erica and Kendra, and lives in Olympia, WA.

Arthur K. Freas was born June 16, 1924, in Berwick, PA. Raised in Huntington Mills and Williamsport, he studied engineering at Bucknell University and served in the army in World War II. While in the service he met Margery Huston, whom he married in 1948. They raised four children, two boys and two girls. He worked for thirty years in the paper business, managing mills that converted waste paper into cardboard. He became an expert at managing old mills, often built near the turn of the century. Retired from the paper business in the early eighties when the old mills were being shut down, he founded a small vineyard on an old homestead farm in the hills near Felton, PA. He enjoys watching things grow, running the equipment, mowing the fields, pruning, herding grandchildren, keeping the pond full.

FATHER IN THE MILL

Some windows to the past have a dark cast—
soot glazing old paint, black ash in the cracks,
dirty sheen on cars, window sills, the collars
of your white shirts. Blood red sunsets brought
evening, and you home. What cycle divided us;
where did you go?

The Ohio river ran below our house,
a brown flood filling the gash between hills.
It carried forgotten north toward the sun,
effluent, ready to burn. On the other side,
steel mills at Wierton, their furnace mouths
orange at night, breathing tongues of fire
over inkwater, furious rolls of smoke
lit from below. Mill town surrounded
by mill towns. Factories full of fathers.

What I've Never Said

I am small, walking with you
among stacks of wirebound wastepaper bales:
leftovers from printing plants, worn out
boxes, offcuts and oddlots, outcast
and reclaimed. A forklift goes by, driven
by a round man looking busy for the boss.
He carries a bale on outthrust tines, ready
to be released from bindings and dropped
into the pulper. His labor feeds scrap
by the ton into the grinding cauldron. He smiles
and winks, asks if I want to go along.
I look over the edge into the vat. Everything
turns, stirs, churns, sucks down, feeding
mysteries you knew but I didn't
somewhere under the plant.

I remember you holding me high
against the ceiling when you came
home from work. Mixture of terror
and awe, my floor so far below.
Your long body a pillar to my pedestal;
you smiling up at me. The relief
of your return rattled routines
of play and food. Overnight visits
to the family fed and housed
by your daily absence.

I see you walking past the wet end of the *Fourdrinier*,
where the endless screen carries draining pulp
to the dandy roller, transfers it to the up-and-down
journey over dryer felt, steam-heated drying drums,
on into clay coaters, glazing rollers—eternal
run of paper board. Keen-eyed workers breathe
the pulse, pull levers, rely on subtle sense to gauge
the steady weight of product. They feel the seized bearing
before it shouts, know the sound of trouble (the way it changes)
better than they know wives and growing children.

What if we had walked
five miles each morning,
cut wood together,

walked five miles back?
Would your gait be worn
into the pattern of my breath,
your silhouette, the curve
of your back burned
in my eyes? Would we share
a world that could keep women out?
Would I know
what my father is thinking?

You admired the mill workers' clever hands:
shimming frames into alignment, setting
rewired motors big as bass drums, welding
a perfect bracket—new machine braced
into the flow, taking the load, singing a new note
in the din. On you walk toward the cutterman,
his neat stacks packaged, orders filled and shipped,
more trucks, train cars, more shirt cardboard and
cereal boxes. Is that where you were my father?
Did you make wheels turn? Order parts? Did you
eat lunch standing, sign papers, file reports,
leave me to mom, as your father left you?

What is a man supposed to do?
What's it like to set a saw,
chop a mortise socket,
dress a buck? How do you
fix a stuck door, tune a motor,
cast a fly far out over white water
to the calm deep where
the big ones hold like silent
torpedoes? How do I say
what is in me; how do I know?
Who taught me these things
I have learned?

Paired suns, we circle one another from a distance,
your pull against mine, no sound in the vacuum.
The women between us lean one way then the other,
shift balance, courting us both. We hold our ground,

look outward, seem "strong." Everyday we're born
again fatherless. He's at work; we are left
to find our own course and direction, apron sails
luffing and tattered, adrift until the breeze returns.
We were not all born to be guided by masculine hands.

Does each lost son
make a new world, crooked
and unique, no longer the image
of the one who planted the seed,
this one successful seed?

There is so much of you
in me. My fingers tap
your drumbeat on
the table edge; I have
that rapacious patience
that awaits the perfect moment
to deliver a long held line.
We both watch for projects
to start, others to complete,
for what's next,
what is required, a woman
to care for who will care for us.
Do you know who you are?
Can I know who I am
and not know you?

Rollers turn, you walk damp concrete alongside
the unceasing machine. Over the scream you
shout something I can't hear, words lost
in the run, embossed in paper. I nod
and keep my betrayal from you. You move on
and I follow, as you follow the only course you see.

The women between us fill
our silence. They have more
to say, bond with tongues.
We need to settle into the pool,

watch what rises. We have to
gather materials, throw tools
in the truck, settle on a plan,
work out details. It takes time,
doesn't work well through
phone lines. Deaf from the din
we need the dance of hands
to bring us close.

It is evening. The horizon to the east is obsessed
with cloud; west brings another wave of storm.
We drink a last blessing slash of light,
a keyhole opened that throws
our separate forms over the curve of hill
below your house: parallel giants wanting
more to say. Talk of chores and projects bridges
our canyon of silence. I want to ask the blessing
of our story: what I don't know
that you would rather forget,
what you think is slight but might
be pivotal, confusion
that must live in you as it does in me,
wordless in my dark, animate, casting my nights.
This eternal silence made me,
makes me over day on day.

The mills have shut down; bats
and bluebirds study their vacant interiors.
Workers have been retrained or retired,
machines silenced, sold for scrap.

I am your son, in a strange way you are mine:
I carry you; I will carry you on.

LYNN FREED

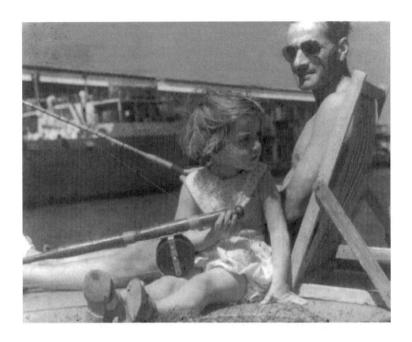

Harold and Lynn Freed, fishing
Durban Bay, South Africa, ca. 1948

Lynn Freed was born on July 18, 1945, in Durban, South Africa. She came to New York as a graduate student in English Literature, receiving her Ph.D. from Columbia University. She then settled in the U.S. She is the author of five novels, the most recent being *House of Women* (Little, Brown, 2002). Her essays, short stories and memoirs have appeared in *Harper's, The New Yorker, The Atlantic Monthly, Newsday, Story, Southwest Review*, among others. She is the recipient of fellowships and grants from the NEA, the Guggenheim and Lannan Foundations, among others. She lives in the town of Sonoma, CA and has one daughter who lives in London.

Harold Freed was born on February 10, 1910, in the town of Bethal, South Africa. His parents sent him to boarding school in England, and then to Cambridge University, where he received an M.A. On returning

to South Africa, he met Anne Moshal, an actress and director, who cast him in one of her plays. They married, and, for the next sixty years, performed together both on stage and radio.

NOT MUCH OF A FUNERAL

When you got to that page in the galleys, Dad, and you looked up and said, "Didn't give me much of a funeral, did you?" I laughed. We have always understood the joke that fiction plays on life—you, me, Ma, the three of us. But, oh, the joke is on me now, isn't it?

Standing dry-eyed at your funeral, and Ma quite mad in the wheelchair beside me—mad or playing mad; once she started slipping, none of us knew the difference, not even you—standing there in the heat and damp of summer, with the men chanting in Hebrew, and a lawnmower somewhere, an African whistling, kikuyu grass and Flamboyants and Indian Mynahs—I could only think how ordinary it all was—eleven o' clock in the morning, people glancing at their watches.

Putting that funeral onto the page was more difficult, weeping as I wrote, as if I were getting it right.

But I didn't get it right. Writing someone else standing at that funeral was quite different. She had known this death was coming, she had always known. I might have known too, but I refused. Year after year, Ma kept saying, "Don't leave it too long before you come back." And I didn't. Every year I came home, like the fondest of lovers. We *were* lovers, the three of us. When you told me her mind was slipping, I changed the subject. Standing at the graveside among the mourners, I thought I must be slipping myself when Nicholas grabbed the spade, thinking it was his job as usual to do the work, and the rabbi had to stop him, and I laughed. Who could have thought that up? I glanced at the others, but they were crying hopelessly. They knew there's no refusing any of this.

When I'd phoned you in the hospital and asked, "Shall I come out now?" you said, "I'll let you know when." And then, one day I just said, "I'm coming, on Tuesday," and you said, "Thank you." I might have known then what was coming. All the way out, plane after plane, it was as if I were flying back from the funeral, taking with me everything I could think of, like a refugee. Our drives through the sugar

cane on a Sunday afternoon, me steering, with the smell of your sweat after golf. You at the mirror, pasting on a beard, strand by strand, and the smell of gum arabic and Pond's Cold Cream and Lake #9, all those powders and paints lined up in the make-up box, and your Brylcreem and Knight's Castille, wool, linen, cotton, everything 100% and light starch only please. Your clothes laid out every morning on the divan in your dressing room. Your dressing gowns and smoking jackets, your hairbrushes and clothes brushes and your silk cravats. Your elegance spoiled me for elegant men, Dad, your beauty for beauty, your manners, your utter English decency.

And if you were fiercely jealous of the men who came to take us away, each one of us, only we knew of this. If we told people that you bellowed and slammed doors and called us "blithering, unimaginative blockheads," they thought it funny. It *was* funny, until you had to cope with Ma, and the bellowing didn't help, and she didn't know what you were talking about anyway, or pretended she didn't, and called you a Jekyll and Hyde, which, in a sense, you were.

I put all that into the novels too, but still you came out less vivid than she. I seemed to give her all the best lines. Or she just took them. That's the way she was.

There are things I forgot, though, like the way you'd lose your voice just before opening night. And how Ma would go mad with the understudy, and you'd be swallowing raw eggs, and have us whispering around the dinner table. And then every time, *every* time, back it would come—the low growl, the fake purr you used on ticket ladies and usherettes, and they always gave you the best seats in the house.

And once I came into your bathroom and found Nicholas brushing his beard with your special nailbrush, and of course I couldn't tell you because no one but you was ever allowed to use that special nailbrush—or that special pair of scissors, or that special tweezers, or that special anything—and, for all I knew, he used your special linen face towel to clean the toilet. You would have laughed if you'd read that in the galleys. You would have looked up and said, "Only you could have thought this up!"

After the funeral, one of my old lovers phoned me, the one I'd loved longer than any other. He phoned to say that he'd only just heard, and how sorry he was. But I didn't recognise his voice anymore, he had to repeat his name three times. You would have liked that too, Dad. You loathed the sight and the sound of him, even though he was the one who told me again and again, over all the years, that I should hold on tight to both of you, you'd be leaving sooner than I

thought. I listened when he said this. He belonged to the Chevra Kadisha, he understood how quickly a person can lock up and go away, leaving nothing behind to come home to.

I listened, and, really, I did understand. I had always understood. What I couldn't bear was the thought of this, now: talking into nothing, nothing coming back. This horrible joke. This dead air.

ALBERT GARCIA

Albert Garcia and his father, Andrew
Red Bluff High School gym. Northern California, ca. 1970s

"I'm the kid with his hands on his knees, watching the action intently. My father (left arm on his right shoulder) sits beside me, my older brother beside him. Two younger sisters and my mother are on the other side of me. We were pretty serious basketball fans. I remember begging to go to these games."

Albert Garcia was born June 30, 1963, in Chico, CA. He graduated from California State University at Chico, and holds an M.F.A. degree from the University of Montana. In 1996 he published his first book of poems, *Rainshadow*, with Copper Beech Press. He teaches at Sacramento City College and lives with his wife and three children in Wilton, CA.

Andrew Garcia was born August 8, 1931, in Westwood, CA. After growing up in the small logging town of Westwood, working in its lumber mill, serving in Korea, and graduating from CSU, Chico, Andrew Garcia taught business and Spanish in high school for 31 years. He and his wife Nancy have raised five children and live on a walnut orchard in the northern Sacramento Valley.

ON MAKING WOOD

I took my job seriously, Dad—
to drag the brush away
through the tall, hot grass
then build a pile for burning.
But I knew you
did the real work,
notching one side of a black oak,
then leaning the blade
and dangerous whirring chain
into the opposite bark
until it all roared down
in dust, leaves, and flying twigs.
You'd let the saw hang
at your side, idling,
your boots, hands, and arms
covered with snow
from inside the tree.

That dusting, in your hair, too,
and covering your pant legs,
was what I, at eleven, wanted.
I wanted to know how it felt
to be a man who could stand with saw
in hand and not worry
about rattlers behind every rock. I wanted
to know which was harder, this
or lifting dead bodies off the snow
in Korea. Why didn't you talk more
of that? Why couldn't I know
how it felt to hear
bullets singing through the chill
around you, the muffled crying
voices of young men
whose last image of the world
was the sweat below your eyes.

What I've Never Said

I wanted you to talk to me, Dad,
to tell me again
how you spent your last shell
on a forkedhorn, had to wrestle
him by the antlers, cut his throat
while an old hunter on a hill
laughed at you. I wanted the whole
story of my great grandfather
hanged and shot by Villa
and how your father, at fourteen,
buried him, then was forced
to dig him up and lay him down
on different land.
All I knew was the dust
of these stories, enough
to tell myself you started
kindergarten at seven, speaking
no English, that you would have worked
your life away in a saw mill
if not for the war, the GI bill,
the rancher's daughter you met
in college. All I knew
was that my arms were skinny
brown things, nearly useless
except for dragging off
what had already lived,
what was now trimmed,
and what would stay in a pile
until dry and lit with a match.

Albert

SONIA GERNES

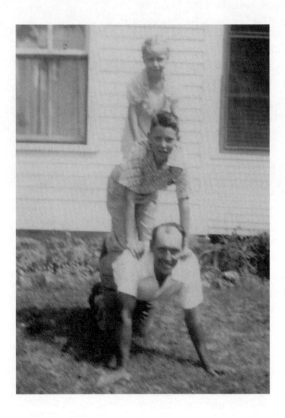

Albert Gernes, his son Jerome and daughter Sonia
Winona, MN, 1949

Sonia Gernes was born in 1942 in Winona, MN and grew up on a dairy farm nearby. She teaches Creative Writing and Women's Literature at the University of Notre Dame, and has also taught in New Zealand, Australia, and London. Gernes has published one novel, *The Way to St. Ives*, and three books of poetry: *Brief Lives*, *Women at Forty*, and *A Breeze Called the Fremantle Doctor (poem/tales)*.

Albert Gernes was born in 1905 on a diary farm near Winona, MN, and lived there until a few years before his death in 1995. He studied agriculture at the University of Minnesota where he met is future wife, Sophia Boerboom. They were married in 1932. Known as a good neighbor and a gentle man, Gernes assumed leadership roles in the rural community, the local Catholic church, and the school board. He and Sophia had four children of whom Sonia is the youngest.

TWO DREAMERS

Dear Dad,

A couple of years before your death, I came onto a box of letters you hadn't intended me to read. When the family farm in Minnesota—the one on which you were born and lived well into your eighties—had to be sold to pay for health care after your crippling series of strokes and Mom's descent into Alzheimers, she said she wanted me to have them—a family archive I hadn't known existed. The box contained three years worth of weekly chatter and love and longing between a young couple deterred from marriage by the Great Depression, a young couple who would not be my parents for another dozen years. Your half of the letters, in addition to teasing proclamations of love and accounts of loneliness, detailed life on the farm—milking, mowing hay, the good potato crop, the rat that killed most of the baby chicks, the way you hated cutting wood for the winter.

I could see myself in some of the scenes and emotions you described—the exhilaration of spring coming to the bluffs along the northern Mississippi river, the lonely malaise of Sunday afternoons, the tendency toward depression—but one phrase stuck in my memory more than all the rest. You were talking about efforts to work consistently and efficiently, and you said, "...but then I go to dreaming." You didn't mean the kind of "dreaming" that produces entrepreneurial schemes; you meant the "long, long thoughts" that Robert Frost says are the thoughts of a boy, and that for you lasted all your life. You descibed this dreaming as a fault in 1931, and I suppose it was, if maximum production and the accretion of maximum wealth are the goals of a life.

They were never your goals, and despite my scrambling to keep up with an academic career, they haven't been mine. When you died, I inherited nothing material, but it didn't matter; I already had a legacy. Along with blue eyes and upturned big toes, I inherited your inclination to "go to dreaming," and it has been, in some ways, the most significant factor of my life. As a "tail end" child growing up on a farm, I spent a lot of time alone, but I don't remember those as unhappy hours. They were filled with the characters who lived in my head, with the plots I acted out on the hayrack and the lime pile, with the minute examination I gave to the shaft of sunlight coming into the haymow after I'd climbed the crusty ladder and roused the birds on the rafters to a great flapping of wings.

I dreamed my way into being a writer, Dad, and though I don't think you understood or approved of everything I've written (my novel contained words you wouldn't want a daughter to know), I've tried to tell the truths that my life and "dreaming" have led to. I've tried to tell the truth of what I learned from you as well. My siblings kindly chose this bit of truth for your memorial card:

THAT PIECE OF EARTH

A Scorpio, I learn from the charts
My region is water, but that's all wrong.
My father, who knows, would say it's earth.

He believes in the dust we'll return to;
taught us to plow around the slopes
rain strips of topsoil, to grow into the element
he'd conserve. He frowned on playing "ghost"
in the graveyard, petticoats like blight upon our heads.
White was better for daylight. Communion days
or Corpus Christi, farm mules, like heathen,
watched our processions from the fence. Two by two,

we were lilies behind a cross, our petals tossed,
our knees bent for the blessing of the Host.
I knelt one year on my grandfather's grave, my legs
shortened stems, while stockings staining in the sod.

What I've Never Said

I am the color of that clay turned windward,
those furrows where my father seeks the flame,
says we live by trust, take our seasons knowing
the part that's clay, the hand that goes back to the soil.

The last time I came to Minnesota to visit you, you told me that you wouldn't be living when I came again. I was stunned. You weren't given to predictions, and you spoke very little in your last couple of years, and then only in brief responses to family efforts at conversation (*Yes... No... I guess so... I suppose...*) I made a fumbling response to your announcement, and then talked about it with a friend who has worked with Hospice for many years. She said, "I think he's asking for permission to die, and I think you should tell him it's all right."

I didn't think I could do that; it wasn't the kind of conversation we'd ever had, but on my last lunch with you before returning to Indiana, something amazing happened. When I finished feeding you and sat down to my own plate of chicken, rice and institutional peas, you said, "Well, what do you think of the old man?"

"What old man?" I said, because the tone of the question hadn't made that clear. "You?"

"Yes," you said.

"Well, I think he's a pretty good old man," I said, "and he was a wonderful father..."

Now what? I thought with a degree of panic. *What does he need or want to hear from me?* In the absence of ideas, my intuition sometimes kicks in, and I began pulling up half-forgotten scenes from childhood: How you used to take me down to our farm's wooded ravines in the early spring and teach me the names of the wildflowers: bloodroot, jack-in-the-pulpit, trilium, anemone... How on those early spring walks we would usually find a plush carpet of moss on one of the stones, and you would tell me this moss was used to line your boyhood Easter baskets.

On winter nights, I remembered, you'd take a break from milking the cows to make snow angels with me, our breaths fogging the air, and the yard light making tiny mirrors of the snow. When I got cold those winter nights, I'd come into the barn and sit on the deeply encrusted feed box with the barn cats, soaking up the moist, fecund heat of the cows. You were always generous with fresh milk for the cats, I remembered, it was part of your kindness to all living things,

and when the milking was done, you would take the cream-soaked filter pad out of the milk strainer and toss it into the air so that the cats would make Olympic leaps trying to catch it. I remembered that we both liked to bring the cows home from the back pasture on summer evenings, thinking our own thoughts, falling into the rhythm of swaying udders and pendulum tails.

When I finished, it was time to go. My "permission to die" was still unsaid, but it didn't seem quite as impossible now. I hugged you, kissed the top of your head, and said "I love you very much." Then I took a steadying breath and said: "I'll try to come again in a few months—but if it's time to go back to God before then, that's fine too..."

Three weeks later you died, leaving in a matter of minutes and without fuss. I wasn't there, and I couldn't even attend your funeral; a diagnosis of bladder cancer had landed me in the hospital for immediate surgery. But I could be at peace with my absence; we had already celebrated our private liturgy, our private goodbye. As I look back now, I only wish I had been more specific about one memory I shared with you at that remarkable luncheon. It's this:

One evening when I was about twelve, I went out after supper to my daily task of driving the cows home from the back pasture for milking. It was a job requiring dispatch since you and my brother were in the barn waiting, but this was a June evening, balmy and full of the breezes of fantasy. My route took me down a lane of oaks where my jeans were transformed to an antebellum gown, and past the edge of the woods where my fancy found a wounded cavalry officer hiding in the trees. I rescued him, of course, our halfbreed collie doubling as a chestnut mare, and smuggled him into my mind's attic, and went on to the back pasture to attend the war-relief ball.

In short, I dawdled. When I came rushing up to the barn, guilty about my loitering, and trying to hustle the Holsteins along, you were leaning on the barn's half-door. You looked at me, at the swinging udders of the herd as they tried to run, and at your pocket watch. And then, a dreamer yourself, you smiled. It was the kind of smile understood only by two conspirators, two dreamers acknowledging that each has travelled in another and valued world.

Love,

Sonia

MARC J. GOULET

l) Marc Goulet, age 4. Potrero Hill, San Francisco, 1970

r) Ed Goulet, age 28. Potrero Hill, San Francisco, 1970

Marc J. Goulet was born September 17, 1966, in San Francisco, CA. He teaches math and science at a high school in Boulder, CO, where he spends his early mornings writing. Occasionally, he sends out query letters regarding the two unpublished novels he is still hoping to place.

Ed Goulet was born August 27, 1942, in San Francisco, CA. He has been an iron worker, wood worker (specializing in decorative animals) and general contractor. He currently lives in Montara, CA.

KILOJOULES AND COULOMBS; BRICK AND ART

Dad:

Where to begin? Some aspects of the truth, I suppose. Reality: the date, the weather, the heat climbing in through my window; day, night, day. Midafternoon. Bloated clouds pasted on sky, white and mottled gray. The drop of rain, the death of tension—climax. The stretch of day toward night. The Long Day's Journey... And so on.

Father's Day this past Sunday, and me with a friend on a bike ride through endless, hot mountains. What was it he said about his father? had sex with his sisters? made him sleep under a collapsible table in a trailer in the Mojave Desert for 7 years (the reason, primarily, he says, for his bad posture). Sounds simple to me: You get a gun... But where to begin? to end? The end, more like gravel in the throat, don't you think? The sound (you must listen) of water running over deep, sun-whitened stones, the slip of tires on dirt, the motion of leaves in wind. Or, the crack of a gun, hard flesh on hard flesh, the plea for mercy, the clatter of baton on skull.

To begin, I start at the end: Warm Spring Thursday. Taking my kids (all twenty of them) to a track meet. Me and twenty teen-aged boys waiting for the meet to begin. I take a walk to get my thoughts back after a day of teaching. I walk into a foreign school, admiring (the detachment of unfamiliarity) arches and balustrades, catwalks and vaulted ceilings. The simplicity of architecture is pleasing: lever on lever on lever. After a few minutes I walk back to the track and take a seat on the fifty-yard line. Mitchell, the only pole-vaulter to come today, sits in front of me and I make the adjustment from self to others. This too is pleasant. Mitchell squirms, running his fingers through scorched dirt. Veejay and Clement seat themselves on either

side of me. "Coach," Veejay says, "I think I pulled a hamstring on my warm-up." I nod. "I think I'm gonna puke," Clement adds. "You are a puke," Mitchell says, rolling and grabbing Clement's arm. They wrestle themselves into a knot. Josh and Aaron sit with us. Then Roberto and Vern. Jonathan, Edgar and Diego too. These boys are fourteen years old. I think I remember something of fourteen: awkwardness, fear, isolation; the necessity of girls and the inability to do much about it. I understand now the impossibility of being the center of the universe, even, I laugh to myself, the center of my own universe (*What ego that would take*, I'll tell my girlfriend later. Sad, sad solipsism).

"Hey, check this out," Jonathan says, rolling onto his side and farting loudly. Roberto, Vern, Diego, Mitchell and Edgar dogpile him. Veejay is trying to say something to me. Clement interrupts. The sun lowers beyond its zenith. A halo of uncertain colors scramble over sky. Veejay touches my arm. Clement plays with my shoelaces. Aaron moves closer and asks if he can borrow my hat. He plucks it off my head before I can speak. The sun shines in my eyes. Jonathan is laughing, buried under four new friends. The day warps and continues. On the bus ride home I sit, as usual, in the coach's spot at the front of the bus. The bus driver, a retired engineer, is telling me about the Mustangs and B-17s he flew during the war. I listen intently, interested. I consider the irony of the past (in front of me) being as needy as the future (behind me farting, standing on its head, talking about girls). I sit still, watching as the Rockies' eastern slope swells ahead of us. There is the failing light of a lengthening April day, the remnants of clouds, faraway colors shot through with snow. There is a curtailing Virgo thinning at the horizon, a crown of light dissipating to every angle. Knowing epiphany to be the ruin of all things transient, I cough loudly. The insignificance of my noise is mollifying. I turn to see what the kids are doing. Mitchell and Diego are playing fast hands. The feet of several boys poke into the air. There is laughter and wind; the smell of cut grass, pollen, evaporating water. "Hey, coach!" I turn in my seat. Nineteen pairs of feet hang in the air. The bus driver mumbles something about the airworthiness of the P-51 and Fokker. The day, its light going quickly away, is nearly over. I think of my girlfriend sitting, pajamaed, in the front room, a book on the pharmacokinetics of drugs slipping from her hands as her eyes slowly shut. I am surrounded by everything I cannot touch. I consider my beliefs in love, weather and God; water and sunlight. I cannot breathe.

And from the end I see the beginning. You: six foot three and big

enough to balance an I-beam over the shoulder (the reason now, you see, for your bad back and those long days in bed, no?) at noon when we came to bring you food and relief (Mom stealing the paycheck before you could lose it at the Texas Hold 'Em). I don't remember much, not, at least, what they can recall: the discipline of elbows on the table and (no) talking at dinner, your hand shattering against the basement pillar (did you think the brick would give first?), your hand on Mom; our first trip to Langley-Porter (the Ping-Pong Palace, our mother said) to visit you while you sculpted wood piece after wood piece, animals of every kind, illustrating, you told us, your faith in rising water. And what about the gay sculptor, the father who tied you to a chair, and the Lotus you drove at 130 miles an hour? To me it's as mythical as dead Greek heroes or the bloodiest day of the Civil War (September 17, 104 years later, you know, my birthday). Time going by with terrific gaps, marvelous jogs in an otherwise flattened road, and what I see of you comes in glimpses: you coming to the house on Potrero Hill, your clean shave, your blue–jeans, your new girlfriend blonde and small and quiet (was she pretty too? I've forgotten), the wood sculptures you made for a living and how we each chose one, an owl, a giraffe, a whale, the beginnings of an Ark, you told me, and the drive from San Francisco to Eugene so fast that I was the only one to remember the dog's head flying over the windshield—the line of blood from tire to antenna the bit of proof. And the fish we didn't catch on the swollen river after the poles were thrown in and the careening drive back to your girlfriend's parents' house over skid roads playing chicken with loggers and sitting down at her family's table with the Lord's Prayer (I ate, they prayed) and the lumberjack carnival where men with saws longer than they were tall fell limbless trees into the pond in front of the grandstand where all of us got soaked by the wave meant to finish the day, the season of sunburnt exuberance. You were hungover at four in the afternoon.

And, as they say, the years are gone now including the ten where you disappeared and turned up at the stop sign in front of us waving meekly, your teeth missing, your back stooped, your eyes masked in folds of skin. You lived minutes away, it turned out, and I called, and you and I and Ed Jr. (my senior, interestingly, when you left) went to the breakfast place off Van Ness where the waitress poured coffee onto the upside down mug and your hands shook and you drank cup after watery cup, black, and talked about the chance of recovery, the

years of abuse—yours to you—and your bad, bad back and aching hand (your body, you said, your primary reason for lack of motion). And later that night Ed Jr. and I made jokes about you that were funny (his gift) and sharp (mine) and, I saw, caused him greater pain than I could know.

 I called you last month and you told me another bad joke (I laughed, it was funny) and we agreed on the weather (it was bad), the interest rate (it was high) and the presidency (our man had won), and then we elaborated on the present: the houses you're painting, the track I'm coaching, your AA meetings (15 years, yes), my first athlete under 5:00 in the mile, your aching back, my tired eyes (too much sunlight, I told you), your second decade without a drink—the end of booze and coffee and nicotine, the new addition I'm putting in above the garage (windows on every side, a sunroom on top). I warned you though, didn't I, that you ought to be careful of becoming clean. You run the risk, I said, of turning into electricity. I, looking in, see you flowing through the lines from your house 1000 miles away, the Pacific to the Rockies, you, my father, measured finally in kilojoules and coulombs and farads. I take notice through the tips of my fingers, the fleshy part of my ears. And, like electricity, you are everywhere then nowhere and, finally, gone. Only a faint and familiar buzz remaining, a discontent which tells me to know better; that there's something which is the center of the universe and if I go to enough practices and meets, enough awards banquets and bike rides through summer mountains, I will find out the truth and manifold of things and it might be this: I'm irrelevant.

 And the question I'm left to ask, now on this sunny, cool spring day, is why it took so long to find center. (Presumably, living on a straight line and always in motion, there is no midpoint, no?) Why so much drinking and destruction on the part of the self that hates self? What is that thing? You, I suspect, having found dead center and bottom of it long ago and horrified with its expression, didn't, in your rush, have time to interpret your discovery for us. I ask why once and let it go, greatly aware now of the possibility of second chances. My first child, maybe (no juniors here, thank you), equal parts redemption and horror. I can't wait to tell him. A little bit every day.

JAN HAAG

Roger Haag, holding his daughter, Jan
Long Beach CA, 1958

Jan Haag was born July 30, 1958, in Long Beach, CA, and moved to northern California with her parents at the age of eight. A journalist who also writes fiction and creative nonfiction, she holds an M.A. in journalism and English from California State University, Sacramento. She worked for several small newspapers, as well as *The Sacramento Bee*, and covered the California Legislature for United Press International before serving as editor for *Sacramento* magazine. She teaches journalism and creative writing at Sacramento City College, where she advises the campus newspaper and the literary journal. Her stories and essays have appeared in newspapers, magazines, and several anthologies, including *Ear to the Ground* (Cune, 1997) and *From Daughters to Mothers: I've Always Meant to Tell You* (Pocket, 1998). She is currently at work on a memoir.

Roger Edwin Haag was born August 2, 1930, in Clarendon Hills, IL, at the home of his parents, Edwin and Anna Haag. He graduated from Hinsdale High School in 1948 and moved to Lakewood, CA. He was drafted into the Army in 1950 and served in the infantry in Korea where he was wounded in action and earned a Purple Heart. He was discharged from the Army in 1952. He married Dorothy (Darlene) Keeley in 1957; they have two daughters and two grandchildren. He and his family moved from Long Beach to northern California in 1966 where for many years they were avid waterskiers on Folsom Lake. He worked a variety of jobs in mechanical engineering sales, eventually becoming a mechanical engineer for Dodge Manufacturing—which later became Reliance Electric. He retired in 1995 and travels extensively with his wife, a holistic nursing practitioner.

DATELINE: GRANITE BAY

Dear Dad:

 I close my eyes and remember the smell I most associate with you—rotten, burning eggs. Sure, other kids remember their dads smelling like Old Spice (which you wore to work, and for "dress up" times: our band concerts, dinners out with Mom) or motor oil (when you were working on a car, the boat or the lawn mower). But every now and then I get a whiff of something vaguely mechanical, and I remember you and the hand-cranked mimeograph machine. It produced ink as brown as a squashed beetle on smooth white paper, but when you cranked it up on the garage workbench its most salient feature was its smell—rotten, burning eggs. I didn't know what sulfur was then, but it must have contained some. I think now about the toxicity level in that garage when the machine was operating. But when I was 11 or 12 and you had the machine cranking, in those days before Xerox, I got hyped on the fumes.
 That smell meant, of course, that "the paper" was being printed. My paper. The one you unintentionally (or was it?) launched when you lugged the machine home sometime in the late '60s. I can't remember where you got it; probably some distributor you sold bearings or belts or chains to traded you something for it. But I clearly recall you bringing home this massive beast of a machine, plopping it down

in the garage, and saying to me, "Think you can do something with this?"

"What is it?" I asked.

"A mimeograph machine," you said. "Kind of like a printing press. It'll make as many copies as you like."

Copies. "Of what?" I said.

"Anything you want to put on paper," you responded.

On paper. Writing? Drawings? "Anything," you said.

And just that fast, the Granite Bay Gazette was born.

I don't recall if you or Mom suggested that I create a neighborhood newspaper, or if it was my own idea. I do remember that Donna, two years younger than I in the room down the hall, was spectacularly uninterested in the project. So was Sue Lester, the girl next door, my best friend, a year older, a head taller and way smarter at science than I would ever be. Not that they weren't nice about it; they helped me distribute the GBG to the neighbors. But it was clear from the beginning that I was to be the writer, the editor and one-third of the production crew.

"What do I write about?" I remember asking Mom.

"The neighbors," she said without hesitation. "They'll give you news. Just go around and ask them."

She donated a steno notebook, and I got the idea that I was to take notes. No problem. I'd been writing stories since kindergarten. I sharpened pencils on the stiff, hand-turned pencil sharpener on your workbench, tucked the steno pad under one arm and trotted off in search of news.

Our neighborhood, it turned out, wasn't the newsiest. Granite Oaks Drive drapes over some casual bumps in the Sierra Nevada foothills next to a manmade lake called Folsom. It was fairly quiet most of the time, except when drunk people got locked in the state park across the street after hours, and they either honked their horns around midnight or occasionally crashed through the locked gate.

I checked first with Mrs. Lester, Sue's mom. "Do you have any news for my paper?" I asked, leaning on her kitchen counter in my most big-time journalistic fashion.

"Hmmmm," said Mrs. Lester, undoubtedly rolling out a pie crust or something good to eat. I figured she knew everything; she was our Girl Scout leader, after all. "Well," she said after a few moments, "I have to take the cat to the vet today."

"What's wrong with him?" I asked.

"He has worms," she said, rolling away.

Didn't sound promising, but I dutifully wrote it down.

Few of the neighbors were any more forthcoming. Some told me how cute it was that I wanted to publish a newspaper. I didn't want to be cute; I wanted news. I recall returning home dejected. "There's no news out there," I said to Mom.

In the words of a true boss, Mom said, "Sure, there is. You just have to keep looking."

I said the same thing to you tinkering in the garage. "You should go to talk to Mr. Swenson," you said. "He works for the FBI, you know."

I didn't know. I had no idea what the FBI was. "The Federal Bureau of Investigation," you said. "They catch big bad guys."

I waited until Mr. Swenson came home from work, put on his grubby clothes, and went outside to work on one of his many boats. (It seemed that every dad in our neighborhood tinkered with at least one boat, except for Mr. Lester, who had a Ferarri in his garage.) I told him what I was doing, notebook in hand. Mr. Swenson had the nicest smile; he did not make fun of me. He did, however, point out that much of what he knew was top secret, and he couldn't talk about it.

"But if you can't talk about it, I can't write about it," I pointed out.

"Yep," Mr. Swenson said. "That's a problem."

I must've looked disappointed because he quickly added, "But that doesn't mean I don't have news for you."

We talked for a half hour. He gave me lots of ideas—about the new neighbors moving in up the hill, about the Ashcrafts who had visited Donner Lake. He advised me to look for ideas "right under your feet." Which I did.

The first issue of the *Granite Bay Gazette* (which I still have, brown ink and all), contained stories that were not surprisingly close to home. Mom played typesetter, typing my handwritten copy on the old Smith-Corona; you were the printer, cranking out copy after copy of the two-page paper for neighborhood distribution.

The lead story in the first issue, under my hand-lettered masthead with the bad drawing of a water skier, was this:

****** LOCAL NEWS ******
LOCAL PERSON SHOOTS BAT

Mr. R. Haag of Granite Oaks Drive spotted a bat flying around his garage Monday, August 11. He described it as an ordinary brown bat. Mr. Haag shot it with his B.B. gun. He also said it took quite a few shots before he killed the bat as his gun was rather worn out. Be on the lookout for bats, they may be rabid.

The second story was this:

****** THE LOCAL POLICEMAN ANSWERS ******

"I am interested in determining if Mr. R. Haag has a license for hunting bats. Furthermore, is his firearm duly registered with the proper authorities?"

In my first issue, I had gotten my own father in trouble! Somehow, Mr. Dewald, the Placer County counsel who lived around the circle from us, had gotten wind of the bat story. I recall feeling genuinely panicked. I didn't know if you had a bat hunting license; I thought I was reporting news.

"It's OK," you assured me. "I don't need a license for a B.B. gun."

Secretly, I worried that you were wrong; that Mr. Dewald, a lawyer, knew about these things, and that you were now in trouble because of something I wrote. Fortunately, no sheriff's car ever pulled up and hauled you off.

Also in that first issue, there was the story about the new neighbors, about the Ashcrafts' trip, about Mrs. D. Haag singing with the Sweet Adelines. We had classified ads, too. One said:

FOR SALE——1 red Renault Automobile. CHEAP! Anyone interested call W. Swenson. 791-1565. (You were right. Mr. Swenson was a good source.)

Mom typed; you cranked; Donna, Sue and I distributed in people's newspaper boxes intermittently over the next three years. I imagined myself competing with *The Sacramento Union* (the Lesters' choice) or *The Sacramento Bee* (the paper we got). I was thrilled.

In between band practices, water skiing in the summers, Girl Scout outings and the dreaded math homework, the Granite Bay Gazette appeared—until I went to high school and soon began to work on a "real" newspaper. The remaining copies of the GBG were relegated to a file folder in your office file cabinet at home.

What I've Never Said

I went to college, majored in journalism and worked for much bigger newspapers—eventually an international wire service and as the editor of a local magazine. And I did, indeed, go to work for the GBG's "competition," the mighty *Sacramento Bee*. But a couple of years into my job as a mostly copy editor/sometimes feature writer, a new editor arrived on the scene. He set about consolidating jobs. Mine was one of them. Some 22 copy editors had to "interview" with the new big guy for their jobs. Only a handful would get to stay.

Desperate, I tried to think of something that would make me stand out from the other copy editors. I knew my chances were slim to none. I took a big leap. During my interview, I whipped out copies of the Granite Bay Gazette for the new big guy.

"Mr. Editor," I said. "I am one dedicated journalist. I've been doing journalism since I was 11 years old. Here's my first neighborhood newspaper to prove it."

I told the story of you bringing home the smelly mimeograph machine, of hunting down news, of putting out the paper with our skeleton staff—even delivering it to *Bee* boxes. I figured the editor could relate; he had apparently grown up working on his family's newspaper. I sang my praises; I was confident and enthusiastic. It was the best interview I had ever done.

I didn't get to keep my job. I remember calling you and Mom, trying not to cry over the phone. For much of my young journalistic life, *The Bee* had been my goal. Now, at 28, I had to find something else to do. You both got on the phone, sympathizing and encouraging. I'll never forget what you said: "You can do anything you want to. If one paper doesn't want you, you go out and find another one that does." You paused. "I still have the machine. I'm not sure I can make it run anymore, though."

It made me smile.

Dad—you taught me to ride a bike and waterski; you came to every band concert Donna and I ever played. You bought and ate enough Girl Scout cookies to fund our whole troop for years. You taught me to drive a stick shift car and change a tire. But the best thing—ever, always—the best thing you gave me smelled like rotten eggs and made me believe I could write anything I wanted, *be* anything I wanted. You and Mom did that, my first newspaper staff. The best staff a kid could ever have.

You still have that machine? I've got an idea I want to run past you....

Love,

Jan

PHEBE HANSON

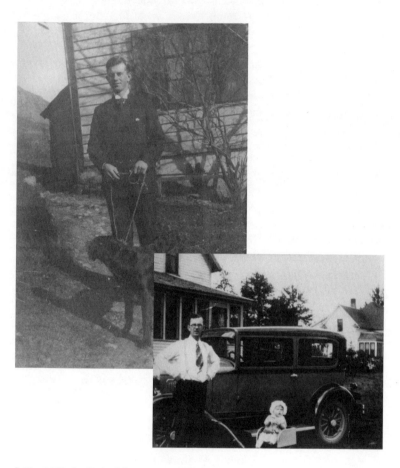

l) David Dale. Dale, Norway, ca. 1920

r) Reverend David Dale and his daughter, Phebe Dale (Hanson) in front of a new car, make and model unknown. Bagley, MN, ca. 1929

Phebe Hanson was born in Bagley, MN, on March 9, 1928. She spent her childhood in Sacred Heart, about which she has written a book of poems *Sacred Hearts* (Milkweed Editions). After rearing her three children, she re-entered the teaching profession and began writing poetry.

What I've Never Said

For almost forty years she taught students of all ages—in a one-room country school, in inner city public schools, in the University of Minnesota's Summer Arts Program at Split Rock, and at the Minneapolis College of Art and Design. Now she is retired and devotes full time to her writing, to her friends, grown children, their mates, and eight grandchildren.

David Dale was born in Dale, Sunnfjord, Norway, on July 23, 1900. "He emigrated to America as a young man, attended Augsburg Seminary in Minneapolis, MN, and became a minister of the Lutheran Free Church. In the 1940s and 50s he started several home mission churches in the suburbs of Falcon Heights and Roseville, despite discouragement from synod leaders who said there would never be enough people, 'only cornfields'. Now two of these churches, Roseville Lutheran and North Heights Lutheran are flourishing suburban parishes, testimony to my father's vision."

CLOSE CALL

Here you are, Norwegian immigrant father
with your adored daughter and your beloved car,

so proud of us both, proud of me your first born,
even though you had hoped I would be a boy,

had planned to name me David Junior, proud of
your first car, bought before you were thirty,

proof to your relatives in Norway that you were
successful here in your adopted country.

All my life you refused to talk about your boyhood
in "the old country," said when I'd cajole you to speak

into my tape recorder (this was in the 1970s when we
were all avidly taping our parents and grandparents)

"No, Phebe, that's all in the past. I'm an American now."
All you'd ever talk about was your "close call," one of your

favorite phrases. You were the only one of your three
brothers and sister who emigrated to America.

"He broke our mother's heart," my Aunt Johanna
told me when I was a student visiting Norway in 1950.

She gave me a picture she'd taken the day of your
departure, the day after Christmas, 1920, and there

you stand, heartbreakingly young, holding the leash
of a black dog (why did you never tell me you had a dog?)

Your hair is dark and wavy and thick but already at 20
you're wearing a black suit, white shirt, vest and tie.

You're ready to go off to America, Augsburg Seminary
in Minneapolis, even if your mother's heart is breaking.

This is how you'll fulfill your promise to God who
let you live when you got the Spanish flu in 1918.

"Twenty two million people died," you often told me,
"twice as many as died in World War I, but I didn't die."

When you felt your throat closing, you promised God
if He'd let you live, you'd serve him for the rest of your life.

God worked through the quick-acting village doctor,
who performed a kitchen table tracheotomy.

"It was a close call," you always said. "Close call,"
I echo, remembering your relish as you ended the story.

How close you came to being one of the 22 million,
how you almost didn't make it to America,

almost didn't spend a summer in Duluth preaching
at the Norwegian Seaman's Mission, almost didn't

What I've Never Said

meet my mother who was serving coffee and cake after the services, almost didn't marry her,

almost didn't make love with her that late May evening of 1927, the night I was conceived

in the white frame parsonage with the wrap-around screen porch in Bagley, Minnesota. Close call. Close call.

Phebe

JOY HARJO

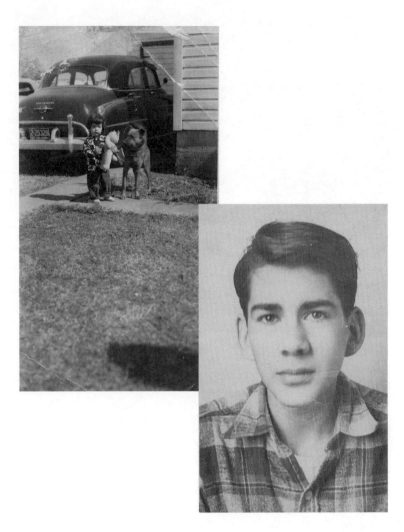

l) Joy Harjo, age two. OK, ca. 1952
 "I am with Lucky, the dog who used to babysit me. We are standing in front of one of my father's beloved cars."

r) Allen W. Foster, Jr., a high school photograph. OK, ca. 1940s

Joy Harjo was born on May 9, 1951, in Tulsa, OK. She is a poet, musician, writer and performer. She has several books of poetry including *She Had Some Horses*. *A Map to the Next World*, poetry and tales, was published by Norton in 2000. A new CD, *Crossing the Border*, is forthcoming from her band, *Joy Harjo and Poetic Justice*, for which she plays saxophone. Her many awards include a Lila Wallace Reader's Digest Writers Grant, and the First Americans in the Arts Award for Outstanding Musical Achievement. She is on the National Council on the Arts.

Allen W. Foster was born in 1930, in Okmulgee, OK. His mother was Naomi Harjo, his father William Allen Foster. He graduated from high school from the Ponca City Military Institute. He worked most of his life as a mechanic (airline and auto) and in later years as a sheet metal worker in south Texas. He died November 22, 1983.

THE VULNERABLE ARCHITECTURE OF MEMORY

Dear Daddy—

It is just before dawn. The mango tree responds to the wind's fierce jostling. A rooster stridently calls to the sun. We are alerted and our spirits trek back through night and the stars to awaken here in this place known as Honolulu. Clouds harboring rain travel fast over the city and now a trash truck beeps as it backs up for collection. And dawn arrives, no matter the struggle of humans and how endless that night might be. And I think of you, Daddy, no matter where I am in this world. We are part of an old story and involved in it are migrations of winds, of ocean currents, of seeds, songs, and generations of nations.

It has been almost twenty years since you died, and more years than that since I was eight years old and you walked away from us. Your leaving always felt like winter, like that stab of cold and ice that whipped our legs as my sister and I walked to school with our brothers, forced to wear dresses no matter the weather. And no matter what, I loved you, though I always felt guilt because I advised her,

our mother, to let you go so we could get on with it. I was witness to your cruelty, to the beatings and the parade of women addicted to perfume and cigarettes you brought into our home to bed. You broke her heart and ours simultaneously. They are linked, the child's heart and the mother's are one organ until we make a home with someone else. That's how the spirit knows where to land when it enters this world through the mothers. Maybe it's how we leave this place, still guided by that little piece of heart that clings to the marrow of the ribs. It sings. I've heard it in the middle of the night when I've been alone and terrified of dying with no one to hold me.

Your mother died just after you were born. I can understand when I see her photograph why she had to leave despite the love she felt for you. The world after statehood was too harsh, a disappointment. Your father did not love her or anyone and she could not love a man who married her only for her oil money, not for love or companionship. Her soul was halfway to the Milky Way when she posed in the only photograph I have of her in her starched dress of excellent taste. What a sour disappointment that you could not keep her close when you so desperately needed her to survive. That began the journey of wanting women fiercely but pushing them away when they got close enough to hear the singing that marked the vulnerability of your heart.

In this life it seems like I am always leaving, flying over this earth that harbors many lives. I was born your daughter, that is: Indian, stubborn and too much pride, in the Creek Nation. It is still grey out as I follow the outline of memory our lives make. Behind us is the wispy trail of the walk between the homelands and Oklahoma. Over there is my teenage self getting out of a car, still a little drunk, waving good-bye to friends. I've been up all night, singing into the dark, joining the stars out on the mesa west of the Indian town, Albuquerque.

"When the dance is over sweetheart I will take you home in my one-eyed Ford. Wey-yo-hey-ya. Hey-yah-ha. Hey-yah-ha."

That song was destined to become a classic. It is entwined in my memory as are all the songs we listened to on the radio as we drove around Tulsa with the voices of Buddy Holly, Johnny Mathis and Nat King Cole.

The shutting of the car door echoes and echoes and leads to the pulse of the music: I always hear that door when I return to the field of childhood memory. It's a holographic echo, turning over and over

into itself. It's the sound of the car door as you returned to us and left us. You are always leaving. You never did return.

I walk to my apartment in the rear, where I lived as a young woman in my early twenties. All of us lived in the back of somewhere in that city where we were defining what it meant to be Indian in a system of massive colonization. It was a standing joke that we all lived in the back, a perfect metaphor. The world is suddenly condensed by the shutting of the door, the sweet purr of the engine as the car drove off and the perfect near silence of the pause in the morning scramble of sparrows, the cooing of the doves. I can still breathe it, that awareness of being alive, the ongoing ceremony for the rising of the sun. I often lived for this moment of reconciliation, where night and morning met like old friends, like lovers. And in that early light it didn't matter that I didn't quite know how I was going to piece together what I needed for tuition, rent, groceries, books and childcare, how I was going to make sense of a past that threatened to destroy me during those times when I seriously doubted that I deserved a place in the world. The songs we sang all night together filled me with promise, hope, the belief in a community that understood that the world was more than a contract between buyer and seller.

And that morning, just as dawn was arriving and I was coming home, I knew that the sun needed us, needed my own little song made of the whirr push of the blood through my lungs and heart. Inside that bloodstream was born my son, my daughter. I was of you and my mother and know you greeted the dawn often in your courtship of amazing passion driven by love, and later heartbreak. Dawn was also the time you often came home after you and my mother married, had four children. You were often dropped off by friends, reeking of smoke, beer and strange perfume.

And I am your daughter? I asked myself that morning. How much do we have to say in the path our feet will take? Is it ordained by the curve of a strand of DNA? Mixed with the urge to love, to take flight? I am writing to tell you our family survived, even continue to thrive which works against the myth of Indian defeat and disappearance.

I was the one who found you that morning in your trailer a few miles inland from the Gulf of Mexico. The television continued to blare the news though you lay without breath in the back bedroom of that sweaty box, the oxygen still blowing into your nose. I turned it off and then prepared you, to the best of my ability, for the next part

of your journey. I pulled out the cedar and sage that I had packed and said prayers, knowing that prayers can be formed of words, clouds of thought, or rituals of action performed with deliberation. I could not think at all because to think of losing you after finding you again was terrifying.

I prayed for you as your spirit headed toward the Milky Way, to the destination of your mother so many years before. I stood over the confused body you left behind in the dank salt air that had corroded your trailer. You climbed angrily toward the sun, furious because I had not been there. Though I had tried to make it on time, I was held up by delayed flights. I prayed knowing that one day this would all make sense to us, and prayed knowing that once again I was without you, that I had been left behind. The coroner arrived to pronounce you dead and once again I heard the echo of a door slam before the silent ambulance drove away.

Since then, I acutely remember you in a boat, a cold beer in your hand and laughter just as you slide into the feel-good phase of a party. When you laugh we are all happy. There's light wind on the lake and gentle waves break the shore like small peals of laughter. We eat my mother's friend's chicken and potato salad, and my brothers, sister and I drink frosty RC colas in chilled bottles. You are telling a story and it continues to unwind through your children, your grandchildren, your great-grandchildren. I am telling it now though I am far from your rough living, your confused dying.

This morning as I write, dressed like you in the same version of jeans, white t-shirt and boots I sense your presence. Of course the clothes remind me of you, but you would have ironed the t-shirt. You were always meticulous in your bearing whether you wore a white pressed shirt or t-shirt. It is another kind of awareness of you that unwinds from the origin of thinking, is present in the pulsing of the blood, the intricate architecture of bones, the swish of spirit. It is composed of waves and they are coming from your heart to mine. It's like this song, this legacy. It hasn't been easy but always there's a flood of compassion behind the fear, the terror, just the other side of childhood. It's larger than all of us and I know you're there now, on a boat in the sun. There is nothing to forgive.

<div style="text-align: right;">with ongoing love,</div>

LOLA HASKINS

Lola Haskins and her father, Peter Behr
Wedding Day, CA, 1967

Lola Haskins was born in 1943 in New York City, where her mother was waiting for her father to come back from the war, which didn't happen until 1945. She can remember that time, how—she must have been a toddler—she pulled up on a windowsill and fell back down, amazed. Why were her hands black? She can also remember the parades at the end of the war, all the confetti, the shouting. The day her father came home, she sat on his dress hat in a fit of pique.

Soon after this, her family drove across the country in a huge (it seemed to her) black car, and settled in Mill Valley, CA, where her brother and sister were born. She graduated from Stanford in 1965 and set out for Greece because she wanted to see where the classics she loved came from. A hand-to-mouth year and a half later, she returned, and took a social science research job at Stanford Research Institute. In 1967, she married Gerald Haskins and the two of them set off on a motor scooter to pursue a checkered career as folk singers in Mexico, the West Indies, and, finally, England. In 1970, they moved to Gainesville, FL. Their daughter D'Arcy and son Django were born there, in 1970 and 1973. In the last of a series of grant-related jobs, Ms. Haskins taught herself to program. In 1978, due to a misunderstanding as to her technical competence, she began teaching Computer Science as a lecturer at the University of Florida, where she has been ever since.

Ms. Haskins has been writing steadily since her time in Greece, first very badly, then a little better. She has published six books of poetry: *Planting the Children* (University Press of Florida, 1983), *Castings* (Countryman, 1984), *Across Her Broad Lap Something Wonderful* (State Street, 1989), *Forty-Four Ambitions for the Piano* (University Press of Florida, 1990), *Hunger* (University of Iowa Press, 1993; Winner of the Edwin Ford Piper Award), and *Extranjera* (Story Line Press, 1998). *Desire Lines, New and Selected Poems*, is forthcoming from Story Line in 2001.

Peter Behr was born in 1915 in New York City, second of four children. His father was Karl Behr, a world-class tennis player who, with his then-fiancée, had survived the sinking of the Titanic. Upon finishing law school in 1941, Peter was drafted into the Navy. After several postings, during one of which he married his wife Sally, Peter was sent to the Pacific, where he served until the end of the war. Shortly after his return, Peter moved his family to California, where he lived for the rest of his life.

After a brief stint at law Peter entered politics. Eventually he was elected to the California State Senate, where he served two terms. All his life he had been a passionate environmentalist, and this passion followed him to the senate. There are rivers in California that are still wild because of him. Point Reyes National Seashore exists because of him. After he retired from the Senate, he and his wife moved to a town adjacent to the seashore where, from his house, he could walk on the land he'd fought so hard to preserve. His tenure there ended with a wildfire, two years before his death, which turned his house and all he owned to ash. He died in San Rafael, CA, on March 10, 1997, of grief and Parkinson's Disease.

DADDY, 1959

Dear Daddy,

This is what I wish I'd told you when I was young enough to say it.

 Oh it's been so long since I talked to you,
 our heads bent in the dark together
 when she was away.
 And the weather's turned cold and wet
 and it's dark by six
 and when I get home I
 don't see you, all those meetings
 that own you keep you gone.
 So Sunday, let's walk to the top
 of Mount Tam, and stop
 at Mountain Home on the way
 and call her to say we'll come
 later. And then, Daddy, we can
 stay all night, we can take a tent
 and camp. And you can tell me
 she doesn't mean it, all
 those things she says, while
 we're sleeping on the ridge
 on the back of the Indian maiden
 who jumped from these cliffs
 for love, and whose hair
 streams down the valley.

 Always and ever your daughter, *Lala*

MARY HEBERT

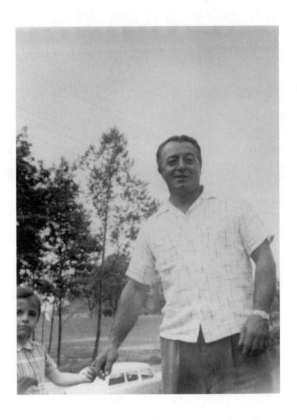

Mary Yorizzo (Hebert), lower left, and her father Joseph Yorizzo.
Tuckahoe, NY, 1954

Mary Yorizzo Hebert was born on July 18, 1950, in Bronxville, NY. She is the author of *Horatio Rides the Wind* (Templar, 1995). A member of the first Bronx Writers Corps, she was contributing editor of *not black & white: inside words from the Bronx WritersCorps*, (Plain View Press, 1996), and a contributor to *From Daughters to Mothers: I've Always Meant to Tell You*, (Pocket, 1997). She has taught writing workshops for children throughout NYC, and currently lives in Brooklyn.

Joseph John Yorizzo was born July 29, 1909, in Tuckahoe, NY, one of nine children. He married Marie Edna Lagana in 1935, and was the father of five girls. A carpenter by trade, he moved his family to Montrose, New York, where his vegetable garden became a local legend. He died in planting season, 1997.

SUMMER SHOES

Dear Pop,

Once I gave you summer shoes.

Never in my lifetime had you summer
shoes, shoes for seasons or leisure, for the father
I knew had only seasons of work and rage,
widower/child; child of the father
who beat you with trees for spilling the pailed
milk at dawn, the Umbrian fire passed on
and on in the blood of blood.

These summer shoes, your favorites as soon as you
put them on fitting perfect; I remember clearly your face
against the green nursing home ceiling as I look up at you
in your steel chair, holding each foot to shoe it, pretending
I have done this always, your large eyes expectant, peeking
over your knees as if a child discovering feet for the first time
at the end of his body, the child we both are looking for the father
against the green ceiling.

It was the end of the last summer when
I brought them home to wash, upset by the salmon pink
blotches and the black scuff marks on the tops, marks impossible
to make from walking

but I never washed them.

For Christmas bought you a winter pair that never fit, dark
and collapsing at your heels.

Your shoes, if nothing else, your shoes
I monitored carefully to contain you, your unruliness
neatly balance your ragged thoughts, your end-of-life sitting
and lying, lying and waiting, your body leaking elsewhere into
 diapers
and bags, your thoughts escaping crusty and pale as the ooze
of your insistent eyes: *You don't know*.

It is the fall after your death when I find them
at the bottom of my hamper, below the soiled things
I cannot bear to look at or free; beneath the pink
once-sateen cover from the broken marriage, the odd socks
solitary but hopeful, your shoes lie buried deep
as seeds, wrapped tightly sole to sole, to keep them
from escaping, touching
being touched.

I study them as if trying to unravel
some conspiracy, as if *if only* were something anyone
wanted, least of all you who called death finally
in your raging ungentle way, exploding
on the table, stranding your blood sent out
for cleaning, no heart to come back to,
free.

I look for you in
the shoes before:
work boots brown and steel-toed

mom in her ill-suited command voice saying
take off your father's shoes
as you sat at her tiny white table in the kitchen
with windows like eye slits, your clothes covered
with the dust of dead trees from the saws
I can still hear whining, the bent whirring,
your socks odorous ripe with
leather rust and sweat
we held our noses

What I've Never Said

shoes you wore when you built me the table
and benches *just my size* my 8th birthday gift
from the timber of your father's heart the planks
moving easily in your carpenter's hands as I watched you
in the July sun your mouth bowed and whistling;

the shoes between: black and mud-caked
from the planting of seeds and trees, the hoeing
and watering of your widower's garden
from the thawing, trusting always the green
promise.

The white shoes a cloud
rising, cloud of my own rage
how dare you end like this
you were never wheelchair bound like this
had a house, tomatoes, roses, 100 peppers
a neighborhood, the strength of hands, legs, the strength
of the carpenter; were never
demented as a result of alcohol abuse
like this; how dare you ask your youngest child
to witness this:
how dare you become a man
without a reason for shoes
like this.

So your white shoes,
I took from you, hid
from the last knowing, hoping
one last time, wanting one last
time to find you finding me, seeing
me, holding me, child again of the father
facing the sun.

Even as I write the shoes lie
still soiled, sole to sole;
what I cannot wash I must bury
perhaps will bury
at your feet where roses are now
growing, where the woman you loved lies beneath

the mother you loved watches from her sky
not a summer sky

and in surrender of the white ghosts, the raging
of bone and hair to the grace of roots and leaves
I will open the holy doors between descent
and planting
and face to face
soul to quaking soul
find you.

 Love,

 Mary

CRAIG HEVERLY

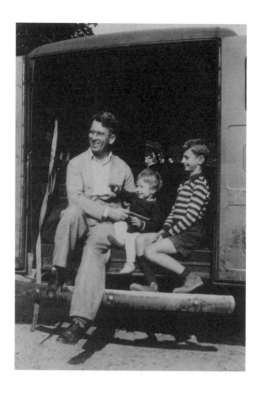

Sam Heverly, left, sitting in his father's delivery truck with two of his sons, Norman, right, and Craig, center. Buffalo, NY, ca. 1940

Craig Heverly was born in Buffalo in 1938. He graduated from Colgate University in 1960. He is married with two grown sons, Matthew and Jonathan. A community organizer, a teacher, and an Episcopal priest, he and his wife Judy, a weaver, now live in Portland, OR where he writes, drives a city bus, and takes joy in being a common man, his father's son.

Samuel B. Heverly was born in 1899 in PA. He married Ruth Pilger in 1927 in Buffalo, NY. They had a daughter and three sons. He worked with his hands all his life, at first helping his father in a small carting business, and, for the rest, in a factory building cars. He was an honest man. He died in 1991.

A FURTHER FANFARE FOR THE COMMON MAN

Dear Dad,

I miss you. Sometimes, at the edge of thought or dream, I talk with you about things we let go by when you were alive. Many things.

For instance, those repeated dinner table stories—the ones about you standing up to the boss at the Chevy plant when he wanted you to let the crank cases slide over specifications or telling him off when he was caustic and mean or setting straight the bully at the drinking fountain—they weren't true, were they? Eventually I realized you would have been fired. But, more to the point, you didn't do things like that. You had an urge to please, even jerks and bullies. You apologized a lot and, with strangers, you turned on a smile which seemed to beg, "Please, like me." You were a "nice" person. And I remember in my sharp and biting adolescence judging you a phony. "What a sad, small man, having to live on lies and wishes, handing them off as true."

I never said that, and I'm glad. Now I hear those stories as a wonderful gift. You were right. Never let a picky concern with facts stand in the way of a good story, particularly a story about justice, decency, fairness, and honor.

And besides there were other times, many other times, when you came to me as big and warm, strong and clear. Squinting into that brightness, I snatch away viscous visions of ways to be that stay with me still.

Once you took me to a United Auto Workers' picnic. I was maybe ten. It was hot Western New York summer, and I remember the cicadas' steely buzz as I went out the door and waited impatiently by the car. When we arrived, the picnic was already lively. In a big, open field there were hundreds of cars. Clusters of people everywhere.

I was excited but apprehensive. I stuck close, shy and a little overwhelmed by the numbers, the bustle, and the strangeness. These people were different from the people of Orchard Park. They looked

What I've Never Said

different, dressed different, even talked different. Loud. Argumentative. Lots of laughter and gesture.

You gentled me into the flow of things. You walked me over to the softball, eased me into the game, and, after a while, slid away, unnoticed.

The game was wonderful. At least 30 to a side. People of all sizes, voices, sexes, ages, skin colors, and abilities. Yelling and laughter with every pitch. One lovely, loud black lady popped a short fly and instead of running to first, ran straight at the shortstop bellowing, "Don't you catch that ball!" And when he did, she chased him all around center field, menacing him with the bat. We laughed until it hurt. No one kept score. We played for hours.

Eventually I came looking for you, eager to tell all. I spotted you standing in a circle of ten or so men. You didn't see me. I remember the sweet, grainy smell of spilt beer. It was hot under the trees and the talk moved slowly and carefully. I began to catch the rhythm, to watch the play.

I was intrigued by a short solid man in a new blue work shirt buttoned to the collar. He seemed to be the one the others looked to.

And I watched you like a kestrel. You were at ease, happy and solid in your place, accepted, relaxed, and attentive. You belonged there. When you laughed, your whole body shook.

Suddenly, out of a quiet lull, the man in the blue work shirt turned to you at his right and said, "Sam, tell about that time with Obie and Warrick. The time with the glasses."

I zeroed in on you, fascinated by what you would do. You were "on." I expected you to defer, expected that apologetic "stranger" smile, but, to my amazement, none of that. You settled for a few seconds, not rushing it, letting the memory come up. Your face lit finally. You shook your head in glee, and then started out.

"Oh yeah. That was something, I tell ya. Never forget it." And you told this wonderful story involving a short-fused Irishman named O'Brien who worked the inspection line with you. One day the foreman, Warrick, began berating the Irishman in front of the other workers for a mistake he had made. O'Brien tried to defend himself.

You told the story beautifully, with just the right touch of detail to make it hum. You even impersonated both the high excited Irish wail and a slimy, sarcastic baritone that everyone seemed to instantly recognize. As the scene played out, the Irish got thicker

and the sarcasm meaner. As you told it, the circle followed the battle back and forth as though the world hung on the outcome. I was fascinated. This was my Dad.

"Jees, man. Didn't you ever make a mistake? There ain't one hell of a lot of difference in the writing of 'five hundredths' and 'five thousandths.' They look a lot alike, you know. Why don't you write the specs clearer anyway?" The chin stuck out. Eyes afire. We could all see it.

Warrick: "You know, O'Brien, all of us know you Micks are dumb, but I didn't know you were blind to boot. Can't you see? Are you blind? Five thousandths. Not five hundredths. Five thousandths. See. Right here. Here, take my glasses. Maybe that'll help. Go ahead. Try 'em out. Here, put 'em on."

The argument had gathered a crowd. Warrick gloated in the belittling. He had O'Brien cornered. The Irishman was one punch away from defeat, confused and reeling, frozen by the dangling glasses at the end of Warrick's extended arm. "Here, put 'em on."

Suddenly, O'Brien snatched the glasses from Warrick's hand. He looked around, searching and befuddled, with quick, frantic movements of his eyes and head.

And then, resolved, pushing past Warrick, he charged at the big tank of acid where the line workers dipped crank shafts. He stopped, drew a deep breath, stuck out his arm, and ceremoniously dropped Warrick's glasses into the acid. Glup!

There was a long beat of silence. The group of men was stunned by the immensity of the act. "...No! ...He didn't. ...In the acid? ...Oh, my God! ...What did Warrick do?"

"He didn't do nothing. He couldn't even talk. He just stood there looking like somebody shot his dog, whimpering and pointing to the acid bath. And Obie just kind of hitches himself up real tall and eases back over to the line and starts inspecting again. And there's Warrick, over by the bath, staring down into the acid."

There was an explosion of laughter that seemed to lift up into the trees like a great wind. Men howled, and looked at each other with disbelief and awe. Some extended their arms in unconscious imitation of O'Brien's momentous act of rebellion. Others shook their heads in wonder and amazement. The uproar rippled, rising and falling, and just as it was about to die out, someone would say something and a new wave would crash out into the sun.

What I've Never Said

I remember you now, standing in that circle of factory guys. The man in the blue work shirt has been laughing so hard, tears run down his cheeks. He wipes them away and leans his face into your shoulder, still laughing and laughing. You are smiling, self-consciously shrugging, taking a sip of your beer, firm and solid. You are at ease and strong. You seem to know you have tapped some deep well of resentment, audacity, fairness, and pride.

I imagine every one of those men had known the humiliation of Warrick's tongue and manner, personally or by proxy. Each knew he was part of a special community based on the work he did with his hands and the all-defining fact that he was not one of the Warricks. Like a priest, you chanted your tale of love and reverence for the little guy, and joined that circle in a holy act of communion. A celebration of Saint Obie. Something powerful, moving and deep was shared.

At ten I had only the hint of what was going on, but I knew in my gut it was important. I stood in the sun outside that circle watching you and something like a warm explosion of well-being erupted in my chest and flooded over me. At that moment I loved you with a full heart. At the same time, I felt I had come upon a stranger.

On that hot summer day of my tenth year I was blasted by a vision. Without either of us knowing it, you gave birth to a dream of easy good will, strength, endurance, and honor among men and women who wear blue shirts and who are called "common." Looking back, I now know I have spent a lifetime chasing that vision.

I moved into the open, moving toward you and the circle. You saw me, and, surprised, your smile changed, ever so slightly but definitely, into that smile for strangers. It was as though I had caught you at something.

You, of course, gave me much more in my growing, more than either of us really know. But had you given me only that one thing, that one good story, that one moment, that one vision of you standing and smiling in a circle of joyful men with a guy in a blue work shirt easily leaning his head on your shoulder, that would have been enough. That has been enough.

Your grateful and loving son,

Craig

RICK HILLIS

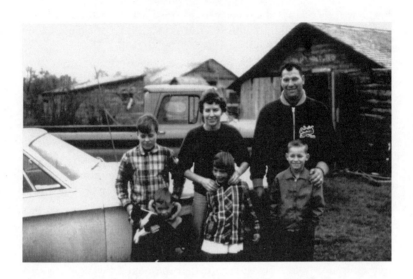

Back row, l to r: The Plymouth Fury, Rick Hillis, his mother Joyce, his father Lyle Hillis

Front row, l to r: Brother Brian holding Boots the dog, sister Shelley, brother Doug. (A sister Karen was born after this photo was taken.)

Saltcoats, Saskatchewan, Canada, 1968 at the grandparents' farm

Rick Hillis was born in Nipawin, Saskatchewan, on February 3, 1956. He was reared in Aneroid, Gull Lake, and Moose Jaw, Sask. He worked for Sask. Power, taught junior high school, then attended the Iowa Writers Workshop and Stanford University as a Stegner Fellow. Publications include a book of poems, *The Blue Machines of Night*, and a book of stories, *Limbo River*, which won the Drew Heinz Prize. He is now Writer-in-Residence at Reed College in Portland, OR.

Lyle Hillis was born in Naicam, Saskatchewan, on February 17, 1936. He was reared on a homestead in northern Sask., the second of seven children. He left school somewhere between the eighth and tenth grade to work in lumber camps, becoming eventually, an electrical lineman, district operator, and the electrical superintendent for Sask. Power in Prince Albert. He retired and now lives in Saltcoats, Sask., where he hunts, golfs, and breaks horses to the saddle and only occasionally gets "spun off."

RIDING SHOTGUN WITH A FAMILY MAN

Dear Dad,

 I was thinking about next year and wondering where the tides might beach us. No word as of yet. Portland's livable, but what with the rain and visa questions, who knows? I wouldn't mind leaving. I was thinking, though, with Cullen turning ten this coming year, we don't have too many more years to just pick up and go. He's got a life, too. That's the same age I was the winter we moved to Gull Lake. Remember that? Our nearest neighbor a maroon granary, snow-stubbled wheat fields stretching on three sides. Living in that pink shack with a snowdrift in the kitchen. You got pneumonia working the high line in a blizzard and for the rest of the winter we started our day with tablespoons of Cod Liver Oil. I've been suspicious of breakfast ever since.

 The next summer you put me to work, hauling water to the old woman down the road, 35 cents a bucket. Remember that? The summer of the big rabies scare? As I recall, a skunk had been spotted doing flips in the fairgrounds and was shot from a front porch with a deer rifle. When I lugged the buckets past the rusted metal cistern that for some reason sat in the empty lot between the old woman's house and ours, rabid dogs growled out at me from the long yellow grass. One time when I was babysitting the little kids, the pack of them slunk out of the grass and crept upon the pink shack, snarling. I herded the kids into the back bedroom, got your .22 off the rack and was loading it as your orange power truck with the ladder on top arrived like the calvary, the big tires splashing through the ruts of the yard, dogs yelping and scattering, never to be heard from again.

 I wonder if Cull will have memories like that, his Dad saving the day. Sometimes they seem more dreamed than remembered, don't they?

 Those were days of rain and sun and dirt, flat endless summer. You didn't know this, but at night I would sneak the BB gun onto the front step and fire into the darkness, wondering if I'd hit the abandoned cistern out in the distance. I always did. *Ping!* A small musical

note that sounded from far away, and somehow made me happy.

These were the years of Woodstock and interpretive rock on the AM dial. You are only a year or two older than Bob Dylan, but who ever heard of Bob Dylan? Our house was filled with the country sound: Whispering Bill Anderson, Little Jimmy Dickens, the Singing Brakeman, Montana Slim...poor old Strawberry Roan...old Shep...

On the turn table we had a stack of records that would fall one by one and fill the house: the guitar stylings of Chet Atkins, The Sons of the Pioneers, "King of the Road," the beautiful harmony of the Lennon Sisters:

...Mister Sandman...bring us a dream...

How often, on that flat trip to visit Grandma and Grandpa's farm, didn't the faded Plymouth Fury with the little fins on back and the push button transmission burst into song as we descended into the majestic Qu'Appelle Valley? All those trees! *And look, there's the lake!...*

...and it didn't matter about being squished or that the car smelled like warm bologna or it being *my* turn to nuzzle Boots or to sit by the window...You, behind the wheel, would start it off, a deep somehow Irish lilt, and our voices would chime in...

...down in the valley, the valley so low...

Even Mom singing, and Mom *never* sang!

...hear the wind blow, love, hear the wind blow...

Those were the best times: horses hooves on a country lane. Summer. Rain. Me on the little appaloosa, you on the buckskin you would later trade for my rifle and $400.00. The hollow thump of hooves. The lights of town in the distance, until the rain made us turn.

There was that one early morning, fixing breakfast, just the two of us. Frost on the windshield...warming up the old blue truck that rattled and choked, and finally died on the rail tracks out by the golf course. We had to hide our shotguns in the ditch and hitchhike back to town in a Coke truck in time for school. You returning later to collect the guns and boost the truck, fixing everything, sweeping it all up into a neat memory of a crystal time: southern Saskatchewan, autumn, 1968...the whole town asleep...just you and me and the yellow fields and the small distant sun and the belief that good things awaited in the tall roadside grass.

All of this lasted only a few short years. Soon we would move to

Moose Jaw where you worked by day and upgraded at night. Head bent to the cone of light over the small desk. I never said so, but that was an inspiration. So was the way you laughed out loud reading a Shell Scott mystery novel, or the way you could lose yourself in a Louis L'Amour even with the TV on and all of us around. But for the most part, after Gull Lake, we drifted apart. I didn't understand why work was so important and you didn't understand sports. When I left home you were thirty-eight years old; you had seven mouths to feed, a grade ten education, and the thick wrists of a man who had worked every day of his life. When I was thirty-eight, I had four mouths to feed, a grade *twenty* education, and hands that blistered playing tennis. Ah, well.

We're all in over our heads. The beauty of it is, you never believed that, and maybe because of this, I myself have never acknowledged it.

Anyway, you spent that last summer in Gull Lake at the kitchen table with my wood burning set, searing a pistol grip into the stock of your antique ten gauge goose gun with the pump action. That fall we took the gun out for the first time. Driving miles into the sand hills, not talking. I am thirteen and I don't want to be there. I'm missing hockey practice.

A kite of partridge sweeps across the windshield. They spread their wings and parachute over a rise, losing themselves in brush on the other side. You stop the truck and we dig our shotguns out of their cases. From the passenger side I hear you ratch the pump on the goose gun, then moan. When I circle the truck, you're leaning against the tool cabinet, examining your left hand. A thick white flap of skin the size and shape of a postage stamp, only much thicker, hangs off the underside of your thumb.

In a patient voice, windy with pain, you explain how the pump mechanism must have seized when you ratched it, making your hand slip off the front stock, your thumb catching on a piece of metal. Cradling the hand, you pull the tin first aid kit from under your seat and pop the snaps. I watch you get out a pair of scissors; then you turn to look at me. You motion with your chin to where the birds had gone, over the hill. *Go ahead...*

What about you?

Don't worry about me. I'll be fine. You go...

So, I go. Climb the rise. In back of me the truck becomes a toy, you lost behind the glare of the windshield. The other side of the hill

is empty except for patches of scrub brush, gnarly and twisted. The wind whistles. The only time I'd seen you injured before was when a power pole had rolled off a stack and cracked the bone in your forearm. You used one of the baby's diapers for a sling and laughed about it.

I descend the sandy slope, watching for birds to burst forth from one of the ragged patches of brush. I hold my gun ready.

I might as well come clean and tell you now the shots you heard that day was just me shooting holes in the sky. I was bored, worried about you...maybe the emptiness got to me... Who knows why? I aimed at the clouds the way I used to point that BB gun into the blackness and hope to hit the cistern. The first blast lifts a spray of partridge and I trace their path, shooting wildly in my nearsighted manner, sky full of pellets.

No birds fall, and relieved...I slog back up the hill.

Do you remember waiting on the other side? You had a handful of blood and expected me to show up with supper. Didn't work out that way. Sorry about that. Hope you enjoyed the *Highwaymen* tape and The Louvin Bros. Kinky Friedman was my mistake, an acquired taste. Anyway, looking forward to getting together some time in the future for a feed of pickeral or deer sausage. Say hello to Mom and the grandmas and everybody, and I hope you've scoped out the hunting terrain around Saltcoats, and that you get yourself a saddle horse soon. Cull and Cassidy would appreciate that when we come to visit, if we ever do.

<div style="text-align: right;">Yrs in Portland town,

Rick</div>

KATHRYN HOHLWEIN

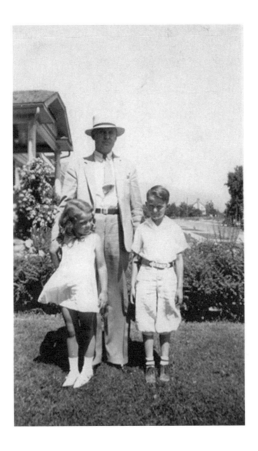

Kathryn Jerrell Hohlwein with her father, Warner Jerrell,
and her brother Robert, Salt Lake City, 1935

Kathryn Joyce Jerrell Hohlwein was born on May 18, 1930, in Salt Lake City, the second child, the beloved daughter. From both mother and father, she received the love of learning, of language, of reading, and ultimately, the love of the classics. She enjoyed a long career teaching Homer. She was married to the German artist and printmaker, Hans-Jurgen Hohlwein, has one son, two daughters and two granddaughters. Newly retired from university teaching, she divides her time between NY and CA.

Warner Phillips Jerrell was born on February 3, 1899, in Oakland City, IN, the next to the last of eight boys (so he always wanted a daughter). His schoolteacher father was strict, severe, fundamentalist. He was also poor. Like many of his generation, my father longed for a more formal education than he could get, and forever after educated himself. He and his wife, Helen, moved to Salt Lake City, UT, where they lived out their lives. For years he was overworked and underpaid as Manager of the Retail Credit Company. Later, he worked more successfully for the Prudential Insurance Company. His was a simple life, solid, and in many ways eloquent.

CIRCLING AT UMBRIA

I would not be sitting here in the Piazza Garibaldi, in Todi, in Umbria, in Italy, in Europe, Daddy, if you had not inculcated in me the irrepressible desire to wander.

It was that longing which uprooted you from the Kansas heartland where you and Mother were young, were valedictorians, were married. It was physical. You wanted to see other parts of the world than the wheat fields and the small flat town of Kingman. And it was mental. You wanted a bigger, more varied horizon than the restricted outlook of your puritanical and poorly paid teacher/postman father.

I believe that nothing gave you that impetus more than the two years you were a sailor, based in the harbor at Marseilles, in 1917 and 1918. (God, how long ago! Could any mind, ever, no matter how provincial, how sweet, have been without knowledge of the Holocaust?!) I try to imagine you there, so dear-faced and barely experienced, but I am your daughter and I missed your youth. As you missed my aging.

We live out the undreamed dreams of our parents. That is why I have this campari before me, why I look up to the mullioned windows of the palace that looks in turn to the Piazza del Popolo. Popolo? What people? All of us, even those dreamers from Kansas, who always wanted more.

Sometimes when I meet a quiet man, a gentle man (there still are some) you return to me as if these where the 1950s. Your quietness was a quietude, deep and steady. Mother flitted around, busy, capable, helpful. She would have liked to be dancing, but you were too

quiet to dance; you were also too somber. There was a time I lied about you, even to my children, saying that you and mother had twice won a Charleston contest in the twenties. That decade seemed so far away that myth and legend might just as well have blended ahistorically. But how remotely impossible for you such a prize would have been. Even as I child I doubt if you could kick up your heels.

How hard it is to describe so inward a person as you were. You wanted nothing but to pay your bills and your several insurances, to know that Mother was happy, that I was growing properly. You seemed to have no desires, none but for travel and thoughtfulness. Oh, yes, and seafood. I could never buy presents for you. You had a tie and a car that worked. Wasn't that enough? You had access to a library. You had enough handkerchiefs.

I should have bought you trips to Umbria.

It has taken me many decades to really grasp the grandiose bravura of your fleeing the Bible belt, how large the escape and bold. It has taken even longer to realize what it was you could never escape—your severe father's escalating hoarse and fervent praying so scary to me as a child that one summer midnight I fled in my nightgown from the kitchen doorway of that small frame town house, into a pulsating hollyhock garden where I crouched and hid under a line of laundry. What was he screaming about? Who was he yelling to? Were there burglars? Was he mad at me? Was he going to spank me?

The warding off of the Devil made at least you want to flee. Your longing for liberation from superstition and dogma threw you out to the Rockies, where you and Mother found like-mindedness, not in the Salt Lake Mormons, but in the Unitarians, a small band of fugitives, interested in Universals and hostile to the Vatican and the prisons of all theocracies or tyrannies. There you found your lifetime friends and my substitute aunts and uncles, one of whom said at your funeral, "Your father was the finest man I have ever known. He could bring any antagonists to a common ground by his calm persuasive reasoning." Remarkable how you became a dogmatic secular humanist and a pious Unitarian (oxymorons both), hating all hierarchical ordinations of power, how you loved eloquence and exactitude in expression and honed a fervent wariness for the abuses of privilege.

I wish I could know how such passions got formed—what renegades could have inspired you, what conversations could have undercut the rigidity of your upbringing. Of course, in the Great Law

of Oddity, you got a daughter sneaking off for pilgrimages, for the hopes of mystical sex, for Gregorian chant and the twilight washed arches of Beato Angelico.

What residual devil made you shout out at night, waking and upright, suddenly cursing? What temptation or fury roiled at your lips, scaring your sensitive son in turn?

Once a California New-Ager, high on her study of rolfing, dug down into my thighs with her fingers, leaving thumb prints on my bones. She told me my father "was sorry" and, in tears, I said, "Sorry for what?" She only answered, "He is sorry." I hope that right now you're not crying, as I am beginning to. The bells (they have bells in Europe) are just ringing. Pigeons just flew by. It wasn't incest, NO, though some keep insisting it must have been. It was some monotone murmuring in my cells, some heart-breaking near-silent negative.

Oh, Daddy, we all are churning. The scratching at our insides is wearing each one of us out.

For you had a son, too, and he is not my friend. He may even be my enemy. Even though you named him in the spirit of the magnanimity you loved, after Ralph Waldo Emerson, neither of us has had peace. Nor adequate self-confidence.

I am circling, circling like these pigeons around a central point. The heart of our dilemmas. We were not to have bodies, were not to know them delighted. We had to deny the softness around these bones. We could affirm the reality of skeleton, but not this possibly sordid flesh. This temptress flesh. (Sinful) Unitarians don't believe in sin; they don't believe in redemption. You hated the dogmas and political oppressions, but we know you shouted in dread, like your father. How were we to kick up our feet and love dancing? How were we to live out our bodies' sweetness? So we traveled and exiled and closeted and sorrowed and distanced ourselves from each other. But we did see the world and loved all the differences and earned up a hoard of new tolerances.

And I loved you all my life, and somewhere, felt sad for you, too. Some panic beneath the loved quietude, some penury and thrift. The place of damage, the place of consequence.

Mother wrote when she could no longer speak, a little note on a bridge card—"Warner is so dear to me." You told me, "I have to live longer than Helen" and you did, too, though your colon was bubbled

with cancer. And you planted marigolds for her sake and you cared for them as they required. But, unlike her, you never brought their softness inside the house—to the bones. I knew you could not live without her, that her death would necessitate yours.

Your beautiful hands fell softly on the sheets.

So you left me the churning, the language, the longing. And how was I to deal? You taught me to love the back roads, to explore even where there were no signposts or mileage charts, running the risk of an empty tank. Narrow single-laned roads. And bad weather coming up. You gave me that bravery.

Joyce

GARRETT HONGO

Top: Torau Hongo. Honolulu Harbor, 1944

Bottom: Garrett Hongo with his sons Alex, 9, and Hudson, 6. Eugene, OR, 1995

Garrett Hongo was born in Volcano, HI, in 1951. He is director of the Program in Creative Writing at the University of Oregon. His recent publications include the memoir *Volcano* (Vintage, 1996).

Albert Kazuyoshi Hongo was born in Honolulu, HI, in 1926. He died in Los Angeles on January 26, 1984. During World War II, he served with the 100th Battalion in Italy, part of the relief force for Nisei (Japanese American) soldiers who had died in Belgium and France.

LET ME GO

26 January
Santa Monica

Dear Dad,

They would not let me into the LearJet factory today when I went to see you in the place where you began dying. The guard at the security station would not let me through, would not accept my reasons, said there was a company policy against it, of course. I don't know why I thought they might let me through to see the cubicle where you worked, the table where you sat where your boss humiliated you for the last time.

I circled the rear of the building and found a large planter with shrubbery, a century plant, and a tall palm tree. I sat on the wall that encircled it and watched the day shift file past me, men, nondescript Caucasian males, but no other Japanese Americans. Were you alone that way? I never really knew. You never took us to your workplace, you know. You kept it hidden and secret.

So the wind blows through the eucalyptus trees shading the parking lot, small planes land and take off in the Santa Monica airport across the street, and I decide to talk to a tall cedar tree in the parkway, letting it stand for you, letting it *be* you, asking it for a new peace, a new leave-taking.

I want to stop grieving for you, Dad. It's been ten years now, this tenth anniversary of your death, and I realize I need to make my own journeys, finally, that what I've done up til now is to take yours and my grandfather's and make them mine. I think, now, that I have finished this karma. I have built a school like Kubota wanted. I have

made people listen, to hear me, as they never would you. If anyone were to cross my path with a smirk, they would feel my enmity first and then my punishments, steady as rain, throughout the rest of their lives. That happens now.

Let me go. I have done as much as any son I know has done to grieve his father. I quit my job. I moved my family back to Hawai'i to be more like you, to learn what you were like. I lived quietly and nestled myself into a local's identity, all the while keeping my journals, living out my grief for you, my missing you, my shame for not being more like you. But it's done now. I have found something.

I need to find out what I want out of living. I realize that what I thought I wanted was what you and Kubota wanted—for me to be strong, shove back when I was pushed, to rise up when the white world tried to make me bow. I have done that. Now I need to be someone for myself, for my children. I need to find out what I want, which is a mystery.

I have gone through most of my adult life resolute in purpose, grim inside with pain made into determination. What kindness I felt, what tenderness I wanted to share I turned away from once, powerfully, when I was younger, about twenty-six. I think now that behaving that way, becoming so strong that way narrowed me terribly, reduced the palette of emotions I've allowed myself to feel, to be open to. It narrowed my company, clenched my soul. It was all a response to a deep hurt I thought would kill me if I gave in to it. I made myself never go there again, closed off what might have been the better part of my nature.

I need to open this up now. I need to live the second half of my life differently. If there is pain, I need not to react with bitterness and resolve. I need to soften to it. Let it wash over me, give in. I think it will teach me more kindness.

Let me go. Absolve me from this quest to redeem your life. I let you go. Let me go. Let me live the life of the son and not the father.

All else has been said between us. Love is first and last.

Garrett

JAMES HOUSTON

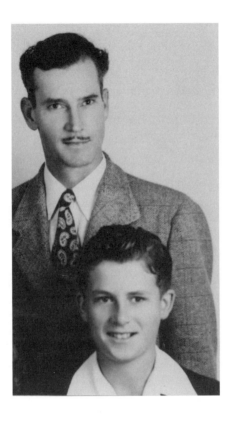

Albert D. Houston and his son, Jim
San Francisco, 1946

James D. Houston was born in San Francisco in 1933 and has lived for many years in Santa Cruz, CA. He is the author of seven novels and several nonfiction works, among them *Continental Drift, In the Ring of Fire, The Last Paradise; Farewell to Manzanar,* co-authored with his wife, Jeanne Wakatsuki Houston, and most recently, *Snow Mountain Passage* (Knopf 2001). His numerous honors include a Stegner Fellowship at Stanford, an NEA Writing Grant, an Arts America Traveling Lectureship in Asia, and a 1995 Rockefeller Residency at Bellagio.

Albert D. Houston (1904–1969) was born in Durant, OK, and grew up in east Texas, the son of an itinerant blacksmith and sharecropper. During the Great Depression he joined the many thousands heading west in search of a new start. Settling in San Francisco, he made his living as a painting and decorating contractor, and in his spare time practiced landscape painting and played steel guitar.

MIRRORS OF KINSHIP

Dear Dad,

Lloyd showed up last week driving a new Dodge pickup. Remember him? He sort of took me by surprise, called from over near Salinas to say he was out here on the coast and would I mind him dropping by for a visit. The word "visit" put me on guard, since it could mean anything from an hour to a week—that and his voice, which is a lot like Andy's, high and nasal, with the same country edge you hear in Willie Nelson's voice. Ordinarily it's a sound I like to hear, since to me it's the sound of the homeland, where so many of the kinfolk can still be found. But considering this was Andy's oldest son, it started me thinking right away about the old days.

I of course told Lloyd to come on over. What else could I do? Blood is blood. We are first cousins, and he was seventeen hundred miles from home. Between the time he hung up and the time he got here I was bracing myself for some younger version of his father, thinking in particular of that first time I saw Andy, back when I was a kid.

I know it was a Sunday because I was up early looking for the comics. I opened the front door and found him sprawled across the porch with the paper in his arms, unconscious, unshaven, smelling of stale cigarettes. A scarred and dusty flatbed truck was parked in the driveway stacked with crates of unspoiled tomatoes. The truck had Arizona plates, which I remember you said didn't make sense. The last you'd heard Andy had a place outside Fort Worth. When he sobered up enough you asked him where the tomatoes came from and who owned the truck. He shook his head, couldn't recall if he'd bought it or stolen it or borrowed it or found it by the side of the road.

I remember that he slept a long, long time and then woke up talking. "You children," he said to Gloria and me, "you come in here and say hello to your uncle Andy. Has your daddy told you about me? If he hasn't, he sure should have. How old you gittin' to be, Jimbo? Fourteen? Fifteen?" I told him I was eight, and he said, "Eight? Shoot! Big as you are, I figured you'd already be in high school. Well, I want you to watch what I'm about to do here. Your daddy ever tell you I was double jointed?"

He bent his hand back until his thumb touched his forearm, and he had us, from that moment on, with all his hand tricks and card tricks and coin tricks and voice tricks. Pretty soon we were on the bed listening to him tell a long ridiculous story—something I'd never heard you do. That afternoon he took us both for a walk in the park, while you called the Department of Motor Vehicles to locate the owner of the truck, and pondered how to get rid of a ton of oozing tomatoes before the neighbors called the Department of Public Health.

It had always been this way—I know that now—even when you were kids together, playing, fighting, sleeping in the same bed, weeding cotton rows in the summer heat. Growing up out west I'd seen a lot of Andy because you could never turn your back on this prodigal brother. You were the steady one, the family man who stayed married to the same woman, got your contractor's license, painting houses, putting money in the bank and keeping us in school clothes, while Andy drifted from job to job, from state to state, from woman to woman, the charmer, the rascal who always left a mess behind, the bronco brother no one could tame. Between women, between jobs, between binges he would turn up on our doorstep, your own personal test and trial, and each time he went away you would be relieved, while I would be disappointed. He was the exotic uncle, the lovable uncle, the one who always made us laugh the loudest. Each time Andy left, it seemed like all the fun and entertainment went out of the house, exposing once again the things that you were not: spontaneous, unpredictable, expansive, absurd . . .

It's hard to tell you that. But I have to talk through this part in order to get at all that's on my mind, and what came clear to me the day Lloyd showed up.

When he pulled into the driveway I half expected to find him slumped over the wheel with drool running down his shirt. Like father, like son. I hardly had the front door open, and he was out of his

truck, standing by the fender. As I walked toward him, he smiled a slow Texas smile, flicked his head sideways. "It's been a while," he said. "But I believe I'd recognize you anywhere."

We'd met once, at that family reunion in Tyler when we were both teenagers. As we shook hands he was searching my face the way I searched his, looking at the temples, the nose, the mouth, the jaw, for signs of family history. In his eyes I was looking for some of the wildness I used to see, the devil glint that said, 'Whatever you can think of, son, I wouldn't mind giving it a try at least once.' It wasn't there. These eyes were blinking, watching, waiting, not at all the eyes of Anderson.

"You drive that pickup all the way from east Texas?" I said.

"No sir. Got me an r.v. parked at the KOA camp. My wife has people in Salinas, so she stayed over there. I just haul this Dodge around on a trailer hitch. Get the r.v. parked, I'm traveling light."

Suddenly this stranger/cousin was no stranger at all. Those were your eyes. And this laid-back, thoughtful delivery was yours too, as well as his double-rigged mode of travel. Andy would never have bothered with that. Lloyd's clothes were what you would have worn, a brown-plaid, long-sleeve shirt, maybe from Sears, and plain slacks of a darker brown. His hands had the same long fingers, a guitar picker's fingers. His grin was like your grin, tight and careful, as if his leathery skin had only so much to give. After all these years, here you stood, looking at me again.

I was soon to find out Lloyd hoped I could do something similar for him. He was on a mission, traveling old roads Andy once traveled, looking up people who had known Andy, looking up me, hoping I could give him some version of his father. You would have known that he was one of those Andy had left behind. But I was stunned to learn that when Lloyd was six, the long-gone trickster took off, never to return. After that, Lloyd only saw him one more time. Now a man with his own family raised, he was still the son, out here in California searching for the father he had never known.

We spent the afternoon talking about relatives, talking about Andy, swapping tales of his deeds and misdeeds. I saw that I knew parts of Andy that Lloyd could never know. The brother who had been your lifetime curse had given me things he'd never been willing to give his own son, rambling tales, jokes and riddles, choice moments of comradeship. I felt an unexpected rush of guilt, as if I'd stolen something

that should have gone to Lloyd. I wanted to tell him he wasn't alone, that you had both been elusive fathers.

I wanted to tell him how you came home almost every night and yet were always reluctant to speak, to touch, to reach, being such an inward man. I didn't say it, though, because Lloyd wasn't looking for that. He was hungry for my memories of Andy, and wistful too, as he heard them. But he wasn't angry. He was past bitterness. He was content to sit and listen as long as I would talk, eyes searching mine again, on the edge of a smile, a tentative, deferential look I'd seen in your eyes a thousand times.

That's when it came clear to me. Lloyd had been sent to remind me of the man you were throughout your life: softspoken and steady, unswerving, unpretentious, trying to stay honest and get through each day as best you could. In his face I could see qualities I'd forgotten or never knew how to acknowledge when the air between you and me was so charged with all the father-son intensities. Even now I doubt that I could tell you all this face to face.

By the time Lloyd drove away, heading back to Salinas, and eventually back to Texas, I knew he had long ago forgiven Andy his many sins. This is not what I would have to do. You were as good a father as you knew how to be. The day Lloyd showed up I had to forgive myself for so long expecting you to be someone else.

<div style="text-align:right">With Lots of Love,

Jim</div>

ALEXANDRA JOHNSON

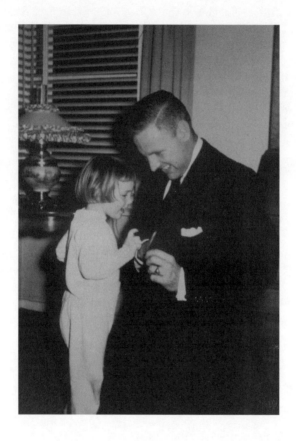

Alexandra Johnson and her father, Norman Johnson
San Francisco, CA, ca. 1951

Alexandra Johnson was born in San Francisco, November 12, 1949. She is the author of *The Hidden Writer* (Doubleday), winner of the PEN/Jerard Fund Award for nonfiction, and *Leaving a Trace* (Little, Brown 2001).

Norman Johnson was born August 10, 1924, in Los Angeles. Until retiring, he was a coffee broker in San Francisco's financial district.

THERE. NOT THERE.

Dear Dad,

That clear spring morning, the sky helium high, she asked how long you'd been dead. It was our second year at college. A close new friend should have known. I stopped to ask why she was certain you'd died. I spoke of you so rarely, she replied, and always in the past tense. That morning, the cool sting of eucalyptus sharp in the air, I couldn't know it would be twenty years before you'd actually die. Or that in the final fourteen months of life, your dying would be the most stubborn of births to free you—and myself—into some present tense of being: father and daughter. Ourselves. Willful. Willfully alike.

On the phone, I imagined the cancer blossoming darkly under your skin. By my first trip home weeks later, the melanoma had rooted in the bones. You held up the radiologist's contact sheet, offering it to me. Scar, curiosity, souvenir. In rows of three, the thick film framed a dozen tiny standing images of you. Back to front. Hands fanning your sides. I studied the exposed x-ray white of your body, staring where the cancer left dark asterisks. All the places the radiologist had calmly noted in her medical report: right shoulder, rib cage, pelvis. In your pelvis, two perfectly symmetrical images. Flowers or dust. They shimmered like stars.

In the second contact sheet, two months later, your whole body was now dotted with a spray of black confetti.

Holding the contact sheet, I marveled at how it had managed the impossible: trapping you. The father always traveling, always gone—even when sitting near me in the living room, the secret thrill of the outside world a smell on your skin. How was it possible that in the MRI images you were only three inches square? In the hospice bed that final week, the sheets still canyoned your 6'2" frame. The bones seemed huge. An ankle, a knot of stone. That final week the nurses kept the bed's steel guard rail up as if sensing it was a perfect metaphor for the man I called father: wall, garden, fence, protection.

The contact sheet was the last photo of you. An extravagant flurry, a series. In our earliest family snapshots, you'd photographed us all

instead: the thin wife, hair dark and slick as a seal; the son insulated by the protective baby fat that clung stubbornly to your own waist. The daughter, adoring and watchful, socks swallowed at the heels. As you lay dying, I scanned all the photos you'd taken for clues. But you'd been careful, not even your shadow showing, nothing cutting across our path. There. Not there. Photos of me, wild with child love; of you rarely touching me. Between ten and seventeen, there are none of us together. By then, you'd released me to my mother's insistent hunger, its Demeter claim of possession, its romance of underworld. Had you just tired? Or were you afraid of that deep gnawing need of hers as she held me instead of the you she wanted? In school, when asked my favorite geometric shape, I always answered: the triangle.

Illness and time changed us. Small gestures in the hospital: stopping sips of grapefruit juice that stung your lips; blotting them with thin cafeteria napkins; sitting quietly as you slipped into the first coma. Hearing, the nurse said, was the last sense to go. So I told you about the father-daughter snapshots I'd never shared with you, scenes from memory, of a childhood spent trying to discover my own presence mid the mystery of your absences.

Between flickers of consciousness, your hand occasionally shot up, gripping the steel bar over your head. In that tight grip I saw the instinct for control you'd schooled me in; the control that, until your dying, had kept us both wary watchers in life. But now as you surrendered to the first unpracticed gestures of caring, so did I. Seeing your hand grip the bar so tight, as if to a subway strap, I wondered if you were hanging on long enough so I'd make sense of the snapshots.

The first exists only in memory. That final dinner out between radiation. At dinner, you folded a napkin, showing me how you used to swaddle my diapers. You did it fast, expertly, with a confidence that thrilled me. I stared at those hands, stunned to find out only now how they'd once cradled me on their own. That October night I didn't know I was pregnant at the time. Or that I'd miscarry. Like your dying, these would be strange gifts, black valentines of loss. Dark gifts that set me on my way.

All those years I'd been watching you from another coast, indirectly learning your survival code: work, drive, discipline. Dying, you showed me another: life's elective affinities. Choosing not to be buried with your birth family, but with your in-laws—those literate, litigating Irish (except for my grandmother, the hidden Jew, the only

one more subtly independent and secretive than you.) With the final vote of your body, you'd said no to that successful failure of a first family, no to their tight competitive love. Just as I'd later say no to a marriage too close to your own.

Soon after the burial, in a fit of grieving masked as cleaning, my brother tossed out the contact sheet with its tiny images of you. (I found instead the journal I'd given you, its pages still irredeemably blank.) I wanted those three-inch square images of you. That huge body, now ash. A poof of magic, like the magician you'd hired for my sixth birthday with his tricks of transformation. In death, you'd once again become the figure of my early memory: a magician who taught me the mystery of forgiveness. You'd saved your greatest trick for last. It wasn't until that day, three thousand miles and a lifetime away, when I first heard of the cancer that I knew, inescapably, the power of fact: you were my father and I was your daughter. I knew it in my bones. And before your final disappearing act, all I wanted was to ease you into a gentle death, caring for you, just as you had for me those first years.

After your death odd things began to happen. Your birthday, August 10th. My new watch suddenly stopped. That night I realized it had stopped at exactly the time you'd died three years earlier. The next day my first book had sold. The watch, now working, never stopped again. Time you go on, it seemed to say, marking not death, but *birth* days for us both.

This year your birthday passed. A week went by. No news about a special work project. I'd been watching, waiting not just for signs of it, but of you. Noting, as I had in childhood, if the air stirred suddenly, a curtain lifting, like an arm beckoning. The small signs. It was the way, in your absences, I'd learned how to trust reading the world on my own. Surely that was this year's birth lesson. I *was* on my own—with or without you. Then, suddenly, a windfall swooped down on me: good news from the city.

Had I missed the signs? Did they even exist? Did you? There. Not there. There. All I knew for sure was that we were, both of us, now strangely in the present tense.

LAURA KASISCHKE

l) Ed Kasischke
Lake Charles, LA, 1963

 r) Laura Kasischke
 Lake Charles, LA, 1963

Laura Kasischke was born in Lake Charles, LA, in 1961, and spent most of her childhood in Grand Rapids, Michigan. She is the author of several books of poems and two novels, the most recent of which is *White Bird in a Blizzard*.

Ed Kasischke was born in St. Joseph, MI, in 1929. After serving in the Air Force for ten years, living in Germany, France, and Luxembourg, he moved to Grand Rapids, MI, where he was a mailman, retiring in 1985. He now lives in St. Joseph, MI.

DEAR FIRE

Every night my father dreams he golfs in Hell
with you. The woods
lick the sky

above my father's game
with flames, and he

is trapped alive
for eternity in the place
where his hope starts
and his patience ends, losing

his ball in the burning
thickets again and again, the burning

thickets into which
everything we hurry through

in this life is lost. When

my father wakes, the grass
is sweet and long with spring. The sprinkler

whirls across the street, and leaves
fall like cool
compresses out of the trees. But even

then you're there. Pennies

on his dresser, his hot pocket
empty of copper. He

shaves too fast, and a trickle of his blood boils
luxuriant as a woman's
red hair down the drain. My

father drinks his coffee
at the kitchen window, pacing while
the red face of a geranium strains

its brain toward the sun, blooms
its aneurysm, waiting, shouts

Fire! in the crowd, which surges

as one body of vivid oxygen against
the jammed door of the microwave.

Fire, you are my father's name.

SUSAN KELLY-DEWITT

Dick Kelly and Susan Kelly-DeWitt
Honolulu, 1951

Susan Kelly-DeWitt was born in San Francisco in 1947. Her first chapbook of poems, *A Camellia for Judy*, was published by Frith Press in 1998. Her awards include a Wallace Stegner Fellowship for Poetry at Stanford University, two 1998 Poets & Writers grants, several Pushcart Nominations and the 1998 Chicago Literary Award from *Another Chicago Magazine*, among others. She has taught poetry classes in the Sacramento area for over twenty years to state prison inmates, high school and college

students, and the community at large. For several years she was the program director for the Women's Wisdom Project, an arts program for homeless and low income women. She has two grown children and lives in Sacramento with her husband and college student son.

Quanah Richard "Dick" Kelly was born in Horton, KS, on March 6, 1920. During the Depression he was forced to quit school and work in the oil fields. He joined the Army early in 1942 and served for the duration of the war in the South Pacific. During the fifties, his career in advertising included working for the Honolulu Rapid Transit Company, the *Honolulu Star Bulletin*, and the *Honolulu Advertiser*. In the years before his death at age 49, he pioneered one of the first radio talk shows in northern California, the "Dick and Dutch Show." The year of his death, he was at work promoting the first cable television station in the Yuba City-Marysville area. He died of heart disease in 1969.

NITRO MOONS

Dear Dad,

I flip open the latch of the little brass pillbox and there
 in the white, crumbling

light are your thirty year old nitros.
Buffed by the smooth rayon weave

 of your trouser pocket, the box traveled

with you everywhere, except to the afterlife, pressing
 a one by one inch square of irritated

rose into your pale thigh. The night
you called 911 to emergency one

last time, a bubble of blood surged in your chest and your
 heart seam split;

What I've Never Said

the pillbox stayed home, latch sprung, lid open, nitro
 grains silting the cluttered walnut dresser top

as though the wing dust from a dozen tiny white moths
which slept each night on your eyelids

 had fluttered up and, in your panic, spilled

their white powders there—
 This is how I found the box

two days after you died. I keep it next
to the color print a poet friend gave me.

Piero della Francesca's *Madonna of Mercy*

spreads her varnished cloak wide to a coterie of sinners:
 A young girl, a hooded executioner, a prince.

There aren't many old radio men like you
kneeling under the Queen of Heaven's cape

 but I might imagine you there anyway, for pity's sake,

if only her face didn't look
 so unmoved, so purely without any visible sign

of pity. That night the whole dark fabric
of the universe fell over you like a winding sheet

 of cosmic blank, I wasn't there to watch

you disappear from this earth forever.
 A father is the tree planted before you were born,

the second wild prototype
you recognize. Even though wolves howl around its huge trunk

 and snakes with their venoms nest there,

if wasps infest its ripening fruits
 or an ice storm snaps its broad branches

treacherously above you, when the Thief
in the Night hacks that tree down, the ax

buries itself secretly inside you and the tree's vivid shape

in the solid anti-world
 sticks. I feel your splayed form, your blood-roots

in my gut, trace the outline of your dense
vanished tangles on the visible.

 My mind will always retain a ghostly imprint

of your vanishing like the shadows
 on the sidewalks of Hiroshima

the human spirit vaporized into concrete.
And that is why I harden myself

against the Purple Heart Veterans

and keep your junk—why I still possess
 the little brass oracle, tarnished shrine

and position it carefully on the white pine altar
of the shelf

 (self!) by the pitiless Madonna

with the three stale nitros preserved inside it
 (having long ago lost all their potency

to save) to remind me how
easily your difficult life was lost.

Nitro moons

What I've Never Said

I once childishly confused
 thinking they could blow up the world

like the nitroglycerin the doomed
soldiers of World War II movies

 transported so gingerly in shock-

proof cases (just as you had described
 doing as a fresh lieutenant at Buna or Leyte).

Not even the true moon can light
the woods, the wilderness, the desert

you were. Who if I cried

would write the correct prescription
 for my confused heart? I open the box

with its three unstable tablets
Memory is the explosive

 I still tremble to hold.

Susan

HARRY W. KENDALL

l) Harry W. Kendall, age 23
Detroit, MI, 1954

r) Wesley C. Kendall, age 63
Detroit, MI, 1954

"These are enlarged shots of me and my father, cropped from a group picture at my sister's wedding."

Harry W. Kendall was born in Tarentum, PA, on August 10, 1931. He is a writer, having published his first novel, *Truth Crushed to Earth*. He holds a B.A. in Journalism from Rutgers University and an M.F.A. in Writing from Vermont College.

Wesley C. (Chap) Kendall was born in Sunnyside, GA, on October 30, 1891. He and his wife moved to Brackenridge, PA, in 1923. After 32 years, he retired from a steel mill and devoted his time to gardening and selling his produce.

FOLLY MUSIC

Dear Dad,

 This is the first time I've written you since 1959, a few weeks before Christmas. We were living in Buffalo, New York. Chris, the kids and I were coming home on the 26th for the holidays, until New Year's. At that point we still called the Pittsburgh area home, Bull Creek, Tarentum, New Kensington, and thereabouts. We had been gone a year and were returning, eager to share our joy at my having steady employment doing work I enjoyed, planning our future. We wanted to heal any sores caused by our departing that you and Chris' folks had called abrupt. After months of soul-searching, I felt strong enough to begin discussing matters of my childhood that still hurt. You had promised since I was thirteen to pass down family treasures, tell me family secrets. More than anything else, I wanted to heal the wounds that divided us.
 Chris had pumped up the children to sugar-plum excitement about Grandpa's Christmas surprise. But there was no surprise, not even a cookie or your Lionel train set. When I spotted the envelope still sealed on the couch beside you, I realized you hadn't expected us. How strange, I thought, deeply religious as you were, not celebrating the holidays, at least not the manner in which we had been accustomed. Once again, the setting was not conducive for a serious heart-to-heart talk. Chris called her folks, making quick the conversation. We agreed with the children's insistence to go back to the place they

had begun to call home, a three-bedroom rented flat on Glenwood Avenue in Buffalo. I visited you several times after that and we talked some by phone, mostly acknowledging each other's existence as father and son.

Five years later you died, in a way of speaking, a mystery man. The sadness I felt, staring down at your cold body, was from not knowing why you abandoned me the summer before my junior year in high school. Though I couldn't fathom the seriousness of it, I was sincere in my rejection of your offer to support me in college only if I would study the ministry at Wilberforce. The words still resounded in my brain: *You're on your own, that's all I can do for you*. Most of what I wanted out of life, you detested. I created my problems in high school, being disruptive and refusing to learn, bent on making your life "more miserable," your words in a note to my home room teacher. Did you ever wonder why I wouldn't go back for my senior year?

Har-Brack, that rabid, racist hell-hole, taught me more than anything else to hate. I hated it first and foremost, then myself. Though it was very painful to admit it to myself, I hated you; I hated black people generally from time's beginning for contributing literally nothing to the world's advancement, scientifically, culturally or spiritually. I lay in bed night after night hating, while my insides churned. Having nothing to fortify what I sincerely believed, I rejected everything except music—history, social sciences, English literature, math and geometry. Since those early years, I have learned that historians, sociologists and literature have lied miserably, and I will gladly tell you some of the reasons another time. The geometry teacher, Miss Broadfoot, was the worst bigot among the host. I learned years later from the high school transcript sent to Rutgers University that she was my counselor. Imagine that.

If the one person in my life during that turbulent summer of my seventeenth birthday had lived, hate would not have crippled me as it did for a number of years. For certain, I would have been an enthusiastic graduate and gone on to some conservatory. Mr. Noce, band director and music teacher, inspired me as much as the jazz musicians I emulated. He learned from me that you despised jazz and called it folly music. You couldn't stand the sound of my saxophone and scorned me for not wanting to be a preacher. His patient ear and encouraging words—*He can't very long scorn a star*—filled me with inspiration. He promised to organize a high school jazz orchestra,

build it around me, and had begun working in that direction. Mr. Noce was a wonderful, kind white man, Dad, the only person alive in whom I trusted enough to share my secrets and my pain.

Leafing through the Valley Daily News a few weeks before school, I saw his name in the obituary column. All vestiges of hope drained from me. Without a doubt, I reckoned God had done that on purpose. Hatred obsessed me again, and though afraid, I demanded that God answer my questions. Was he that jealous? Did he call that vengeance. Why me? Mom had already been taken away from us; wasn't that enough? I believed that you and Reverend Ivrin had conspired in prayer to block my path, like you and Dr. Harris told that yarn about a heart murmur to keep me from playing junior high school football. You remembered how my penetrating questions about Adam and Eve, the man-woman-creation-rib tale, and Noah's connection with the Black race had already bedeviled you. I'd been only eight or nine then, but brainy enough to grill God for reasons why he had divvied out such harsh punishment to Black folk. We seldom talked religion after that. But attending church was a prerequisite for living in your house.

After Mr. Noce died, the Sunday you announced in church that a devil was in your home, I struck a deal with God. I would go back to school, study religion, compare the teachings of the White minister at United Methodist with Reverend Irvin's sermons, search for where I had sinned. What a waste! My presence, one Black student among four or five others, apparently stunned what's-his-face (I don't remember his name). Where is your church? Why are you here? An old cracker slave preacher loomed in my imagination. Maybe I did suggest he hurry on to hell. My memory of that is vague. Embarrassed and disillusioned, I bid farewell to Har-Brack.

I often wonder if you had known this back then in 1959, would your attitude toward me been more pleasant. It's not important now. I have forgiven myself and you a thousand times over for the misery I endured, the result of me causing you suffering and pain. I am long past seventeen, Har-Brack, and those idiotic bigots. Years ago I resolved that if whatever was locked in your inner sanctum were to be revealed, let it be by whatever means available. You taught me heaps, mostly by assimilation. I feel your presence often, some times stronger than others. Usually at some point in my introspection we revisit my seventeenth summer. But I've never been so compelled to write as I was last August in (you would never guess) Holly Grove AME Church.

You did talk, though not much, about your early days in Georgia, passing through Fayetteville in a mule-drawn wagon on your way to the church that Grandpa Harry helped build in 1897. But I don't remember you telling me he was a carpenter. I know you were unhappy about leaving the South. For fifty years after you, Mom and Grandpa joined the mass migration to industrialization, other offsprings of the original founders held on to the rustic site. Theirs was a sparse congregation, meeting back there in Fayette County's woods once a month in the summer. The Holy Ghost moving swiftly about the sanctuary couldn't keep it warm enough in the winter. Today it is a modern brick chapel on Holly Grove Church Road in Peachtree City, a middle-class to aristocratic, racially integrated development of modern homes and schools, industrial parks and country clubs.

Pride engulfed me, Dad, when I was introduced as Harry Kendall from New Jersey, grandson of our founders. While I praised the church for its spiritual kinship and historic achievement amid a rush of amens, a man my age, slight of build, entered and sat with the church trustees. He was definitely a Kendall, such as I haven't seen since you passed.

Sitting there, reading the church's history, feeling a magnetism drawing me close, I began relishing the bond between him and me, a bond established by Grandpa. A perplexing thought about you wanting me to be a preacher commanded my attention. Perhaps you had hoped or envisioned leadership in the African Methodist Episcopal Church being a family tradition: Grandpa the founder, you a long standing trustee, me a minister. Knowing your chances of being part of the struggle to keep Holly Grove afloat were smashed when you left there, I believe your demands of me were really what you longed for yourself, realizing they were out of reach. But know that our family tie with Holly Grove is intact. It and the founders have been nominated for inclusion in the National Register of Historic Places. Know too that I have thoroughly enjoyed writing to you.

<div style="text-align:center">Your son,</div>

What I've Never Said

JAMES KILGO

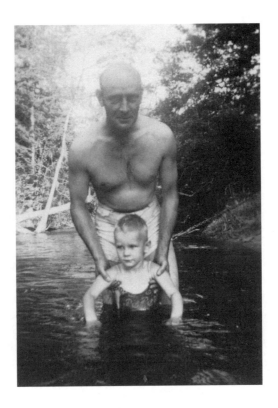

John Kilgo and his son Jimmy, in Black Creek
Darlington, SC. Summer, 1944

James Kilgo was born June 27, 1941 in Darlington, SC, educated in the public schools, at Wofford College (A.B. English, 1963) and at Tulane University (Ph.D. English, 1971). He married Jane Guillory in 1963. They have three children. Jim has taught at the University of Georgia since 1967. He is currently full professor in his final year of employment. He is author of two books of essays, *Deep Enough for Ivorybills* (Algonquin, 1988), and *Inheritance of Horses* (University of Georgia Press, 1994), and a novel, *Daughter of My People* (University of Georgia Press, 1998). He loves the Bible, the Braves, and Black Creek.

John S. Kilgo was born February 9, 1912, in Darlington, SC, educated in the local public schools and at Wofford College (B.A. English, 1932). He married Caroline Lawton in 1940. They had four children. John operated several businesses in Darlington, mostly having to do with the sale of petroleum—gasoline, kerosene, and heating oil. He was active in church and civic affairs. He loved baseball and basketball and he loved to fish. He died at home in April, 1991.

OFF TO A GREAT START

Late September 1998

Dear Daddy,

I've been wondering lately if you remember our last conversation, such as it was. I called on Sunday, three days before you died. Mammy handed you the phone and suddenly I couldn't think of anything to say, not one word. I couldn't ask how you were feeling. I already knew. "Hey son," you said, and still I could not speak. So there we were, connected by two hundred and fifty miles of wire and nothing but empty air between us. I think I must have been silenced by the moment itself, my feeling that I had to carve my words in stone. A simple 'I love you' would have done, but I didn't think of that. I thought of baseball. The season was three weeks underway. What I said was, "The Braves are off to a great start, Daddy."

Baseball had saved us before, you know, more than once. During those years when we had not been able to discuss much of anything without bitter disagreement, baseball had been our refuge. We argued about it too, of course. Remember the night at Atlanta-Fulton County Stadium when we saw Hank Aaron hit one out? You said Ruth was the greater player. "How can you say that?" I demanded. "I saw Ruth play once," you said, as though that solemn fact settled the question forever. But in those clashes, in which you opposed your generation to mine, we met as boys, baseball the very medium of our simultaneous and perpetual youth.

But it didn't work this time. You did not respond to my report on the Braves but handed the phone back to Mammy. She tried to explain. "You know that song that goes, 'Turn your eyes upon Jesus, look full in his wonderful face, and the things of earth will grow strangely dim in the light of his glory and grace'? I think that's where he is now."

I think so too, Daddy. But still you would have loved the season of '91. The Braves won the pennant and went on to lose to the Twins in one of the greatest World Series ever, seven games, extra innings. It would have broken your heart.

Bart Giamatti, who was commissioner at the time, said baseball is designed to. "The game begins in the spring, when everything else begins again, and it blossoms in the summer, filling the afternoons and evenings, and then as soon as the chill rains come, it stops and leaves you to face the fall alone. You count on it, you rely on it to buffer the passage of time, to keep the memory of sunshine and high skies alive, and then, just when the days are all twilight, when you need it most, it stops."

I went to Cooperstown this summer, Daddy, to the induction ceremony, with Aubrey Coleman, who lately has been going every year. Larry Doby made it, by the way. Did you know he was born in Camden? I bet you didn't. Because if you had, you would have mentioned it. Anyway, the climax of the weekend was the ceremony itself and especially the introduction of the Hall of Famers in attendance. There must have been thirty or more—Yogi Berra, Stan Musial, Peewee Reese—the icons of my youth memorized from baseball cards, old men now seated on the platform but from that distance icons still.

By the time we turned in that night, my emotions were overloaded with nostalgia. I had had all I could take for that trip. Or so I thought. We were staying at a Hampton Inn in Albany, maybe sixty miles from Cooperstown. Next morning, still half asleep, I went downstairs for a cup of coffee, and while I was sitting there, reading the paper, I noticed a guy standing at the desk. He had his back to me, but I thought, "What an impressive looking man." He appeared a bit over six feet, with broad shoulders and a trim waist; he was neatly dressed in pressed jeans, and his hair was silver. Then he turned and I saw his face. "Oh my goodness," I thought. "It can't be. What would he be doing in a motel in Albany? Wouldn't he be staying in that big hotel

in Cooperstown with the other Hall of Famers?"

He walked over to the coffee urns. "Maybe he's staying here to avoid the limelight," I thought. "I've heard that he's shy. If he stirs his coffee with his left hand, I'm going to speak to him."

He did.

I walked over to the urns, drew a second cup. Quietly, I spoke. "Are you Sandy Koufax?"

"Yes."

"May I shake your hand?"

He looked me in the eye, extended his hand. It was large, his grip as firm as you'd expect.

"Thank you," I said.

I'm not easily dazzled by celebrities, but this was Sandy Koufax, for Pete's sake, possibly the greatest pitcher of all time. Ageless, he moved in an aura that transformed the room and turned me into a little boy.

Now, back at home, I'm fifty-seven again. As I write, summer is turning to fall, and the Braves are headed to the playoffs for the seventh straight year. It's come to be expected. Even so, they may well break our hearts again, leaving us to face the winter with nothing but hope for next spring.

Sooner or later, of course, we all run out of springs; not even baseball can change that. Two years after you died, Daddy, I was diagnosed with prostate cancer. I have wished so many times that I could tell you that, that we could talk about it. But it occurs to me now, in the writing of this letter, that we have had our conversation: I told you that the Braves were off to a great start and you, lost in the glory and grace, said nothing.

I look forward to seeing you again, Daddy, but you'll understand that I don't mind waiting.

Love,

Jim

SYDNEY LEA

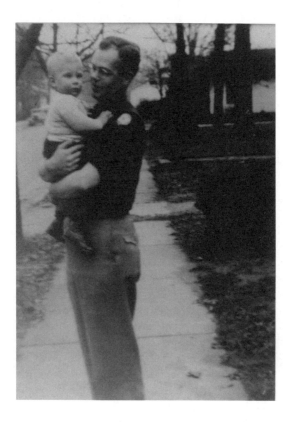

Sydney Lea, Sr. holding his son, Sydney Lea, Jr. AL, ca. 1943

Sydney Lea, Jr. was born in Chestnut Hill, PA, in 1942. A graduate of Yale College ('64) and Yale University (Ph.D. '72), he has taught at Dartmouth, Middlebury, Wesleyan, Yale and Eotvos Lorand University in Budapest. Recipient of fellowships from the Rockefeller, Guggenheim and Fulbright Foundations, he is the author of seven collections of poetry (his new and selected volume, *To the Bone*, won the 1998 Poets Prize), the novel *A Place in Mind*, and a collection of naturalist essays, *Hunting the Whole Way Home*. He lives in Vermont with his wife and five children.

Sydney Lea, Sr. was born in Germantown, PA, in 1909. He attended Quaker schools and then the University of North Carolina (1932). He worked for a chemical corporation, Pennsylvania Salt, before training as an officer in the U.S. Army. He became commander of a company of African American troops in the then segregated army; his troops were valiantly engaged in World War II, particularly in France. After armistice, he was discharged from the military at the rank of Major. Thereafter, in addition to being father to five, he worked in medical market research, ultimately founding his own company, Lea Associates, in 1961. He died of a heart attack in 1966.

THAT LITTLE BOY YOU'RE HOLDING

Dear Dad,

Remember how you'd ask me why I couldn't ever "say things straight"? Well, forgive me again: I dug up this old photograph, and my mind just took off. Can you let me ramble?

I wonder if you're sweating in the picture. Like you, I sweat like a racehorse myself, even when everybody else is shivering. Odd that I thought about this when I found the snapshot. The photo's ancient enough that such details are left to my strange imagination. But that's true of so much between us. I can see the trees are leafless, but that could mean early spring, late fall, or winter. All the Alabama seasons are hot by our standards. So, yes, you'll soon be mopping your brow; I recall the gesture well.

You had other reasons, good ones, to sweat, as in *sweat it out*. There you are in Gadsden. Some place to be commander of an all-black company of troops! You and your men are waiting for overseas assignment; you'd think terror would show up on your face, then, not mine, as it does in the photo. But what the hell would a kid of eighteen months know about history? And anyhow there's another kind of history, the one we share to this day. It's a history that makes our expressions on that Alabama street seem completely logical: I'm confused and afraid, you're trying to soothe me.

What I've Never Said

I don't mean that I recognized the half of all this till well after you died. 57 years old. Lord, you were just three years older than I am as I write this letter. It wasn't my fault—I was still a naive child when you were taken away—but I hadn't had many recognitions of any kind by then.

It wasn't your fault, either, but you missed some recognitions too. You never knew your grandchildren, for example. Like you, I've fathered five kids, and as much as anything in this world I regret that they can't experience your affection. A brain aneurysm blew your second son off the planet before he was 35. One of your daughters was brave enough to affirm her lesbianism. All those unpredictables. How would you have responded to them? And what on earth am I getting at, that you were naive too? Old soldier, what a hell of a nerve I have.

But don't you think a certain family naiveté is inevitable, maybe even desirable? Do we really want to know each last detail about our kids or mothers or fathers? It's only because you're gone that I can mention a few concerning you and me. Of course, since you'll never really be gone, you can hear me clear my throat here, hear me sigh. I scuff my metaphorical boots in metaphorical dirt. I have to sneak up on what passes for frankness, even though compared to most we were pretty open with one another. It's just that I've learned how real candor always threatens a wound. To someone. That's why I'm feeling my way, traveling with care.

In this later life, it takes so little to rock the world.

I resemble you physically nowadays, more than the photograph predicts. Why would that rock anyone? It shouldn't be shocking, the likeness of son to father ... and it wouldn't be if I didn't so often catch it in my truck's rearview mirror, especially when I'm sunk in one of my baffling melancholies. The set of our jaw, the raccoon rounds under our eyes, the diminished hair and incipient jowliness: these make me shudder, because—in these thirty-odd years since your coronary—you've been my benign muse, my model of hope. So the fact that our faces most resemble each other when I'm at my least hopeful threatens me with incoherence. What if my sustaining vision of you is made up out of whole cloth, if naiveté has blinded me all my life? Is the truck's rearview more accurate than mine ever was? Must I completely revise our history together?

You can see that this damned snapshot kicks up a lot of rabbits, so many that I want to chase them all. Or none. Every memory or

thought seems random *and* relevant. I can touch the past anywhere, and you're in it somehow. Even when you're not.

There's a day at nursery school, for instance, which you can't ever know anything about, off in France somewhere to kill Hitler or whatever. Since early September, I've been competing with a boy named Granville to be Lord of the Playground, especially its green wooden playhouse, into which, according to my classmates, a yellowjacket has flown. I'm apparently the only one who saw it flare at the last minute. Not even Granville will go inside. What an opportunity.

I can't imagine how I convince anyone that I pounded the yellowjacket into the dirt. Don't my playmates want to see the corpse? In any case, this little charade makes me king of the mountain for a long time, right into grammar school. I have it made.But I don't fool myself with my own smoke-and-mirror tactics. I'm scared all the time. Of what? I usually can't say.

I do recall one particular scare from the same general period, though by now you're home from the War. "Butterfly bite me," I tell you. It must be August. The air above our meadow is almost liquid; the meadow itself is eccentrically mowed, and grasshoppers hide in the strips of hay left standing; that old pigeon-toed Farmall tractor seems to doze at the edge of the woods. These things I do know, but I can't be specific about other matters. Butterflies don't bite, of course; and yet—this is one of the things I *can* be sure of—there's some early pain lying under this memory.

I'm crying. There's a wet circle on your chest as you gather me up. That circle represents succor at its purest to the child in your arms. Or no: the very impurity of it succors him, the non-ideal somehow implying the ideal, as he'll one day learn was true for Plato. There is earth and there is *effort* in that odor, and—though I could never have told you as much—there's some encoded notion of honorable adult maleness, a notion that guides me today. All that rank, brawny, bodily presence suggests the sort of haven I wish on the vulnerable: on women, gays, racially oppressed people, and above all on my children.

It isn't that you'll protect me from all the scary stuff—death, time, injustice—which I'm too young anyhow to recognize, except perhaps subliminally; no, it's just that for my private, inscrutable miseries there exists a literal solvent. Manswe at.

Nowadays nothing can be solved. Not with you gone. Or that's the sort of thing I mumble whenever I see my face looking like yours

in the rearview. Sure, I melodramatize; but in such moments I do crave some warm refuge from the challenges faced by any adult, particularly those awful night thoughts of mistakes and omissions, of people whom I may have hurt.

I must even have hurt *you*, made you feel inadequate. In fact, there's something in the photograph that makes me re-experience my own many moments of inadequacy in twenty-five years of fatherhood. You'll be leaving Gadsden within the month, leaving the country; meanwhile, it seems impossible to soothe that little boy you're holding.

I can't find any snapshot of your return from the European theatre, except the one I have in my mind. It shows a stranger in soldier's uniform, paused in our driveway, a cone of summer evening light falling on him from a gap in the clouds, as if to emphasize his larger-than-lifeness. Mom sweeps me up and rushes to greet my father, Captain Sydney Lea. (No! I'll insist for months: my name is *my* name!) As you take me from her, I scream my lungs out. I have, after all, been the only male in a house full of women (aunts, cousins, wives and children of men at war). Again, I've been king of a mountain, and you're an intruder.

In 1980, thirty-five years after that moment in the driveway, I wrote a cycle of poems in your memory, a sort of blessing on the intrusion. At the time, I thought it was the best stuff I'd ever written, that it made me look at last like a grownup. Today the whole thing seems sprawling, amateurish, negligible ... except, precisely, for its dwelling on your memory.

Good or bad, all the poems mention hunting, for which you kindled my lifelong passion. It's stood up against the rants of People for the Ethical Treatment of Animals and the like, mostly because you showed me that a hunt has damned little to do with body counts and everything to do with human involvement in a huge and wondrous process. (Non-human too: all our breathtaking dogs, all the splendid game!) You never resorted to my sort of hifalutin prose about all this, but from you I did learn that hunting is sacramental, that Meaning with a capital M is its real prey.

One of the few poems in that sequence that I'll stand by is the opening one:

> Late February. Orion turned
> the corner into the long
> sleep, blindness

> on the earth's black side,
> as you did.
> Sleet. Cloud.
> Woodsmoke creeping
> like a whipped dog flat
> to the ground, and heaven
> was all occultation.
> So the few last bitter lights,
> down to Betelgeuse,
> in familiar constellation —
> they slipped away
> before I'd caught the art
> of seeing, harder art
> of naming. Early
> fall now, now again
> the wanderers—the winter
> planets, memory, restless birds —
> begin to shift. It will be greater
> darkness if the language skulks, unrisen.
> Flesh of my flesh,
> you pause to take
> quick breath
> against the quick descent of evening.
> I feel that exhalation
> along the throat, I wear you
> as I wear your threaded
> hunter's coat, my father.
> From which in this gust
> into night there climbs
> —like word or star—
> a single feather....

When I wrote that, I was happiest with the single feather: I believed I could offer accurate testimony by talking about the scantest of your leavings, which meant that your influence was very much alive. I could take some detail and move from it to the constellations, and more: I could see the whole universe.

But I didn't understand my own poem back then; today that feather-figure seems most eloquent of my ineloquence. Or maybe it's just that, being older, I have a different response to the same experience. I don't deconstruct so much as I re-construct. Now I'm most drawn

to the line that says "I wear you." If I peek into my rearview and see your face, maybe that's a mere matter of genetics. (In terms of practical life, we hardly resemble each other at all. You were the small businessman; I'm the "artist." You were steady, deliberate, handy with tools; I'm impulsive, and all thumbs. You were addicted to your dog-and-cat story, *The Incredible Journey*; I'm a bit of a book snob. And so on....) But of course I'll metaphorize our likeness. For better or worse, after all, metaphor is part of my stock-in-trade, one of the things that keeps me driving whatever road I'm on.

"I wear you/ as I wear your threaded/ hunter's coat, my father." So I do. The idea holds up. I still wear your hunting clothes, and I'm still hunting—the same way that you were, I think, for all your brief life. In other words, I see how wrong I've been to think of your road as any freer from the melancholies than mine. I was supposed to be a poet, but, however much I loved you (and that was plenty), I was stuck on surface details for too long a time, too caught up in our visible differences. It's taken me more than a few decades to see that you and I shared so many spiritual garments. To see that now is to recognize that I don't have to give you up as Hope's muse after all. Yes, it turns out that history must be revised, day by day, maybe minute by minute; but some part of it will remain intact.

How can I make myself clear about this?

You probably never read John Keats, since, besides that dog-and-cat tale, you didn't read much of anything, least of all poems. I only think of Keats because he once objected to calling the world a "Vale of Tears": he called it "a Vale of Soul-Making." You vanished too soon from that vale, but you'd probably have said something similar in your own words. Which makes you still a model, an inspiration.

Maybe at last I've learned from you that to be a father, which I consider a nobler job than being a poet, isn't a matter of being king of any mountain, having it made. Instead it's a matter of effort, which you can never let up on. I think that's what I keep seeing in my rearview mirror, through my unKeatsian tears: like you, I'm struggling to make a soul worth passing on for my children to wear.

Sometimes the struggle feels almost physical, as if I were following you and a hard-going bird dog through heavy brush, the way I did when I was a kid. And as I say so I get the smell of manswear—the solvent, the small salvation.

ANNE D. LE CLAIRE

Anne D. Le Claire with her father Edward Louis Dickinson
Monson, MA, February 1, 1964

Anne D. LeClaire was born in Ware, MA, on October 7, 1942, and was educated at the MacDuffie School in Springfield, MA, and at Miami University in Oxford, OH. The mother of two, she is married to Hillary LeClaire and lives on Cape Cod. She is the author of five novels, the most recent of which are *Grace Point* (1992) and *Sideshow* (1994), and the forthcoming *Entering Normal* (Ballantine 2001).

Edward Louis Dickinson was born in North Brookfield, MA, on October 29, 1913. He married Louise Eekhoff on May 4, 1936, and was the father of four daughters (one died in infancy). He was a farmer and master electrician and died on January 31, 1986, in Harwich, MA.

IN BRIEF: DISPATCHES FROM A DAUGHTER

Dear Dad,

The wind is up, ruffling the leaves on the oaks and locust, revealing their backsides, and so I know it is going to rain. When I was a child, you taught me this, told me that when the silvery gray underside of leaves are upturned rain is on the way, a piece of farmer's wisdom that I took in as fact. Just as, without question, I believed you when you told us that riding a cow bareback would cause her milk to sour. Years later, Mother laughed and laughed when she heard me repeat this to my children. Your father just didn't want you girls riding the cows," she said.

I had pneumonia last winter. "Grief," said my acupuncturist. "The lungs hold grief."

Twelve years.

Twelve years have passed since you died and I still mourn.

It catches me unaware. Today in the supermarket I saw a man who looked like you. Twelve years and still I had to turn away and hide my tears. Again I do the heavy work of grief.

I miss your smile. I miss the way you always squeezed my shoulder when you walked by my chair, a signal I took to mean you loved me beyond my sisters, just as I thought we shared a special bond because both of our birthdays were in October, truths I held tight with a child's fierce need to believe.

Because you withheld words, because you never told me you loved me, I had to weave the myth of our relationship using secret signs,

silent signals. My heart was heavy with all that was unspoken, and I grew to wonder if my perception of our special connection was any truer than cow's milk turning sour.

In this memory, it is evening. You sit in the corner of the living room, encircled by light cast from a lamp, its single bulb too dim to read by. A dictionary rests in your lap.

You, the least educated of the family, never went to college. Did you know I used to lie about this? Without shame, I would tell new friends you had gone to an Ivy League college, inventing a father who satisfied my ideal. I never once wondered if this disloyalty was ever revealed to you.

Alone, in the living room you read and read from the dictionary. Some nights you chose a volume from the encyclopedia set.

"What are you looking for?" I once asked.

"Knowledge," you said.

A snowy afternoon. Two years before your death. You stop by for a visit. I pour us coffee. "Would you look at these?" you ask. Suddenly shy, you hand me the pages. Some of them are curled with age, the ink so faded I can barely make out your concise handwriting. "What are they?" I ask. "Ideas," you say. "Inventions."

After you leave, I sit for hours, reading your work. The pages cover decades. To my eyes your ideas—energy-saving inventions, improvements for machinery—seem original, startling. When had you written these? I cannot remember ever seeing you write. What hopes spurred you? Why had you never mentioned them? How could none of us have known?

I used to fantasize that I was not your daughter.
Of course, I am.
More than blood connects us.
My hands, too, are most at home in the warm earth of spring; my
 mind, too, turns out inventions.
I want you to know this:
Like you, I often sit in the hushed circle of a single lamp, seeking.
And all the dreams you never pursued have added fuel and fire to mine.

Love,

MARY MACKEY

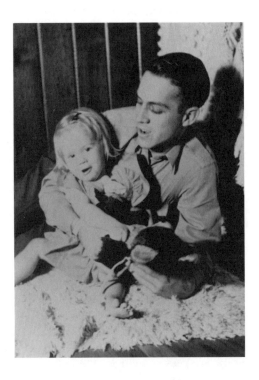

Mary Mackey with her father, John Mackey
Arlington, TX, 1947

Mary Mackey was born January 21, 1945, in Indianapolis, IN. She graduated from Radcliffe College in 1966 and received her Ph.D. from the University of Michigan in 1970. A professor and Writer-in-Residence at California State University, Sacramento, she is the author of four collections of poetry and nine novels, including *The Earthsong Trilogy: The Year the Horses Came*, *The Horses at the Gate*, and most recently, *The Fires of Spring* (all from Penguin). From 1989 to 1992 she served as chair of the West Coast Branch of PEN American Center. At present she is working on a new novel entitled *October at Fools Hope*.

John Edward Mackey was born August 31, 1920, in Marion, KY. He graduated from Evansville College in 1942 and received his M.D. from

Indiana School of Medicine in 1944. In 1954, after a residency at Wishard Hospital in Indianapolis, he received his Certification from the American Board of Obstetrics and Gynecology. He was made a member of the Alpha Omega Alpha Honorary Medical Society in 1944, and elected to the American College of Obstetricians and Gynecologists in 1954. His awards include a Fellowship in the American College of Surgeons (1961) and the Edwin L. Gresham, M.D. Recognition Award for advancing care of neonatal infants (1985). He is a Clinical Professor at the Indiana University Medical Center and has practiced Obstetrics and Gynecology in Indianapolis for forty-six years. He and his wife, Jean Mackey, have three children.

THE BIG SEAL

Dear Daddy,

I float just over your chest; you are the big seal; I am the little seal bobbing in your wake. *Don't be afraid,* you reassure me. *The water is our friend. Relax in the water and it will hold you up.*

I relax, go down, come up bubbling and laughing and bobbing. You manage to imply (without actually saying—you're not a man given to poetry) that we Mackeys come from a long line of Irish seafarers, island people who have swum miles from their sunken ships, breasting the waves like dolphins. My colossus of a father turns and stands and his feet actually touch bottom, and he rises like Neptune, the swimming pool water dripping from his chest hair and off his nose, and I know I am in the presence of an unsinkable being who is the bravest daddy in the whole world, and who has never even considered being afraid of water.

Years later, on an island named San Andreas a hundred miles or more off the coast of Nicaragua, this childhood lesson saves my life. Caught in a rip current while snorkeling, my husband and I are dragged out toward the limitless horizon of the open sea, but we don't panic, and thus we don't drown. My bravery comes from a simple source: you. I, after all, am the daughter of the seal man, the dearly

beloved child of the Irish fish people. There are gills in my blood and fins in my family tree. The current is pushing me toward Africa three thousand miles away, but I don't thrash and go down. I swim a bit, let it carry me parallel to the shore, let the water bear me up, swim some more, don't get exhausted. In the end I am forced to come straight in over coral so sharp it cuts through my thighs like razor blades, leaving scars that still show thirty years later when I put on my summer shorts. Sea urchins stab me and bury their black spines in the fleshy parts of my hands and feet. I bleed into the salty water and grimace with pain, but the water itself, which is my friend still, carries me to safety, and I do not drown, and although I get the worst sunburn of my life, I survive to write about this, thanks to you.

But that is not the end of the story. Because later I discover what you never told me: that your mother—my grandmother—always fearing that you would drown, would not let you swim at all as a boy. Convinced that her children were doomed to die like Great Uncle Amerigo who fell into the Platte River during the Colorado Gold Rush, my grandmother sewed up the necks of her boys' shirts, and except a few times when you and your older brother ripped out the stitches, took a quick dip (and sewed your shirts back up again with stolen thread), you had no experience with water as a child. In truth, Mother told me, you were a poor swimmer who feared the water.

But for years you managed to hide that fear, giving my sister, my brother and me one of the greatest gifts a father can give his children: the illusion that they are safe, that no matter what happens, if you just relax, everything will be all right.

Mary

DALE MAHARIDGE

Dale Maharidge was born October 24, 1956. He's the author of five books, including *And Their Children After Them*, which was awarded the 1990 Pulitzer Prize in non-fiction. He teaches at Stanford University in Palo Alto.

Steve Maharidge was born May 10, 1925, in Cleveland, OH. He was a U.S. Marine in World War II, in the Pacific island battles. After the war, he became a tool and cutter grinder.

WINTER MORNING, 1963

A wind whistles against the panes, with violence. I am awake, like so many of these winter mornings, listening to the sound of your shovel against the drifts. The blade bites driveway gravel like a spoon scraping a burned potbottom. It is still night for me, yet my seven-year-old body rises from the bed's warmth to peer out the window. You are a hunched form dark against the whiteness. The snow races horizontal against the light atop the utility pole. You are halfway to the street, working in knee-deep snow. The car idles, steam pouring from the garage below my room. The car will wait for another half hour of digging. I burrow back beneath the sheets, shuddering from the radiating cold and the barren meaning of becoming an adult, going to a job in the dark and cold, coming home in the dark and cold.

When you are done and the car squeaks up the drive, it will carry you down white roads to that valley of smoke. You enter a cavernous plant, a realm of showering sparks and dust, where you grind steel. I saw it once when there was an open house for you to bring the family into the place that swallows your daylight hours.

You want to escape; you don't want me to become trapped. Even though you're paid well—the job makes us working middle class—it's dirty and miserable labor. I think it was hard for you to be a father but you have the right instincts, you want better for me. "Get that

piece of paper," you say of a college degree. With the paper, you work in the front office, you don't get filthy, you have control over your life. When you are factory working class, you have no control. You eat dirt. There are layoffs, hirebacks, layoffs. And there is always the dread that it will all end, that you'll be left with nothing, that they will close the factory and move the jobs to the South, the fear in the days before they started blowing up factories and sending the work overseas.

So you say, "get that piece of paper." I hear this so many times that I cannot remember a time this phrase was not part of my very being, like the steel dust that wells up from the basement where you grind cutting tools at night. You struggled to buy those machines, the kind you use at the factory, and your dream is to have your own grinding business. Tool steel is what you know, so you see it as salvation—the only salvation.

You name the business after the initials of me and my siblings. You see it as our redemption, in case we don't get that piece of paper. The odds are not good, after all. No one on your side of the family has ever gotten that paper. Night and day you sharpen steel. There is always dirt under your nails, impossible to wash away. Your hands are perpetually slashed from wounds in various stages of healing, inflicted by the razor-sharp cutting tools, or grinding wheels that explode at three thousand rotations per minute, spraying sandy shrapnel in all directions. Cuts and grime are part of your essence, as it was part of your father's; Grandpa, who has just died, spent a life at dirty work. I knew him only as a child knows a reserved old man, but I would learn in the coming years that when he came from the ancient land, he labored in a Pennsylvania coal mine, then on the B & O Railroad, fixing the freight cars that hauled the coking coal for the Cleveland mills; it was his job to be on call winter nights when there were derailments; he worked by day in the unheated roundhouse, in the icy pits. Grandpa was a silent Russian-Ukrainian who lived with Grandma in a tiny house on the rim of the sulfurous steel valley, where flames erupted from smokestacks and brown grit settled over everything. Grandma never learned much English. Her life was centered in that old neighborhood, where everyone spoke Russian and went to the Orthodox church with its thirteen onion domes a few doors down on that street named Starkweather.

Grandpa's silence was punctuated by spectacular rage. Grandma has it too. Grandma's face is hard and her hair is tightly-pulled.

Grandma doesn't like me or my brother and sister. We're not fat. Fat children are good: something is bad about skinny ones. Mother will later tell me that when your sister, my aunt, announced she was pregnant, Grandma kicked her with sharp boots, body blows that drove her beneath a table, then Grandma laughed. When Grandpa died, one of my aunts tried to put her arm around Grandma. She bellowed, "Don't touch me!" It was a family that did not know hugs or communication, eight souls in a small house of profound silence—broken by fits of screams.

Anger is part of the very being of this family. You are embittered. It comes especially when you work, which is always. There is the sound of the big machine in the basement, the two-ton Cincinnati No. 2 grinder, as its wheel digs into steel and gives off a roar, dimming the lights of the house, sending an acrid blast of burned metal up through the heating ducts; then something will go wrong and you will shout. There's the clang of a wrench hurtled against the wall, a torrent of mother so and sos. When you emerge from that chamber, dirt blackens your face and fury is in your eyes. I too am angry. At school I give the nuns problems. I'm antisocial and am always in the principal's office. I will not understand until much later that this anger reaches all the way back to peasant Europe, the bleak eastern frontier of that continent where grandma and grandpa lived in thatch-roof houses and labored in the fields; centuries of exploitation and defeat nurtured the anger that came with them on the boat and it resided in the Orthodox church down in the old neighborhood where you grew up. That church was founded by grandpa's cousin and others with the help of Nicholas II, the last Tsar.

The lives of the peasants were ground down, just like steel, by that Tsar and his forbears. All those ruined lives and what comes of it? Thirteen onion domes, a missionary outpost of Mother Russia reaching across the ocean to continue its stranglehold on its Americanized serfs. The Tsar is gone, but his legacy continues in a Rockefeller, a Carnegie, a Wall Street investor. The peasant soul is beaten in the sweat given over to producing each chip of coal, each drop of life's fluid surrendered to exploding grinding wheels.

Maybe this is why you hated religion and wanted nothing to do with that onion-domed church, where Grandma took the Christmas bread to be blessed by Father Kappanadze. The order of things is that a man will work in the mill, his son will work there, that both will always be peasants who eat the sacred bread.

What I've Never Said

Getting that piece of paper means escaping this past. You cannot articulate the reasons why I must flee this history, but it is imperative, even if you or I at this moment understand nothing of it. All I know this cold morning is fear as I hear the shovel working, the wind against the panes. Growing up means digging snow in the cold of night, sparks and cuts and burned steel and unquenchable anger. How will I do this enormous thing, becoming such a man?

I will work with steel, on your machines that explode wheels against my flesh. In another factory I'll run a lathe and will see a man's thumb severed. In one plant I'll witness a mist-shrouded chamber with smoke-blackened windows that disallow daylight, save for a single broken pane through which a beam of sunlight drills the haze, illuminating a three-story stamping press with a holy glow. When it crashes down, it mashes a metal part with a thunderclap that echoes across the steel valley where my grandparents lived and died their angry lives. I will end these days drinking beer, angry.

But this will last only a very short time. Even though I will never get that piece of paper, I'll escape. You'll sell the business with our initials to another man. I will not shovel snow in the night and will not swear at steel tools or breathe choking dust. I will not have hands like yours, hands that have done big things, hands that have taught me so much. Mine will be smooth and uncut—at least on the surface.

NJOKI MC ELROY

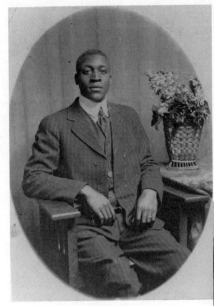

l) J.D. Hampton. Dallas, TX, ca. 1925

r) Njoki Hampton (McElroy). Xavier University, New Orleans, 1945

Njoki McElroy was born February 12th in Sherman, TX. She grew up in Dallas and New Orleans, and spent most of her adult life in the Chicago area. After frequent sojourns to Africa, the Carribean, South America and Europe, Njoki describes herself as a "Woman of the World." She

divides her time as professor of Performance of Black Literature and Folklore between Northwestern University, Evanston, and Southern Methodist University, Dallas. Twelve of her plays have been produced. She is a master storyteller/folklorist, performing monologues from her book, *A Black History Review*, at festivals, concerts, seminars, schools and colleges. She credits her late entry into writing to a 1989 residency fellowship at the Ragdale Foundation. Now she is working on a memoir, *Fruits of the Spirit*, which offers unusual insights into Black middle-class life from Reconstruction to the 1950s. Njoki and her husband, Clenan, parented six children.

J. D. Hampton was born in the 1890s in the farming area of East Texas, on land his father and grandfather secured after Slavery ended. The land remains in the family today. He went to Prairie View College but left for army service during World War I. He then went to Dallas where he met and married his wife, worked as a Pullman porter and postal employee, and retired in the 1940s. He passed in 1961.

EPISODES

Dear Dad,

After you passed, Mother sanctified you and refused to discuss anything that she considered negative about you. It was as if she had shut a door that she never wanted opened. I am opening that door for the first time to tell you that your verbal episodes (Mother called them your "spells") caused us a lot of pain and tension. As your health declined the episodes gained intensity. Mother and I lived in constant fear of saying or doing something that would trigger an episode. Most of the time a very innocent incident would trigger a tirade from you. Starting slowly and building intensity, the tirade was like a runaway box car barreling downhill. In order to prevent some episodes, Mother and I learned to hide new purchases of clothes. We tried to avoid seeing you illustrate your point of frugality by tossing items from the closet and saying:

"See here. How many sweaters does one person need. Every time I look around, you and your mother are spending more

on clothes. As long as you're neat and clean and if you take care of your clothes, you don't need to keep going out and buying more and more! Do you know there are people out there starving to death while you are buying clothes you don't even need?"

EPISODES:

The comedy series "Amos and Andy" was another source of your irritation. During my childhood years, the "Amos and Andy" radio show was the most popular show on the radio. Mother and I joined the thousands of other listeners to laugh at the antics of Amos, Andy, Kingfish, Sapphire, Madame Queen and the other characters—all played by two white men. The show was controversial and divided the Black community. While Mother and I laughed you reminded us:

> "You know these are not Negroes playing those parts. No, Negroes can't get a job playing themselves. But two white men using racial stereotypes that demean our people and put our race back two hundred years—these two white men have become rich and famous making fun of Colored folks and you two sit there laughing!"

Mother and I understood your argument, but like many Blacks at the time we hungered to hear *anything* pertaining to our people on the air waves. Even the game shows sent you into tirades because you believed that if the sponsors lowered the prices on the products, everyone could hit the jackpot.

I found a letter recently that Mother wrote me six months before you passed. She wrote:

> I don't know how long I can stand the crossness and plain meanness that exist here—getting worse. Has to do with him trying to buy a car. The doctor said he should never drive again and explained why. The aorta, main heart artery, is gone. When I agree with the doctor he says the most hurtful things to me. My migraine is acting up and I have lost my voice. Spirit is so low I feel like I would be better off dead.

Well, Dad, you bought the car and this is what *you* wrote me:

What I've Never Said

...Yes, I have bought a little Willys. I like it. It runs good, looks good. Your mother didn't want me to get it. She swore she would not ride in it with me and she didn't ride for the first two weeks. But now she is riding and smiling.

You had owned/driven a car since the Model T Fords and you knew that your days were numbered. It made sense to you that you would spend your last days doing what gave you great joy. I was married and in Chicago by that time and I don't remember receiving another letter from mother concerning your episodes.

Mother and I always knew that you were very smart, that embedded inside the eye of the storms, your arguments were cogent and thought provoking. The problem was the frenzy in which you expressrd the arguments. With fire dancing in your eyes, you made Mother and me the targets of your brimstone. The pitch of your voice would become louder, more strident with each sentence. The shrillness pierced our very souls.

I know now, however, that Mother and I were not the main sources of your fury. One major source of the fury was your reaction to the stress resulting from racial injustice, oppression, white superiority. Faced with daily indignities your stress turned inward and manifested itself in physical illnesses. And then you were furious and enraged because your lean, handsome athletic body had turned against you. In railing at us you railed against the injustices of racism and the injustice of your impending demise; you recognized that we were all ultimately powerless. You were really spewing your venom on fate—against going into the night and against the flickering of the flame.

I must tell you, Dad, that I remember more than your misdirected anger. For when you were free of "spells" you were smart, witty, caring, adventurous, charming and always particular about your grooming and wardrobe. You compensated for Mother's overprotectiveness—you knew that a wimpy little Colored girl was not going far in the real world. From following you on train track trestles high into the air, walking on logs across waterways, hiking in the Cliffs, fishing in streams, driving your car at thirteen, I learned to conquer fears. With a strong sense of self, I've lived an exciting/diverse/rich/fulfilling life. In spite of your argumentative episodes and the societal stress of that time, you and Mother sustained a comfy haven where I received enough love and attention to establish my sovereignty/specialness.

Dad, you know we have strong anti-discrimination laws now. But the same racial stressors exist—more difficult to define because of covert tactics. Our people are suffering from a much higher incidence of stress related diseases than whites. Armed with this info, I manage stress in my life by whatever means necessary. Writing this letter—acknowledging your virtues as well as your frailties and identifying the sources of your stress—has been a great stress reliever for me.

<div style="text-align: right;">
The struggle continues
My love/devotion endures

Njoki

Your one and only daughter
</div>

JOHN MC KERNAN

John McKernan with his father John McKernan and his brother James.
Omaha, NE, 1945

"That's the *World Herald* on the grass."

John McKernan was born in Omaha. He studied at St. Cecilia's Grade School, Cathedral High, Creighton University, University of Omaha, University of Arkansas, Columbia University and Boston University. Since 1967, he has taught at Marshall University in West Virginia where he is Professor of English. His awards include fellowships from the NEA and NEH and Benedum Foundation, Boston University, and scholarships from Columbia University and Bread Loaf Writers Conference. He has published *Handbook for Writers* (HBJ 1991), *Walking Along the Missouri River* (Lost Roads 1977) and his recent free-verse sonnet sequence *Postcard from Dublin* won the 1997 Dead Metaphor Press Chapbook Contest and was published in 1999. His poems have appeared during the last twenty years in *The Atlantic Monthly*, *The New Yorker*, *Paris Review*, *Field*, *Antaeus*, *New England Quarterly*, *Virginia Quarterly Review*, *Manoa*, *Prairie Schooner*, *The Little Review* and many others.

John Joseph McKernan was born in South Omaha in 1911, the son of Irish immigrants. He had a career as an auditor, realtor, and builder. He

died in June of 1958 with a brain tumor that had been variously misdiagnosed as exhaustion, depression, etc. He was married to the former Monica Nagengast and was the father of seven children.

LETTER FOR MY FATHER

My father came to me in a dream on a cobweb
Gleaming In sunlight Through a window
A lake of stars suspended in each thread Saying

"Remember Those threads of incense Nothing's left
Remember Those altar candles at noon Nothing's right
You think that I'm here But I'm not Or there"

"You're not my father" I said "My Dad had
Thick coal black hair slicked back tight with red
Wildroot Hair Oil Tonic A rough gray beard

Prickly bristles as my brother Jim & I
Gave him the haircut special & a shave
As he lay exhausted Barely breathing

On the living room couch There Forever
In the hum of Omaha's purple twilight
On Cass Street The neighbors' pop-bottle

Whistles screech-herding their children home
"What was it like to die?" We wanted to ask
"Anything like washing the blue Buick

In the street Saturday mornings In front
Of the house Those huge pale orange sponges
Oozing soap suds Whisking the dirt & grease

Into a concrete macadam rainbow
How in the fall football Saturdays
You'd lug those huge filthy storm windows

What I've Never Said

From the coal bin basement Orange sponges
Leaking their reeking vinegar The squeegee
Whispering its mirror clarity in a noon sun

Bringing the world tighter into our bright eyes
"Come back!" we wanted to chant "Here To your death
The doctors got it all wrong Look We will try

To squeeze the insulin back into the tubes
Of the green IV We want to peel your eyes
Open again We are slapping your face

Again Bringing some color back to your eyes
And here are my small hands pushing on your chest
Trying to get you to drink another quart

Of air You can't go yet into the other world
You have to protect us from the neighbors
Their smiles and the chatter of Boys Town

Girls Town Coils of foster love & hope
And look There is your brother with his tray
Of fly-specked day-old doughnuts & cheese

Sandwiches You have to push him out the door
Again Disconnect doorbells Dim the lights
Pull shades Save us from . . . [Who were those people?]

With their parade of red Radio Flyer wagons
Dripping sugar flour kidney beans Malt-O-
Meal pickled okra canned turnips beets mush

Your beautiful wife in her stunned brown hair
Will circle the room staring at 7 kids
Their eyes peeled open by sleep Tiny arms

Glowing like chicken bones in a crock pot
Their toes inside new shoes clawing the green
Airs of a new smelly carpet If you don't

Return We will spend all of our lives
Undoing that day When the hammered morning
Of your scream Like a bright red kite Floated

Over Omaha When the June noon sky was
A needle and each of our eyes It in all
Was the target Point-Blank You never missed

<div style="text-align:right">John McKernan</div>

PABLO MEDINA

Pablo Medina and son,
Florida, ca. late 1980s

Pablo Medina, the son, was born in Cuba in 1948. He moved to the United States in 1960, at the age of twelve. He is the author of five books in English, his adopted tongue, including *The Marks of Birth*, a novel. He lives in Montclair, NJ, and teaches at the New School in New York City.

Pablo Medina, the father, was born in Havana, Cuba, in 1921. He attended the University of Havana and received a degree in Accounting from that institution. He left the island of his birth in 1960, settling with his family in New York City, and moving to Miami, FL, in 1986.

LETTER FOR MY FATHER

I want to tell you how the late flowers bloom,
how the sun shivers
behind clouds and the trees gather their roots
and the groundhog sleeps by the river.

I want to tell you how the earth hardens
in winter and the gravedigger's backhoe moans
as it bites the ground. You were a man
who dreamed of mirrors and who moved through doom.

You drew invisible faces and sang to invisible walls.
I want to tell how a spider wove the western
light and joined us to the night
beyond the womb's cave, beyond the cask of love,

tumbling in the freedom of the grave.

You lived by diving and by diving grew.
You knew the risks of your downward flight:
hard earth, hard water and the black holes under.
Time and again you survived. Time and again

the earth bared her chest
and kept you from black winds
that twisted the wings off a million men.
You passed through the surface like a needle,

felt the water's lips on your breast,
reached the bottom thick with roots,
studded with stones. You saw the bones
of your father, you heard the siren songs,

What I've Never Said

the splash of the boatman's oars.
I looked into the lake where you dove
and followed your frog-like figure.
I counted seconds till you rose, open-mouthed,

glassy curls streaming from your head.
You called to me to jump. I froze,
afraid of the moment when the feet let go,
when the stomach hangs and the body holds.

Years I watched you, heard you calling,
years I counted as you swam away
until I could barely see you,
couldn't hear my name bubbling from your lips.

I found a mirror in your room, square and shallow
as I wanted, and when it was time
I dove head first. The glass shattered,
shards flew to the floor and I never looked again,

loving you for calling, hating you for urging me on.
With wet hands fresh from diving
you tried piecing me back.
You called to God and the dark echoed a moan.

You looked for my face in the flowers
and found the eyes of your enemy.
A white shroud waved in the distance,
nettles grew on the shore.

In a morning like all other mornings I remembered
how beautifully you'd swum, how you left me
by the thorns and mud, out of numbers, out of name.
I saw you shining with watery work,

happy, diving water bird,
until a piece of darkness struck you
and you fell like a diver twisted by black winds,
you moaned like a lake does when it shatters.

In my dreams I see your mouth.
It swallows pianos, butterflies, old sorrow,
older joy. I see your pillow of warm bread,
your heart unsheathed to the night.

I watch you go to the City of Birth
and lie with the truth of your wounds.
In a morning like all mornings
I watch you strip the ground of illusion,

look on the water of shadows, dive, disappear.

E. ETHELBERT MILLER

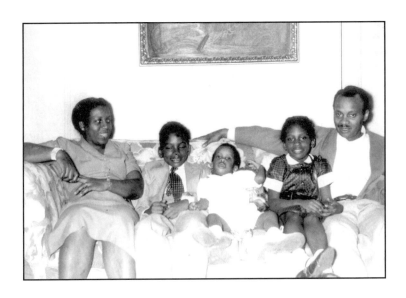

l to r: Enid Miller, Richard Miller, E. Ethelbert Miller,
Marie Miller and Egberto Miller
New York City, 1951

E. Ethelbert Miller was born on November 20, 1950. He has published several collections of poetry, including *First Light* (1994) and *Whispers, Secrets and Promises* (1998), both from Black Classic Press. Miller is also the editor of the award winning anthology, *In Search of Color Everywhere* (Stewart Tabori & Chang, 1994).

Egberto Miller was born on May 20, 1915, in Colon, Panama. He died in New York City in 1987. He was married to Enid Marshall and was the father of three children: Richard, Marie and the author.

DAYBREAK

Dear Dad,

It is midnight as I write this letter. The end of one day, the beginning of another. I have spent the last few days putting my papers and books in order. Once again, I've started reading a book which attempts to outline the best way a person can organize his life. I'll be forty-six next week, so the book encourages a person my age to think about retirement. The word retirement makes me think of you. It has been almost ten years since your death. Ten years since your funeral where I stood on a hill in Mount Hope Cemetery and said goodby to a small urn which contained your ashes.

If I were eight or nine again, I would be waiting for you to come home from work. Around two o'clock in the morning I would listen for the sound of your key in the lock. Your cough, mixing with the voice of my mother as she prepared a meal for you. On nights like these I push the covers off my bed, rise, and walk into the kitchen to see you resting your head in your hands.

Your work and what you did is still strange to me. There are so many things about your life I don't know. In my metal case where I keep important items such as birth certificates, social security cards, and divorce papers from a college marriage, I discovered a copy of your certificate of death. I vaguely remember my mother handing it to me as I was packing to leave New York and return home to Washington, DC I don't recall reading it to check for any mistakes. How could I tell if there was an error? There was so much about you I never knew. Tonight, prior to writing this letter, I read the document of your death, hoping to learn a little more about your life.

Egberto W. Miller, born in Colon, Panama, on May 20, 1915. Father's name, Adolphus Williams, mother's name, Marie Miller. So I see my last name belongs to my grandmother and I recall somewhere in my memory that someone said your father remained in Panama and did not come to the states. I assume you spent your entire life wondering about this man, your father. Did you know him? Did he ever write you a letter?

Once, I was asked by a young student in a school I was visiting,

What I've Never Said

"Why do you write?" I began by saying that my father lived a quiet life and I wanted to make it more heroic. I wanted to restore dignity and beauty to your life. I didn't want you to die unknown or to be forgotten. You left a remarkable legacy, one which should be told during these times of turmoil, when we find our values and institutions being challenged. I don't know how many articles, talk shows, reports, books, panels and conferences I have encountered that have focused on the problems of young African American men, their future and their families. None of these things seemed to explain how you raised a son from the late forties to the early sixties, who would decide to enter a monastery and become a monk. When I interviewed your eldest son, Richard, for a class project in the early seventies, he informed me that a major spiritual influence on his life had been you. For many years I thought it was simply the work of Thomas Merton.

I guess your relationship with my brother was different from the one you had with me. Was your silence something that grew as your family became larger, as you struggled to make ends meet, pay bills and keep the food on the table? There is a family rumor about giving me away to another relative; I think of you wondering how to feed another mouth. Before my birth, I suspect you were excited with your first son and then the arrival of my sister, Marie. There are pictures you took of them outdoors, proof that you did have days to enjoy the company of your family. Why are all my images of you going off to work, or sleeping in preparation for work? How did my birth affect you?

My own children are asleep now. Jasmine-Simone is fourteen, and Nyere-Gibran, whom you never met, is nine. In these early morning hours, I enter their rooms, to check on them before I seek my own rest. This is something I don't remember you doing. The bedtime stories and hugs were missing from our relationship, as was the title I could call you. Were you dad, daddy, father, or pop? When you were in your sixties, Marie started calling you "little man." You never disputed her although the term seemed to summarize your life. When I was growing up you never appeared large to me. I know some people described their fathers as big men. I always saw you as a quiet man, distant and alone; your shadow extending over your family.

Together we embraced a "silent love" and felt the need to close ranks against even cousins, aunts and uncles. All our relatives in Brooklyn became strangers to me. Only now do I realize how you had redefined the meaning of family to include only those individuals who

slept under your roof. I recall you mentioning on several occasions that one had "many acquaintances in life but few friends."

How much has the world changed? I travel around the country meeting people, exchanging words and business cards. There is an emptiness that knocks now and then on my door. I find myself becoming very much like you. Alone, on a city street, heading home from work. How often did you want to change your direction and go somewhere else? What motivated you to keep working and taking care of your family, as others around you gave up, left, or simply accepted defeat inside bottles and needles. What song did you hum as you turned your collar up against the cold?

"I thought I heard Buddy Bolden say…"

Tonight, the blues leaves like a man carrying a guitar on his shoulder and I think of you. There is no one at the door coming home; inside my family is safe as I continue to count my black blessings. There are moments in the dark when sons think about their fathers and the simple remembrance is enough light to usher in the dawn. This letter marks the beginning of daybreak and the first words of the new day—I love you.

Your son,

Gene

JUDSON MITCHAM

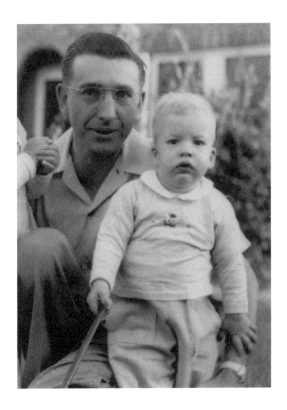

Wilson Mitcham and his son Judson Mitcham in front of
their house on Church Street
Monroe, GA, 1949

Judson Mitcham was born in Monroe, GA, on June 12, 1948. His work has appeared in many publications, including *Poetry*, *Georgia Review*, and *Harper's*. His first collection of poems, *Somewhere in Ecclestiastes*, won the Devins Award and was published in 1991 by the University of Missouri Press. His first novel, *The Sweet Everlasting*, published in 1996 by the University of Georgia Press, won the Townsend Prize and was a finalist for the Southern Book Award. Mitcham is Chairman of the Psychology Department at Fort Valley State University, and he serves as Adjunct

Professor of Creative Writing at both the University of Georgia and Emory University. He and his wife, Jean, have two children, and they live in Macon, GA.

Wilson Mitcham was born in Walton County, GA, on March 19, 1914, and he died on April 9, 1989. One of eleven children, he dropped out of high school to help support his family during the Depression. In 1937, he married Myrtle Cofield; they had three children, Ben, Judson, and Lynda. He was employed by a local cotton mill for over fifty years, serving in a variety of capacities, including Office Manager and Coordinator of Sales and Production. He was appointed to the Walton County Board of Education and the Monroe Water, Light and Gas Commission, and he served as Secretary and Treasurer of the Charles M. Walker Foundation, an organization providing support for local college students. In 1958, he began attending evening classes at the University of Georgia, and in 1963, he graduated *cum laude* with a major in finance. Wilson Mitcham was a veteran of World War II. He served in New Guinea, the Philippines, and as Battalion Sergeant Major of the 243rd Ordnance Battalion in Japan. For many years he was Superintendent of Sunday School at Monroe First Baptist Church, where he was also a deacon and an active choir member. He was a soft-spoken man with an easy laugh, a generous heart, and many friends.

THIS MORNING

Dear Daddy,

 I am fifty years old, and my hands
look exactly like yours—No surprise.

How many times a minute must it happen:
a son or daughter, somewhere, meets the dead
resurrected in a gesture or a word

or suddenly alive inside a mirror. And today,
when a mist like jewel dust flares in the hills,
I think of you, of how you loved the mornings,

What I've Never Said

as I have come to do; of how you'd rise
at 5 o'clock and make a pot of coffee,
and sit there with your Bible by the window

till the light eased in. I was once young enough
to love the other stars more than ours, to prefer
the sun going down to the dawn,

to walk out in the dark like I belonged there. Now,
I am thinking once again about the times
I made it home so late that you were up

already. You would shake your head and laugh.
"Good morning," you would say. The only thing
I wanted was to sleep, but I'd complete

our ritual of one thin joke: going down
the hallway, I would counter with, "Good night."
But now the hills burn gold with kindled air.

The day is here. I'll say it. You were right.

Judson

JIM MOORE

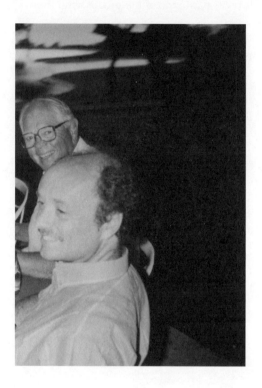

James W. Moore with his son Jim Moore
Hawaii, ca. 1985

Jim Moore is a poet who lives in St. Paul, MN. His most recent book is *The Long Experience of Love* (Milkweed Editions, 1995). He was born in Decatur, IL, in 1943.

James W. Moore was born in 1915 in Ventura, CA. He moved to Decatur, IL as a young man and worked as a journalist. He served in World War II, after which he went to work in Decatur for A.E. Staley's Manufacturing Company until his retirement. He died in 1989.

JUST LIKE *CASABLANCA*

Dear Dad,

I have to tell you something. Something that happened long before that morning—ten years ago now—when you died. What strange dreams you had been having the night before your death: elephants on parade in India, houses that you didn't recognize through which you wandered. You weren't hungry the last morning of your life, but when I offered you grapes you smiled, and I handed you one which you held a long time before finally eating. Then you suddenly sat up in bed, started tearing at the tubes in your nose, and said, "She's coming, she's coming!" Those were your last words. Afterwards, I sat with you a moment, as was so often the case when you were alive, not knowing quite what to do around you, loving you, longing for a connection that seemed always to just elude us.

It was only on the evening of my first night without you that the connection I had always longed for began to happen. That I can say to you now this thing that I have so long kept secret is because of the new connection that began the evening after your death. That night I dreamed that you were taking a nap and that I leaned forward and stroked your thinning hair. As if you were the son and I was the father. And then you woke, but continued to lie there on the white couch, as if waiting for something more to happen. I sat in the brown chair watching your lovely clouded eyes open onto the world.

The next day I took the walk you loved to take each morning, along the neighborhood streets of that small, flat midwestern town, all the way to the rose garden in the park. As had so often been the case when you were alive, we were silent together. This time though, the silence was not empty, but filled, on my part, with your presence. Can grief carry with it happiness? Because it was happiness I felt at that moment, pure and undiluted. There was nothing I needed to hide, no emotion that I feared would embarrass or frighten you.

The hiding was the problem, wasn't it? I think you hid from me, too. Neither of us ever wanted to upset the other. Neither of us wanted to make waves. We, too, obeyed the unspoken commandment which

rules so many families: don't ever do or say anything that would upset anyone.

Here's what it is that I need to tell you, what I no longer want to hide from you. Imagine we are at the duck blind—that hiding place, par excellence—where you loved to go early on weekend mornings and wait for ducks to fly overhead. It's one of those chilly autumn mornings, six a.m., the sky beginning to lighten. We are both standing there on that small wooden platform that is perched on stilts just above the sluggish, barely moving Mississippi. You have the thermos of coffee, spiked with whiskey. We've been standing a long time, silent as usual, peering at the sky which is also silent and empty of birds. Back and forth the thermos goes. We haven't eaten breakfast yet. We're tired, maybe a little bored, maybe a little drunk. Suddenly, who knows why, the barrier goes down. You turn to me and say, "There's something you want to tell me, isn't there?"

It doesn't take long to say it, though I have lived with it for so long it seems endless, this story with an afterlife that has never let go of me. So I do it, I tell you about the high school English teacher who so encouraged me during that year you sent me away to boarding school: how enthusiastic he was about my writing, how he introduced me to Shakespeare. And then, how he raped me. He told me he loved me, then sent me out into the world, my life in ruins, though I didn't know it yet. Didn't understand what it meant to live in a world where trust so easily turned into betrayal, where passion could be manipulated with such ease. After he had finished with me, I went into hiding. Finally, after many years, I began to tell the people I loved what had happened. But never you.

It's fully light now in the duck blind. There are tears in your eyes, anger at my teacher in your voice. And that's enough. You don't turn away and you don't fall apart. You are a father who loves his son.

* * *

Our last holiday together we sat in the living room on Christmas morning, looking out the window (it feels as if we were always looking out windows together) at the oak tree and the bare ground, no snow, but no grass either. It was the very image of winter, of death. You were already sick, though none of us knew just how sick. But you were talking like a man who knows it's time to pass along his past to

his children. When you began to talk about World War II, you turned towards me, your face animated in a way that I had rarely seen it. I remember that clean, merciless winter light falling across your skin that already was beginning to withdraw its color.

You were talking about the war because I had asked you what had been the most exciting time in your life. Is that what we had been waiting for all those years, to find a way to talk about our passions, what excited or horrified us? That secret passionate life that is inside us all. You spoke of France, of being in a country for the first time where the language was foreign, where so much was in ruins and so much was beautiful. You smiled as you spoke and I understood you to be saying that the ruin and the beauty are inseparable.

Remember that time we stood on a balcony together at dusk, looking out at palm trees and the ocean beyond? As usual, we were silent. Just before we went inside, you said, "I love this time of day. It's like..." you paused, looking for the right word, "it's like *Casablanca*." And then you looked at me and smiled, happy to have found the way to say it, the strangeness of this life, its beauty and mystery, its lurking danger. "Yes, it is," I said. "It is like *Casablanca*." And we turned and went inside.

Mac

PAMELA MOORE

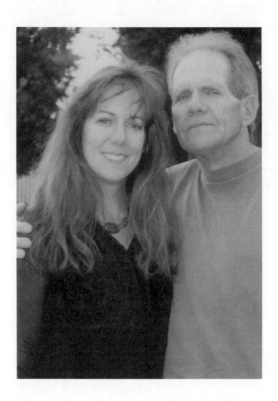

Pamela Moore and her father, Dwight Louton
Fair Oaks, CA, 1996

Pamela Louton Moore was born June 12, 1958, in Gridley, CA. She recently completed a Masters degree in English and Creative Writing at the University of California, Davis, where she twice won the Academy of American Poets Prize. She currently teaches at American River College, Sacramento. She has published poems in *Painted Bride Quarterly, Willow Review, The American River Literary Review, California Quarterly, Estero, Java Snob Review, Americas Review*, and the on-line magazine, *Spark!*

Dwight Louton was born May 3, 1939, in Porterville, CA. He grows tomatoes and sunburst squash well into Fall; rescues abandoned kittens,

stray dogs, and occasionally lovelorn daughters in their times of need; can be seen peddling his bicycle well past sanity at the sixty mile mark or looking for burst buttons at graduations and poetry readings.

MEETING MY FATHER AFTER MANY YEARS

you started me

in the back of her daddy's big green Lincoln,

spun me out of you like icing,

tiny seed, me,

her Evening in Paris cupcakes blessing you,

a letter sweater twisted and rubbing

at the small of her back

barely walking when she left you, I forgot

my daddy, you just some visitor

in grandmother's quilted house—seen fuzzy now

as if through curtain sheers, more color

in the african violets lining the table,

(a picture in her album named buddy)—

two years absence, half my life then nothing much

after that

but when my own marriage ended,

the voice on my answering machine

would you call me, and when I did

could we meet for lunch yes

and I began to know you, shy as an anemone

edged around with guilt, and oh god

afraid that I could hurt you

and each summer week in the heat by our cars

after lunches, from your hands into mine

tomatoes, viney smell still on their skins

peaches crisp and flushed, hard and clinging to the seed

small yellow squash shaped like a sun and later

with summer fattening into fall

you brought the persimmons—not the kind

so astringent they can't be eaten until their flesh

has turned to pudding—

these were hybrids flesh cinnamon speckled,

taste subtle and sweet as flowers,

tiny pumpkin shape and skin like vinyl

What I've Never Said

wrapped one by one so as not to bruise, like so many gifts

when I told you I loved them

you brought them week after week until they spilled

the blue bowl on my table and filled me

with their flamey sweetness, the round weight in my hand

the crunch in my hungry mouth

Daddy, as a teenager, you eloped with my mother in order to do a right thing about an unexpected pregnancy—me. Your marriage endured for two-and-a-half years. You went out of my life at that point, and except for a few memories, faceless and sadly uncomfortable, I did not see you at all when I looked back through my years on this planet. But in 1994, hoping I would agree to meet with you for lunch, you called me on a summer afternoon. In real life, we have few opportunities for true bravery; how many ways did you make that call, in your mind, before picking up the phone?

Thank you, Daddy. You've shown me what sometimes happens when we take chances for the sake of happiness, where my long face and dimples come from, why I sometimes speak from the side of my mouth, to understand the introspective and sometimes melancholy turnings in my mind, why I talk to animals; knowing you has brought half of me into focus. I always wondered where that came from; so that's why I do that . . .

Pam

DAVID MORSE

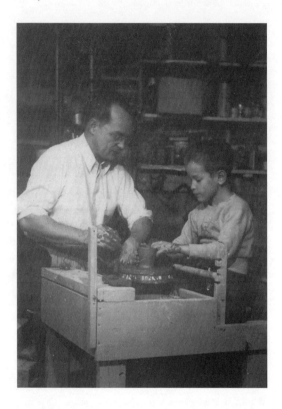

Wilbur Morse helping his son David at a potter's wheel he made himself. Photo taken in the basement of their home.
Arlington, VA, 1948

David Morse was born in Vinita, OK, in 1940. He attended Brown University and the University of Iowa Writers Workshop. He left teaching to become a freelance journalist and restorer of old houses, publishing in *Boulevard*, *Esquire*, and the *New York Times Magazine*. In 1992 he received a National Endowment for the Arts individual grant. His first novel, *The Iron Bridge*, was published by Harcourt Brace in 1998. Married to fiction writer and poet Joan Joffe Hall, he lives in Connecticut, where he is at work on another novel.

What I've Never Said

Wilbur Morse was born in Okmulgee, OK, in 1908. He worked as a carpenter and received a law degree from the University of Oklahoma. He began a private law practice during the Depression, served in the Oklahoma legislature, and later became General Counsel for MSTS, a bureau of the Navy. Following his retirement, he and his wife, Edna Goodner Morse, served as VISTA workers. He now lives in Raleigh, NC

YOU DANCE OUTSIDE MY FROZEN IMAGES OF YOU

Dear Dad,

You may recall that at the age of eleven I turned my room into a spaceship. The idea was inspired by Mom's offer to help me paint it. I could pick the color. Sis had just redecorated her room with ruffled bedspreads and walls festooned with cheerleader pompoms and travel posters, befitting her junior high school sophistication. I was getting equal treatment.

I chose gray—as close as I could get to the metallic bulkheads of the rocket in Space Cadet, my favorite TV show. I cut a round hole in a bulletin board and painted that gray also to turn my window into a porthole, and was ready to blast off for Venus. Sometimes, lying in bed, contemplating the steamy oatmeal swamps of Venus, I heard you and Mom talking softly in your bedroom, voices muffled. A peaceful sound. Adult talk. I felt excluded and yet safely attached to that world. I remember too a feeling of waiting. What was I waiting to hear?

It seemed a perfect marriage. I never heard you raise your voices against each other. My sister and I were loved—equally, you insisted, although I always suspected she was the favorite. You and Mom showed your affection for each other and for us. I remember your hand clapping Mom's fanny when you gave her a smooch in the kitchen, how you used to tease her for not understanding the funnies. Sometimes you teased too hard. She yelped and pushed you away. But we were cheerful, and it seemed to me close to an ideal family.

So how do I account for my two failed marriages?

Only now, at the age of sixty, twenty years into my third marriage, do I feel that I have finally learned how to love. For years I have sought to explain this conundrum.

I know that in my teens and twenties I rebelled against your rationalism. You were the lawyer: even-handed, didactic, detached from your feelings. Mom was the suburban homemaker: warm, intuitive, vulnerable, willing to be silly. She was all heart; you were all head.

What I think I was longing to hear, lying there in my spaceship, was passion. I don't mean lovemaking necessarily—although I was curious about that too. You had given me the book, *Being Born*, so I had some glimmering of the mechanics of reproduction, but the whole subject remained inscrutable beyond the author's dry tone. Why would anyone do such a thing? And the idea of my own parents doing it was ludicrous.

No, I think my curiosity was broader than that. I was waiting to hear any kind of passion. I would have settled for anger. Everything seemed filtered through the veil of nationality.

Not once did I hear you and Mom vent strong feelings. There must have been exceptions, but I don't remember them. It left me longing for dissonance, for some extremity of feeling that would legitimate my own emotions—my disappointments, jealousies, anger, fears, need for recognition.

We did not discuss such things, except in a prescriptive way. I was not to feel jealous of my sister. It was wrong for me to attract attention to myself. Some sadness was expressed at the deaths of your parents, but no real grief. Among your wider circle of friends and from among my own peers came occasional glimpses of a less predictable world. The words "divorce" and "alcoholic" were whispered. A friend of mine at twelve was knocked across the room by a raging father. These were all unknown terrors.

Once something I said to Mom in an adolescent pique brought her to tears. I complained that you didn't understand me; you didn't understand any of us. Her eyes filled with tears. I felt bad. Yet the tears were a validation. They were real.

At twenty-one I rushed into marriage, defiant and proud. Confused strife with intimacy. My first wife and I argued vociferously and cruelly; threw dishes, screamed at each other. Was this how one

discovered one's feelings? I hadn't a clue. Under my wife's fists beating my chest—I had driven her to it—I felt smug and terrifyingly cold. Who was I, in all this?

When the marriage was over, I found myself drawn to women who seemed to know their feelings, who could help me discover mine. I embarked on sexual adventuring. How difficult it was to put that need for intensity aside, to search for what was missing in myself, to stand naked in the complexity of marital dialogue. It helped to find the "right" woman, but first I had to find me.

Mom's decade-long descent into Alzheimer's forced something different from you. A year before her death, you told me something that surprised me. We were sitting together on a motel bed talking, the morning of my niece's wedding. You observed that in all your fifty years of marriage, you and Mom had never wept together. You had shed tears yourself, but always alone. You assumed that she too had wept, alone.

"We had our private griefs," you told me, "but we kept them to ourselves. I never carried my troubles home from work." You shrugged. "Some things you don't share."

I was stunned. Your voice betrayed no recrimination. But I was sad for you. We were none of us able to grieve Mom's death, it went on so long, her spirit pilfered by the disease, her personality collapsing into something unrecognizable. But beyond that frozen grief, and beyond the sadness I felt at what you had just told me, I was struck by the distance I had travelled in my own quest.

I cry easily, make love noisily, dance with joy, share difficult feelings, confess complicated ambivalence, anguish over relationships, put a fair amount of energy into what your generation of men called "women's talk." That whole emotional life which was largely unexpressed in my childhood is close to the heart of my marriage.

Some of it is generational and ethnic. You grew up poor and white in dustbowl Oklahoma, a kid with glasses who learned to stand up to a bullying older brother. Surrounded by ignorance and intolerance, you worked in the oilfields with a copy of Plato in your coat pocket. You practiced law during the Great Depression. Moved east, learned the finer calibration of the Eastern establishment. You did your best.

And I—raised in affluence, given art lessons and fed a diet of praise—have had to struggle for authenticity.

You gave me much. A deep-down knowledge that I am lovable. A

belief in the possibility of good in the world. A readiness to make my own path. The model of manhood that you embodied could not have prepared me for the cataclysmic changes of the past half-century: prosperity, the sexual revolution, the shifts in values and gender identities. But it helped, as I hope my model will help my sons to find their own truths.

And you continue to evolve. You developed a keen sense of humor to see you through the infirmities of old age. You laugh and weep. You dance outside my old frozen images of you.

I wish you and Mom could have grown old together. You deserved that. But it occurs to me that as her personality disintegrated, you learned to find her within yourself. You became more intuitive, gentler, readier to laugh. I sense her presence within you.

<div style="text-align: right;">Much love,

David</div>

MIRIAM MORSEL NATHAN

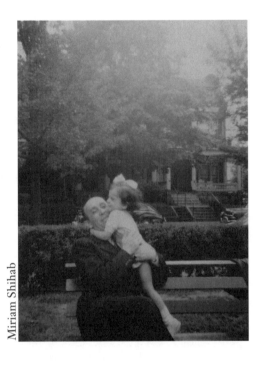

Miriam Shihab

Miriam Morsel Nathan with her father, Marek Morsel
Richmond, VA, ca. 1951

Miriam Morsel Nathan was born in 1947 in the Dominican Republic. Her poems and essays have appeared in such journals as *Gargoyle; The Hampden-Sydney Poetry Review; Sojourner: The Women's Forum; GW Forum; Arts & Letters: Journal of Contemporary Culture* and the anthology *Daughters of Absence: Transforming a Legacy of Loss*. She has read her work in such places as the Knitting Factory in NY, the Smithsonian Institution, Cable TV's Takoma Coffee House and the U.S. Holocaust Memorial Museum. Most recently, she was awarded a fellowship by the VA Center for the Creative Arts. She is Director of the Washington Jewish Film Festival: An Exhibition of International Cinema. She and her husband live in MD and have three children.

Marek Morsel was born in Czechoslovakia on March 6, 1907, the second oldest of six children. He left Prague in 1939, and after a year of avoiding the Nazis by hiding in Italy, the former Yugoslavia and Greece, made his way to the Dominican Republic where he became one of the first settlers of Sosua, a refuge for European Jews fleeing Europe. There he helped clear the jungle, then became a chicken farmer and finally an importer/exporter. Unable to obtain exit papers, his wife Zdenka Morsel remained in Prague. In 1945, she was liberated from Terezin and joined her husband in the Caribbean settlement. In 1949, they emigrated to the United States. Marek Morsel died on January 29, 1998. He was a vibrant, engaging man. He was a man who loved his family, music, art, literature and life.

SUCH A BEAUTIFUL WORLD...

Dearest Daddy,

It has been eight months since I talked with you. I've never gone this long and I need to tell you a few things. I don't know if you know that last December, after you told me you were craving Matjes herring, I jumped into a taxi to get it for you. I laughed the whole ride, and told the driver how absurd I felt buying herring for you. Well, that's because you were dying. But it really wasn't so absurd because you can't mistake the life force of herring—the strong smell of it, the heavy salt, the stuff of sea and earth. I guess you knew that and you were definitely craving life.

Do you remember, the day before, you listened to Maria Callas and sadly said to me "Such a beautiful world and I have to leave it." I thought that was it. But then, you craved herring. And in the morning you called and gave me a list of things to bring—your pajamas, chess board, book, freshly brewed coffee from home. I was so relieved that you had returned to life. Now, it's eight months later and we haven't talked, I haven't seen you. We are in the era of an endless separation. That's why I want you to know, there are so many things I will never forget.

When I sat in a taxi again, that bleak December day, holding the herring for you as if this briny tidbit would stop the dying, I thought

about the birthday you sent me a pop-up card of red roses and your note: "I send you roses which you always wanted." I loved that you called me "sugar" or "little girl" even after I was a grown woman with children of my own. I loved how you stood by the window waiting for us when we came to visit. As you watched for us to pull up, I looked for your silhouette at the window. And it was there, each time.

I can still see you moving paintings around the house or going to the market to buy imported plum jams packed in sturdy jars. I can picture you planting lilacs, gooseberry bushes and dogwood trees in the backyard. I remember how you added glycerin to an empty bottle of French perfume so the glycerin would pick up the fragrance. And I can still hear you quote Goethe and Schiller, as you moved your hand with the rhythm of the poems.

Of course, there were other things, as well. I wonder if you know how loved I felt on those winter mornings when you came into my cold room and lit the oil furnace so it would be warm when I woke. Did you know that when I got out of bed I sat with my back to the small open door of the furnace? I sat there for a very long time while the chills raced down from my neck. Sometimes now, in winter, I sit on the floor next to the heating vent and think of those dark cold mornings and how much I love you for warming the room for me.

And do you remember how in summer on those sweltering nights, we all lay on a blanket in Byrd Park until midnight to escape the heat of the apartment above the store? The fountain in the park spurted colored water and I wandered between the other blankets eavesdropping on those hushed voices. Then you and I looked up at the black sky and you would say to me, "See how the trees are swaying? They are talking to each other, telling stories." And you would tell me one of the trees' stories. I think you would like that I began to tell the same stories to my children.

I loved our rides to the store early on summer mornings before the heat broke the back of the day. The light was golden-purple as we drove in your Oldsmobile. Cool, deserted streets, a stray dog sometimes. You know how dark the store was when we came in, leftover night tucked into the corners. And then, as soon as you turned on the electric light, someone would come in for a quart of milk. It was fun sitting in the front watching for customers, sometimes reading romance comics, sometimes eating coconut cream pie, sometimes ringing up a customer. You blasted the Metropolitan Opera from the

brown radio in the front of our little grocery store. I laugh when I think of what the customers must have thought while the arias wafted over the chicken feed and Wonder Bread.

Such a beautiful world and you had to leave it. I know you tried to stay. You played chess and sometimes listened to music, even in the hospital. You thanked friends for coming to visit, even as you fell back to sleep mid sentence. I leaned close to your ear in those last days. Could you hear me hum the Czech lullaby Mommy used to sing? I struggled with the words and parts of the melody. Did you recognize the New World Symphony and the processional from *Aida* that I sang to you? I know you couldn't hum back any longer. You had to leave. I know that.

But here's something, Daddy. Remember how you used to clip articles for me? Here's one for *you*. The article is about a woman whose apartment view has suddenly been blocked by developers. What she says to the reporter is as impossible as my thinking you have died. As absurd as my writing this letter. She says, "Can you imagine someone taking away the moon?" An impossible and absurd thing. But that's how she feels because she can't see the moon anymore. And I understand because that's how *I* feel Daddy—like someone took away the moon. Such a beautiful world. But the moon is missing.

<div style="text-align: right;">With all my love, Miricka</div>

NAOMI SHIHAB NYE

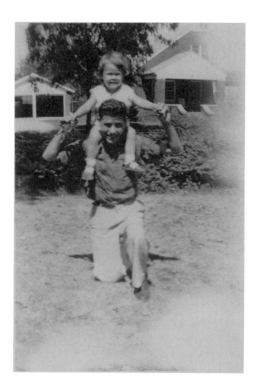

Naomi Shihab (Nye) on the shoulders of her father,
Aziz Shihab, St. Louis, MO, 1953

Naomi Shihab Nye was born in St. Louis in 1952 and lives in San Antonio. Her most recent books are *Fuel* (poems), *The Space Between Our Footsteps: Poems & Paintings from the Middle East*, *Habibi* (a novel for young readers), and *Mint Snowball*.

Aziz Shihab was born in Jerusalem, Palestine, in 1927 and lives in Dallas. He worked both as a writer and editor for *The Jerusalem Times*, *The San Antonio Express News*, and *The Dallas Morning News*. His memoir/cookbook, *A Taste of Palestine*, was published in 1993 and is in its third printing.

THE ORANGE, THE FIG, THE WHISPER OF GRAPES

Dear Daddy,

All my life, from the early Mississippi River days to the steamy Texas summers, people have said you're cute, you're funny, you're adorable, what might their lives have been if they had a daddy like you? Singing in the shower in Arabic. Poking around with a shovel in the dirt, your pants rolled up. Lifting the night with your laugh. Short smart sentences. Coffee in tiny cups. Waving your hand back when you speak—as in *so what, who cares, are you kidding?* Talking to your fig tree, handing bags of ripe fruit to any Ethiopian lady who hikes down your street.

Take two, take more. Saying *I love you* 20 times during the same phone call. I have grown-up friends whose fathers never said that yet. Whose fathers are dead with no more chance of saying it. Your love was a solid mountain, not a hope or a guess.

You said, *The house is happy when you're in it.*
First one to say I love you in September!
Hi darling. Did you know I'm proud of you?

Rarely did you say—*Do this, don't do that* —because you were trying to figure out what to do yourself.

Let's have an orange party. Humid St. Louis evenings, savory fragrance of overturned earth in our lungs, sunstruck weeds and mown grass, you'd peel the orange skin around and around so it came off in a single springy coil, placing cool sections into our mouths. We closed our eyes for the sweetness. Somehow you and Mommy brought us up to taste a sweetness everywhere. Not to be scared.

You'd say, *This pear is AMAZING!*

The grapevines told you a story in their own language. You translated for us. Today, the fig tree you planted in my yard, born of a single magical stick, child of your own enormous tree, towers over our clothesline. White shirts billow forth beneath it. I pinch my eyes shut, sailing to the old country of smoky stones, figs and birds.

What I've Never Said

What were you thinking of at sundown when you stood outside in the yard staring at the sky, hands locked behind your back? You grew so silent. I always imagined you making a get-away. I worried about it. You and I, the fiction-writers of the family. But I never had your endless immigrant gaze.

Once in the dark somebody cut all your sunflowers' heads off, leaving a startling line-up of giant empty stalks. Heads on the ground. Refugees don't need that kind of weirdness.

Refugee: *one who flees for safety. One who flees to a foreign country to escape danger or persecution.*

Well, you never seemed as if you were fleeing. You seemed more comfortable everywhere than most people do. You settled in. *How's my friend?* to the salesman you'd never seen before. But when I gave you Allen Say's beautiful book *Grandfather's Journey* with the Japanese-American grandfather feeling homesick for his other country no matter which country he's in, you understood completely. You said, "This is me."

When the drunk man crashed through the brick wall of your house in the night, he ended up apologizing on his knees, hugging your legs. You were groggy in pajamas. He was Eastern European with a heavy accent. The police asked him if he knew where he was and he said, "I'm home!" *The hell you are,* you said. But then—didn't you invite him to dinner or something?

We never talked much about how brave you'd been to travel by yourself to a new land, but I think of it often now. Now that I have a son and the thought of him going anywhere far pierces my heart. Though you were known later as the least brave of our family—you couldn't stomach blood, hospitals, funerals, and if anyone vomited in your presence, you vomited too—we must also consider: you took a spanning leap wide as an ocean. Sailing off on a ship—*Ensha'Allah!* —with your mother's wild tears fanning out behind you. Immigrant courage, leaving the known lands, and every single person who had steered you, far behind. Till they became smaller than sesame seeds.

I couldn't do it. Couldn't be the person who goes away so far forever. Never, not for the sake of any country or dream. But you saw your own country being pummeled all around you. You trusted the horizon that much.

Once my college class watched a Jerusalem documentary filmed in 1949. The Old City, Dome of the Rock, then there you were with

a BBC microphone, solemnly reading the news. I shot forward in my seat. My father, before he was my father! Wearing a khaki uniform, lean and serious in a black-and-white world.

Impossible to say what the pain of Palestine's struggle has done to shape your psyche, your heart. A part of you never leaves there, of course, is bound forever to the terraced olive trees, the sprouting fields, the quest for simple honor. A part of you is always going back. *Home*, you called it, which, after many years, made our mother mad. "Isn't this home yet too?" How hard for you to hear the twisted evening news again and again. Walk outside, stare at the sky. Always a horizon to bandage the wound.

Now that your mother is dead, along with all your brothers, the full and the half ones, what is left? The heart of the story. Outliving everyone's words. The land and its fastness. Memory, history, strong blue thread. Jericho oranges sweeter than Texas. Children shouting, wearing tattered jackets, wandering cobbled streets where you once ran. And all the Palestinians scattered 'round the world who extend the borders of their lost land wherever they travel... still bound together. I see you in their eyes when they find me. *What is his name? Where did he go to school?* They want to remember you from way back, to know you shared a desk, a circle of bread, a pen.

You *are* Palestine and you have always been free.

At Ellis Island I step into the main building, where you *didn't* get off your boat *(oh, some unknown pier, some dock, I don't know where we landed)* and the heap of suitcases, rattan carriers, displayed in a beautiful tumble of arrival, all that hope and trust, even if the linens and cottons and silks have been removed, makes the tears spring up in my eyes.

There is no prize for such bravery.

Now that you are getting old and you hate it, what will you do? Your restlessness haunts me. Your distractedness. How does one emigrate away from age? Your anger with me because "I don't see your side of the story." Daddy, don't you know I consider "the other side of the story" my daily duty? *Oh, the hell you do*, you say. *Maybe other people's, not mine.*

All I want is peace, you say. Yet that may never be yours—elusive peace in your first homeland, your marriage, your wildly scheming dreams and plans. Is elusiveness what makes you mad?

I would be happy to keep our first relationship intact: daughter delights in father, sits on father's shoulders, looks at the world.

What I've Never Said

Father is laughing. Daughter is laughing. Daughter knows very little. I am the one who could never let go of first things.

Better for people to think we are less than we are and have less than we have. You'd say, *Not me! I'll take the opposite!* Being bigger. Being Someone. You bought 50 acres with a little house on it. You bought a donkey. You called it a ranch.

I found your first American drugstore in Kansas once—the archival SODA FOUNTAIN vintage. Freshly arrived at the university in that little town in 1950, you'd visit that drugstore, sit on a swivel stool at the counter, buy a Coke, and stare. An ancient druggist was in there when I went, polishing silverware with a white towel. I asked if he remembered as far back as 1950 and he pulled himself up proudly. "I remember everything since 1935! What do you want to know about any of it?"

My father. Used to sit here. At this counter. Would you possibly recall? Palestine. Jerusalem. Thick black hair. And before I could say your name, he said, "Aziz!"

The druggist held two spoons up high. "He would put his head down on the counter between sips of Coke. I thought he was either awfully tired or awfully lonely. We hardly had any foreign students here in those days. He really stood out. He didn't talk much. But I asked about his parents and the holy places. You know. Back there where he was from. He would put his head down on his arms, then lift it and stare so hard as if he could see right through that mirror over the fountain."

The mirror had clouds around the edges of it, Daddy. Your same old mirror. *First one to say I love you every day from here on out.*

Who would you see if you looked into that mirror now?

Love you,
Naomi

JOYCE CAROL OATES

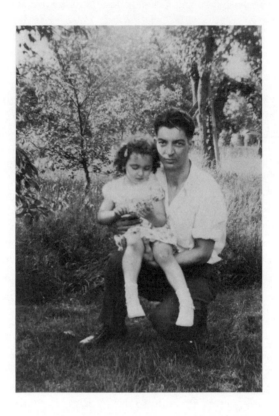

Frederick Oates with his five-year-old daughter Joyce Carol, Millersport, NY, Spring, 1943

Joyce Carol Oates was born in 1938 Lockport, NY. She is the author of a number of works of fiction, poetry, plays and criticism. Among her recent titles are *My Heart Laid Bare*, a novel, and *The Collector of Hearts*, stories. Her upcoming book is *Where I've Been and Where I'm Going*, an essay collection. She has taught at Princeton University and has been a member of the American Academy of Arts and Letters since 1978.

Frederic James Oates was born in Lockport, NY, on March 30, 1914. For much of his life he worked as a tool and dye designer for Harrison Radiator in Lockport. He was also a professional free-lance sign painter and has been an amateur pianist with an abiding interest in music and literature. After his retirement he enrolled as an adult auditor at the State University of NY at Buffalo where he took predominantly English courses. "Those were probably the happiest years of my life," he has said.

TO MY FATHER: WHAT I'VE NEVER SAID

It must have been when I was in my early thirties
that I first realized this simple and profound truth—
You should be me.

The thought swept over me leaving me faint!
I don't mean *I should be you*, still less
I should have been you.
Only just *You should be me.* The writer, the
 teacher. The one who has made a life,
 & how cherished a life, of literature:

It didn't happen that way.
You were born in 1914, I was born in 1938.
You were born poor & had to quit school when you were a boy.
The Depression hit your generation & you.
Assembly-line worker. Tool & dye designer.
Professional sign painter.
Orchard-keeper.
& through the decades, a reader of passion and zest.
The reader for whom every writer writes.
& after your retirement, for 15 years you were a student
 auditing courses at the State University at Buffalo
& you were the student for whom every teacher yearns.
You loved books & you loved your professors.

Now you no longer take the bus to the University,
& you no longer read ambitious books.
"Macular degeneration."
But can it be cured?
Please tell me it can be cured!
Though you still read, slowly. At your ingenious magnifying
 machine. The book's page suffused with light & the
 type enlarged.

I see your face in mine, Daddy. I hear your yearning in my own.
Your love of the imagination, your wild & unpredictable
 sense of humor.
Your stubbornness, your inviolable pride & integrity.
Your unexpected eloquence—"I take 17 pills through a single
 day. I'm held together by pharmaceutal glue."
Your droll dark humor now, in your mid-80s, & I
 just turned unimaginable 60, we talk together frankly
 as we'd never talked before.
As if, with time, we grow closer in age to each other.
As if, with time, the old distinctions between us melt away.

"These nights, I can't read prose very well. I guess I won't
get through your new novel. It's wonderful and I love it but
my eyes… I read poetry. In the college anthologies.
Frost, Dickinson, Whitman. Sandburg. That's how I spend
my nights, now."

CAROLE SIMMONS OLES

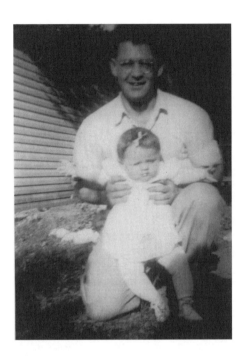

Henry R. Simmons with his daughter, Carole Simmons (Oles)
New York City, 1939

Carole Simmons Oles was born first child of Henry and Helen, born January 7, 1939, in New York City. Sister to Jan Marie, mother to Brian and Julia, grandmother to Logan. Author of five books of poems, she teaches at California State University, Chico, and at the Bread Loaf School of English, Middlebury College, VT.

Henry Reginald Simmons, seventh child of eight, born to Edward and Katherine, née O'Reilly, in Wingdale, NY, September 1, 1911. Studied at Corcoran Art Gallery in Washington, DC, where he met and married Helen Kampmeyer in 1933. Lost work, lost heart, labored back. Died of emphysema in 1981, having eagerly heard newspaper accounts of the first space shuttle voyage.

TRACED WITH YOUR LONGING

In black-and-white grainy footage, The Babe heads home with the casual stride of a pudgy man who's just knocked the ball into the stands. *One afternoon at Yankee Stadium, you're on your feet in the bleachers, leaping to make the catch. Later, outside the ballpark you wait for the team to leave, intercept your hero for his autograph on the ball you hold tighter than anything you've ever caught in your grip. That ball sits for years on a shelf in our living room, signature turned out toward the viewer—signature you'd by then inked over for preservation, or for getting inside the hand of its owner, a place you'd dreamt to be. Now, in an era when bogus autographs on baseballs are rampant, we know you ruined forever the value of that plucked name when you traced it with your own longing.*

The TV show cuts to McGwire in color video of the 62nd, record-setting homer, the six foot four inch bearded sequoia rounding the bases, leaning into the curves like a monument set into motion. Would you holler foul when dusky Sosa, for equal runs gets less press? From your seat out of this world, what do you think of these late-century heroes? Could you guide your own hand into their names?

All those summers on 32nd Street, two storeys over the traffic: me on the fire-escape eating corn on the cob while you watched the game, cheering, on your feet, waving your arms at the double-play that tied the score.

Growing up in New York City meant every summer your loyal obeisance to the team you loved, the men who took you from us to a green place that at least didn't send you back to us reeling.

It's all a different game now. What I know of it comes from you and those years. You never read this poem in which I sat again beside you.

THE INTERPRETATION OF BASEBALL

It took time to figure out who was missing
from the dream ballclub that paraded
through the dark in uniforms and numbers
holding up posters of the lost teammate
as if campaigning for their man.

I had to walk the dream railroad track again
where my son followed me at first, then took
the lead, balanced, leaped forward over the ties,
poof—gone!
And to sit with the inquisitor who wore
my dachshund around his neck like a precious
fur with lacquered eyes.

I had to listen then to memory,
your fastball, your grand slams out of the park.
And go back to the bleachers at Yankee Stadium
where you took me at 7 though I was not the son
whose heart, that sly courser, unseated him.
He was the one you saved your prize for,
the baseball Babe Ruth signed.
You tried to show me what you saw
but I was gabbing about something else:
another hotdog, how many more minutes.

It took time, Father, to see
you swinging, connecting.

In an oddly-composed black-and-white photo—one half in darkness, in the other your back to the camera—you lift me over your head. I cling to your wiry hair, my two lower teeth shining from the void of my smile. Your right hand around my waist looks smaller, more graceful than the actual broad, calloused fingers I grasped.

Another photo, same period, in the backyard at Grandpa's house: you kneel on your right knee, your left reaching under my left arm, propping a hand that supports me as my arms fling out toward the limits of the frame. My right leg curves onto yours. My Daddy is holding me up, smiling into the camera, glad to be where he is, with my head at the level of his heart.

When did that girl child become insufficient? I think after your son my brother Gary died at one week when I was seven. For a long time then, nothing was right (I forgive you some songs of the belt), until you went out yet another night with the "boys," fell down the subway stairs, fractured your skull. Near-disaster shook you awake.

Much later, your only grandson arrived to great acclaim and you

were awkward with him—the way you'd turn your head away from TV dramas, your face red, eyes filling. And now, your granddaughter's son, a redhead like baby you, by her design wears your last name.

Always on the first of this month, late-summer baseball season, I think of you. Two years ago we wondered if your great-grandson would arrive on your birthday. But he left that day solely for you, came as close as he could on the second. How Mommy loved him last Christmas, her last—reading him *Goodnight, Moon*, taking him onto her lap where he could operate the brass buttons on her sweater. He kept asking her to pick him up from a standing position, raising his arms and his gaze. She lacked the strength, had to sit and let one of us hoist him onto her knee.

Asked once how she thought it would be in the afterlife, she said she expected to see you there young again. I guess she'd be young again too. Almost four months since she journeyed, I want to think she's unfolded her hands (they had in them mother-of-pearl rosary beads), reached, and found yours...

Your hands that carved the head of Cicero outside the U.S. Supreme Court and patron saints on neighborhood churches, before work ran out and you had to twist wire, instead, for buildings with sheer, blank faces. Your hands giving the foreman your card from the brown plastic Heliograved case—*Henry R. Simmons representing Architectural Sculptors and Carvers Association, 31-28 32nd Street, Astoria 6, N.Y., AStoria 4-5893*, with the union seal in the upper right corner, Local number 485. On Labor Day I hear on the radio just minutes of John L. Lewis's five-hour, ringing testimony before the U.S. House on behalf of the mineworkers, and I'm stopped in my kitchen. You're here. My father, Henry Reginald, "Harry," "Reggie"—a good man with bushy eyebrows like John Llewelyn's, with rough, thick hands and broken nails. You, Daddy, with a swift current of feelings you half-knew how to ride.

Love,

Carole

"The Interpretation of Baseball" from THE DEED (LSU Press: Baton Rouge and London, 1991); first publication in *Poetry*.

WILLIAM O'ROURKE

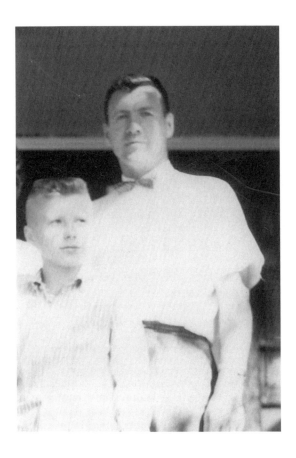

William O'Rourke and his father, William O'Rourke,
"The photo is cropped from a larger one."
Kansas City, MO, ca. 1957

William O'Rourke was born December 4, 1945 in Chicago, IL. He is the author of *The Harrisburg 7 and the New Catholic Left* (1972) and *Signs of the Literary Times: Essays, Reviews, Profiles 1970–1992* (1993), as well as

the novels *The Meekness of Isaac* (1974), *Idle Hands* (1981), *Criminal Tendencies* (1987), and *Notts* (1996) and is the editor of *On the Job: Fiction About Work by Contemporary American Writers* (1977). His most recent book, *Campaign America: The View From the Couch*, appeared in 1997. He has been awarded two NEAs and a New York State Council on the Arts CAPS grant. He was the first James Thurber Writer-in-Residence at the Thurber House in Columbus, OH, and is the founding Director of the Graduate Creative Writing Program and a professor of English at the University of Notre Dame. He married Teresa Ghilarducci in 1986 and has one son, Joseph, who was born in 1990.

William O'Rourke was born May 19, 1923 in Chicago, IL. He graduated from Mount Carmel High School in 1941 and worked for the Pullman Aircraft Company during World War II. He spent the years 1946-92 with Bearing Distributors, Inc., both in Chicago and Kansas City, MO. He married Elizabeth Kompare in 1943 and they have eight children.

US TOGETHER, ALONE

Dear Dad,

I am struck by the fact that this may be the first time in my fifty-two years of life I have written "Dear Dad," addressed only you in a letter, not both you and mom, father and mother, parents. "Dear Folks." I have used that one a lot, not that I have written so many letters in all these years.

When you and Mom had your fiftieth wedding anniversary, like any good writer/professor, I did some research: I stood at a greeting card display and read many examples of the form most often used on such occasions: expressions of best wishes written by professionals, people being paid for their words. And what words! Public endearments, scraps of diary entries, treacly testimonials. My hands were sticky with sap from the experience. But some important themes emerged clearly: the cards for the early years, minor milestones, were always full of encouragement; those for twenty-five years of marriage were thick with celebration; but those for the fiftieth anniversary all glowed with amazement. Fifty years a couple! Who could

believe it? I would have offered that coupleness fact as my chief excuse for never writing to you directly before.

So: *Dear Dad.* There is something powerful in the singularity, since I now feel the weight of having never used it before. I have been looking for a photograph of you and me together, just us two, for the last year and haven't turned one up. I expected there to be one at least—just me, a kid in your arms. I noticed, the absence of a picture on my mind, that I have a number of photos of me with my son, Joe, your grandchild. The one I like best is the snapshot of me holding him in the delivery room, the "birthing" room, some preternatural light beaming out of my eyes, taken by the doctor who delivered him.

Finding no photograph of us alone was troubling, because many memories I revisit are of us together, alone. My mind is filled with those snapshots. Us late at night in a car, you at work delivering a critical part to an anxiously idled factory, me along for the ride, you bringing them salvation, a bearing that would allow everything, those massive buildings, those giant machines, to start up again, to throb and hum.

And our talking alone, the infrequent brief conversations, their brevity and rarity making them indelible. They were often about work. Times I let you down. The one time you hit me, so shocked at my impudence, complaining about the adequacy of a favor to me you had arranged. Even then I thought I deserved to be slapped. And the time, at sixteen, I flattened the side of the new car, which provoked no violence at all, but mainly silence and disappointment. All that alienation we felt those years I wrote off as part of the times. It was the fifties, you were one of the silent generation. I had grown my hair long before the Beatles (my models were the Beat Generation, not the Brits), and when you saw my high-school graduation picture, you ordered me to the barber shop and I returned home thoroughly shorn. (Had you not seen me until the picture appeared?) There weren't that many orders actually, which is why I never questioned them.

You were of your times and I am certainly of mine. But all the cliches came home to roost when I had a son eight years ago, my only child, but everything was different, I told myself, except for that arc between you and me, between him and me.

Unlike yourself, who had your first child, the first of eight, when you turned twenty-one, I was one of the OAFS, a founding and charter member of the Older American Fathers Society. I really began to

notice the duplications. Even to small, intimate things: when we moved into a house in South Bend similar in kind to the one in Kansas City we lived in, I was surprised to find, screwed to the back of a closet door, a rack for ties, and to watch how quickly it filled up to resemble the one you had, the same soft waterfall of fabric, that I used to stare at so often that it became a symbol of your presence in my life. And how, in so many more profound ways, my interactions with Joe remind me of yours with me, especially the dutiful and awkward manner I often assume. When we fall into silence, me behind the wheel, Joe next to me looking out the window, I am reminded so piercingly of you. And me.

Yet I remember when I was around ten and fell atop a small red metal step ladder, while jumping into a half-filled wading pool, and sliced open the back of my leg, leaving a torn, ragged horseshoe of tissue, large blood vessels exposed, but luckily not severed. The wound needed stitches and later when it was time to go to bed that night you carried me up the stairs. You must have done that task before, but this was the only time I recall it happening. I think ahead of carrying my son up a long set of stairs when he becomes ten and wonder at the strength required; then I realize you would have been thirty at the time and when I was thirty I could have carried you up the stairs.

But I do remember being in your arms then. No picture of it, though, except in my mind.

And I have another such mental picture of you with a son in your arms—not me, but the next, Terry, who was some nine years younger. It was in the fifties, and we were in our neighbor Max Sanford's car, a sand-colored Ford coup. I was in the backseat; the stiff whisker feel of the upholstery on my bare legs is still easy to recapture. Max took a turn a bit fast and the Ford's large passenger-side door sprung graciously open. Terry was in your lap, no more than a year or so old. Out you both went and I stared in amazement. Everything slowed down and what amazed me was that you never changed position. It was as if the seat had disappeared (which it had) but you remained a mime of repose sailing through the air, finally landing on the street, knees still bent, arms still locked around Terry, as if you had become, many years before they were introduced, his human car safety-seat. Bump, bump. Max let out a yell, and pulled the car over and stopped. We all ran back and found you not really hurt as I feared, your rear end a bit bruised and scratched, but that was all.

But the image of you and your young son flying through the air has always been vivid in my mind. From that day on, before puberty and the onset of battles and conflict, displeasure and disappointment, I thought two things: one was that you were a hero. And two, I knew that you would have done the same if it had been years earlier and me in your lap. You would have never let me go either, flung me out into peril. You behaved, I thought then, like a *father*. A man who could be trusted. As I always have, even through our years of many silences and nursed complaints. That trust has never been violated, or that clear picture shattered of you, my father, flying through the air, my dear dad.

Willie

LINDA PASTAN

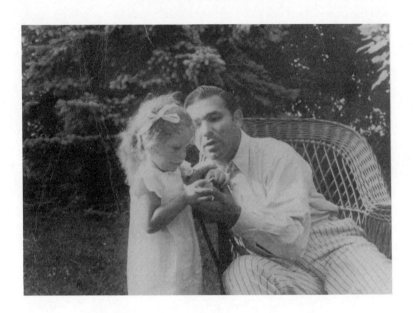

Linda Olenik (Pastan) with her father, Jack Olenik,
when she was 4 and he was 40,
Armonk, NY, 1936

Linda Pastan was born in 1932 in New York City. Her tenth collection of poems, *Carnival Evening: New and Selected Poems 1968-1998*, was published by Norton in 1998. She was Poet Laureate of MD from 1991 to 1995.

Jacob Louis Olenik was born in Poland in 1896 and came to America as a very young child. He lived in New York City and Armonk, NY, and was a surgeon.

LETTER TO A FATHER

What is left of you, in grainy black and white,
is the masked face of the surgeon leaning
over a draped body, in a concentration
that is almost ecstasy—a photograph
that hides the nose I hated
you for giving me, the strong
peasant face that obliterated in mine
the classic features I longed for, of my mother.
You gave me language—the love
of it, rolling the forest primeval
on your tongue until I too
had memorized Longfellow's
great soap opera, those murmuring
pines and hemlocks, bearded with moss.
You gave me your blue/black moods—
those gathering clouds settling over your brow,
but not the sunny charismatic highs
that made your patients worship you
in the lost kingdom of The Bronx,
saying your mustached face
was pure Clark Gable.
I remember how you taught me the bones
of the head when I was five (frontal and temporal)
but let me off the doctor/daughter hook
because a daughter, after all,
even an educated one, is just a girl.
I learned to understand
my mother when I had a child
of my own. But all the clues to you
(immigrant, track star, inventor,
God-fearing atheist) like jigsaw pieces
made of untempered glass are slippery
and sharp and break off in my bleeding hands.
And I am left here, almost as old
as you were when you died,
still trying to keep afloat on the memory
of the fearful silences I nearly drowned in once.

DAWN RAFFEL

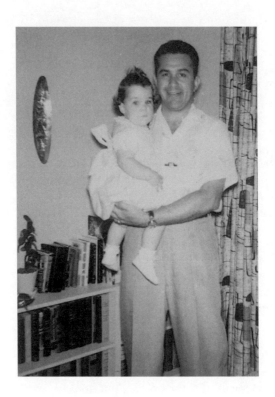

Mark Raffel holding his daughter Dawn Raffel.
WI, ca. 1959

Dawn Raffel was born in Wisconsin in 1957. She is the author of a story collection, *In The Year of Long Division* and of a forthcoming novel, *Carrying the Body*. She is also a magazine editor in NY.

Mark Raffel was born in Chicago in 1921, and moved to Milwaukee with his family during the Depression. He was the President of Raffel's, Inc. and The Mart furniture stores, and was President of Raffel Product Development. He was also a licensed private pilot and a serious ballroom dancer.

—Mark Raffel died on December 12, 2000,
while he was dancing.—

FURTHER ADVENTURES IN THE RESTLESS UNIVERSE

Dear Dad:

Do you remember my ninth birthday? I do. It was a birthday I anticipated eagerly, believing it would be special because, for the first recollectable time in my life, it was to fall on a Saturday; my party could take place on the actual, authentic date. But on that long-awaiting morning, I awoke with a blazing fever, and I lay abed, wretched, as my mother called the mothers of a dozen little girls to reschedule. To make matters worse, one of the mothers let slip that the following Saturday was *her* child's party, to which I had obviously not been invited, a bit of news that my mother, wounded herself, let slip to me.

After an interminable morning of ginger ale and tears, during which time you disappeared on an "errand," you and my mother came into my room in rare unison and delivered my gift. No, it was not a Barbie doll, a Ouija Board, a game of Twister, or any of the other preadolescent, perisexual playthings then (and now) in vogue. My gift, fresh from Radio Shack, was a telegraphic device with which to tap out messages in Morse Code. Did I know Morse Code? No, I did not. But you, who spent most of your scant free time in our unfinished basement, signaling strangers in foreign lands with your home-made ham radio rig (which included not only desktop apparatus, but a tall, forbidding cabinet chock-a-block with wires and strange bluish bulbs, and which smelled untouchably metallic) pledged to teach me.

I was puzzled and delighted by my gift, but although you spent many hours coaching me, the exercise was hopeless. I could not seem to acquire even the most rudimentary facility with this unspoken language, nor could I decode the little messages you sent.

It was around this time, however, that you and I developed another pastime—that of reading together from a book titled *The Restless Universe*. It was, as I recall, a kind of astrophysics for laymen. I suspect it appealed to you because you spent seven days a week working in the family furniture store—a place as grounded in the objects of dailiness as one could find. We'd sit on my bed; you would read one page aloud and I the next. You claimed with pride that I understood

what this book had to say about heavenly phenomena, but in truth, although I could usually sound out the big words, their meaning was opaque to me. It was my first experience with feeling both loved and misunderstood, and that lesson—that love so often comes with imperfect understanding or downright incomprehension—is one I still struggle to learn.

I grew up; we both drew away from our not-very-happy family. By my thirteenth birthday, I was calling you by your first name, sassy as you please in search of a reaction; none was forthcoming. Your attention was elsewhere. By my sweet sixteen party, you'd moved out of the house but, for appearance's sake, pretended otherwise. This was in the 1970s, when novelty was *du jour*, and my party's program was to tour a winery (in Wisconsin!) whose wine the guests were all too young to drink. You played the bland, gladhanding dad; my mother's smile fermented. Oh, the tipsy ritual cha-cha of the Middle West!

By my twentieth birthday, it was I who was leaving. You were taking me east for my junior year of college at the end of my final summer anywhere near home. (I remember saying goodbye to my mother in the driveway of the split-level house that would soon be sold while you sat in your car with your eight-tracks, waiting. "You're not coming back, are you?" my mother said, in her newfound "Don't lie to me" tone of voice.)

We sang "Happy Birthday" with a friend whose house was on our route. I still have a photo of that night; I'm bending over the cake, my long, dark hair too close to the flames.

"Whatever you do," my mother said when I announced plans to visit New York, "stay out of Greenwich Village."

And so, of course, I moved there.

My mother toasted my twenty-first birthday with me uptown, at Tavern on the Green, a Wisconsin girl's vision of Oz.

Twenty years have come and gone since I have spent a birthday with you, Dad, not by design, but because we are a half a continent apart and because time escapes us. You live in Wisconsin still, farther out in the country now, in a place where you can see the stars in all their brilliance in the night, and even on a clear winter morning. The family's store, with its ever-hopeful, empty, pre-arranged rooms: the sofa, the loveseat, the La-Z-Boy recliner—ashtray on the coffee table, flame retardant toss pillows, tags attached (removal unlawful!) is closed down, gone.

What I've Never Said

Do you remember the same birthdays I do, in the same way? Or do you remember a whole different story? Experience loses so much in translation, memory, which is private, even more.

I have learned Russian, its tricky declensions; I have learned something that passes for French, but I have never learned Morse Code, nor have I learned to chart the restless universe between us, the way the light refracts.

Late last summer, my young son, named for your father who founded the store, had a cake at your house to fete his beloved, imagined companion. Joy was in his eyes. His heart had been opened, I suspect, to mystery and absence.

The candles were lit.

Dawn

KEITH RATZLAFF

l) D.P. Ratzlaff with his Star Route mail delivery truck.
 Henderson, NE, 1938

r) Keith Ratzlaff in front of the Ratzlaff home
 Henderson, NE, 1959

What I've Never Said

Keith Ratzlaff was born July 29, 1953, in Henderson, NE. He's been the recipient of the William and Kingman Page Chapbook Award, The Theodore Roethke Award from *Poetry Northwest*, and the 1996 Anhinga Prize from Anhinga Press which published his *Man Under A Pear Tree*. His most recent book of poetry is *Across the Known World* (Loess Hills Press).

Dietrich Peter Ratzlaff was born July 27, 1912, in Henderson, NE, where he lived his entire life and served as mayor for 20 years. He died in 1984.

LETTERS

Two "letters" we found in my father's papers after he died:

Item one: A personal history filled out for a company named Sadler & Associates of Chicago. I have no idea what it was for—a job, life insurance, a loan? At any rate, he never sent it. On August 10, 1953, he was 41, 5'9", 145 pounds. He had dependents aged 16, 12, 8, 6, 2 weeks (me). His father was identified as a grocer, his brothers and sisters variously employed in sales and ordinance work; he was a Lion's Club member; his hobbies were civic improvements, community development, woodworking.

Then the questionnaire takes an odd, chatty tack:

> *Did you sleep well last night?* yes
> *Do you ordinarily wear glasses?* no
> *Are you wearing them now?* no
> *What do you like to read most?* daily newspapers
> *What did you read last week?* newspapers
> *Are you now engaged in any serious course of reading, study, or other means of self-improvement?* no

Item two: A cheap get-well card, the kind you buy by the boxfull from some door-to-door charity group. On the cover are three badly printed, pink-faced children holding a sign that says, *Hurry and Recover! Right Away!* A bluebird perches on top of the sign. The card is creased and shiny, curved in a way that signals it had been carried around close to the body for a long time—in a wallet or a back pocket. A second card is tucked inside, a reminder from the Faith Prayer and

Tract League of Grand Rapids Michigan:

> When you swear:
> It may hurt others
> It does you no good
> It reflects discredit upon your training
> It is a SIN against God

This unsigned message is inscribed in a round hand:

> *Dear Fellow Church Member*
>
> *Disappointed to hear the language you use in public. You also sounded very unhappy. Praying you will turn yourself and these problems over to Jesus. Take time to pray. He is listening.*

Dear Dad,

This is odd—actually writing to you—since I never wrote you a single letter while you were alive. But then, you never wrote me either. What could I possibly tell you now? I'm 45, 190 pounds, no dependents. My father sold irrigation equipment most of his life, but other things, too. My siblings are all professional something-or-others. I don't have many hobbies: gardening, baseball, and golf—the game you taught me and which I play sporadically and badly. Mom tried to give me your birthstone ruby ring, but I wouldn't take it. The only things of yours I own are your golf clubs (I hope you're pleased) and your bowling ball (which I've since lost somehow.)

I'm writing because I'm puzzled about those pieces of paper, those "letters." Why in 13 boxes of cancelled checks and expense diaries are these the only written things that seem to tell me about you, that seem intimate? What did they mean to you? Why would you keep them?

The first one is easy, I think. You had five kids; it was hot. You'd barely made it in off the road the night I was born. It's easy to lose yourself. And after 40 even easier. This was a base line, someplace to tell yourself who you were, a diary entry you were tricked into writing—but one that was satisfying the way drafts of old poems suddenly appear to tell me who I was and who I am.

The second one is harder, but I'm too much like you—my temper's yours—to not guess why you saved it. Because it hurt and you could

live off the hurt. Because a little shame made you superior to the shitass (your favorite vulgarity) who wrote it. He (or she?) was obviously a coward who couldn't confront you in the postoffice or the cafe or wherever you let loose with the kind of ranting that used to send me out of the living room and up the stairs to hide.

I wished growing up I'd known you could be upset—even shamed—by anything, much less something written. I think I could have approached you on that ground, gotten to you. But it never seemed possible. I was ashamed of you—scared of your flashpaper bursts of temper and language that I knew, *I knew*, was sinful. As a ten-year-old I could have written a card like that to you. I was capable. I was a sanctimonious little chickenshit (your second favorite curse) then.

I can remember Mom telling me once, after you'd died, that I was a lot like you. I'd never even considered it, and I've carried that idea with me for years, both proud and ashamed she could think so. Proud because you had such faith in your kids' futures and our Mennonite roots, in the little Nebraska town you were mayor of. I admired that part of you from a distance. But I didn't want to be the loud, often angry man you were: the one gone for days at a time, driving gravel roads in Nebraska or South Dakota selling sprinklers and pipe to farmers. But I'm 45, and beginning to feel inarticulate anger welling up at almost anything—tools, students, all things that should be better than they are. I'm beginning to know what it's like to see your life unrolling like a scroll ahead of you. The travelling life and the writing life are both invested in failure—and in going on in spite of failure because there's nothing else. And sales or poems come then, miraculously, just when you've given up. You lived the writing life—my life—without knowing it, page after page, draft after unwritten draft.

Mostly I don't sleep well. I just bought my first pair of bifocals. In the paper this morning I read an article about Bill Clinton that you'd have liked because you could call him a shitass. I never told you that at 14 I read *Death of a Salesman* and cried because I thought I saw your life there.

> *Am I now engaged in any serious course of reading, study, or other means of self-improvement?*
>
> <u>Yes. I'm finally learning how to be your son.</u>

ANNIE REINER

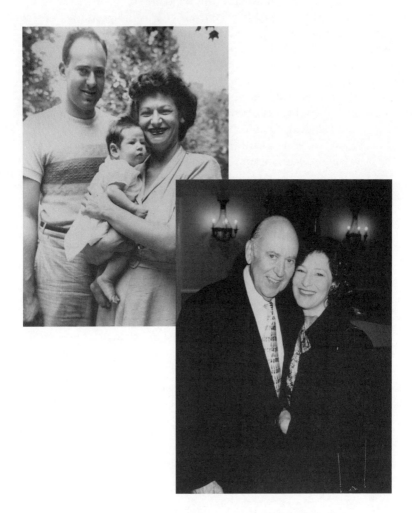

l) Annie Reiner, aged 3 months, with her parents, Carl and Estelle Reiner. New York City, 1949

r) Annie Reiner and her father, Carl Reiner Los Angeles, 1997

What I've Never Said

Annie Reiner was born in NY in 1949. She is a poet, playwright, painter and psychotherapist, and a few other things which don't begin with "p." Her works include *The Naked I* (poems), *This Nervous Breakdown Is Driving Me Crazy* (short stories), and four children's books. She has lived in Los Angeles since 1960.

Carl Reiner was born in NY in 1922. He is a father, husband, actor-writer-director. His endless list of credits includes *The Dick Van Dyke Show* (TV), *Where's Poppa* (film), *The 2000-Year-Old Man* (records & CD), *Enter Laughing, Continue Laughing* (books), and—in collaboration with Estelle Reiner—Annie, Lucas and Rob.

CENTURY CITY HOSPITAL

To Dad:

For a child, life is on the line
all the time.
There is so much to say about those days
of magic and pain,
so much to say
about the silent spaces of love
whose fine music is too highly tuned for our ears,
so much to say
that cannot be said, anyway,
but there is no time now
for sentimental musings.

So many legacies,
so many dreams you gave me,
so many moments in your fine mind,
so many book reviews to ignite mine
and movie reviews to pass the time,
so much advice
and lunch
and kisses and hugs.

So I sit here
beside your battered body
in which your soul is so tenderly hidden—
but not from me.

No time for grief
for grief is a heart empty as the Grand Canyon
and mine is filled with love.
I see your face
swollen and numb as a basketball
with eyes staring blind into space,
and in those spaces
what deals are being struck?
I see you negotiating with angels
and devils, trying to decide
if it is time.

I advise you to stay.
There's so much more for you here—
can you hear me?
I guess you do
in the soul that never dies,
for you decide to stay alive in space and time,
in the body your parents gave you
within love's body, always new
and like you—
clean and snappy as light.

A family's love is one light
reflected through a prism,
and we are each refractions
off the facets of each other's mirrored souls.
In the dark, our true light,
unknown and centuries old
explodes from our nuclear core
to shine beyond each of us alone.

You belong to the world—
we all do—

but we won't let you go—
not yet—
we need you
and will help you through.
We will help each other
let go of each other
and hold each other tight,
the better to embrace the light.

I love you —
Annie

SCOTT RUSSELL SANDERS

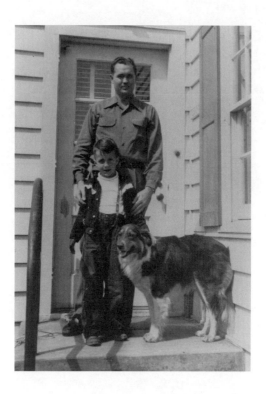

Scott Russell Sanders with his father Greeley Ray Sanders and dog, Rusty. Ravenna Arsenal, OH, May 1, 1951

"We're on the back steps of the house in the Ravenna Arsenal in Ohio, where we had just moved from Tennessee only a few days before."

Scott Russell Sanders was born October 26, 1945, in Memphis. Author of twenty books, including *Staying Put* and *Writing from the Center*, and winner of a Lannan Literary Award, he is Distinguished Professor of English at Indiana University.

Greeley Ray Sanders was born April 25, 1916, in Aberdeen, MS; he died February 8, 1981. Reared in the South, married in the North, he worked in farming, carpentry, and manufacturing, from the Gulf Coast to Canada.

FATHER WITHIN

Fifteen years after your death, you still reach through my hands whenever I saw a board or stroke a horse or plant a tree. Your country sayings rise to my lips: bright-eyed and bushy-tailed, busy as a one-armed carpenter, meaner than a junkyard dog. When I drive the back roads, my gaze goes where yours used to go, over the fields to see what's growing, into the woods to inspect the trees. Like you, I admire well-kept farms, tight fences, black soil plowed on the contour, horses in long grass, equipment in sheds out of the rain, and the sheds cleanly painted. I don't actually taste the dirt when I come to a new place, the way you did, because my tongue wouldn't know how to read the flavors; but I often take a pinch of dirt in my palm and stir it around and lift it to my face for a sniff.

I'm as old as you were, Dad, the year I graduated from college, old enough to see my body following after yours. Thinning hair, thickening waist, scarred hands. My back gives out now and again, the way yours did, from too much lifting. My shoulders ache. Your tricky knee was the left one, as I recall; mine is the right. The nose I see in the mirror when I shave may not be as flat as yours, broken seven times in boxing, but mine, broken only twice, is just as crooked. I remember noticing how veins showed like a map of rivers through the pale skin below your ankles, a surprisingly tender spot for a man so tough, and now I see the same pattern in my own feet. The same calluses, too, from our habit of going barefoot in summer.

You valued toughness. So when the pony bucked me off, I climbed back on. When the bully knocked me down, I staggered to my feet. I learned to shrug off cuts and scrapes. "Nothing that won't heal," you'd say. After a heart attack nearly finished you when I was seventeen, you never mentioned it, not once. You never complained of injuries or fatigue, never talked about your feelings at all. There I haven't been able to follow you, for when I cross a limit of worry or pain, words begin to leak from me, onto paper, into the air.

Because you scared me when you got mad, my temper isn't as hot as yours, but many of the same things get my goat. Laziness irks me, and so does sloppy workmanship. It riles me when somebody else isn't pulling his load. I hate cheats and liars, shoddy materials, and frills. I hate being late. Like you, I figure everybody ought to be ready

to go when I'm ready to go, so I'll stand at the door, tapping my foot, saying, as you did, "If you're waiting on me, you're backing up."

I'm still confused about God, as you seemed to be, but I know for sure I mistrust those who claim to speak in God's name, especially on television, especially when they rant and rave and beg for big donations. "He's phony as a four-dollar bill," you'd say, waving a screwdriver at the screen, "crooked as a dog's hind leg." I don't like people selling me things, over the TV or on the phone or in stores. I don't like shopping, either, except for books, which you never much cared about, and lumber and hardware and tools, which you cared about a great deal. I twitch under the weight of owning things, which reminds me of how you seemed to carry house and cars and appliances and furniture on your back. When I get irritated by the latest corruption or cruelty in the day's news, I remember you grumbling as you read the paper, the way you folded each page in half with a knife-sharp crease.

You never swore in the house, and rarely swore when you knew I was within earshot. When I came dashing into the shop or barn, though, sometimes I'd hear you cursing a broken tool or stubborn pony. Then you'd cock an eyebrow at me and say, "Don't you go telling your mother. I was only exercising my vocabulary." I heard plenty of swearing at school, in locker rooms, on camp-outs, but none of it matched yours for music. Mine doesn't match yours, either, which is why I swear only as a last resort, when I've run through the rest of the dictionary.

I got in trouble for reading the dictionary, remember, when I drove a forklift at the plant in Louisiana, and things were slow on the graveyard shift, and Webster's was the only book available. I know it puzzled you that I was always reading. "You're going to wear out your eyes," you'd warn me. "Watch you don't fill up your head with words and squeeze out the sense." All I ever saw you read were newspapers and woodworking magazines and how-to books, and even then you never stuck at it for long. You'd rather be running a lathe or a bird dog than sitting in a chair and running your eyes over print. My own books began to appear only after you died, so you never knew what I was up to all those years with my scribbling. Since I took up this trade, I've always wanted my writing to satisfy you, as someone who liked things honest, solid, and plain.

To remind me of how you insisted on making everything plumb

and true, I keep a wooden carpenter's level with brass fittings on a shelf over the desk where I write. Because the shelf sags a bit under the weight of books, I slide the level back and forth until I find a spot where the bubble rests between the marks. On the same shelf there's one of the miniature wheels you made for a wagon. I often gaze at it when I'm supposed to be writing, and my thoughts are wandering seven directions from Sunday; it steadies me to see those twelve spokes converging on the wooden hub. Beside the level and wheel, I also keep one of the walnut jewelry boxes you made, the top inlaid with contrasting grain, and inside the box I keep the buckeyes that were in your pocket when you died. The buckeyes are dry now, hard as the nubbins of bone that showed up in your ashes. I finger the shriveled seeds every once in a while, like beads, hoping they'll keep my hands free of arthritis as you promised they would.

I'm still filling my head with words, as you can see, yet there's plenty of room for memory, if not for sense. Even though I've given up fishing since you died, I watch for likely holes in rivers and creeks. When I see branches drooping over a bank where the water runs swift and cold, I think, "Dad would love to wet a hook there." Though you taught me to aim a BB gun when I was five, gave me a rifle at eight, and took me hunting with you at eleven, I never would shoot at pheasant or rabbit, squirrel or deer. That also puzzled you, I know, why I never became a hunter or a fisherman, just as it bewildered you how a boy reared with a gun in his hand could refuse to fight in Vietnam. "A pacifist?" you said to me when I told you of my decision, "where'd you ever learn to be a pacifist?"

I learned it from you, indirectly, because you taught me to search my conscience before I acted, and to stick by what I found there, no matter what other folks urged me to do. Like most of the standards I inherited from you, that one is too hard for me some of the time. Yet even when I ignore my conscience, I usually know what it's saying, and what you would say: "Why'd you think the Lord gave us a backbone? To hold up a hat?"

There are deep ties between us, you see, however different we might appear on the surface. Although I carry binoculars in the woods instead of a shotgun, I love to stalk animals as much as you ever did. My business may be stories rather than tires or bombs, yet I make my living mainly by talking, just as you did. Whenever I get the chance I use my hands. I'm not half as skillful as you were, but I, too, build sheds and shelves, fix broken machines, putter around the house and

yard. Because I'm warier of strangers than you were, I don't pick up hitchhikers on the road or help stranded motorists, but I wince with guilt as I pass them by, and like you I help my neighbors and friends as often as time and strength will allow.

I'm about ninety percent vegetarian, which would have baffled you, yet I eat with relish many of your favorite foods—watermelon, cornbread, fresh green beans, black-eyed peas, hominy grits, cheddar cheese, any kind of pie. On the other hand, your fierce appetite turned me away from smoking and drinking, the two poisons that I figured would kill you, and that finally did. Again and again in photos, a cigarette dangles from your hand. When I turned sixteen you told me I could smoke if I wanted to, but only if I was a fool. You'd started puffing at twelve, to ape the older boys, and by the time you knew better the hook was in you so deep you'd never be able to pull it out. The hook of alcohol was also deep in you, but that you wouldn't confess, not even when I caught you tipping the bottle to your lips in garage or basement or barn. "What whiskey?" you'd say in blank astonishment. "What wine?"

I never knew you to lie about anything else. Having come to the age of hard questions, I wonder more than ever what drove you to drink. I can't bring myself to believe it was only a chemical fix. Addiction is powerful, I realize, but so were you, strong-willed and stubborn. Even as a boy I sensed there was a hunger in you, an emptiness that you tried to fill with liquor, with cigarette smoke, with gambling at cards, with boxing and fast cars, with tinkering in the shop. Now I'm sure there was a hunger in you, because I carry my own dark craving. You were silent about your fears and confusions, so I speak about mine. I fling sentences at the ache, stretch a web of words over the emptiness. What gnawed at you? What woke you before dawn and sent you prowling through the house? What made you doubt yourself, a man with more talents than time?

I suspect your doubts had something to do with being near the last of eleven children, with coming from the country and marrying a Chicago girl, and with moving north from Mississippi at a time when all white southerners were presumed to be racists. You had the best practical intelligence of anyone I've ever known, you were state champion in mathematics, you could decipher repair manuals written half in gibberish, and yet you apologized for not graduating from college. "Would you believe, there's people working alongside me with graduate degrees!" you said uneasily. I earned the degrees for you, working

my tail off, riding scholarships through famous universities where you could never have afforded to send me; yet all these years later I keep studying, keep writing, more than ever convinced of my ignorance.

In all of these ways, and more, I carry you inside me. I've also met you outside, moving around in this fleshy world. For several years after your death, whenever I saw a hefty man with blunt fingers and rust-colored hair, my heart would leap. Mind knew better, of course, but heart wasn't listening. I've tried to cure myself of seeing you on the street, because, after the leap of illusion, it hurts to fall back on truth. The truth is, you're never going to lay your arm across my shoulders again. You've been exiled from the land of touch.

Strangely, I don't feel the pain of loss when I meet you in the eyes of a buck staring at me across a meadow, in the cry of a red-tailed hawk circling overhead, in the twisted limbs of a white oak, in the stamp of a horse's hoof. It's as if, having worn out your old body, you can only stick around by changing forms the way shamans do. So steady in life, in death you've become a trickster, like Raven or Coyote or Hare, flowing on in shape after shape.

I never know where you'll turn up next. Jesse and I were backpacking in the Smoky Mountains this past August, not far from your Mississippi stomping grounds. He was barely three when you died, your fourth grandchild, so he remembers you only through family stories. As we made camp in a grove of hickories and oaks that you would have admired, I was telling him about my own hikes with you. Then along toward supper time, the sky turned dark and ornery with a coming storm. Before the rain hit, we decided to rig our ponchos into an awning to cover the stove. In order to reach from one tree to the next, we needed to tie a pair of ropes together. I knew the best knot for the job was a sheet bend, favorite of sailors and weavers and farmers, as you explained on the day you taught it to me. I hadn't tied one in years, and so long as I stared at the ropes I couldn't remember how. Then I shut my eyes and my hands began to move; when I looked again, there was the knot. Jesse and I stayed dry under the awning. After we ate, he asked me to show him how to tie a sheet bend. So I did, and there you were again, reaching through my hands, reaching through his.

Scott

STEPHEN SANDY

l) Alan F. Sandy
 northern Minnesota, ca. 1935

 r) Stephen Sandy
 Cambridge, MA, ca. 1983

Stephen Sandy was born on August 2, 1934, at Eitel Hospital in Minneapolis. His poems have appeared recently in *The Atlantic Monthly*, *The New Yorker*, *The Paris Review*, *Western Humanities Review*, *The Yale Review*

and other periodicals. His translation of Horace was included in *The World Treasury of Poetry* (W.W. Norton, 1997). His latest collection, *Black Box* was published in 1999 by LSU PRESS, which will bring out his long poem, "Surface Imrpessions," in early 2002.

Alan Sandy was born in 1892 in St. Paul, MN, to parents of Irish Catholic descent. Alan went to school through the eighth grade (1906, the end of his formal education). By 1908 he was working as a stock clerk in a hardware store; soon he started a garage in a barn. In 1917 he enlisted in the Navy. After the war he returned to Minneapolis for work at Dayton's. He founded a women's apparel company and spent decades in the dress business. Briefly, Alan had been a professional dancer; when he was choreographing a show at the university, he met and soon married Evelyn Martin. Deciding not to spend life running any business, in 1952, Alan became a salesman. He read widely in (among others) Boswell and Shakespeare. These writers Alan read with zeal, memorizing (and often delivering) long passages. He died at 94 as the result of a stroke incurred after tap dancing on New Years Eve.

LETTER TO MY FATHER: DECOY

1

With son and father talking, it's no trouble
killing time. The duck with glass eye stares,
shellacked, between us on the carpet; gift
of old Ted Freeman, who years ago skinned off
the painted feathers (where now we see a great
lead slug wedged in for ballast) and christened it
a doorstop. Once more you're praising me for what
I hardly possess and—out of modesty
or guilt; or truth—stoutly deny. So why
are we talking about poetic meter and
poetic form? Our lives are late for *belles lettres*.
We've known each other thirty years and more.
Was it so hard so long to show some life?
But you will inquire again about rhyme scheme,

what rhyme is, honestly now, beyond the sound.
I will respond, rhyme is as when your thought
resembles a thought your father had, just as
though my face is mine, all see my father in it.
I might tell you a rhyme is when a man
becomes a father, but then you will say something
about a scheme, and have me falling silent
and watching my daughter, now playing with the duck.
The mallard's a doorstop, but truly it had been
a decoy, "perhaps a Joe Lincoln," people said,
and, had it not been stripped, today worth thousands;
not one of those replicas machines engender.
You quote me Shakespeare and Sam Pepys; your art
of conversation highballs past midnight through
the room, the green-eyed mallard on the pond
of carpet by your grandchild, exhausted girl,
in sleep touching her imagined bird.

2

We did not turn (this was my dream) to drive
around the block and back to our front door
but veered into a wood, bucking the curb
into the dark, where soldiers of the Great War
stole past us, benighted silhouettes alive
with strobelike backflares, wary not to disturb
a wire or the superb composure of a mine,
a quiet kindled by the whine
of an occasional artillery shell above.
You drove smoothly as ever, cognizant of
each chuckhole; tightlipped, intent, cruising along
without speech for love
or me—into that stealthy, helmeted throng.

3

Snow fell at length
like a gift
to cover
your journey; the worn

hermit post; your
path in time.
More to fear than this
brief time to break

camp was that
last encounter shaking
hands by the shaded
lamp; briefly your

boy making his way
to you and you
man torn then
toward friend

pulling still
with more to fear than
this knowing about
being over, father.

* * *

Dropped in
this field
by love,
which did

not cease
but passed
onward
like a winter

falling back now
down to
the developed
horizon

smoke
beckoning, you
rise at hand
pinching my sleeve

with nailed
fingers numb
and move
around my

attention now
like the sparrow
hawk, high
out the window,

slowly
circling the forenoon
of small shadows;
high noon

that illustrates
the white
hoard of your home, your
high headland.

GREG SARRIS

(l) **Greg Sarris** was born February 12, 1952, in Santa Rosa, CA. He is a professor of English at UCLA and the former Chairman of the Federated Coast Miwok Tribe. He is the author of several books, including *Mabel McKay: Weaving the Dream*, and the novel *Grand Avenue*, which he adapted for a three-hour mini-series on HBO and co-executive produced with Robert Redford. His latest novel is *Watermelon Nights* (Hyperion 1998).

(r) **Emilio Hilario** was born June 30, 1930, in Los Angeles, CA. A professional boxer and later a salesman, he was an angry man who died of heart complications at age 52 due to chronic alcoholism. He had several tattoos on his body, many of them simply the number "13."

YOUR BLUE-EYED SON

Dear Father,

What to say? How to say it?
I only know things about you, stories people have told me. Because I never knew you. You exploded, undid your raucous life, freed your bound heart, only three years before I would have shook your hand, hugged you, maybe, and said, Dad, here I am your first son.
Things: boxer, frozen fish salesman, drunk.
Anger colored so much of your life; and color had so much to do with your anger—your color! Born: Emilio Hilario; father: Filipino; mother: Mexican. And already the lies, the burying of the past, that which only plagues the heart, was started. Because your mother was not Mexican—oh, maybe she had some of the colonizer's blood in her, say Spanish or Portuguese, the story varies—but she was Indian, born of a Coast Miwok mother. Did she tell the county recorder, or whomever, that she was Mexican or did the county recorder, knowing her to live in Boyle Heights, the Mexican-American community in East Los Angeles, assume as much? When you were born—1930—it was easier to be African-American in the state of California than it was to be American Indian. Like many other California Indians at the time, did Grandma claim Mexican to protect herself and her children? So the lies, the denial, started. But brown is brown is not white. Filipinos couldn't get a marriage license in this country, the antimiscegenation laws were passed; Grandpa had to marry Grandma in Tijuana, a marriage license that was never valid here. And the Mexicans, didn't they work in the same kitchens and fields and canneries as the Filipinos—and the Indians?
Your Spanish name and Latin coloring enabled you to fit in well while growing up in Boyle Heights. But when you moved to Laguna Beach, when Grandpa got a job in the kitchen of that tony waterfront restaurant, things were not so easy. If there was anything to distinguish you before, if your friends at school and neighbors talked about you in a disparaging way, it might only have been to mention, more than likely behind your back because you were a tough kid, that your father was "slanty-eyed" and that your mother wasn't quite

like the Mexican mothers of the neighborhood. Something funny, strange about her, they might have said. Now it was much different; your difference clearly marked by the mere color of your skin. Now you were brown: a monkey, a spic, an injun, a nigger. Until your family arrived, there was only one family of color in the town, a Black family, the town's janitors. Immediately, the school put you back a grade, unquestionably a source of great embarrassment for any adolescent schoolboy of twelve, much less a boy that was brown in an all-white classroom. Angry and frustrated, you sat in the back of the class and carved the number thirteen into your arm with a pocketknife. A few years later, when a chum asked you the question entire town wanted the answer to but none until now had nerve to ask—what are you, anyway?—you answered, nigger.

Still, Father, you blossomed. You grew beautiful for all to see. An unusual and colorful flower in the middle of the garden, a poppy that no one planted. "Dark, virile, dangerous," one of the town's matrons told me. "Unlike the other boys of Laguna Beach, forbidden fruit." An opium poppy. And the girls flocked to you. A superb athlete, you arrived at their front doors in your letterman's jacket, that mantle of victory for any high school kid, only to be told by their fathers, "Sorry, boy, we're not hiring any gardeners. Get lost." These were the same men who exalted you for running the winning touchdown in last Saturday night's football game. But they didn't keep you away; you found their daughters, their daughters found you and five of them conceived your children.

Things: a boxer.

You played football at a local junior college. You played football at U.S.C., one of the first men of color to do so, before you had a quarrel with the coach and quit. Then the Navy and professional boxing. They say you knocked down Floyd Patterson. They say that when you started boxing, your coach had to teach you not to kill. Was each opponent, even perhaps as dark as you, the word "nigger"?

Two of the pregnant women found, or were pushed to, those back alley places, the kitchen tables we've heard about, where they stopped what you and they had started. Three children then: two were adopted out (I was one of those), and one was not, the only one you ever knew on account you were married to his mother for a short while. Perhaps you never learned what happened to my mother, Bunny. She was the one with the big, buggy blue eyes. Remember her? I know you do because she was the one that died.

You went crazy after you heard the news, jumped out of your bed in the middle of the night and ran naked in circles around the house, stabbing at the black air with your first wife's butcher knife. For months this went on. Until booze or time or both intervened. Was it guilt, Mama's ghost you awakened to? The number thirteen or the words nigger, injun? Father, you didn't kill her—something you should have known all along—not any more than I killed her. She didn't die in childbirth; two days after I was born the hospital gave her the wrong type blood. That's what killed her, not you, not me. So my life started this way: mother: Bunny Hartman (Caucasian); father: unknown (non-white). Mama with her short sixteen years forever behind me; and you, Father, fighting the night with a knife.

Your children grew, separate from each other, and all of them, even the one you knew briefly, separate from you. What was to be our legacy then? Father, what was my inheritance? What history? What people?

A poppy. An opium poppy. The exotic flower that nobody planted, that was found instead. It dropped its seeds, cast itself where it was, in a hot and terrifying southern California wind, and started again, finishing what was a long time in the making: a no name no history child.

Adopted. That was the first word I remember hearing. I knew that along with my name. "Isn't he the adopted one?" "Isn't that the one that's adopted?" "Your Mother and Father died in a car accident," my adopted mother told me, "and we took you. That's what adopted means." But I never believed it, not the car-accident bit anyway. Because adopted was more than made-up stories; it was black hair, yes, with fair skin and big, buggy blue eyes. Father, in a family of blondes, it was difference, it was strangeness, it was not like others' stories. And it was my adopted father, who, after finally fathering his own three children, reminded me of these things with those mean drunken words of his: bastard, nigger, freak.

I wandered, Father. Early on I wandered away from the abuse. Somehow I knew Mama was dead; and, you, well, I knew that you were not dead, that you were alive, someplace. I went from home to home. First, a dairy ranch. That was when I was about six. Then a horse ranch. Then the streets. The gang: Mexicans, Indians, Blacks. The White kids called me the "white beaner," the "white spic," not to my face because like you I was a tough kid. *What are you, anyway?* people asked. "I was adopted," I told them. "I don't know." Funny,

Father, here I was Indian and Filipino, and most people figured I was White. Funnier yet, I was related to my Indian friends—even to one of my girlfriends—and didn't even know it. Yes, ironically Mama's mother hid Mama out in Sonoma County, the homeland of your mother's, my grandmother's, Coast Miwok people. I doubt Mama ever made the connection since being Indian was not something you—or your mother—talked about much. Still, I was born in the homeland. Funniest thing of all.

Things: home, stranger.

You knew the streets. Not easy. Rough times, rough ways. I'd look to the night sky and pray to Mama for help. I'd look to every man I met, even some of those I just glimpsed on the street, those with eyebrows, say, that arched like mine, those with a similar mouth or eyes, and whisper: *Claim me.*

Were my prayers answered? Did anyone hear my whispers?

I've had blessings. Mary Sarris, my adopted mother, who had the sense, I'm sure against her better judgment, to allow me to roam, to keep me away from her abusive husband, never asking me to believe even for one moment that that man might be a father to me in any way. And then Mable McKay, Cache Creek Pomo basketweaver and medicine woman, who always reminded me that the world was bigger, greater even than the binds of my own problems, and that those same problems need not be crippling ills, heart-souring poisons, but that, if explored and understood, could be turned inside out, turned into powerful medicine. "Keep on," she told me. "Live the best way you know how. Do good."

And, oh, did I keep on. From nearly dropping out of high school to graduating one of the top ten students of my senior class. From Hollywood pretty boy to Stanford Ph.D. and university professor. Books. Movies. And along the way, I found you, Father; searched long and hard, and found myself at your grave (where you are buried next to Grandma) and listened as your father, my Grandfather, took my hand and said to you: *Rest now, Emilio. Your boy is home.*

I talked to your father, my grandfather. I talked to the son who knew you, my younger brother. I talked to your sister and brother, my aunt and uncle. I talked to your friends. I talked to your enemies. I heard things, the stories. Your great physical beauty and prowess. Your charm and anger, and how in time that anger consumed you, lived like a parasite within you and multiplied until you—the good you—disappeared. Alcohol. Violence. Hatred. Hatred of White

people (even though each of the three women you married was White). All the meanness, the harsh words poured into you, you digested then spit back. You spent so much of your life spitting back.

A poppy. An opium poppy. Strange fruit. The inhospitable climate found its core. I know the frost, Father. I know the rending winds. And I've hit and I've spit. But, like I said, I've had blessings. I can clothe myself against the frost. I can name the rot. It's called separation. Was it Tillich who said separation is sin? Well, he was right. Separation in any form—from the past, from one another, from family, from nature—is sin and only begs trouble, the replication of itself in the most heinous and often unsuspecting ways. Everybody loses. Nobody wins. It's an unchecked virus that spreads and spreads and dies only with its host, life itself. We deny it and that way give it life. Sure it comes from the outside, but we take it into ourselves also. We catch the virus, give it new form. Look at the stories. Look at our story, Father: from the missionizing Spanish colonists, who were the first to work so hard at taking us from ourselves, to a no name no history baby in a hospital nursery.

Could've been the end, mission complete. But I fought back, stood out the cold frost then climbed aboard the hostile winds and rode them back to the empty place of their origin. I went back to the garden where you grew strange and beautiful, I went back to the lies, the burying of truth; yes, from the word "Mexican" on your birth certificate to the first time one of our great-great grandmothers referred to her Mexican captors as "the higher people." And I've gone forward. My books, my movies, my classroom lectures, my politics (Father, I've been elected chairman of our tribe three times!) work to cross the vexing chasms in our lives.

You were sick and unhappy at the end of your life. Alcoholism and heart disease. You fought with your last wife. "I'm going to kill the White bitch," you told your cousin who still lives in Boyle Heights. You hated Whites, hated your neighbors, hated this group and that group of people. You detested the faggots in town. (It was said that when you were young you hustled the gay men, took them under the pier, then beat and robbed them.) You never left Laguna Beach, the town that was so hard on you. Of course I know why. It's how you and I, indeed so many of us, *know* home. Only by hurt, separation. And then, when you were fifty-two, when I was but an hour away by plane and just three years from finding you, you broke, ended. "He made a loud, heavy sigh," your last wife said of your passing. "It was frightening, wordless." Yes, that darkness. The space between us. My legacy.

But, Father, I'm talking.

In 1974, the year you had your first heart attack, when you were forty-four years old, I took a trip to Laguna Beach. I was living in Los Angeles at the time; that summer, in fact, I took several trips to Laguna Beach. But I am thinking of one visit there in particular. A friend of mine said, "Shit, my father lives in this town. I hope he doesn't see me." I thought of you for a moment, for no other reason than that my friend had mentioned *his* father, but certainly I entertained no notions that you too might live in the town. Truth is, you lived only two blocks from where I was standing at the time.

Where was I standing?

In front of the gay bar. Me, my friend, and dozens of other beautiful beach-tanned gay men. Me: angry, laughing, frightened, bold, in torn Levi's, a white cotton tank top, construction boots, all two hundred and ten muscular pounds of stoned and sexy me, your blue-eyed son. A prince there. A flower. A stud. If you had seen me, if you had looked, might you have recognized something familiar?

I still ask many of the same questions. Sometimes, late at night, I go out and sit on my deck and think of you. I have a wonderful southwesterly view of Los Angeles. The lights are stupendous. I look above them toward the beach and south, and ask: Father, would you claim me?

Greg

HAROLD SCHNEIDER

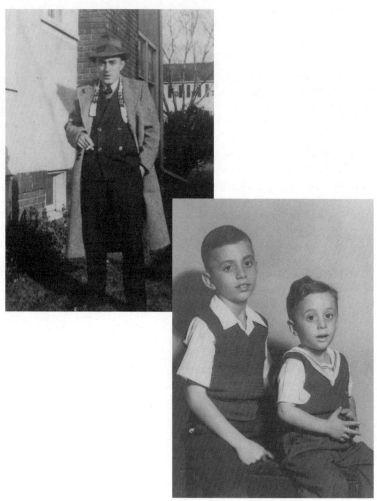

l) Nathan Schneider
Omaha, NE, ca. 1930s

r) Brother Ed Schneider (left) and Harold Schneider (age two)
Omaha, NE, 1947

Harold Schneider was born April 14, 1945, in Omaha, NE. Formerly a lecturer at the University of California, Irvine, where he received his M.F.A. degree, Harold is now Professor in the English Department, American River College, Sacramento, CA, where he teaches writing and advises the award-winning *American River Literary Review*. A published poet, short story writer, and essayist, Harold won an Emmy Award for writing the original *Hollywood Squares*, 1974. His teenage son Dylan, a green-eyed vegetarian, thespian, and pianist, spins similes on his index fingers and makes bunnies and door-to-door fanatics disappear in a hat.

Nathan Schneider was born May 5, 1911, in Omaha, NE. Nathan Schneider: connoisseur of gefilte fish and rye toast; wizard of the Sunday pancake; devout fan of the Brooklyn Dodgers in years tobacco juicy and bone lean; riveter in the bomber-building plant, Offutt Air Base, site of Strategic Air Command, World War II; men's clothing salesman (Chamber of Commerce Salesman of the Year Award, Omaha, NE, 1970); sleeper under the tear-white glow of the clock radio; beacon at the bus stop in snowy Omaha, unaware of angels carrying him to the back row.

INTO THE LOVE

Father,

This moment a stranger rides your face, for I have put you in a book, you who walked solitary on the planet into the long room of the next world, and what would you make of a stranger who, this moment, stands in a book stall in Brooklyn, his lips moving these words, your thin life, into his dark heart; or a stranger propped in Ohio against his pillow or his wife, looking you over as if you were a figure in a blue ballet, that blue down wind and sky of a thick tornado; or maybe in a salsa-red dining room south of Tucson, a stranger eats you with his eyes, this precise and hungry moment, his Christ, the one who fondly called you Jew Boy from the cross, leaning from a stale red picture on the wall, also studying this journey, you disciple of loneliness, Father; and what of the other fathers—all those who are not my father, those steel or pallid sticks of men—like the ones in the closing-down barracks of the war factories in the now 1999, those fathers who like you put the last rivet in the Nazis and now put their

lips to this page as if kissing the holy book; those fathers who are not my fathers who tonight will walk your story into the demonic toilets of barrooms or overwrought delis whispering your name *Nathan, Nathan* to the steamy porcelain, *how could you leave America in a hearse? how could you leave us for the lonely table upstairs, and is God your wife? why do you abandon your Dodgers in their sick hour, you who gave your nights and adulthood away to the bedroom radio in Nebraska, the damn Bums forsaking you in the bottom of the ninth, year after year, until defeat propped you up like a display in a coffin for all your sons to see?* for God's sake, Father, will you come down from there! give me the kiss that life squeezed out your soul before I ever flew through you, a seed from the first dark world into the soft woman pocket of the big bang; yes, now that you are dead, I remember you, something familiar about the hum of emptiness; it is the background noise of love; Father, how can I tell you who I love if you turn your nakedness away from me? see, when I shoveled dirt on your grave, I came there to you, I said what we all say in our crazed walk backwards from each other; I just want you back, this moment on the page, *this one*; I won't ask you if your god leads you by the hand of your misery through his solitary city; I will tell you who I love, and you will know that when you gave me life from your brief evening in the one world that matters, you did what a man will do in the universe: and it was good, Father, it is what I tell the strangers about my father, that bewildered by it all, still he fired me into the love, and it was good.

Harold

JOHN SEARLES

John Searles and his father. Seymour, CT, December 1999

John Searles, the son, was born in 1967 in Bridgeport, CT. He is the Senior Fiction and Books Editor at *Cosmopolitan* magazine. He has written articles, essays and reviews for *The Washington Post, Redbook, Mademoiselle, Maxim, Out* and *Jump*. His novel, *Boy Still Missing* was published in 2001. He lives in New York City.

John Searles, the father, was born December 30, 1946, in Sanford, ME. He was in the Navy for four years, then worked at Electroloy manufacturing, then as a cross-country truckdriver and now as driver for Dalling Construction. He lives in East Haven, CT.

SECOND LIFE

Dear Dad,

If you could have custom-ordered a son, I know you wouldn't have picked me. You wanted a football player, a mechanic, a beer buddy, a man's man who drove a truck, hunted deer, chased women, kept his mouth shut. Instead you got me: a talker, a reader, a writer, someone who quit the factory job you and Mom wanted me to keep so I could put myself through college, move away to the city and become even more different than you.

Back when I was fourteen, you sat me down to talk about the type of son you wanted me to be. We were splitting wood, I remember, and you shook the sawdust from your gloves and said, "People are saying things about you. And I just want you to know that it better not be true, because I love you, but I could never love you if you were like that."

Even then, in my foggy adolescent mind, I knew exactly what 'like that' meant.

And this is what I thought: "Then you don't love me at all, because if you really loved me, it would be unconditional. You would love me no matter what."

What you didn't know was that I carried that conversation with me like a tiny watch battery powering an enormous time bomb.

Your father doesn't love you.

That's what I thought when I made a mess out of my life with Alysa and Paul.

Your father doesn't love you.

That's what I thought when I met stranger after stranger.

Your father doesn't love you.

That's what I thought when I worked and worked and worked to be successful and prove myself to you.

I am not overlooking the good things you did, Dad. I remember that racing car you helped me build, that advertising project you worked on with me, the year you were my scout leader and favored me over all my friends. I remember once in third grade, I was writing a poem at the kitchen counter and got up to use the bathroom. When I came back you had fixed a line for me—and made the poem rhyme better. I remember one night when you and I drove to pick up Grandpa on Christmas Eve and we talked about out of body experiences, sled-riding disasters and a million other things. I remember when we were obsessed with Mario Brothers and played it constantly together. I remember when I got out of the hospital after my appendectomy and you drove me up to college and waited outside while I took a two-hour exam. I remember that you showed up at my graduate school commencement out of the blue. I remember that when I was a kid you were always the cool father—the one who went on roller coasters, drove a motorcycle, did giant splashy cannonballs in the swimming pool. Even as a child I remember looking at you sometimes and knowing that you were just happy to be alive.

But, Dad, I remember some bad things, too.

Really bad things.

I remember Mom crying endlessly because you were missing, lying, cheating, hiding. I remember holiday after holiday when you vanished. I remember spending endless nights when I was a kid out looking for you—finding you drunk, catching you with women. I remember picking up the telephone when I was 10 and listening to a raspy-voiced stranger tell me that she was your *other* wife who lived in Kentucky and that there was another John Searles out there the same age as me. And worst of all, I remember that night when you dragged Mom by her hair out of a broken car window and held a rifle to her head until I grabbed it from your hands and hurled it into the woods. I remember punching you in the face as you dragged her down the street by her hair. I remember you ripping the phone out of the wall when I tried to call the police. I remember running to my sisters' bedroom and frantically dialing the operator as you beat the shit out of our mother.

I was sixteen that night, dad. Most kids my age were at the movies.

So what do I do with all these memories, bad and good?

Here in the city, almost every person I know lets the negative outweigh the positive when it comes to parents. (I even have a friend who's in therapy because her father was too nice to her.) In their

book: alcoholism cancels out volunteering to be my scout leader, disappearing for weeks cancels out fixing my elementary school poem, and pretending to shoot my mother cancels out everything.

But something in me won't let you go that easily.

And maybe that's what other people reading this letter won't understand.

Despite everything, I know that you do love me, even 'like that.' And you know what? I love you too. I guess that's why I don't think about those memories—good or bad—because they're so intertwined. Instead, when you come into my life, I take you for face value. In the moment only. Partly because I know I can't expect more, partly because I think that may be what works best for two people who are so different. And that's what gives us our second life together.

The perfect example is when my car broke down Labor Day weekend two years ago. I hadn't spoken to you in eight months but when I called, you came. My engine was shot so we left the car by the side of the highway. You were on your way to the stock-car races, a place you had been trying to drag me for years, so you brought me along. You walked me around the track, introduced me to your friends. You explained that the cars were hauled out of junk yards, made fifty times stronger and faster than they were originally supposed to be. There were even cars like my crappy Hyundai back on the highway—only painted bright red and blue, hollow inside except for the roll bars and tangle of seat belts. As we sat and watched those old cars that had been given this unexpected rebirth, patched up, zooming round and round the track, I saw us as other people must have. "There's a father and his son," people might have thought. "It's a holiday weekend and they're at the races together."

For all anyone knew, we were made for one another.

For all anyone knew, it had always been like this.

We loved each other. No matter what.

Love,

John

DAVID SHIELDS

Milton Shields and his son David Shields
Los Angeles, 1965

David Shields was born in Los Angeles in 1956. His books include the novel *Dead Languages* (Graywolf Rediscovery paperback reissue, 1998) and the nonfiction work *Remote* (Knopf, 1996). His most recent book is *Black Planet: Facing Race During an NBA Season* (Harmony/Crown Random House, 1999).

Milton Shields was born in 1910 in Brownsville, NY. At age 89, he is a sports reporter for the *Foster City Progress* in the San Francisco Bay Area. In addition to being a newspaper writer and editor, he has been a minor-league umpire, union organizer, and director of the San Mateo, CA, Poverty program.

LIFE & ART

Dear Dad,

After our phone conversation last night—in which you said, apropos of *Dead Languages* and the "uncomfortably close" resemblance between yourself and the character of Teddy, that your pride in my accomplishment was at least matched by your anger and shame at seeing your foibles publicly paraded—I thought I would sit down and try to write to you some of my thoughts and feelings about the relationship between "real life" and fiction. Your response to all of the following may only be (though I hope it isn't): "Methinks he doth protest too much."

Any novel, no matter how autobiographical—and mine certainly looks plenty so—is a verbal machine that wants only to function, and the writer will do everything he can to get the book to work. More specifically, it seems to me that a writer uses a combination of characteristics from different characters or character types—based on memory, imagination, popular mythology, and his own odd will—to create "characters," who are pieces of language that the author wants to work together in a way that makes a meaningful puzzle. "Yeah, yeah," I'm sure you're thinking, "but how would he like it if I wrote a book in which all his most embarrassing moments (e.g., Lido Isle, summer of '55) had been resurrected for all to see?"

One of the things I've learned about writing a novel is that once you get certain characters and certain relationships set up, it's virtually impossible to alter these relationships or change these characteristics in any significant way. Once you put a character on a particular path, e.g., Teddy suffers from bouts of manic-depression, that's sort of what he tends to go on being throughout the book. The rhetoric, grammar, and coherence of the book demand that. I mean the portrait of Teddy (of you) as a sympathetic one, and I hope that comes across—the ferocious identification and empathy between Jeremy and Teddy. Some of my favorite scenes in the book—Jeremy observing his father at the dinner party in the opening chapter, Jeremy buying his father a lime Sno-Cone, Jeremy going to Montbel to tell his father that Annette has died—are pretty much, so far as I can tell, love letters from me to you.

What I've Never Said

Novels, at least the ones that I seem to want to write and read, are about problems, failures, pain, and so when I wrote *Dead Languages*, the characters tended to take on the one most problematic quality of members of my family as I remember them from my childhood. The dominant trait of each character in the book—in some ways almost the only trait of each character in the book—is the one that stood most powerfully to me as the symbol or symptom of some sort of tension: my stuttering, your manic-depression, Mom's obsession with political causes, Paula's struggles with her weight. The imagination—my imagination, in any case—feasts on one quality, takes that one quality and can't let go. All good novels are about fully-dimensional characters, and yet there is something, it seems to me, of the cartoon to all memorable characters in fiction.

Maybe I'm just not a good enough writer yet to create fully dimensional characters; maybe it takes an exceptionally talented or experienced or mature writer to create characters who are not only interesting but also not always pained; to show them in their happiness and fullness and glory, and yet not sentimentalize them, either. Maybe writers cartoonize what they can't fully understand.

I've tried to cut a subjective swath through my own patch of experience, as any writer must do, and I hope I haven't harmed anyone in the process, particularly you. Because this is a book about inconsolable pain, the portrait of Teddy leaves out many of the wonderful times and good moments and full feelings. I needn't tell you—or maybe I do, but certainly you must know—that I love you with all my heart and soul for all the love and support you have given me, all the nourishment and encouragement, all the laughs and discussions and insights, all the jokes and games and tears and tribulations, all the complicated, joyful, mysterious legacy handed down from father to son. If I didn't get all this into the book, it's because I'm not a good enough writer yet.

Love,

David

LOUISE FARMER SMITH

Louise Farmer Smith and her father, James Luther Farmer,
waltz at her wedding
Norman, OK, July 3, 1965

Louise Farmer Smith was born in 1940 and educated at the University of Oklahoma and Yale University. A 1995 PEN/New England Discovery and 1996 winner of the Antietam Review Fiction Prize, she has published stories in literary journals including *The Virginia Quarterly Review*. Her novel, *One Hundred Years of Marriage*, is nearing completion.

James Luther Farmer was born in 1915 in McAlester, OK. He is a graduate of the University of Oklahoma, a veteran of World War II and Korea, as well as an engineer and manager for the Oklahoma Gas and Electric Co. He lives now with his wife, Virginia, in a retirement community for army officers near Washington, DC.

MEMO

TO: Daddy
FROM: Louise
RE: the car
MESSAGE: You're grounded!

That 1985 Crown Victoria, 4 door, leather seats, extra chrome you've been treating like a bumper car has been 3 x 5 advertised, test driven and sold to a V-8 craving nostalgia buff.

And where'd this girl get the nerve to blackmail and bamboozle you out of your wheels? Not from your gracious wife, that velvet-tongued artful dodger who loved those leather seats, who said getting into my Honda was like trying to scoot across Velcro, who for years actually told you what a good driver you were. No, that veil-tosser never held with standing toe-to-toe. Hers was the Old School of Coo and Cajole.

I learned nerve that afternoon I visited your office when I was just 16, a newly licensed driver wearing high heels to pay her Daddy a visit. Something in the standard father-daughter gears shifted, and you couldn't sit still at your desk. You introduced me to everything that moved, got me a Coke from the little cooler in the back, told everyone how I played the cello and sang in the choir and went away to music camp. You demonstrated the new light fixtures like I was Princess Elizabeth inspecting the Armory, like I was some rare creature that only flew in once a year, not just your oldest girl.

There in the office like a secret between us, I became a powerful somebody. That's where I got it, that nerve to stage a high-handed generational flip and take your keys away. Only this is forever, Daddy. Your behavior will not improve. Life slides further out of your grip and into mine. I'm stuck on the parent side of things, and I beg your pardon while I push you around.

Weeze

DONNA BAIER STEIN

l) Martin Baier
South Bend, InN, ca. 1948

r) Donna Denys Baier (Stein)
Kansas City, MO, ca. 1958

Donna Baier Stein was born January 5, 1951, in Kansas City, MO. She now lives in New Jersey with her husband Larry, son Jon, and daughter Sarah. Her fiction and poetry have appeared in *Prairie Schooner, Kansas Quarterly, Florida Review*, and many other journals. She has been a Johns Hopkins Writing Seminars Fellow, Bread Loaf Scholar, and recipient of a Virginia Commission on the Arts grant and prizes from the Poetry Society of Virginia. Her novel *Fortune* won the 1998 PEN/New England Discovery Award and her short story collection was a finalist in the Iowa Awards. She is also an award-winning direct mail copywriter and her nonfiction book, *Write on Target!* was published by NTC/Contemporary Books.

Martin Baier was born December 7, 1922, in Kansas City, MO. His article in the 1967 *Harvard Business Review* first proposed the idea of using zip codes as tools for market segmentation. He is an international consultant, speaker, and educator on direct marketing; founder of the industry's first professional certification program; an inductee into the Direct Marketing Association Hall of Fame; and author of two acclaimed books on the subject. He has been married for 51 years to Dorothy Baier and now lives in Wintergreen, VA.

INDIRECT MARKETING

Dear Dad,

What a pleasure to write you! As the highly introverted daughter of a highly extraverted man, I'm more often passive listener than active contributor when we talk. So this is a gift to me, and I hope it will prove one to you as well.

There's no doubt you've been a great dad, a great man, though I've sometimes griped for more, different, other. Your mind—and its capacity to retain facts, knowledge—amazes me. Your true passion for your work—direct marketing—is awesome to behold. And your generosity—with students, friends, family—is both legendary and truly admirable.

The other night at dinner, Larry and I were telling friends about you: how your love of direct marketing seems a calling. In a business

most people enter in order to make money, you stand out as someone who seems truly driven to first define, then refine, then *share* the process of marketing.

I've hated that at times, felt and still feel deep ambivalence about this, and live out that ambivalence with one foot in the world of advertising and one in the world of art.

I grew up wanting to be a writer. I didn't grow up wanting to be in advertising. But your passion was contagious, even overpowering, to my occasional dismay.

You're a pioneer, the father of zip code marketing, and the father of me. On my piano I have a photograph of you in your Navy uniform. You are so handsome—with your straight white teeth and beautiful smile; alert, engaging and warm gaze. A man I definitely would have wanted to love.

I'm not sure either one of us knew how to let that happen as much as it could have.

Last September, after your bypass surgery, I spoke to you when you were still under anesthesia. I told you the surgery had gone well, that everything was just fine, and you were going to be OK. Seeing you lying there unconscious was the first time I'd ever really glimpsed your vulnerability. The anesthesia prevented you from assuming your normal take-charge, good dad role. I wanted so much to reassure you, and care for you. And because I am someone who believes in what's unseen, I spoke over and over again to your closed eyes and silent face. And, as you proudly told people later, you *heard* me.

The next morning, of course, when I came to visit you, the nurse was already raving about what a great person you were and how much you'd been telling her about direct marketing! You were back to your old self, and yes, I am grateful for that.

Here's what I make of your passion for direct marketing: You are a true capitalist and believe that everyone benefits from an efficient, effective consumer society. OK. I also think that your life-long belief in the power of one-to-one advertising signals something else—a life-long drive to unite two disparate entities. Whether it be marketer and customer, author and reader, father and child, I think that desire to bridge the gap between our separate selves is universal and a task well worth pursuing.

I love your energy and enthusiasm for life.

Here's a poem I wrote many years ago that speaks of the ambivalence an introverted daughter may feel in the presence of a very-present father:

THE BEAR PAW

It stuck from my mouth
like a bristled tongue;
once I left the dream
I knew it was my father.
The name of the animal
and the way it spoke for me,
filling in the o-shaped spaces.

It's impossible to confuse
a true bear with any other animal.
But it took years for me to speak,
always assuming the probing muzzle
and insatiable love of honey
had belonged to someone else.
But he was the one.

And really, bears will eat anything.
Gorge themselves on scooped-up salmon,
grubs, fruits and roots, meat
whenever they can get it.
Think of dancing bears,
membrane-toed polars,
and you'll understand my attraction.

But then those lips and long muzzle,
eating what they shouldn't,
and the assumption I'd like the same diet.
So it took years to speak plainly,
and even then I still tasted wet fur,
understood his heat against my skin.

 Dad, I am incredibly proud and lucky to have been your daughter. God bless you always.

Donna

MICHAEL STEIN

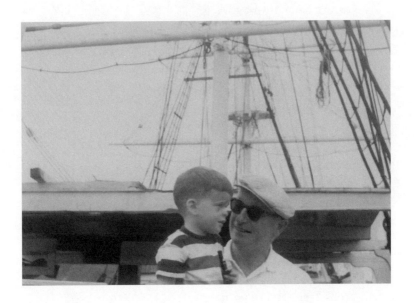

Michael Stein with his father Samuel Stein, ca. 1962.

Michael Stein was born in NJ on January 15, 1960. He is the author of 3 novels, nominated for the PEN/Hemingway and Pen/Faulkner awards. His most recent novel is *The Lynching Tree*. He is a medical doctor, currently Director of AIDS Services at Brown University hospital in Providence, RI. He is married and the father of two children.

Samuel Stein was born on February 10, 1909, in New York City.

A SLIVER FROM YOUR LIFE

Dear Dad,

You would be 88 this year. Thank God you're not. Eighty-eight is too old for anyone. Too many complications, too much sadness unless you're incredibly lucky, and you weren't. At ninety, weight and age moving from opposite directions reach equivalence. I've known only one 90-year-old without serious slippage. And that itself was a problem; his friends were all dying or dead. You wouldn't have been one of those Arizona, pitch-and-putt retirees, all white chest hair, jackass pants and thatch shoes. You would have hung around the east, taking on the New York freeze. Tough guy, carnivore, Bronx-born school teacher, teaching winter a lesson.

Your wife is still here, my mother. Twenty-four years your widow. She hasn't gotten near 88 and her mind is a weakness, although you're still on it. She has few mental means, a failing memory. She has in that brain the young you. Unfortunately, she's not sentimental; she doesn't share. Not that I'm looking only for pleasant stories about you. I'll take the bad with the good. At my age, it's odd that I am asking for stories at all. Sometimes I don't ask; I make the stories up since your wife won't talk about you. I bring her a fiction and ask her if that's the way she remembers it. "Who remembers anymore?" she answers. She only wants to know, often six times a day, who hired the aides hanging around her apartment.

So who can I ask for a sliver from your life? I get tired of running my own memories over and over. I'm looking for someone to trade with me; I'll give you two 1977's for a 1973. Your younger brothers are still alive, sharp, conspiracy-minded, writing editorials to their local papers. To them, you were a hero, a figment, a romance, you were gone from the house first, the smart one, the handsome one, the one with talent. I can't get details. "You want to know about when he was young?" they repeat. "All Steins were born old and sick." They will share pharmaceutical and political advice, not memories. My mother is losing her memory, but they bury theirs. I am a nephew, and nephews aren't worth so much. Last time I saw them, I traded each one an op-ed piece idea for what they remembered of the night

Billy Jean King played Bobby Riggs, the night you died.

Every few years I see a man who looks like you. Looks like I imagine you looked. Having you die when I was thirteen frees me to make things up, as I've said. I have no memory that I have to protect, or hold to. I catch a sharp-nosed profile that looks familiar, a wide-shouldered tall fellow with uneven teeth. I see thick red hair. I look closely at all men with red hair. I feel I've met them before. Is that you in there? The funny thing is I didn't even know you when you had red hair. It was white already. But what I hear from your brothers and my mother is red hair. In my mind, this has been transformed to: All people with red hair know something about you; they are your kin. I want to ask for their memories of you. But I stop myself and just stare. I love red hair on men, women, children. I wanted my children to have red hair. My remaining hair bronzes in the summer sun, but I did not have enough chromosomally to overcome my wife's corncrake black and push my boys toward auburn.

There is really no one for me to talk about you with, so I'm glad to get a chance to write, to catch up. I am done dating, which is the second to last time in life you get to talk at length about parents, the last being when their bodies and minds start to cause trouble. My neighborhood pals care mostly about their kids' interests—snakes, karate, cockatoos—their wives' lost voices, new business schemes, the price of slate, their shade flowers. And the parts of their own parents that are attriting, that require attention—uncemented hips, swan-necked fingers. My wife heard all that I had to say about you when we were dating, and my sons are not old enough to ask much. Your grandsons. Steins. They will get the photos of you, but also photos of me, plus my clothes, stethoscope, bibliography, furniture. Who knows what they'll keep. I will be their burden in this earthly cycle and you will be part of it.

By the time I got married, I had lived more than half my life without you. My new wife missed meeting you by fifteen years. By then, I didn't know where you were buried, couldn't describe what your voice sounded like, wouldn't have even mentioned you during the wedding ceremony. Even then, I couldn't remember details about you. I would sit in bed and try to remember everything that happened one day when you were there. I thought that I could sit down and go backward through a day, all we saw and said and did together. And when I failed at that I tried to remember one afternoon with you, or one morning, or one smell, or one texture. And when I failed,

What I've Never Said

sorrow, which I had always assumed would bring insight, simply became sorrowful. These days, when my boys see me still struggling at this task, heart-wounded, they know to comfort me.

Here is one thing I got from you: I love my sons. This is not unusual I suppose, since it is the primary function of fathering, although differentially expressed. But I love my boys in a way that takes into account your long absence, in a way that perhaps not all fathers would describe: I'm in a rush to love them. I feel the need to squeeze affection into a short space of time. Looking ahead, I am prematurely disappointed that they will grow up. Shameless, pushing, extravagant, I have a love as fast as light. They don't mind me mostly. They say I'm silly, crazy. They haven't learned other words: frenzied, irrational. My sons do not look like you or me, but I adore them. I love when they come into my bed during thunderstorms. I love clipping their nails. I love the way their writing curls. I love kissing them when they're asleep and don't know I'm there. I love the diameters of their wrists and ankles, the pebbles of their vertebrae. I look forward to reading their camp letters.

After they were born, I stopped trying to recapture details of you. It was hopeless; I was tired. Instead, a new and unusual form of memory became available to me. I began to think of those things you had missed doing with me. I began to think about events in my past that you didn't attend, that took place after you died, and I imagined us at them together. Graduations, birthdays, concerts. I didn't miss these occasions; you missed them. So I gave them to you. I imagined activities: the two of us side-by-side pulling on long elastic-ribbed black socks, evening walks to the letter box, helping adjust each others' ties. I simply placed you in scenes I did remember, and I made sure you had a good time.

Writing to a dead person. I feel like Herzog. I rarely write letters anymore. People in hospitals and prisons write letters. Children at camp are under postal orders to get something on paper once a week. If an adult writes to a parent it's usually seeking reconciliation, or money, or both. If an adult writes about a parent, as we near the millennium, it's usually for revenge. I wish I could say that you ended in madness or guilt or bitterness or pure fury, broken from a dark emotional life. I can't. I wish I could say that you left me with moral clarity, with an unshakable faith in something, with old-home quotable prescriptions. You didn't.

I last wrote letters when I was a morbid teenager, after you died.

By morbid I mean I thought too much about you. When I learned what morbid meant, I became a doctor, although now I know doctors use the word differently. Some days I take care of people with red hair, or widows who have grown sons trying to imagine what's coming next, sons who make things up. I take care of 88-year-olds until they've had enough. Now and then I take care of men from New York with exploded hearts. Despite the complications, I try to keep them alive.

Michael

SHARAN STRANGE

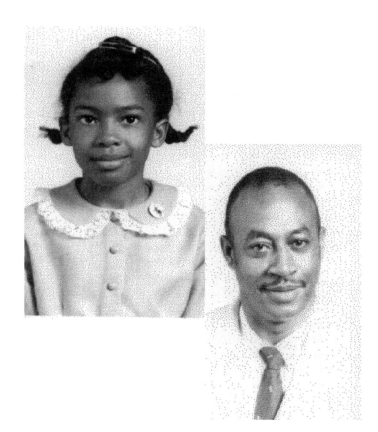

l) Sharan Strange. Orangeburg, SC, 1967.

r) James Strange. Orangeburg, SC, 1976.

Sharan Strange was born May 3, 1959, in Heidelberg, Germany, and grew up in Orangeburg, SC. She was educated at Harvard and Sarah Lawrence Colleges, and now lives and teaches in Washington, DC. Her poems, which mostly deal with her family and childhood experiences, have been published in several journals and anthologies.

James Strange was born July 28, 1930, in Rowesville, SC. He was educated in public schools in Orangeburg County, and received vocational training in several trades, including shoe repair and electrical repair. He married in 1955, served in the U.S. Army, worked at various blue collar jobs and raised seven children. He also hunted, fished, raised livestock and planted. He died on August 28, 1983, in Orangeburg, SC.

IN THIS NOW I AM LIVING

Father,

What are the questions I should ask? If I am to speak to you, it must be with questions, because what are you but unknown. Now, I see you only in dreams; in life, I felt your presence always, yet you curved away from me in some unfathomable arc. Who were you? But I am getting ahead of myself; surely that is as much the last question as the first. Who am I? I am your daughter is merely the first answer to the myriad it would take to resolve that question—as if it could be resolved. A whole lifetime it takes a self to know.

You have become a legend to me. A god. A monster. Larger than life. The giant in my first memory at four (three? two?), towering in a kitchen as I pointed to a single bulb swinging above your head—an image which returns in another memory of you, mother, violence. As with other memories of violence that not even your death could bury. I am small in my pale blue favorite pajama shirt with a horse embroidered on the pocket. How we are ensnared by the past! Your past and mine brought me to this: writing posthumous missives to a man I could never speak to, except guardedly, fearfully.

What is this fear you left me with, Father? I try to be unafraid enough to speak. But fear is my shape. I am so afraid the words will not come. You taught me silence. My life now has become one of letting go of its security. I remember the childish nickname: Skinny-Minnie-with-a-Plenty. You said it to tease me—and praise me?—the rare times I felt what felt like your love. No one knows that this thinness is from a diet of words I had been swallowing whole all my life. Undigested, they won't stay down. And so this bulimic need to

What I've Never Said

rid myself of words I have been eating all my life. Yours and mine. I give them up. I regurgitate words. As if....

You are fifteen years dead. Yet you were dead to me so long before. Who were you? Someone I feared. Someone I killed off daily. A bogeyman, a murderer in the closet. A boy of the South, your dreams of dignity, of being respected, thwarted. A backwoods boy of Orangeburg County, with its pulp novel landscape, defying the sheriff in your Jim Crow childhood. Boy become man of the family too soon. Son of a self-destructive woman who was both terrible and dependent, the woman you tried most to love. And, also: Sonny Boy, drop-dead handsome brown. A soldier. Envied, feared, arrogant, angry. Big Boy, generous, ladies' man, charmer. Man-about-town. Small-time hustler, gambler, drinker. Man's man. Maker. Worker. Killer. Daddy.

I have reached the point where I can look at my life as something whole. Each piece, each phase, of a whole. How do I connect my life to yours? Who have you become in this now I am living? Do I seek you in each failed relationship? Childless me. Is this your legacy, Father? Childless me who adopts others not tainted by my father-blood. Fatherless me who grieves for all loss. Even your loss. Especially your loss. Where are you? Father who could not be approached, could not be known. Made vulnerable by liquor. That was the reason, then, for the anger? So as not to feel vulnerable? Not to be defenseless? Strike or be struck. Hurt or be hurt. Hurt anyway.

Where are you, Father? In me. In my face which each year grows to resemble yours. In my anger that I learned from your hand. If I give it up will there be anything left of you? Here is your daughter, almost lost amid daughters who fought you but learned your words, your ways. I am building a new body, Father. Not shaped by fear. A recovery. Reclamation. What shape could we then become? Self-loved? Hopeful?

I have come to the end, which is also the beginning. Who were you? You were my father—raging, brilliant, thwarted, underloved, bold, fearsome. Who am I? I am your child, still—voiced, learning to trust, forgive. Cutting a new form.

Unafrid,

Daughter

AUSTIN STRAUS

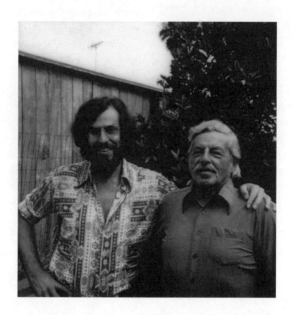

Austin Straus with his father, Frank Straus
Outside the Ocean Beach apartment shared by his parents
Spring 1986, San Diego

Painter and poet **Austin Straus** was born on June 12, 1939, in Brooklyn. His paintings, prints and one-of-a-kind books are in collections including the Sackner Archive of Concrete and Visual Poetry in Miami Beach. His collage, "Rosetta Speaks," was recently featured in "The Next Word" exhibition at the Neuberger Museum, SUNY Purchase, Fall/Winter 1998-99. Over two hundred of his poems have appeared in literary magazines and anthologies including *The Maverick Poets*, *Men of Our Time*, and *Grand Passion: Poets of Los Angeles and Beyond*.

Frank Straus was born in Brooklyn, NY, October 25, 1915, and died in San Diego, CA, on September 23, 1986. He was athletic and played football and baseball. He worked as a mail carrier to support his family, and then for the Railway Mail, taking early retirement at age fifty-five in 1970. He used found objects to create his whimsical "Natural Art." One of his pieces is in the Brooklyn Children's Museum. His poems were published

in many magazines, and his poem "Zip Code 92107" hangs in the Ocean Beach community post office in San Diego. He and his wife, Roslyn, founded the Ocean Beach Poetry Circle. He left behind two sons, Austin and Dennis.

SMALL TALKS WITH MY FATHER
In Memory of Frank Straus

1. An Old Photo

I'm a fat baby
in an oversized bonnet
and I resemble
a girl.

A kindly old couple
beams at me
while you
thrust me up
to the camera

like I'm your record-
breaking
tomato.

2. The Clown

1945
Madison Square Garden

I'm six/first circus/dizzy
vivid colors/horses/lions
trapeze fliers/clowns

I didn't see
the shocked faces,
tears, didn't hear
the sudden silence of
the crowd, didn't see
the sawdust cloud, her
body on the ground

I was there
when the aerialist fell
but I missed
everything

saw only the funny clown
who'd popped up
in front of us, the clown
you pointed to, who
made me laugh

3. The Coach

"Never run in glass shoes,
they might break
if you hit a rock.

Always run forward, never
backwards, so you don't
get squashed by a truck

And be sure to pick yourself up
after you fall down
if you ever fall down..."

Oh coach, you were there
whenever I needed you, like
the time I scraped my arm

What I've Never Said

you drove by in your car
and yelled out as you passed,
"better get that fixed, kid,
you're bleeding!"

4. At the Table

Pass the cliché please...

More nostalgia? one lump
or two?
Needs a bit more ambiguity,
no?

(How your pretentious
chewing of silence
rattles my digestion!)

More cliché please...

How's the broiled
generalization tonight?

Delicious.

Maybe a pinch more
folksy humor?

No thanks, I already...

Mmm, Ma, you really cooked this
contradiction
to perfection.

(How does she stand
those canned
exaggerations,
pontifications
made from concentrate?)

A toast
in hackneyed liquors!

To your long and happy
soggy
piecrust!

Anybody want the last
piece of
cliché?

5. Cemetery

flat field, scattered trees, no headstones,
some plaques and markers, flowers
in bunches, a February breeze
riffling petals, leaves, grass, ladies'
hats, my thoughts buzzing around
in the heat like dazed bees, this
sadness a weight, here, at the heart
of daylight, thinking not just of my father-
in-law, deceased, but of you, father,
and myself, the whole terrible/lovely
round that's life and death and sky and grass,
as we bury her father and I remember
you, cremated, gone into the sea,
gone into the moon-driven tides, gone,
and where does life go, so quickly,
so faintly marked, some tears,
all dreams, the flow of hope and love
down into earth and ocean gone
as this hot sun will sink too, a
flaming heart seeking peace,
sink, and die, and rise, and be again
a beating drum at noon.

ARTHUR STRINGER

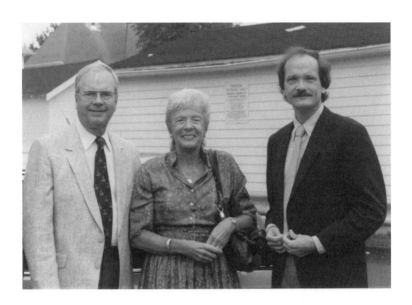

Arthur E. Stringer with his wife Marianne and his son Arthur, Jr. Northern Virginia, 1988.

Arthur E. Stringer (Jr.) was born on March 7, 1949, in Elyria, OH. He is the author of *Channel Markers*, a poetry collection from Wesleyan University Press. His poems have appeared in *Antaeus*, *The Nation*, *Ohio Review*, and others. He earned the MFA from the University of Massachusetts in 1979 and has been studying and teaching writing and literature for over twenty-five years. He is Chair of the English Department at Marshall University, where he lives with his wife, Drema, and stepfathers her grown children.

Arthur E. Stringer was born on February 3, 1924, in Elyria, Ohio. He is a WW II Marine Corps veteran of the Pacific Theater. With luck, he married Marianne Hobert in 1947 and graduated from Cleveland State University in 1948. He spent his career at work for the Bell System in New York and Cleveland, starting there on the day his first child, Arthur, was born. He fathered three more children in the 1950s. In 1982, he retired to a small dream home in Florida where he continues trying to master the game of golf and enjoys married life, family, and long-standing friendships.

REITERATIONS:
A Letter To My Father, With Stories And Poems

Dad:

I see how the days can fall, disconnected. What awakens a man in midlife lies outside the common whirlwind of work and home. Still, there are pleasures to having a son I can only try to imagine through you, whose son I am ever becoming. When we were younger, were the standards of significance lower? My ignorance, surely greater. That other world, rich with connections, crosses into this one, especially when we look back. The nerves and senses dull with age, clearly. We look inside. The mind reiterates.

I had a couple of stories to tell you, now that we're old enough:

I played the game—I take the liberty of saying *played*, saying *game*—maybe two years. You were a patient teacher, even if, at times, an impatient player. Golf can do that to a person. Summer weekends, we walked into the woods together searching for every ball I never kept my eye on, or else, there it was right in front of us, having caromed off oak roots into the fairway a mighty forty yards off the tee. I doubt if anything teaches a boy character better than the challenge of whatever sport his father loves. The laws of nature and the limits of ourselves come instantly clear. We aren't in control, but with skill with practice with time, we might abide the larger game, its unknown rules.

It was a short par four, close to the end of the round on a course called Sleepy Hollow for none of the literary reasons. A deep ravine cut across the fairway, steeply inclined to a plateau fronting the green. I drove it straight and low, about a hundred and fifty yards, and caught the upslope hard just where it leveled out. The ball bounced straight up, but somehow landed clean, an easy iron to the green. I don't remember that shot, though my luck had not run out. For the first and last time in my life, I'm on a green in regulation. At least in this story.

I don't know it yet but it's time for me to quit playing the game for thirty-five years. I guess the lag was long, and I sunk the three-footer

coming back. We were thrilled together.

Many years later, no doubt thanks to the relative calm that settled over my life once I no longer played golf, I evolved this philosophy, for which I here declare my debt to you:

The golf ball is that tightly wound representation of the self which we cast violently into the world—call it intention, call it action. We aim for a goal, the hole, the cup, take our stance, line the body up, think past our training, and feel for the groove of recurrence in this moment in this place. Then swing, and the club face sends the ball into one of ten thousand futures. This one. We follow that dimpled white compression. And swing again. It don't mean a thing if it ain't got that, does it?

It might have been the Tribe against the Twins, 1961. You knew the announcer, Mr. Bob Neal, who invited us down on the field to meet Harmon Killebrew, then at the peak of his celebrated long-ball career. I shook hands with my first genuine celebrity and felt a duller thrill. He wasn't one of ours.

A few innings into the game, we were sitting near the press box. Mr. Neal set me up with headphones to hear his play-by-play on the audio feed. When he started to tell the story, as baseball announcers will, of this young man meeting the great slugger, I got so excited at the words "a look of mutual admiration" that I ripped the headphones off and put them to your ear, probably with some incoherent explanation. By the time you could listen, the story was certainly over—I don't know, I never heard the end.

To this day there must be thousands of northern Ohioans who heard my name. If they could remember, I would tell them it was my father, not the hero, who had planted something then. I've been trying to impress you ever since, or just give one brilliant moment back. I knew you were no fan, no spectator. The whole day was to give me a chance to be a son unlike his father.

Let the truth be told at last: we were the worst of sportspersons. And I am grateful to have been taught so well. Those things which truly matter are not learned in physical competition only. I don't recall the outcome of the game, but we were there together, in the service of good memories.

Later in life we would realize a common interest a good distance from field or fairway: music. If this letter had a score, it would be some recorded version of the blues, the great American tragicomedy,

or jazz, though you'd prefer the melody with the softer edge, the straighter rhythm. Probably we're no different from thousands of other fathers and sons in the phases we passed through: distance, conciliation, respect. The other day I said to another man in middle age—one of those miraculous remarks that emerge from nowhere to surprise you—I said "I now see not how my father misunderstood me, but how I misunderstood him."

I wrote a couple of poems for you, now that we're older yet:

MY FATHER ASLEEP

Evening settled, family chatter over,
my father retired to the news, his body
lying aside, poured onto the couch
as water into a saucer. He drifted off,
he had to, free of parking, of dust of office,
a thousand unnatural shocks
while the clock circled the moon.
We lived it up all through his house.

Now understand, he worked the years
into shadows that I might lie down
his age, exhausted in my own
living room, bathed in the glow
of dramas I search for meaning.
I can't keep his eyes open.

SUNDAY FATHERS

Beside the altar, boys dressed holy,
we sat ludicrous, profound, and saw
the faces promising good. I could not
read them then (and now do not believe).

Father John gestured, spoke of duty
and the letter of the law, the sinner's
consequence, the news that all's forgiven.
Sermon done, we washed his hands.

What I've Never Said

When the faithful knelt before the rail,
tongues extended for the body
of the bread, the word made host,
I held the paten to their throats.

Home after Mass, a boy's literal mind
naturally indulged. Table by the bay
window, pink yolks on a platter, claims
for the comics, the scores, the puzzle.

Dad settles in his chair. His creed
is the world, beginning after breakfast.
Inked fingertips turn pages of news
which crackle as he shifts for light.

A headline, promising good, flags my eye
and I kneel to read, his face hidden
inside the paper, where the story,
between sure hands, has unfolded.

Chips

JERVEY TERVALON

Hillary Tervalon at his son Jervey Tervalon's wedding
Los Angeles, June, 1987

Jervey Tervalon was born in New Orleans and reared in Los Angeles. He received his M.F.A. from UC Irvine and is the author of two novels, *Understand This, Dead Above Ground,* and a collection of stories, *Living for the City*. He lives in Altadena, CA, with his wife and daughter.

Hillary Louis Tervalon was born in 1918 in New Orleans. He served in Iran as a staff sergeant during World War II and returned home to marry Lita Villavaso. He has four sons and four grand children and one great-grandson. Currently, he lives in Chino, CA.

HURRYING HOME

Dad:

Mama said it was your idea to leave me in New Orleans with my Grumma while the rest of the family moved out to California. Though I know you loved me I still don't understand how you could have left me there with my sixty-five year old grandmother.

Was it your idea to move out west? Did Mama want to? Was it an idea which appealed to her? Or did you at that time have power over her that you lost along the way? The mountains, that's what you told me, not like the flat land of Louisiana where you could see the sky curve into the sea, but I don't believe that. You are a creature of the same old same old. A chance? Taking a gamble because you liked the mountains doesn't sound like you.

And even though I was very young I vividly remember the panic I felt when I realized I would be left alone there, a four year old boy frightened of his Grumma's cramped, dark and cluttered but very clean shotgun house and of her relentless prayers all through the evening. I loved Grumma, but she was so old. I was afraid she might die and I'd be left alone in that quiet, little house with the ghosts I knew to be there. At night I listened to her mumbling the rosary, wondering if she'd keep on breathing long enough for you to come and get me like you said you would. After a few nights I decided to run away. Maybe I thought I could find you or maybe I was hoping to make you magically appear. Somehow I ended up under Grumma's house, in the dusty, crawl space. Grumma called my name but I ignored her, even when I heard the anger in her voice turn to anxiety. Night fell. I watched the neighbors walking about, looking for me with their flashlights, calling for me as they searched the neighborhood. Finally a blinding flashlight shone into my hiding place, and a deep voiced, "Here he is," startled me. A big man grabbed my arm and lifted me out of there and brought me to the porch. Grumma flung the screen door open and hugged me. She thanked the man and carried me into the house. But soon as she did, she sat before her shrine, a low chest of drawers with pictures of Christ and statues of

the saints, and her rosary hanging from the side of a mirror. She took down the rosary, and began to cry.

"Why'd you hide from me? You almost broke my heart."

"I wasn't hiding from you, Grumma. I was just hiding."

I felt guilty watching her cry, wondering if I would try to run away again but I didn't have time to plan another escape. You finally arrived to take me to our new home in Los Angeles.

I must have been a happy little four-year-old boy to see you after all those months but I don't remember that. What I do remember is night in Texas, blanket-like black sky shot through with flecks of white, and a road, a ribbon running into the black horizon and the occasional glinting red or green eyes of deer poised on the edge of the highway scaring me so bad you talked about it for years, how I trembled so hard I got you scared, tried to get closer and closer, rooting a space under your arm, that's how scared I was. You knew it and tried to calm me by singing "Deep in the Heart of Texas," as though that gigantic state—blacker than any closet I ever managed to lock myself in—could have a heart.

I thought of you when I left Gina and Giselle for that professorship at Saint Mary's College. I couldn't explain to a two year old that it was only temporary, that her Dad would be back. No, she just cried and cried as I boarded the plane.

She was too young to stage a runaway like I did but Gina said at day care she was inconsolable, and would fall to the floor crying and calling for me.

I don't need the answers I wanted earlier. You did what you thought was best as I had done and we both hurried home to make amends. I quit my job and came back to Pasadena hoping to make up for lost time with Giselle just as you had with me.

I headed home to my wife and daughter along another dark highway, with that song you sung to me thirty-five years before, "Deep in the Heart of Texas," ringing clear as if you were there behind the wheel, with me rooted under your protective arms.

Love,

JOHN THORNDIKE

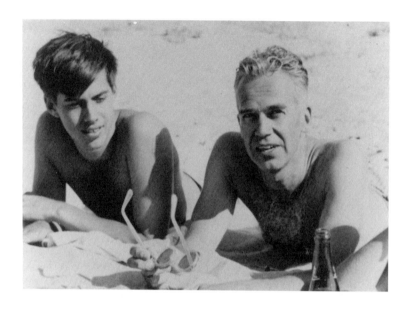

John Thorndike and his father, Joseph J. Thorndike
Sagaponack, Long Island, NY, ca. 1962

John Thorndike is the author of two novels, *Anna Delaney's Child* and *The Potato Baron*; and a memoir, *Another Way Home*.

Joseph J. Thorndike is an editor and writer with many books to his credit. He lives in New England.

BROKEN HEARTS, EMOTIONS AND FEELINGS

Dear Dad,

I know this letter will make you uncomfortable. I also know you'll forgive me for writing it, because no matter what craziness I've committed you have always stood by me. When a New Jersey state trooper busted me in 1969 with a bag of pot and some LSD, you found me a lawyer and never uttered a word of reproach. When I abandoned years of privilege and education to move to southern Chile and raise chickens, you sent me a book on aviculture.

Later, when I divorced my wife and brought my son Janir up to the States to raise him alone, you accepted those choices. You came to Ohio and swung a sledgehammer, driving a hand well for the house I was building. For the next ten years I farmed and laid bricks and wrote novels, and you let me find my way.

But now I want to write about our family: your marriage to my mother, the divorce and her midlife collision with drugs, alcohol and depression. Mom is dead, so I can't ask her about the details. I can ask you, but you don't want to talk about it. You shy away from what Janir calls "broken hearts, emotions and feelings."

Sometimes I ask you anyway. One Christmas I asked, "When did Mom start wandering?" You were carving a turkey at your kitchen table, bent over the browned aromatic breast, paring slices and laying them on a platter. I meant, when did she start having affairs? You neither looked up from the job nor responded. After fifteen seconds I said, "Now I don't believe you didn't hear me."

You went on carving. You said, "I heard you." And that was the end of it.

Every year I bring up her name at our family reunions on Cape Cod. I'm the only one who does. My brother Alan comes with his family, my half brother brings his girlfriend, Janir drives down from his summer camp with three other counsellors. His cousins bring their own young friends, and sometimes a dozen of us sit down to

your corn and bluefish dinners. Every day at the beach we bodysurf, we play volleyball and paddle tennis and "heat-seeking missile." Why worry about the past when there is so much life going on *now*? The next generation wells up behind us, the kids are tireless, after dinner they shoot pool or play ping pong in the garage. It's like the Labor Day vacations we used to spend with friends in Sag Harbor, the very best days of my childhood.

Except Mom isn't here.

More than thirty years have passed since the divorce, and more than twenty since her death. But to me she's dying now, because we never talk about her. Alan says nothing. All his good memories have been overwhelmed by her troubles at the end: the night he came home, only seventeen, and found her naked in the downstairs bathroom, talking to herself and taking a bath—without any water in the tub.

But Alan is securely married. He's devoted to his job and family—whereas I'm still peering into relationships and trying to understand why they don't work for me. I married a woman who went crazy, then fell in love with a neighbor, a woman wrapped up in her own marriage and divorce. That was years ago, but I still don't choose well. I turn away from the women who want me and pursue the ones with secret lives, the luminous hiders. Women like my mother.

Something about your history with her is still awash in my life. Something is out of kilter, and I need to explore it. I know Mom's sensual nature runs in my blood, in equal measure with your restraint. You see it yourself every day, in the smiling photo you keep of her above your dresser, stretched out on a deck chair on the S.S. Cunard, half wrapped in a steamer rug. I have her dark skin and hair, her full lips, her love of warmth and water. And of sex. That's clear in a dozen photos of her, starting with a sultry portrait when she was barely sixteen.

You and I are the same size. Ever since high school your shirts, jackets and shoes have fit me perfectly. One evening during my sophomore year in college, on a visit to your mother's, we emerged from her kitchen after dinner and descended the three wooden steps to the lawn, side by side, both wearing loafers and tweed jackets: one two three down the steps and out onto the grass in precisely the same gait. To this day, no matter how far apart we've lived, I carry in my posture your standards of decency, propriety and respect. Yet now

I'm about to betray the care you take never to hurt or embarrass others, by writing about our doomed family. No matter that it will be a novel, you will recognize my mother.

Some months ago I was attracted to a tall, dark-haired young woman. She was outgoing, smart and accomplished—but after a couple of dates she warned me off. She said, "I like a man who's confident... bordering on arrogant." She already knew I wasn't that man. Like you, I'm too considerate, too polite.

Is that what my mother went in search of? Someone more commanding?

When I tell friends I want to write this book, they often ask how old you are. Their suggestion is clear, that I wait until you die before I write it. But I don't want to be waiting for your death. I don't want to plan around you in any way. I only wish I could protect you and still write what I need to. I'm reminded of that old childhood conundrum: if my house were burning down and I could save only one parent, who would it be? Our house has already burned down, I guess, and you are the survivor. But I want to examine those painful years in which my mother disengaged herself from you and our family. She didn't give Alan or me the attention we needed, and before I turned 14 she sent me off to prep school, where every telltale sensuous response was pounded out of me. Forty years later I've begun to feel the swell of buried anger. I have loved my mother, I've defended her, I've fought to keep her alive in our family. But I'm not blind to her transgressions.

A few months ago I tracked down one of her lovers—call him Julio—and drove to Miami to talk to him about their affair. Few sons want to know the details of their parents' intimate lives, but I want to know everything. We had dinner in an ornate Miami Beach restaurant, we talked freely, at the end of the evening I got back in my van and headed north. I drove half the night, doing eighty miles an hour through the featureless landscape, smashing bugs against the windshield and letting my anger rise. Not at Julio, nor even at Mom for having the affair, but because she had let her affections dry up when Alan and I were still young. That was long before she met Julio—but he had not been the first. Did she fear that if she held her sons, if she took us in her arms and hugged and kissed us, the warmth of her behavior might betray her secrets? That was cowardice.

Over the years I've become a historian. Not one who writes, as

you do, about emperors, generals and industrial magnates, but about our family and its camouflage. I do my research where I can. I worry about hurting you, but I need to know what happened. I don't want to marry another crazy or careless woman.

I tell you all this, knowing you'll question why I have to write about it. You'll be concerned for how my brother might feel, and others in the family. And then, I think, you'll tell me to write the book I have to.

John

ALMA LUZ VILLANUEVA

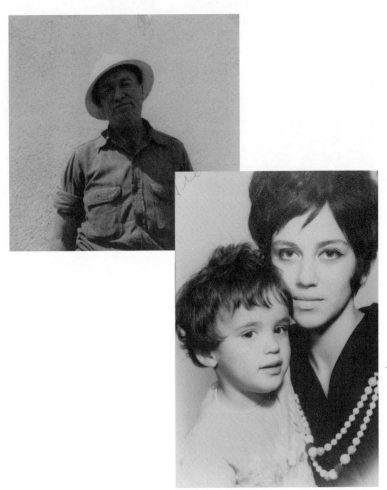

l) "Whitey" (Claire Lewis) McSpadden, working for PG&E. San Francisco, 1956

r) Alma Luz (Villanueva) at 18 years old, with her daughter, Antoinette, age 3, San Francisco, 1963

Alma Luz Villanueva was born in Santa Barbara, CA, October 4, 1944. Her sixth book of poetry, *Desire*, was published in 1998. She has also published novels, *The Ultraviolet Sky* (listed in Penguin's *500 Great Books*

by Women) and *Naked Ladies*, as well as *Weeping Woman, La Llorona and other Stories*.

Whitey (Claire Lewis) McSpadden was born in New Mexico on January 21, 1911, and died January 22, 1996, in California. He grew up in El Paso, TX, ran away from home at 12 to raise himself in the world, took part as an airplane gunner in World War II, and worked for Pacific Gas & Electric for 25 years. He planted his garden every spring, and fed the hummingbirds and every stray cat.

YOU ALWAYS BROUGHT ME WATER IN THE DESERT

*To Whitey (Claire Lewis) McSpadden
born January 21, 1911
reborn January 22, 1996*
"*Like birdsong beginning inside the egg.*" Rumi

I.

Dear Whitey, dear father,

You come to me at sunset, on your birthday;
you, my father, 80 miles away, leaving, oh leaving,
your body (you are not the father of my body,
you are the father of my soul). Your soul comes to

me, I feel it floating in the air, I breathe it in,
tell stories: "He fed me when I was 12 and hungry,
a wild tomboy kid, called me Pocahontas when I refused
to say my name, my grandmother gone, now it was his

turn. He gave me all his money when he drank on
payday (he worked the manholes in San Francisco),
told me not to give it back, even if he asked,
begged, demanded, until Monday morning, so

I hid it in a can, in the dark, in the cobwebbed
basement. Monday, I gave every dollar back. In
return, $20 for the movies, Playland At The Beach,
new tennis shoes, white socks, my first AAA bra.

I stole his Kools, smoked them one by one in the
back row of the movies on Mission Street with
friends, and when boys tried to sit next to me
I'd threaten them with my fists or a burning

cigarette. He gave me his old wool army jackets
(which I loved), loaned me his
fishing tackle, pole and reel.
This stranger who sometimes drank

too much and told me stories of his life—
how he ran away from home at 12,
hopped the rails from Texas to Los Angeles,
leaving his younger brothers and sisters

behind to be beaten; he threw rations to the
hungry children that ran after the jeeps in
World War II: "I ain't never seen kids that
hungry, that kinda hunger's a crime, some

a them carryin' a baby as big as themselves..."
Worked in the burlesque house, the women
let him sleep there, safe, each woman
his dead mother, sold papers on the

corner, ran errands for everyone, the
lively, smart-talking, wiry, towheaded
kid nick-named Whitey.
This generous whiskey in the stomach,

tears in the eyes never falling,
maker of stews, spaghetti, deep-fried
chicken with frozen carrots and peas,
baker of cherry cakes and too sweet

pink cherry frosting, with sweeter yet
blood-red cherries on top, their stems
teasing the air: he was,
oh yes, he was

my father.

II.

You brought the doctor to my bed
when I was 13, when I knew I had
to be a girl, stopped eating, wanted
to die. You brought me soups, juices,

sat while I ate in a silence thick with
words never said, but felt, your
presence. You helped me get my first
apartment when I was 16, your constant

supply of groceries, something here,
something there, to tide me over.
At 17, when my second child was born,
in the projects, I was so ill

you stayed for 3 days, taking care
of me, my newborn son, my 2 year old
daughter (their father gone to soldiers);
I could hear you playing with them,

the soothing comfort of your rich
careless laugh. In the 40 years
I have known you, you never said
the words *I love you* or called

me *daughter* out loud.
No words are necessary in this silence
as I feel your heartbeat in the palm of my
hand; I touch your infant's face (palm to each
cheek); your granddaughter and I change your

diaper for the last time; they lift your body to the
gurney (I hold your knees, the ones you were born
with); I tell the men who will take your body to the burning:
"This is the most generous, most kind man, I have ever

known." I don't say I love you or that you are my father;
they understand this. They know this when I ask (they've
wrapped you, plastic/cotton): "Can I see his face one more
time?" Palms to your old man's face,

I whisper, I love you, go to the light, I love you,"
and I know I said it for both of us,
and I know you were seeking
the light,

father.
The goodness
in you is ripe,
full of creation's song,

wonder: birth.

III.

I receive your ashes, wrapped
in a blue velvet bag;
I hold you in my arms
like a baby, carry

you to my car, take
you home. Your ashes
aren't ashes but white
ground crystals, specks

of darkness. Your bones,
your secrets (light and
dark) are safe with
me. I measure a cup,

What I've Never Said

dig into your apple tree;
every year you turned the
soil in spring; now you
are the soil, bud, blossom.

The apple. Ripening. Into summer.
I place your crystals in my
bedroom. I dream of mountains,
eagles, the deadly, life-giving

Sun. I release your measured
crystals into a stream where egrets,
herons, wild ducks find sanctuary.
I weep to see the spray of light,

glowing, the dark, wet bank,
the softly flowing water
so close to the sea. High tide
greets all life here; how beautiful

your light, exposed to earth, creek,
sea, swirls of wind and rain (when
I return 2 days later, I laugh to find
a mess of beer bottles, an entire bottle

of Jim Beam whiskey, your favorite,
empty). Later, my daily morning rock,
the highest tides engulf it, today
not quite. Measured cup in hand, I climb

lower to meet the sea, spray wide,
showering sea, mostly stone. I feel
foolish, having missed the sea;
I sit and stare at my mistake;

anyone can see your crystals,
the light, the dark.
Shame, guilt, sorrow, that's me,
until the rising Sun strikes

stone, and I see your crystals
love the stone, they marry;
the sea explodes with life:
I see it: all life has come to bear

you home: the celebration.

IV.

Once, when you were drinking,
you told me (at least 20 years
ago): "you always brought me
water in the desert."

You were born in the desert.
Your mother's name was Claire
(a piece of paper tells me).
You were born: Claire Lewis

McSpadden. Claire. Clara.
Clarity. A feminine light.
How well you hid it. But not
from me. This summer

I'll take a measure of your bones'
crystals (a measure I'll keep)
to my sacred granite lake
in my mountains, where my eagles

know my voice and shadow,
my feminine light.
When I call,
when they come,

I will give this last measure
to the mountain, to the lake.
You loved these places as a young
man, and you always wanted to return,

What I've Never Said

I know. A dream: You're young,
in your Army uniform, you're so very
handsome, your spirit entirely intact,
you're standing on a field, smiling,

arms waving with excitement, waving
in your plane. "You always brought me
water in the desert."
These are the words

I'll say to the eagles,
to the lake, to the Sun.
Now I understand, father.
You always loved me

in that desert, Clare.

<div style="text-align: right;">Your daughter,

Alma (Pocahontas) Luz</div>

CONSTANCE WARLOE

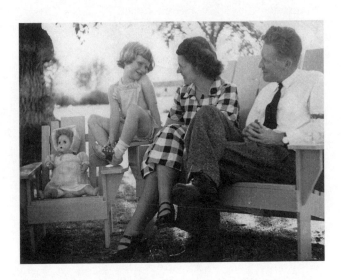

Constance Bower (Warloe) with her mother Mary Elizabeth and her father Harlan Bower. Missoula, MT. Summer, 1949

"This was taken at the University of Montana faculty housing area, located outside of Missoula near the Bitterroot River, at what had been a military installation called Fort Missoula."

Constance Bower Warloe was born on December 25, 1944, in Charleston, WV. She is the mother of twin sons, and stepmother to three daughters, one of whom, Delerie, died in 1998. She lives in Somerville, MA. The author of one novel, *The Legend of Olivia Cosmos Montevideo* (Atlantic Monthly Press, 1994) and the contributing editor of two anthologies, *From Daughters to Mothers: I've Always Meant to Tell You* (Pocket Books, 1997), and *From Daughters and Sons to Fathers: What I've Never Said* (Story Line Press, 2001), she holds the M.F.A. degree in writing and literature from Bennington College. She is serving internships in pastoral counseling/narrative therapy at the Bedford Veterans Hospital and Children's Hospital in Boston and will receive the Master of Theological Studies (MTS) degree from Harvard Divinity School in 2002.

Harlan Goodwin Bower was born on June 5, 1914, in Calhoun County, WV. He holds degrees from Glenville State Teacher's College and the University of Missouri at Columbia. He taught journalism at the University of Montana at Missoula and at New Mexico Western University in Silver City. He left an academic career to become communications director at Kennecott Copper Corporation. Since his retirement in 1975, he has served on the national board of the Manufactured Housing Association and lobbied the NM state legislature on behalf of that organization; in addition, he has led Elderhostel tours to Ireland and England. He lives in Las Cruces, NM.

TIME-SHARE

Dear Daddy,

What was that sound? The swish of a calendar page turning, the soft tick of my watch? I'm aware these days of calendars and clocks. The century is ending and a new millennium awaits. I've passed 50 and you're headed for 85. I think of you every day, look at photographs of you in frames on my bookshelves, viewing our shared legacy from across the continent—I in Massachusetts, you in New Mexico.

I've started this letter so many times, thinking that surely I would take the easy option of choosing an anecdote from the vivid, if relatively small, store of experiences that we have actually shared. Yet we go over those memories every time we get together. They've begun to have a static quality about them. I don't think the loss of spontaneity is unique to our relationship, with you as the divorced father who did not have custody nor live in the same city. I lived with Mother every day until I left for college at seventeen, and at some point I actually felt the same sense of repetition when going over memories with her. No, this hesitation has been something different. And this strange letter is the result.

Bear with me here, Daddy. I'm looking to examine the odd, out-of-time connection that held us when the chronological threads were broken. I need to rehearse with you not so much our shared experiences but certain chapters of *your* life, and then I want to tell you a

fairy-tale story about mine. Because it has occurred to me recently that—as father and daughter—we seem to have a similarity in the patterns of our lives that defies cognitive analysis. Would you think me too far gone if I say that I think of our shared legacy as a Time-Share condo we have both inhabited as itinerant occupants, but not necessarily at the same time?

Here's why I'm thinking that way.

You were born poor and smart in rural West Virginia. At eighteen, you were the responsible eldest son when your father, Romeo ("Rome") Bower, died. High blood pressure, untreatable then, had rendered him weak, weepy and ineffectual for years before that, and you told me last year that you and your strong mother, Edna Williams Bower, saw the family of seven through the Depression by gardening and canning, and "never spent a hungry day." You taught school during the school year and took college classes at Glenville Teachers College only during the summers.

Eventually, you married Mother and the two of you went off to start graduate school in Morgantown in 1940. You took an entrance test and they called you in to take it again; Mother once told me that you figured you must have flunked that test. But after the second test, they told you that your scores were so high they thought at first they'd made a scoring error. Highest scores they had ever seen, and from a country kid who had taught himself to read at the age of three. Born smart and poor in rural West Virginia, having raised your brothers and sisters, you were ready, at last, to write the fresh new story of your own life.

Then came World War II and what you've called "The Blank Page"—your years in the army. You avoided the wars on either side of the planet because an officer liked the way you wrote his letters for him; he kept you stateside the whole time. But your younger brother, Oral Bower, blew up in a German tank battle in the fall of 1944. When my mother gave birth to me on Christmas Day of that same year, she was crying for him. The war would be over soon, but no one in the delivery room knew that. She set off the nurses' wailing and lamentations, since in that time everyone knew someone lost, someone to cry for. The doctor said I had entered this vale of tears through a "veil" of tears.

But you weren't there. You had to apply for leave and arrived days later to gaze briefly at me, the daughter you had "given" my mother:

Nine months before, you had asked her what she wanted if you were shipped overseas, to be left with a child or without. She'd said "with," and there I was. Then off you went, back to the officer and his letters, back to your blank page, with Mother and me penciled in very lightly. You didn't rejoin us until the war was over almost a year later.

Five years later—after graduate school and three years of teaching journalism—you were once again feeling the press of time, in this case, the press of all the sensual pleasures you would miss if you stayed married. So you lived like a man who was not married. I even met some of your girlfriends. Before long, you and Mother divorced.

Our lack of early connection and your eventual departure—events written on the page of my life that reads *FATHER*—could, I suppose, be read as a sad sort of absence. Yet at some level I understood your flight from responsibility far better than I could comprehend Mother's choosing to stay married to you for as long as she did. What I did *not* comprehend until only recently was the similarity in the patterns of our lives and the fact that I had missed our shared legacy.

For just as you took on the husband and father role in your family because of your father's illness and death, I was thrust into the parental role of taking care of Mother after the divorce. Not only was I strong for her, the light and cheer in each new "veil of tears," right up till she died at age 82. But I also identified so completely with her as a woman betrayed, that I think I held my breath for years, convinced that I must hold off the legacy that would surely cast me as a victim. Or as a perpetrator of pain: I carried an expectation that my pleasure meant pain for others, just as your pleasure had meant pain for Mother. I took on a legacy that wasn't mine.

In the enclosed photograph, Mother is in the middle. Now she's gone. Without further Freudian adieu, I send you this little fairy-tale story, Daddy. Just as I remember you reading to me in those early years, I picture you now, reading this story. I even wrote the tale with an elderly gentleman for a narrator, so that I can hear your baritone voice every time I read it to myself.

Maybe you are sitting at the McDonald's in Las Cruces, where you go every morning after taking your diuretic and before your workout at the gym: "I piss and read the paper, piss and read the paper, for about an hour. Then I start the day!" you told me last year. Here's a story to read between pissing and reading the newspaper. The story's in code, yes. For instance, the grandmother's legacy is really Mother's legacy. But I think you'll get the message, the moral, which is that I have moved

into my own life now and I am, in a word, delighted. It's your delight that lives in me, the delayed delight of our Time-Share legacy.

LILY'S DILEMMA

Once there was a girl who had walked for a long, long time—well, maybe it was a shorter time than I am telling, since she left our village so long ago and I am an old man now. The memory fails, but the heart remembers. But the girl had been walking for quite some time. Let that stand. Her name was Lily. She walked in the forest, she stayed in motion. She believed someone was following her.

Her grandmother's prophecy started it all. My darling Lily, her grandmother had said upon first seeing her granddaughter. It's poison you'll use, or it will use you. There was more to the prophecy, but that was all anyone knew for sure then. The midwife overheard it that morning as she was leaving the nursery.

The grandmother gave Lily two animals to protect her from whatever, or whomever, was following her. For the winter, when glittering white covered the forest, Lily walked with a beautiful snow leopard she called Vaza. Vaza could be invisible; even on a sunny day, the light played tricks with the pale tan spots on her pure white fur. "Was that a shadow?" I used to ask my wife. "Or was that Lily and Vaza going by?" On winter mornings. On cold afternoons. In slanting moonlight.

The warm blooming seasons were different. For then Lily took with her a peacock whose name was Peli. When Peli spread his feathers, there was no hiding him. The tall magnolia trees with their creamy white blossoms the size of platters could not outshine Peli. The twinkling wood violets that scattered themselves on the mossy green carpet of the forest floor seemed to dim when Lily and Peli passed by.

Maybe it was when Lily was a school girl that we first learned of the larger dilemma she faced. She confided, as girls so often do, in a friend. "My grandmother," she told my daughter Fiona. "My grandmother has given me magic. I can poison whatever, or whomever, is following me. All I have to do is turn into a snow leopard or a peacock."

"Oh," my daughter Fiona responded. "Which do you want to be?"

"First I have to choose a poison," Lily said in a somber voice.

But Lily had made no choices then, and it worried my daughter Fiona. That's why she told my wife and me about Lily's dilemma. "How shall Lily ever choose a poison?" Fiona asked us. We did not know.

Years passed, and Lily kept walking. Vaza the snow leopard seemed never to age, her fur so white, with its dim pale spots. Peli the peacock shed his beautiful feathers only to grow new, more dazzling ones. But some things did change with time.

As Lily grew to be a woman, her hair shone with fine gold strands and coarse copper strands that blended together in metallic fire. Her skin gleamed tawny and moist in summer's heat, smooth and creamy-white in winter's long nights. The more beautiful she became, the closer she felt to "the presence," as she came to call it, the whatever, or whoever, was following her.

But instead of feeling fear, which would have caused her to walk faster and study harder to learn the poisonous plants in the forest, Lily began to question her grandmother's prophecy: "Why must I become one or the other?" she cried to the white faces in the tall magnolia trees. She liked being invisible like Vaza in the winter. She delighted in the showy exhibitions she shared with Peli in the summer.

And most important of all, Lily turned one day and saw whatever, or whomever, was following her. She ran to Fiona's house, for Fiona was grown by then, with a family of her own. "I cannot fulfill the prophecy!" Lily cried as Fiona led her to a soft chair in the kitchen.

"Do you mean the poison? Do you mean the animals?"

"Oh, no. I mean I've seen him. I've seen the betrayer."

"The betrayer?" my wife and I asked Fiona later. "What betrayer?"

Lily confessed that her grandmother's prophecy had included the story of a false-hearted lover who had left the grandmother destitute to raise her children alone. *You must wait until the time is right,* the grandmother had said. *Then you*

must turn, face the presence which is following you, and decide which poison you'll use. If the presence is a winter presence, Vasa will know where the red winter berries grow. Pluck them and feed them to him. He will sicken and die. If it is a summer presence, Peli will lead you to the stream where the orange gases hiss on top of the water. The presence won't be able to resist you when you preen like Peli. He will breathe deeply and the orange gases will choke him to death.

Hearing the full content of the grandmother's words, Fiona was terrified for Lily. "Your grandmother gave you no prophecy, Lily. She gave you a curse."

"I know," Lily said. "But how shall I break it? And what will happen to me when I do?"

Fiona had no answer. She could only offer Lily a cup of tea, a soft chair, a moment's rest. Then Lily was off again, walking, walking, walking. But more slowly then, ever more slowly. Until The Presence was again right behind her. She could feel his breath on her neck. His breath was as warm and as sweet as a Reese's Peanut Butter Cup melting on a summer day. His breath was as cool and as fresh as a mouthful of just fallen snow. She could have taken a bite of him and spit him out. She could have poisoned him.

"But I didn't do any of those things," she told Fiona. They were standing on Fiona's doorstep. Lily carried a small suitcase. Vaza the snow leopard purred quietly beside her, rubbing her pale white ears against Lily's legs. Peli the peacock strutted in the yard as two wagons and a tractor stopped in the road to gaze upon him. Fiona kept staring into the woods to see The Presence. She kept asking Lily who it was, what it was, what it looked like, for she knew Lily was preparing to join it. But Lily never answered.

"And then," Fiona told us, "she just walked away."

"Walked away?" I asked Fiona. "Where did she walk to?"

Fiona said that as Lily walked toward the forest, Vaza the snow leopard seemed for a moment to float like mist beside Lily, and then, like dew at sunrise, was gone. Peli the peacock was there one moment, his iridescence dazzling like green light, and the next thing Fiona knew, Lily was wearing a brilliant green dress that clung to her shoulders and followed the shape of her down to her toes, and Peli was gone, too.

What I've Never Said

I am an old man now. Memory fails, but the heart remembers. Lily left our village so long ago, but I know this much and have lived to tell it: She questioned the grandmother's prophecy, she broke the curse, but she also fulfilled the grandmother's prophecy in her own strange way. She became invisible and she put on a brilliant green dress. And if she ever needs the poisons, she knows where they can be found, the red winter berries, the orange gases that float on the water. She will use them; they will not use her.

The calendar sheds pages like sheets of skin, Daddy. My watch sloughs off seconds on my wrist. I send you my love and delight from the Time-Share.

<div style="text-align:right">Your loving daughter,
Connie</div>

WILLIAM WHARTON

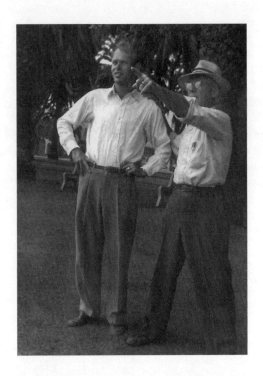

William Wharton (aka Albert W. du Aime) and his
father Albert H. Duaime, Los Angeles, ca.1945

"This is the *only* photo of us. We were poor and did not take many photos. This was taken when I was just back from World War II."

William Wharton, aka Albert W. du Aime, was born in Philadelphia in 1925, the first child of a two-child family. He was in the infantry from 1944 to 1946. He was a student at UCLA from 1949 to 1953 and taught there 1952 to 1958. He took a doctorate at UCLA in 1960. He has lived in Paris from 1960 to the present. Married and the father of four children, he supported his family as painter from 1960 to 1978. In 1977, two years after his father's death, he published his first book, *Birdy*. Other works include: *Dad*, 1980; *A Midnight Clear*, 1982; *Scumbler*, 1984; *Pride*, 1986; *Tidings*, 1988; *Fast Lovers*, 1990; *Franky Furbo*, 1992; *Wrongful Deaths*, 1994; *Ever After*, 1995.

Albert H. Duaime was born in Wisconsin, in 1902. He died in 1975 in California. He worked most of his life in factories: General Electric and Douglas Aircraft. He never earned more than $6,000 a year in life, but earned respect.

INTERRUPTIONS

4th of July, 1996

Dear Dad:

I don't know if this is a good idea writing to you like this, but let's give it a try. I wrote a book about how hard it was for you to die and how hard it was for me to try helping you. But that was all twenty years ago. This is now.

Mom has died. She managed somehow to stay on for an additional five years after you died. I don't think she ever forgave you for dying. She sincerely felt that you had abandoned her and that you died on purpose. I don't think that way. Only *you* can know now. I think if I were married to her, I'd have died long ago, just to escape, even though I know the reasons why she was the way she was. It's amazing how early unfortunate experiences can warp one's personality.

As you know I married a wonderful woman and we're happy together. This Christmas it will be forty-six years. They do go fast. Our time together has been good. We've had four children, as you know, and we've lost one, our first daughter, with her husband and two of her children in a horrible mass automobile crash in Oregon caused by field burning. But, that I think you know. I wrote a book about it, called *Ever After*. Kate would have told you first but I wanted to write it, I tried to help her.

Our other three children have varied lives just as we would want them to have. None of them has followed me in my writing or painting. One, Camille, is a teacher for UNESCO in Hanoi. Yup, as you know now, we made peace with the Vietnamese. It took long enough. Our oldest now, Matt, has been teaching Mathematics at the Bilkent University in Turkey. He's married to Juliette, a lovely French woman. You never got to know her, and they have two beautiful little girls. Next year they go to teach in Oman. That's near Saudi Arabia. I'm

glad you don't need to suffer your grandchildren spread all over the landscape in outlandish places. I know you've always preferred the simple, uncomplicated life. America was always good enough for you.

I've often felt badly about how Rosemary and I left America in 1960, especially for you and Mom. I could never explain to you or Mom how we were uncomfortable with things that were happening in America, especially with young kids growing up there. We objected to what was for you the center of life, TV. We didn't want our children glued to the tube and not knowing the joy of real life. I guess we were selfish, but we couldn't think of any way to keep them away from it, except to move away. Now, it's caught up with us. Running away from TV is like running away from your shadow. In a certain way, films, TV, etc. are sort of shadows of real life, easy to sleep in their shade.

We still have little Will home with us, except he's twenty-nine years old. I think you'd like him. I've always considered your idea, that doing a dumb job unrelated to your interests or talents was "wasting your youth," had real validity. We've tried to bring up our children with this in mind. We've discouraged them from going out and doing something just for the money. Each of them, in his/her way, has followed your precept. It was because of this, despite our not having much money, that they all finished university and some took advanced degrees. This was because they could stay young longer, not bind themselves in economic slavery when they were young. We thank you for this.

Will, our youngest, is a natural scholar, like you. But he's had the chance you've never had to develop this capacity. He reads everything that comes his way and absorbs it. It's fun to be near him. He completed his university work, but universities in general are developed for people without internal motivation systems or goals. Will has these built in. Right now, he's in Poland feeling out the situation there.

I know all this must seem as if we're not American enough, at least by the standards you've held in your lifetime. But life and lives change. I'm sure now you know this, but I can't help mentioning it.

I could sure use some of your building and handyman skills right now. We've been living on a houseboat for the past twenty-five years. In fact, my new book is called *Houseboat on the Seine*. It's interesting and a shame that you've never had the chance to read any of my

books. This book emphasizes my ineptitude at thinking and acting practically in relation to the physical, material part of living. You tried all your life to transfer these incredible skills of yours but they never really took. The desire is there, but the capacity never has been. In this way, I'm more like Mom. Bringing up houseboats from the bottom of a river, trying to keep them from sinking, then winding up by putting one boat on top of another is definitely not the kind of thing I'll ever be good at. But you also taught me another thing. NEVER GIVE UP!!! I didn't give up on this boat and we have a nice place to live now. Thank you.

The other side of the coin is that, this morning, we found that our water source, a tube running along the bottom of the river for over a hundred yards, bringing fresh water to us, has developed a leak. I'm wracking my brain trying to figure ways to find the leak. You taught me enough to know where to go to turn the water off at the meter. I've done that, and we're flushing the toilet out with river water, temporarily, until I get it figured out, but it isn't exactly comfortable. We drink bottled water and wash little, until this problem has been resolved. This morning I was about to throw in the towel until I thought of you. NEVER GIVE UP!!! I'll think about you and you think about me and between the two of us we might work this problem out. This is the kind of time I wish I had my sons here, with me, or better yet, you. I'm sure you'd come up with some creative solution to my problem.

I remember when I was building a house in Topanga Canyon in California, and I managed to get it all crooked because I didn't put in proper foundations. You showed me how I could use clear plastic hose to level it, corner to corner, because water seeks its own level, then borrowed jacks from everywhere so we could jack up the building all along, a bit at a time. That's the kind of things you taught me, how to think on my feet; not give in, or walk away from the impossible. I can never thank you enough. Although I never developed hand skills or mechanical ability. I think the attitudes about work you passed on have stood me in good stead, as student, teacher, more important as painter and writer. You managed to make me think that with concentration and effort I could solve most problems.

But more than all that, you always made me feel, despite my limitations, that I was valuable. You helped me to believe this by insistent, consistent repetition. If I doubted myself sometimes, you were

there to make it clear, help me level myself and jack up my foundations. I learned through you to love myself in the best sense, to value myself as I am, to make the most of what I have. That's the best gift any father can ever give his son.

I've talked to sister Jeanne, and she's had the same feelings only as a woman. She, too, grew up with an inner feeling of confidence in herself and in life itself. Not too many people have those confidences, especially in these times of insecurity She, in turn, passed her feelings onto her five children. I've said it before and I remind you, how she actually used to play with her children as if she were a kid herself. She never leaned back on her supposed dignity as mother. She tried to prove herself worthy of their love and appreciation by involving herself in the lives they lived, as they lived them. It was a joy for all to see.

We've always respected you, as you know (I was interrupted in this letter right here). It's one of the reasons I don't write many letters, my life is a series of interruptions. Actually, probably life is an interruption of a kind.

This interruption was my wife coming down to my office to tell me that a pillow case had just fallen into the water when she shook out a sheet and she wanted me to climb down into our little boat and fish it out. I dashed up behind her, and sure enough the pillowcase was in the water, but there was no way I could fish it out. Life's little distractions. I close now. I hope your existence, now, whatever it is, is a joy to you and you are not "wasting your second youth." Much love to you from far away in time, space, metaphysics and all the dimensions.

<div style="text-align: right;">Your loving son,

Dan</div>

MARGARET ROSE WITHERS

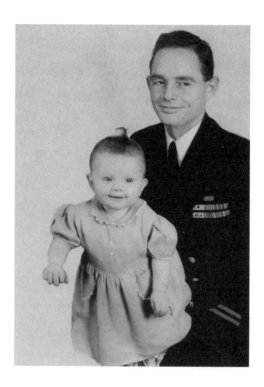

Henry Lightfoot Withers and his daughter,
Margaret Rose (Meg) Withers,
Cecil County, MD, 1947

Margaret Rose Withers was born in Cecil County, MD, on April 8, 1947. Named for both her grandmothers, she is the eldest of five children. She has married and divorced several times, all to different men. She has had one son and three stepsons, all of whom she loved and taught to make "something besides hamburgers" in case they should ever want anything else. She has been a gypsy, mother, grandmother, writer, artist, counselor, businesswoman. She holds degrees in Chemical Dependency and Human Services, and is currently studying English at the California State University, Sacramento. Her poetry and prose have appeared in various literary reviews and poetry forums in Hawaii and California.

Henry Lightfoot Withers was born in Nelson County, VA, September 3, 1918. He was the second youngest of the five children of Thomas Austin Withers of Nelson County, and Margaret Scruggs Withers, originally of Lynchburg, VA. He entered the U.S. Navy in 1940 and maintained a career until 1963. He met and married Christine Theresa Lombardi during World War II. She was his nurse at Mare Island Naval Hospital in Vallejo, CA, after an injury suffered in the bombing of one of the ships he served on. He was the father of five children: Margaret Rose, Philip Lightfoot, Victoria Marie, Robert Vincent and Henry David Withers. He was a sailor, a storyteller, a scholar, a reader, a writer, a fixer of anything broken inside or outside the house, and last, but not least, an eater of licorice and rock candy. He died in 1976 from suffocation in a house fire. He was a good man.

RAGGED MOUNTAIN DREAM

Dear Dad:

August, 1940

Maple trees, with their shapely henna palms,
are washing their hands of Summer again,
fanning the sizzling grasses in the yellow fields.
It's the way of the world to do these things,
the way you did each beginning Autumn
as you made your soft way into the Virginia woods,
as careful and quiet as one of Zane Grey's men.
You were twenty-two and clear-eyed as any
furry beast, long-toed, sliding into the foliage.

Softly you tread, with your Collie, a sack of beans,
hunting gear and bedroll tucked tidy at your back,
your life glimmering, a numinous green dream.
It was August, the summer of Maria Massie, slow talk
on the verandah, wading in the cool Tye River,
before Kwajelein and Suva, before Tokyo Bay and

the Pacific, so blue it hurt your eyes, filled with Haze Gray
Navy battleships, like the huge bathtub of some willful child,
slapping the water to see which ships would float,
in such devastation as it chose to make with its
simple chubby fists, its face a mask of glee.

Your ships sank, two of them in the next 5 years.
You survived in the fiery water, pulled each time,
gasping, a slender white fish, crouched
into the bottom of some sweet lifeboat passing.

Something inside you sank in those years,
some connection snapped, the way the smallest branch
in the quiet of a morning forest can sound like gunshot,
some lifeline whipping back and away with fierce power,
the sudden release of tension from the break,
slamming you down, as sure as if you'd died there,
in the terrible heat, in the furnace of flammable water.

What you did afterward, when there was no cure
for the invisible hole in your gut, when there was not even
a name for the disease you suffered from; I imagine it vast and
black and filled with cold ashes, a groan which lay unspoken
in your heart, gnawing in the night with some tiny
dreadful sound, the mastication of some horrid insect,
thousands of them, and only you could hear them,
and WAR was an "honorable" enterprise.

January, 1956

Eating tart, small oranges from the backyard tree,
the frost scorching our fingers and noses.
Bundled in Winter clothes on the back steps,
I was proud to be your eldest child, the Chosen One,
the shining bright coin in the dark pocket of your life,
the one for whom you spun stories, leaning out over the side
of the skiff, scooping tales from the lake of your memory,
silver story fishes, wriggling and leaping in the light.
You left out the bloody gutting, the scaling,
parts unhealthy for your daughter's ears.

I recall each time I turn a corner into some forest,
your voice, vowel-heavy, the slow Virginia chant of it,
rolling us into the green Piedmont of your innocence.
The dark humor of your family permeating every tale,
limning each ancestor with compassion, a storyteller's eye
for unvarnished truth. Uncle Henry, "with hands the size of hams,"
living in the forest 'til he died at 103, carried
inside my mind in a wash of light, watercolors swathed on
fragile, layered vellums of memory.

Even the war years and terrible aftermath were tinted—
just for me. Fiji in tropical washes, drinking in an open-air bar,
7-foot constabulary, scarlet British military jackets
stiff over pleated white skirts. Drinking Tooth's Lager,
Brisbane, an Australian sailor named Red,
drinking at the California bar in Sasebo,
pulled back over the cliff by a tiny Japanese
woman, a lifeboat, as all women were:
your diminutive mother with her dark premonitions,
your wife's stubborn, Italian peasant sense,
my devotion, when no one else would listen,
when the relentless darkness moved over you,
unassuagable.

April, 1963

The charred oblivion visiting our house in your form,
the bottle of Old Granddad, handfuls of Librium, locked-down
in J Ward. I watched you struggle in five-point restraints.
"Why is Dad tied up?" After that,
silence, in the 50s and 60s version of *hejira*
for the spiritually too-competent,
the eventual journeys to Napa State hospital,
your uniforms with the gold stripes exchanged for
humiliating backless gowns, paper slippers, the grimace
of pain and "extensive medication," electric-shock.

The worm in you growing and gnawing, hungrier
than ever, the stripes on your shins from hatchways,

diminishing in size as you come forward on a ship,
as your connection to the everyday shrank year by year,
until there was nothing left but the empty bottles and
cans of baked beans with spoons stuck in them
tipped over on your "important papers"—a husk,
an empty whisper left of you, death you
prayed for every day but could not
manage to accomplish.

July, 1976

The last time of fire in your brief life, you were
unconscious, smoke taking you down
spiraling long and slow, over the barrier,
across the dark water of the last night,
more flames charring your life,
as if you were nothing more than a crumpled page
in some unimportant book. I did not want to believe
in your young death, did not attend the funeral,
would listen neither to the sighs nor the hallelujahs.
I was still drunk that year, at 30.
I had grown the same dark messenger in my bowels,
the scratching noise inside my head
years of insomnia, the fervent, mad charge
out of my own skin, a rash of journeys
when the gnawing became unbearable.
I had learned to hone my own heart
begged the empty promise on a ticket, in a bottle.

August, 1994

After tossing my last bottle into some bush
on the first day of Spring in 1985, in Honolulu
or London. One place is as good as any other,
when you drag your self-created bit of Hell
behind you, a sick and noisy umbilicus.
Arlington was muggy that hot afternoon,
cicadas scraping in the high Summer grass,

a water-laden sky, as if heaven wept for all of us,
the air of vivid predawn dreams, glazed by humidity,
an expectant tension humming with memories,
backwashed by sounds of the sea,
or perhaps the sighs of a million sad daughters.
I passed unnoticed, beyond the still guards,
living monuments doing time, an atonement of sorts
for those destroyed by "honorable" Wars.
I crept to your graveside, crouched, overflowing
with grief, left you the gift of tears unshed,
wept for you, and for myself, all the disallowed
tears.

That distant Summer afternoon,
row upon marble row of other daughters'
buried grief and love,
hazy in the protective shade
of black oaks, maple trees and elms.
I grew up. At the tender age of forty-eight
I released myself, freed you
from the prison of my wishing,
the cramped, clear jar I'd kept handy,
on the mantle, always there, always there,
sharpening the selfish edge of pain.

When I walked slowly from that place
I left you a bowl of tears, a statue of a Collie,
a sack of beans, some licorice.
I wanted to give you all the things you would need
for your journey, everything I could think of,
to help you back into the hills.

I love you, Dad,

Margorie Rose

HILMA WOLITZER

above) Abe Liebman, surrounded by some of his "girls" in his beloved shop. New York City, ca. 1940s

below) Abe Liebman, at 92, holds hands with his daughter Hilma Wolitzer and his first great grandchild, Gabrial Panek. New York City, ca. 1990

Hilma Wolitzer, born in Brooklyn in 1930, was the middle daughter of Rose and Abraham Liebman. Reared in Brooklyn, NY, she now lives in Manhattan with her husband, Morton, a clinical psychologist. They have two daughters and two grandsons. Ms. Wolitzer is the author of six novels—including *Ending*, *Hearts*, *Silver*, and *Tunnel of Love*, and four books for children. She's taught in the writing programs at several universities, and her new nonfiction book, *The Company of Writers*, has been recently published.

Abraham Victor Liebman was born in Besserabia in 1897 and died in New York City in 1997. He emigrated to the U.S. when he was 16. At 25, he married Rose Goldberg and they had three daughters and several grandchildren and great-grandchildren. When Rose died in 1995, they had been married 71 years. Abe worked in the garment district most of his adult life. He was a wonderful story teller and attained a certificate in public speaking in his mid-nineties.

THE GOOD DAUGHTER

Daddy,

Only six more weeks and you would have made one hundred, a dubious goal given your circumstances. Yet somehow I cheered you on, planning your centennial and calling you Lazarus behind your back, when Job would have been more appropriate. Of course I was just trying to help you carry out your frequently expressed wish to live forever. How not, when there were trees, stars, chimney smoke, music, voices, and food to enjoy? You wouldn't discuss living wills or heroic measures with anyone; mortality was your least favorite subject. Once, in the emergency room. when you were a mere ninety-seven, you astounded an exhausted young resident by asking if he thought you'd live out your years. He muttered, out of your earshot, that you'd probably lived out some of his. Another time, certain that you were dying, you warned me, "Darling, the world is coming to an end!" What ego, I thought, admiringly. Yet I was confused. You were an observant Jew, with a comfortable, Tevye-like relationship to God. Didn't acceptance usually accompany such true faith? As a vacillating atheist/agnostic myself, I couldn't be sure.

You were brought to the emergency room so many times, and I was always there with you, often for hours and hours, the good, dutiful daughter, seeing that you were seen to, feeding you supper from a tray (I remember that, in the midst of all that *Sturm und Drang*, you'd complain that the chicken was salty or the potatoes cold), and generally lending support to your stubborn will to live.

When I finally worked up the nerve to ask if you'd changed your mind about eternal life, given the terrible deprivations: Mother, your eyesight, most of your hearing, your appetite, your bowel and bladder control, and your left leg, you'd also conveniently lost your mind. In that shadow world, your own parents were still alive, subway fare was a nickel, and all that was missing were the keys to your shop. I learned not to argue with you about your reality. Don't worry, Dad, I'll deal with those pesky FBI agents and the police and your creditors, and I'll send your regards to all of the living and the dead.

More and more often, it was up to me, your aging child—imagine, both of us on Medicare at once!—to make difficult medical decisions. Antibiotics? Surgery? Feeding tube? Respirator? The doctors and I tried to measure the quality of the life they felt committed to save, but they didn't really know you—your passion for work, your sense of humor. Like the ambitious mother of a limited child, I gave you points for recognizing me, for smiling, for eating a piece of chocolate. I consulted with my sisters and your nonagenarian baby brother on the other side of the country, and although they were concerned and sympathetic, they all more or less deferred to me. I was *there*, after all. How I prided myself on being there, and how I hated and resented it. Every middle-of-the-night emergency led me, wildhearted, into Brooklyn, into the nightmare landscape of Maimonedes or King County Hospital. Was this it, at last? Was I merely scared, or just a little bit relieved, too? The thought came unbidden: Why don't you just die in your sleep like other parents and let me have my own life? Then I'd see you, bristle-bearded, milky-eyed, terrified, as yellow-skinned as a hospital chicken, one among the many sufferers, but *my* sufferer. And I'd rush to you, sick with guilt and love, and re-enter the conspiracy to keep you among us.

You died at another hospital, conveniently near my Manhattan apartment, on a mild April afternoon, while I was at the library. I'd really begun to think, with a certain smug pride, that you'd live forever. Three bouts of pneumonia (the old man's friend) hadn't taken you down that winter, and now you were recovering from yet another systemic infection. I visited you daily, at my leisure. That

day I strolled down the hallway of your floor at Beth Israel, carrying a pile of library books—the new Joanna Trollope among them—and I was eager to get home and start reading. There was no one at the nurses' station, so I went directly to your room without stopping to inquire about you. Your bed was empty and stripped of everything but a black rubber sheet. The dying old man in the next bed was incommunicado. I went back out to the hallway and a nurse came toward me and said that you had died peacefully about a half hour before. Another nurse, who was on her break now, had been in the room with you. They'd been trying to reach me; your body was already down in the morgue. I wanted to go there to see you, but she gently discouraged it, and I didn't go, didn't perform that last daughterly duty. Instead, I wandered into the patients' lounge to await some final, formal information about you.

There were three stout black women about my age sitting in a cluster in the lounge, and as soon as I saw them, I burst into tears. They got up as one and surrounded me, fluttering and clucking. Sobbing now, I told them that you'd just died, and when they offered to pray for you, I said yes, thank you, thinking vaguely that this was something they'd do later, in church, probably. But they took my hands right then and there and we formed a circle, and they beseeched Jesus in songlike prayer to carry you safely home, and to comfort me in my sorrow. Even as it was happening, I couldn't help thinking how this Christian service would have disturbed you (he must be *spinning* down there, was my precise thought). But, forgive me, Daddy, I *did* feel comforted, by their utter faith and their utter kindness. Forgive me, too, for wantonly helping you live long past any conscious pleasure in the world you so dreaded leaving, way after the music stopped and the trees and stars became invisible, and the voices whispered only paranoid nothings in your ear.

The nurse who'd been there when you died came into the lounge and reported that you hadn't offered any final words, not even "Help me," or "I'm afraid," which you had said many times before in what you'd thought were near-death moments. Now I've come to believe that if you *had* spoken at the very end, it would have been to me, your superdaughter. "Thanks for nothing, kid," you might have said.

And if I had made tougher, braver choices in your behalf, this letter might have focused on the sweet, vital middle of your life instead of its bitter, extended closing. I would have remembered my childhood hero, the good father who kissed bruises and scrapes

to make them better, who sang me to sleep in a Yiddish-accented baritone, and always left a light on somewhere in the house before he said good night.

Your Hilma

IRENE ZABYTKO

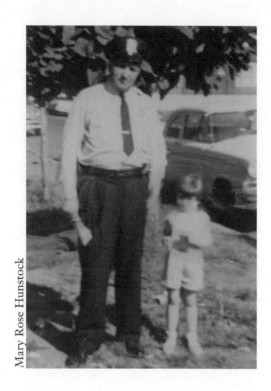

Stanley Zabytko and his daughter Irene Zabytko
Chicago, IL, 1959

Irene Zabytko, was born in Chicago in 1954. A past recipient of the PEN Syndicated Fiction Award, she has published her fiction and non-fiction in numerous anthologies, journals and newspapers. Her first novel, *The Sky Unwashed*, was published in 2000 (Algonquin Books).

Stanley Zabytko was born in 1910 in Chester, PA, the only American-born offspring of Ukrainian immigrants. For over twenty years he was a Sergeant with the Cook County Sheriff's Department in Chicago, and along with Maria, his wife of over 50 years, retired to Florida in 1977. Stanley died in 1993 of Alzheimer's Disease.

FALL OFF FROM A GOOD HORSE

Hey, Tato!

You're probably still angry at me for not talking up on your behalf during the memorial service the nursing home gave for you and others who passed on. I'm so sorry I sat passively among the stricken grievers; a mute witness to the director's inadequate struggle to say something valiantly noteworthy about you. But how could she? You were only there for two weeks before the last vestiges of your sharp mind slipped, entombed forever inside the erosive haze of Alzheimer's; a mere few days before you spared us the cruelty of wasted hope when you heaved that final tortuous sigh out of your exhausted chest. Really, even you wouldn't have recognized yourself lying wane and gasping in that strange bed. You would have looked disgusted and askance at your withering body groping for lost syllables and you would have said, "That poor sonavabitch can't be me."

And that wasn't you. Give me another chance to correct the misconceptions the stranger at the nursing home uttered about you. She was wrong when she mentioned that you came from another country somewhere in Eastern Europe. You were actually born in Chester, Pennsylvania—the only one in your family by a fluke of timing to have the good sense to claim an American birthright and passport. That valuable document gave you the authoritarian advantage to return to your desolate ancestral village in Ukraine, buy a dandyish three-piece suit (with a watch fob and walking cane) and court the nightingale-throated blond whose sweet vibrato followed you back to America after you married her in the village church.

Nothing was said about how that wool dandy suit was worthless in the factories of Chester and Chicago. Still, you always managed to find jobs during the Depression and all throughout your paternal tenure with when we three children made our demanding appearances. Your personal evolution got you out of the factories as you constantly tried to better yourself by studying for the Eastern Orthodox priesthood (a noble quest), attending barber college (a quixotic attempt) and owning a neighborhood bar (a mad investment) before you finally hit upon the brilliant notion of becoming a cop.

Sure, that suited you perfectly. That uniform dignified your natural bravado and commanding persona far better than the woolen suit ever could, and your fair sense of justice and quick readings of character types saved more than one life. You were honest, sharp, and brilliant with an astounding wit that could stop conversations cold or buoy a dull party, and your natural storytelling ability was my first glimpse into fiction.

All of us in the family owe you big time. Mom certainly does, for the trouble you took typing byzantine documents with your gun finger when you sponsored her bossy older sister from Ukraine during the pre-perestroika, dark Brezhnevian days. An amazing feat considering that Solzhenitsyn and Sakharov were still being persecuted, and no one was leaving the Soviet Union for privileged exile to America then.

Oh, and the boys, my brothers, should also announce out loud what you did for them. Remember the time the eldest son was a child and fell off the porch and was about to have his arm amputated? You wouldn't allow it. You fought the big-shot surgeon's logic with your demands for a skin graft procedure on the shattered limb instead of sawing it away. How did you, with such a paltry education, ever know about such things? And remember when the other son was about to go to the death jungles of Vietnam? You wouldn't allow that either, so you argued with unseen courteous generals on the phone and made them honor your orders to transfer him to a safer stateside post.

There were numerous other selfless acts of familial obligation that always centered on drafting documents or defying authority. How great you were at that. Was it the uniform that gave you that edge, that fierce unrelenting focused courage and determination to get your way when all seemed lost or simply insurmountable? God, how I wish I had a streak of your heroic stubbornness and confidence!

And as for me... What I should have said in that candlelit room in the nursing home was a clear loud *thank you*. I want to say it now: Thank you for seeing in me the possibilities I barely knew I possessed. Thank you for taking an interest in me as an intelligent young girl, an independent person with vision, when I first told you how I was thinking about going to college someday to study the sciences and work as a lab technician. You took me seriously and advised me to achieve higher things by becoming a doctor. "Fall off from a good horse," you told me. An old-country saying with its not too fatalistic message of going for the best even if it means failure.

And I did fail. When I had to forego my dreams of medical school because of my disappointing grasp of rudimentary chemistry, you still saw the value in me even when I settled on the nebulous profession of being a writer. You told me that writing was "a hard piece of bread" (Yes, it is very hard). And even though you may not have understood every word that I published, you read everything all the way through with pride and, I truly believe, a bit of awe. Thank you.

I'm still falling off horses, but at least I'm choosing the best ones to climb back on. I'm riding off into sunsets so dazzling, I can just make out the outline of your jubilant arms waving me onward.

<div style="text-align: center;">All my love,</div>

MARY ZEPPA

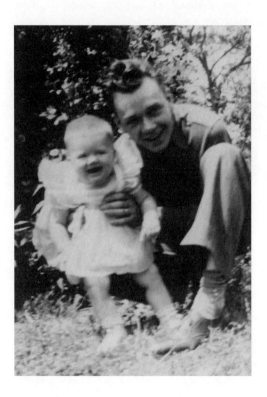

Mary Hunstock Zeppa and her father, Norman Hunstock
Homewood, IL, ca. 1944

Mary Zeppa was born in Wisconsin in 1943. Her poetry has appeared in, among others, *Mixed Voices, I Am Becoming The Woman I've Wanted* and *From Daughters to Mothers: I've Always Meant to Tell You*. Zeppa is also one-fifth of Cherry Fizz, a quintet specializing in loose and unlabeled *a cappella* music.

Norman Hunstock was born in Homewood, IL, in 1921. He grew up on the family farm. When he met Mary Rose, he was working as a milkman in Chicago. They married before he enlisted in the Army. Mary Zeppa is the eldest of their five children. At his retirement, Hunstock was an executive for Equifax.

HELLO! *from the first-born, the black sheep*

Dear Dad,

Hello! from the first-born, the black sheep,
the weed in the hollyhock patch! Hello!
from the poet begot in your family,
born out of her element.

Hello! from The Widow, the wife once
removed. Hello! from her Indispensable
Other, that widower with two grown sons,
who joined up with the bootless one, fruitless

one, childless one. Who took up with
the skull at the feast. Yep, some days, I feel
worthless as tits on a boar, worth only
a hillock of beans. It's on days like this,

thinking how far apart we are: miles,
light years, parallel worlds. It's on days
like this, knowing how little I weigh
on your shiny, family scale.

2

Linked by the twinkle-in-my-daddy's-eye.
Linked by the family jewels. Young
Blue Eyes, your name in that legend
Illinois milk-men still tell. When

you winked at my Mom-to-be, swinging
her hair and hips, fortune's wheel
stopped on a dime. World War II
came with my territory: you

in Germany, Mom on the edge. You
cried on that 78 rpm and came home
for The Beer-Barrel Polka I danced
on the tops of your shoes. You were

front guard and rear guard, shield,
knuckle sandwich, Attila, my tall
champion. Once, you stormed
the walk, six feet of thunder,

to roar away boys with snowballs.

That was the winter before puberty:
Double-Dutch brought my blood down.
Mom let you in on the secret and you

came to me on the couch. Where you slid
your right arm around my waist, slipped
warm fingers beneath my waistband,
grazed my belly till you hit elastic,

Mom's hand-me-down Kotex belt.
You gave it a tweak before you
popped your question: "Your
'strap', does it... bother you much?"

3

That was the last of our halcyon days.
No more complete daddy's girl. Now,
we both look for clues in old mirrors.

Now, I watch you sink into your spine,
shrinking backward, one eye on
a stranger. You don't see

the woman I am. Just a black hole
in your constellation: I'm
as loose on the planet as dust.

4

"In the real world," writes my brother,
the entrepreneur, describing your

shared galaxy. So call this a letter
from Never Land. "In the real world,"

I may be small potatoes, but
there's plenty to write home about.

 Love,
 Mary

FEENIE ZINER

Feenie Katz (Ziner) and her father Morris Katz
Mohegan Colony, NY, ca. 1940

"This is in front of our family's summer cottage near Peekskill."

Feenie Ziner was born in 1921 in Brooklyn, NY. Married to Zeke Ziner, artist. Their five children are Marc, Joe, Ted, Eric and Amie Ziner. Feenie Ziner is the author of *Within this Wilderness* (Norton, 1978), *A Full House* (Simon & Schuster, 1967), *Bluenose, Queen of the Grand Banks* (Nimbus, 1980), *Cricket Boy* (Doubleday, 1978), and Professor of English, University of Connecticut (Retired).

Morris Katz was born in 1883 in Yassi, Romania, the youngest of five (surviving) children. After the death of his father, the family emigrated to the USA around 1892 and settled in Brooklyn, NY. Morris Katz was a diamond dealer. He was a member of the Diamond Club, the founder and president of the Adult Education Student's League of New York City, and served on the Board of Directors of the Brooklyn Society for Ethical Culture. He died in 1950.

THE SAME STARS

Dear Dad,

Here is a candle I light in your memory. Not a description of your character nor an appraisal of your capabilities nor an analysis of our family's ordinary dysfunctions, but a particular song in praise of the father you were to me.

When I was born, in 1921 being a girl put a person in a very small box surrounded by very high walls. But it never seemed to have occurred to you that there was anything I might want to do that I could not do because I was not a boy. Consequently I grew up believing that if I could imagine it, I could do it, and for the most part, I have.

You were an immigrant boy from Romania who sold newspapers on the Bowery and survived on free lunches in the saloons. You always dreamed of becoming a doctor—the highest calling you could envision for yourself. Against all odds you managed to study chemistry at Cooper Union, memorizing formulae as if to hew them out of rock. But in spite of a mighty will your aspiration only took you as far as becoming an appraiser for the Provident Loan Society, a job which secured you a respectable if not a glorious place in society. By the time you were thirty-something you had become a diamond dealer with a little office at 68 Nassau Street (phone: John-0961) from which I, and thousands of others in other windows, watched the ticker tape parade for Charles F. Lindbergh go by.

You were a modest New York success story.

I was the second in a family of three and the only girl; not the smartest nor the best-loved, but a chatty companion, an eager learner.

If yours had been a happier marriage I might not have been the beneficiary of so much of your attention while I was growing up, but I accepted what was offered with a glad, unquestioning heart. I became your chosen child, the *tabula rasa* on which you inscribed your convictions about Progress and Civic Responsibility, your appreciation of the wonders and obligations of Democracy.

You made New York City my story book. You began by taking me to the top of the Woolworth Building, then the tallest building in the world. You liked epic sights, overviews. You showed me the Daily News Building in whose lobby a huge revolving globe impressed me with just how big the world really was. You recited the names of the constellations on the great, arched ceiling of Grand Central Station, then located them in our very own sky, from the tar roof of our Brooklyn apartment house. *See? The same stars!*

You took me to the Metropolitan Museum and the Planetarium and the Natural History Museum and the Bronx Zoo. Extravagantly, you maintained a subscription to the Brooklyn Academy of Music, where I saw children's theater and puppet shows while you and my mother improved your minds with lectures, including a talk by one Dr. A. A. Brill which evidently impressed you—thirty years later I realized that Brill had translated Freud.

You took me rowing on the lake in Prospect Park and enrolled me in gardening classes at the Botanical Gardens. While my mother monitored my practicing, you took me to piano recitals at the Sculpture Court of the Brooklyn Museum, "to inspire me" and to demonstrate that mastery of an art gave a person power to alter the emotions of others, a suggestion I found intoxicating then, and which motivates me, still. You took me ice-skating at the Red Ball rink at 59th Street where the Coliseum stood and finished off the excursion with a ham sandwich at the Automat. I marched with you in the first Peace Parade down Fifth Avenue with the Brooklyn Society for Ethical Culture—the first of many times I took to the streets to change the world.

One of our greatest adventures took place in 1931, the week the George Washington Bridge was opened. Fortified with extra sweaters, you and I walked from the 180th Street station of the IRT across the bridge to its rural terminus at Fort Lee, New Jersey—a distance of about a mile and a half. By the time we reached the middle of that colossal steel structure, the wind was so high that I had to hold tight

What I've Never Said

to the handrail of the walkway. But I knew it was a great moment in the history of my country, a glimpse into the very heart of America, because you told me it was, and you were absolutely right. I could even see it for myself.

Now it seems as if it must have taken decades to go to all the places you took me to, but your role as my tour guide probably lasted only five or six years—from the time I was seven until I was twelve.

Things changed when I started high school. I began to find friends my own age—arty types who read poetry and listened soulfully to Sibelius. As the Depression slowly receded, History began to gallop through our lives like the Four Horsemen of the Apocalypse—first the Civil War in Spain, and then Hitler, and then The War; our War. While I was grinding out leaflets and boycotting Japan, you went to lectures and read book reviews and suffered through social evenings with the morose doctors and their stuffy wives who were my mother's dinner guests of choice. I remember how you would prepare yourself for these ordeals by memorizing something from Bartlett's *Familiar Quotations*, and then spend the entire evening trying to work the conversation around to the point that you could remark, "As Aesculpius said..."

A few years before leukemia got you, you decided—finally—to do what you'd always wanted to do. You closed your office and registered at New York University to continue your study of chemistry exactly where you'd left off forty years earlier. No refreshers. No make-ups. You were sixty then, and the next-oldest student was eighteen. You did not do brilliantly but you passed; learned enough to qualify as a volunteer in the laboratory of the Brooklyn Hospital where you racked up more hours of service than any other Civil Defense volunteer in the whole of the City of New York.

What a person you were!

How much easier it was to begin this letter to you than it is to end it! It brings you back, and I find out how much I miss you, all over again.

<div style="text-align: right;">

Your loving daughter,

Jeenie

</div>

WRITING TO YOUR FATHER

TIPS FOR GETTING STARTED
from novelist and contributing editor, Constance Warloe

Dear Readers,

From Daughters and Sons to Fathers: What I've Never Said will inevitably stir in you a desire, however mild or intense, to write your own letter to your own father. Yet you may hesitate, not knowing how to get started. Perhaps you are searching for a way to get past your resistance. Perhaps I can help.

Your reluctance is not surprising. We hardly know how to begin when faced with such a complex, lifelong relationship. When the first volume of this anthology series came out in 1997 (*From Daughters to Mothers: I've Always Meant to Tell You*), I was struck by the number of reviewers who wold readers to buy the book and then write their own letter. It wasn't long before I began receiving notes and calls from readers saying, "Help! I want to write a letter to my own mother, but I'm resisting." I offered a number of suggestions at that time.

I have now written letters to each of my parents for these volumes, and in both cases I ended up first writing each of them a story, using variations on children's-book or fairy-tale voices. Only after each story did I actually write the letter that precedes it. I needed to crawl in through the window of storytelling. Maybe that's really my first Tip for Getting Started: Sometimes the best way in, is through the window and not the door; that in, "indirection."

All the suggestions that follow here will involve that indirections. Maybe you can try doing only one exercise a day for the first few exercises. You might also try writing in a different place each day—a cafe one day, the backyard the next. Maybe a library or an airport or

train station other days. You could try a different time each day. What may work best is to do exactly the opposite of what I'm suggesting!

What we are trying to do is distract our judgmental conscious minds so that we can drop deep—into memory and emotion. This way of "loading your unconscious" will allow you to first discover the material you most want to use in the letter, and then start to make observations about it.

As a former teacher of creative writing and as a facilitator of writing workshops, I can say that these techniques have worked for me and for my students. I hope they will work for you. Maybe you will let me know.

Meanwhile, good writing.

Constance Warloe

1. MAKE A LIST OF 10 ANECDOTES, memories that you think would characterize your relationship with your Father. For now, let the incidents be a only sentence or two long. Some will be pleasant, others not. Some may tell about absence as well as presence. Whatever their content, do not try to judge them or interpret them. Write steadily. Then stop when the time is up. Use a notebook or a computer, whatever is comfortable for you.

 WRITING TIME: no more than 10 minutes.

2. MAKE A LIST OF 5 THINGS YOUR FATHER SAID AND/ OR SAYS. These can be characteristic phrases or one-time statements. Keep them short.

 WRITING TIME: no more than 10 minutes

3. DESCRIBE 3 PLACES YOU ASSOCIATE WITH YOUR FATHER. In addition to visual detail, use at least 2 other senses in each description: sound, smell, taste, or touch. This can be a room, a house, a natural setting, an urban setting such as inside a taxi cab, a street corner, a restaurant. Try not to interpret the place. Try only to describe it.

 WRITING TIME: no more than 5 minutes per place

4. DESCRIBE 3 OBJECTS YOU ASSOCIATE WITH YOUR FATHER. In addition to visual detail, use at least 2 other senses in each description: sound, smell, taste, or touch. This can be a small object like a tool or book or piece of jewelry or clothing, or a larger object like a car or a boat. Try not to interpret the object. Try only to describe it.

> WRITING TIME: no more than 5 minutes per object

5. SELECT A PERSON IN YOUR FAMILY WHO KNOWS YOUR FATHER WELL. Write about the ways in which your views of your father are similar. Make short statements. DO NOT interpret the similarities.

> WRITING TIME: no more than 10 minutes

6. SELECT ANOTHER PERSON IN YOUR FAMILY WHO KNOWS YOUR FATHER WELL. Write about the ways in which your views of your father are different. Make short statements. DO NOT interpret the differences.

> WRITING TIME: no more than 10 minutes

7. Dear Dad, Father, Pa, Daddy, Papa. Include in this first attempt at a letter, the following:
 - One of the anecdotes you listed in Exercise #1, or a new anecdote that occurs to you.
 - A sentence that begins, "You said,...", not necessarily from the list in exercise #2.
 - Descriptions of place(s) and objects, not necessarily those listed in exercises #3 and #4.
 - Mention of a family member whose view agrees with yours, such as in excercise #5.
 - Mention a family member whose view differs, such as in exercise #6.

You can write the letter now. You may already have it written. Why? Because you have staked your claim on the memories and associations you will need. The critical conscious mind will always stand aside when the authority of the unconscious surfaces! Now you can begin to establish the emotional tone of your letter.

A NOTE TO BOOK GROUPS & WRITING GROUPS

If you are planning to do this together, you might want to schedule two writing sessions about a week apart.

The first session could include much discussion, and the only actual writing would come at the end of your meeting, and only on Exercises #1 and #2, only for 10 minutes apiece. Members can then do Exercises #3 through #6 by themselves during the week.

When you gather again for the later session, you might want to arrange the actual writing of your letters together at the beginning of the session, so that you can have an optional reading at the end for those who feel they can share their letters.

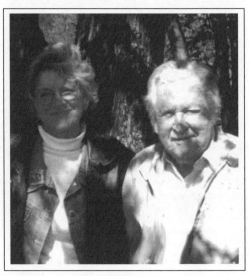

Constance Warloe and her father Harlan Bower
(Notice the inherited squint)
Parkersburg, WV, April 1999

Constance Bower Warloe is author of one novel and the contributing editor of two anthologies. She holds the M.F.A. degree in writing and literature from Bennington College. She is serving internships in pastoral counseling/narrative therapy at the Bedford Veterans Hospital and Children's Hospital in Boston and will receive the Master of Theological Studies (MTS) degree from Harvard Divinity School in 2002.